Graphic Design
USA: 17

The Annual

of the

American Institute

of Graphic Arts

The Annual of the American Institute of Graphic Arts

Written by Janet Abrams, Steven Heller,

Philip Meggs, J. Abbott Miller, and Ellen Shapiro

Book interior designed by Beth A. Crowell,

Cheung/Crowell Design. Design production by

Mark F. Cheung, Cheung/Crowell Design

Jacket designed by Milton Glaser

Marie Finamore, Managing Editor

Studio photography by Jeff Hackett Photography

Copy photography by Jellybean Photographic Services

Distributed to the trade by Watson-Guptill Publications,

1515 Broadway, New York, NY 10036.

ISBN 0-8230-6518-9

First printing, 1997.

Distributed outside the United States and Canada

by Hearst Books International, 1350 Avenue of the

Americas, New York, NY 10019.

Printing. Everbest, Hong Kong

Color Separation: Dynabest, Hong Kong

Paper: Utopia Two, Blue-White Dull Text, Basis

Weight 100#, generously donated by Appleton Papers

Type Composition: Page layouts were composed in

Adobe Quark Express on a Power Macintosh 8100/80.

Typefaces: Bauer Bodoni and Folio

Contents

The AIGA Building Campaign

We would like to thank those individuals and corporations who have contributed to the three-year Capital Campaign to support the renovation and restoration of the AIGA's new home at 164 Fifth Avenue either through the building campaign or the Patron's Endowment Fund. As of October 1996, we have pledges totaling over $750,000.

Friends $1,000 +

Allworth Press
Charles Spencer Anderson
Art Center College of Design
Eric Baker Design Associates
Merrill Berman
Bernhardt Fudyma Design Group
Bruce Blackburn
R. O. Blechman
David Boorstin Associates
Roger Cook
Cooper Union
Paul Davis
Kenneth & Patricia Doherty
Lou Dorfsman
William Drenttel
Hugh Dubberly
John M. DuFresne
Lois Ehlert
Alvin Eisenman
Nancy and Joseph Essex
Stephen Frykholm
Howard Glener
Roz Goldfarb
Peter Good
Robert M. Greenberg
Richard Grefé
Carla Hall
Sylvia Harris
Jessica Helfand
Cheryl Heller
Jerry Herring
Heidi Humphrey
Richard Koshalek
David Leigh
Leo Lionni
Lippincott & Margulies Inc.
Ellen Lupton
Michael Mabry Design, Inc.
Judith A. Majher
Anthony McDowell
James Miho
Mohawk Paper Mills
Jennifer Morla
John D. Muller
Murphy Design Inc.
Janou Pakter

Arthur Paul
Chee Pearlman
Grant Pound
Paul Rand
Red Ink Productions
David Rhodes
Silas H. Rhodes
Robert Miles Runyan
Karen Salsgiver
Paula Scher
Shapiro Design Associates Inc.
Paul Shaw
Lucille Tenazas
George Tscherny
Bradbury Thompson
Clare Ultimo Inc.
Veronique Vienne
Wiggin Design Inc.
Fo Wilson
Henry Wolf
Allen Woodard
Richard Saul Wurman

Contributors $3,000+

Adams/Morioka
AIGA/Washington
Roger Black
BlackDog
Doug Byers
Bob Callahan Design
Margo Chase
Mark Coleman
Concrete [The Office of Jilly Simons]
Concrete Design Communications, Inc.
Michael Cronan
David Cundy
Sheila Levrant de Bretteville
Joe Duffy
Joseph and Susan Feigenbaum
Martin Fox
Hopper Papers
Hornall Anderson Design Works, Inc.
Kent Hunter
Meyer Design Associates, Inc.
J. Abbott Miller
Wendy Richmond
Dugald Stermer

Donors $5,000+

Primo Angeli
Bass/Yager & Associates
Carbone Smolan Associates
James Allin Cross
Richard Danne & Associates
Graffito/Active 8
Diana Graham
Hansen Design Company

Hawthorne/Wolfe
Steven Heller
The Hennegan Company
Mirko Ilic
Alexander Isley
Karen Skunta
Sussman/Prejza & Co., Inc.
Vanderbyl Design Inc.
Wechsler & Partners, Inc.
Weyerhaeuser

Sponsors $10,000+

Addison Corporate Annual Reports
Harvey Bernstein Design Associates
Chermayeff & Geismar Inc.
Designframe, Inc.
Donovan and Green
Fine Arts Engraving Company
Frankfurt Balkind Partners
Milton Glaser
Steve Liska
Clement Mok
The Overbrook Foundation
Stan Richards
Anthony Russell
Arnold Saks Associates
Siegel and Gale Inc.
Team Design
Vignelli Associates

Patrons $25,000+

Adobe Systems Incorporated
Crosby Associates Inc.
Drenttel Doyle Partners
Pentagram Design, Inc.

Benefactors $50,000+

Champion International Corporation

Special Benefactors $100,000

Strathmore Paper

AIGA Chapter Donors $5,000+

AIGA/Minnesota

AIGA Chapter Leadership Donors $8,000+

AIGA/Atlanta
AIGA/Boston
AIGA/Chicago
AIGA/Los Angeles
AIGA/New York
AIGA/San Francisco
AIGA/Washington

A
I
G
A

The American Institute of Graphic Arts

Members of the Institute are involved in the design and production of books, magazines, and periodicals, film and video graphics, and interactive multimedia, as well as in corporate, environmental, and promotional graphics. Their contributions of specialized skills and expertise provide the foundation for the Institute's programs. Through the Institute, members form an effective, informal network of professional assistance that is a resource to the profession and the public.

Separately incorporated, the thirty-eight AIGA chapters enable designers to represent their profession collectively on a local level. Drawing upon the resources of the national organization, chapters sponsor a wide variety of programs dealing with all areas of graphic design.

By being a part of a national network, bringing in speakers and exhibitions from other parts of the country and abroad, focusing on new ideas and technical advances, and discussing business practice issues, the chapters place the profession of graphic design in an integrated and national context.

At the AIGA's Strathmore Gallery in New York (named in appreciation of a major gift to the Institute), exhibitions include both the AIGA's annual award shows, based on its design competitions, and visiting exhibitions. The visiting exhibitions of the past year are highlighted in this annual and include collaborative efforts with the Cooper-Hewitt, National Design Museum, and the Museum of the Book, The Hague. The AIGA's own award exhibitions include the perennial *Communication Graphics* and *fifty Books of the Year,* as well as a new addition to the perennial list, *Information Graphics: Design of Understanding.* Other AIGA competitive exhibitions change in subject each year, focusing on wide-ranging areas of design, such as environmental design, entertainment graphics, and corporate identity. The exhibitions travel nationally and are reproduced in *Graphic Design USA.* Acquisitions have been made from AIGA exhibitions by the Popular and Applied Arts Division of the Library of Congress. This year, the *fifty Books and fifty Covers of 1995* exhibition is being documented in *Speaking Volumes,* a catalogue published and distributed to our members by Mohawk Paper.

The AIGA sponsors two biennial conferences, which are held in alternating years: the National Design Conference and the Business Conference. Seattle '95, the National Design Conference, was held in September of that year, while D2B, the AIGA's second business conference, took place in New York in October 1996. The next National Design Conference will be held in New Orleans in November 1997. Plans are also underway to hold a new conference, focused on the critical issues of trans-cultural communication among the Pacific Rim nations. The first PacRim conference will be held in Honolulu in February/March 1998.

The AIGA also sponsors an active and comprehensive publications program, featuring the ongoing publications *Graphic Design USA,* the annual of the Institute; the *AIGA Journal of Graphic Design,* published three times a year; and the *Membership Directory,* published yearly. Other publications include *The Ecology of Design* (1995), *Graphic Design: A Career Guide and Education Directory* (1994), *and Symbol Signs,* second edition (1993).

More information about the AIGA can be found by visiting our website: http://www.aiga.org.

Board of Directors 1995-1996

William Drenttel, President
Doug Wolfe, Secretary/Treasurer
Richard Grefé, Executive Director

Directors
Michael Bierut, Meredith Davis,
Janet DeDonato, Hugh Dubberly,
John DuFresne, Sylvia Harris, Steve Liska,
Anthony McDowell, Chee Pearlman,
Karen Skunta, Lorraine Wild, Fo Wilson

Board of Directors 1996-1997

Lucille Tenazas, President
John DuFresne, Secretary/Treasurer
Richard Grefé, Executive Director

Directors
Michael Bierut, Meredith Davis,
Janet DeDonato, Steff Geissbuhler,
Sylvia Harris, Louis Lenzi, Steve Liska,
Anthony McDowell, Chee Pearlman,
Samina Quraeshi, Fred Seibert,
Michael Vanderbyl, Lorraine Wild

AIGA National Staff

Richard Grefé, *Executive Director*
Denise Wood, *Director, Information
and Member Services*
Trudie Larrabee, *Director,
Corporate Partnerships*
Richard Dodd, *Director,
Finance and Administration*
Moira Cullen, Director, *Programs*
Marie Finamore, *Managing Editor*
Martha Dunn, *Conference Coordinator*
Gabriela Mirensky, *Program Coordinator*
George Fernandez, *Membership Coordinator*
Rita Grendze, *Chapter Coordinator*
Jennifer Rosenfeld, *Gallery Receptionist*

AIGA Chapters and Chapter Presidents 1994-1995

Anchorage – Cindy Shake
Atlanta – Steve Martin
Baltimore – Brenda Foster
Birmingham – Barry Graham
Boston – Paul Montie
Chicago – Nancy Essex
Cincinnati – John Emery
Cleveland – Judith A. Majher
Colorado – John Skrabec
Detroit – Dave Buffington
Honolulu – Eric Woo
Indianapolis – Scott Johnson
Iowa – Doug Byers
Jacksonville – Mike Boyles
Kansas City – Dan Auman

Knoxville – Cary Staples
Los Angeles – Mary Scott
Miami – Thomas Weinkle
Minnesota – Grant Pound
Nebraska – Dave Brackenbury
New York – Kenneth W. Doherty
Orange County (CA) – Dean Gerrie
Philadelphia – Mark Willie
Phoenix – Michael Kroeger
Pittsburgh – John Sotirakis (co-president)
Pittsburgh – Scott Witalis (co-president)
Portland – Lydia Hess
Raleigh – Jessie Crouch
Richmond – Frank Gilliam
Rochester – Gabrielle Peters
Salt Lake City – Tracy O'Very Covey
San Diego – Bennett Peji
San Francisco – Mark Fox
Seattle – Allen Woodard
St. Louis – Scott Gericke
Texas – Lance Brown
Washington, DC – Donna Lomangino
Wichita – Karen Long

AIGA Chapters and Chapter Presidents 1996-1997

Anchorage – Cindy Shake
Atlanta – Steve Martin
Baltimore – Brenda Foster
Birmingham – Barry Graham
Boston – Paul Montie
Chicago – Nancy Essex
Cincinnati – Beverly Fox
Cleveland – Kurt Roscoe
Denver – John Skrabec
Detroit – David Buffington
Honolulu – Lynn Kinoshita
Indianapolis – Scott Johnson
Iowa – Steve Pattee
Jacksonville – Jefferson Rall
Kansas City – Dan Auman
Knoxville – Cary Staples
Los Angeles – Mary Scott
Miami – Robin Rosenbaum
Minnesota – Dan Woychick
Nebraska – Dave Brackenbury
New York – Kathleen Schenck Row
Oklahoma City – Sarah Sears
Orange County (CA) – Dean Gerrie
Philadelphia – Matthew Bartholomew
Phoenix – David Rengifo
Pittsburgh – John Sotirakis and Scott Witalis
(co-presidents)
Portland – Alicia Johnson
Raleigh – Jessie Couch
Richmond – Frank Gilliam
Rochester – AIGA/Rochester
Salt Lake City – Traci O'Very Covey
San Diego – Bennett Peji

San Francisco – Mark Fox
Seattle – Jesse Doquilo
St. Louis – Scott Gericke
Texas – Lance Brown
Washington, DC – Samuel Shelton
Wichita – Karen Long

Past AIGA Presidents

1914 – 1915 William B. Howland
1915 – 1916 John Clyde Oswald
1917 – 1919 Arthur S. Allen
1920 – 1921 Walter Gilliss
1921 – 1922 Frederic W. Goudy
1922 – 1923 J. Thompson Willing
1924 – 1925 Burton Emmett
1926 – 1927 W. Arthur Cole
1927 – 1928 Frederic G. Melcher
1928 – 1929 Frank Altschul
1930 – 1931 Henry A. Groesbeck, Jr.
1932 – 1934 Harry L. Gage
1935 – 1936 Charles Chester Lane
1936 – 1938 Henry Watson Kent
1939 – 1940 Melbert B. Carey, Jr.
1941 – 1942 Arthur R. Thompson
1943 – 1944 George T. Bailey
1945 – 1946 Walter Frese
1947 – 1948 Joseph A. Brandt
1948 – 1950 Donald S. Klopfer
1951 – 1952 Merle Armitage
1952 – 1953 Walter Dorwin Teague
1953 – 1955 Dr. M. F. Agha
1955 – 1957 Leo Lionni
1957 – 1958 Sidney R. Jacobs
1958 – 1960 Edna Beilenson
1960 – 1963 Alvin Eisenman
1963 – 1966 Ivan Chermayeff
1966 – 1968 George Tscherny
1968 – 1970 Allen Hurlburt
1970 – 1972 Henry Wolf
1972 – 1974 Robert O. Bach
1974 – 1976 Karl Fink
1976 – 1977 Massimo Vignelli
1977 – 1979 Richard Danne
1979 – 1981 James Fogleman
1981 – 1984 David R. Brown
1984 – 1986 Colin Forbes
1986 – 1988 Bruce Blackburn
1988 – 1991 Nancye Green
1992 – 1994 Anthony Russell
1994 – 1996 William Drenttel

The AIGA Medal

The medal of the AIGA, the most distinguished in the field, is awarded to individuals in recognition of their exceptional achievements, services, or other contributions to the field of graphic design and visual communication. The contribution may be in the practice of graphic design, teaching, writing, or leadership of the profession. The awards may honor designers posthumously.

Medals are awarded to those individuals who have set standards of excellence over a lifetime of work or have made individual contributions to innovation within the practice of design.

Individuals who are honored may work in any country, but the contribution for which they are honored should have had a significant impact on the practice of graphic design in the United States.

Past Recipients

Norman T.A. Munder, 1920
Daniel Berkeley Updike, 1922
John C. Agar, 1924
Stephen H. Horgan, 1924
Bruce Rogers, 1925
Burton Emmett, 1926
Timothy Cole, 1927
Frederic W. Goudy, 1927
William A. Dwiggins, 1929
Henry Watson Kent, 1930
Dard Hunter, 1931
Porter Garnett, 1932
Henry Lewis Bullen, 1934
Rudolph Ruzicka, 1935
J. Thompson Willing, 1935
William A. Kittredge, 1939
Thomas M. Cleland, 1940
Carl Purington Rollins, 1941
Edwin and Robert Grabhorn, 1942
Edward Epstean, 1944
Frederic G. Melcher, 1945
Stanley Morison, 1946
Elmer Adler, 1947
Lawrence C. Wroth, 1948
Earnest Elmo Calkins, 1950
Alfred A. Knopf, 1950
Harry L. Gage, 1951
Joseph Blumenthal, 1952
George Macy, 1953
Will Bradley, 1954
Jan Tschichold, 1954
P. J. Conkwright, 1955
Ray Nash, 1956
Dr. M. F. Agha, 1957
Ben Shahn, 1958
May Massee, 1959
Walter Paepcke, 1960
Paul A. Bennett, 1961
Wilhelm Sandberg, 1962
Saul Steinberg, 1963
Josef Albers, 1964
Leonard Baskin, 1965
Paul Rand, 1966
Romana Javitz, 1967
Dr. Giovanni Mardersteig, 1968
Dr. Robert R. Leslie, 1969
Herbert Bayer, 1970
Will Burtin, 1971
Milton Glaser, 1972
Richard Avedon, 1973
Allen Hurlburt, 1973
Philip Johnson, 1973
Robert Rauschenberg, 1974
Bradbury Thompson, 1975
Henry Wolf, 1976
Jerome Snyder, 1976
Charles and Ray Eames, 1977

Lou Dorfsman, 1978
Ivan Chermayeff and
Thomas Geismar, 1979
Herb Lubalin, 1980
Saul Bass, 1981
Massimo and Lella Vignelli, 1982
Herbert Matter, 1983
Leo Lionni, 1984
Seymour Chwast, 1985
Walter Herdeg, 1986
Alexey Brodovitch, 1987
Gene Federico, 1987
William Golden, 1988
George Tscherny, 1988
Paul Davis, 1989
Bea Feitler, 1989
Alvin Eisenman, 1990
Frank Zachary, 1990
Colin Forbes, 1991
E. McKnight Kauffer, 1991
Rudolph de Harak, 1992
George Nelson, 1992
Lester Beall, 1992
Alvin Lustig, 1993
Tomoko Miho, 1993

The Design Leadership Award

The Design Leadership Award recognizes the role of perceptive and forward-thinking organizations that have been instrumental in the advancement of design by applying the highest standards, as a matter of policy.

Past Recipients

IBM Corporation, 1980
Massachusetts Institute of Technology, 1981
Container Corporation of America, 1982
Cummins Engine Company, Inc., 1982
Herman Miller, Inc., 1984
WGBH Educational Foundation, 1985
Esprit, 1986
Walker Art Center, 1987
The New York Times, 1988
Apple and Adobe Systems, 1989
The National Park Service, 1990
MTV, 1991
Olivetti, 1991
Sesame Street, Children's
 Television Workshop, 1992
Nike, Inc., 1993

UTOPIA

T W O

THIS BOOK HAS BEEN PRINTED IN ITS ENTIRETY ON UTOPIA TWO, ONE OF THE HIGH QUALITY COATED PAPERS
PRODUCED BY APPLETON PAPERS. UTOPIA TWO COMBINES EXCEPTIONAL PRINT QUALITY, INK GLOSS, BRIGHTNESS,
AND SURFACE CHARACTERISTICS WITH CONSISTENT, RELIABLE PRESS PERFORMANCE. IT IS PART OF THE BROAD
RANGE OF UTOPIA COATED PAPERS THAT NOW INCLUDES UTOPIA PREMIUM, UTOPIA TWO, AND UTOPIA THREE. UTOPIA
IS AVAILABLE IN GLOSS, DULL, AND MATTE FINISHES; A BRIGHT BLUE WHITE OR WARM IVORY SHADE; SHEETS AND
WEB IN NEARLY EVERY BASIS WEIGHT AND SIZE; WITH A MINIMUM OF 20% POST-CONSUMER WASTE. FOR SAMPLES,
AVAILABILITY IN YOUR MARKET, AND THE NAME OF A STOCKING MERCHANT NEAREST YOU, CALL 1-888-4-UTOPIA.

UTOPIA, THE PERFECT CHOICE IN COATED PAPERS.

Clockwise from top: Muriel Cooper and a student at work (1975); image produced in 1980 at the Visible Language Workshop (VLW); a Polaroid 2024 print produced by VLW students (1979); a layout and design Cooper produced for Transitron, an early transistor manufacturer (Boston, 1950s).

wherever there's electronics...

There's Transitron

Transitron

A strange and marvelous flying machine is poised on its tail above the sand and scrub pines and sluggish deep-water lagoons of Florida's Cpe Canaveral. The sun lights the Atlantic's far, flat horizon in the dim advent of dawn, brown pelicans from their roosts and fly in formation above the surf; are over trees and dunes; swift ospreys lift up and begin to search for fish above the coastal sloughs. But the flying machine remains motionless. Just beyond the bech at Playalinda, it stands on Pad 39 A like an enormous ruddy bullet flanded by two thin Roman candles, to

by Janet Abrams

M uriel Cooper's Visible Wisdom

When new land is sighted, the Corps of Engineers is sent out to survey its hills, vales, caves, and treacherous rocky shallows. They take theodolites and plumb lines, the tools of their trade, and hike the terrain — one step at a time, with plenty of loose footings and clumsy backward tumbles — then stand in the baking sun measuring the features of the land. Later, they translate their notations into maps on which snaking contours and numerals will tell future travelers where to climb for pleasant views, where not to steer a boat, where fresh water may be drunk. When the map is made, few who use it think of the exertions of those who trod the slopes the first time, how they read the land before a path of symbols had been laid to follow. Their names are scarcely known; dedication to the tasks at hand diverts them from the limelight they might otherwise enjoy.

One such pioneer was Muriel Cooper, a designer and educator who charted new territory for design in the changing landscape of electronic communication. I had the great privilege of meeting Cooper in late April and early May of 1995 for this profile of her work as director of the Visible Language Workshop at MIT's world-renowned Media Lab. Those two occasions turned out to be her last major interview. Three weeks later, Cooper died suddenly of a heart attack, just as *I.D.* was arranging

to send a photographer to take her portrait. Four hours' worth of tapes now seem both wretchedly meager — given how much more we could have discussed — but also, under the circumstances, an exceptionally valuable bequest.

The official history of the Media Lab by Stewart Brand (*The Media Lab: Inventing the Future at MIT*, MIT Press, 1989) makes scant reference to this remarkable woman who was, at the time of her death, the only female tenured professor at the lab. Three entries in the index lead to passing mentions but, despite chapter-length discussions of other departments at this latter-day Bauhaus, not one is devoted to the VLW.

And yet, when Cooper showed the latest work of the VLW at the TED5 conference in February 1994, no less than Bill Gates of Microsoft personally asked for a copy of the presentation. As Nicholas Negroponte, director of the Media Lab, comments, "The impact of Muriel's work can be summed up in two words: Beyond Windows. It will be seen as the turning point in interface design. She has broken the flatland of overlapping opaque rectangles with the idea of a galactic universe."

"Muriel was a real pioneer of a new design domain," says Bill Mitchell, dean of MIT's School of Architecture and Planning. "I think she was the first graphic designer

to carry out really profound explorations of the new possibilities of electronic media — things like 3-D text. She didn't just see computer-graphics technology as a new tool for handling graphic design work. She understood from the beginning that the digital world opened up a whole domain of issues and problems, and she wanted to understand these problems in a rigorous way."

And in her last few months, with the triumphant presentation at TED5, she had the sweet victory of knowing that she had proven her case. "Her peers had really pooh-poohed her," says Ron MacNeil, co-founder of the VLW and Cooper's closest colleague for over twenty years, alluding to the skepticism among graphic designers about the "Brave New Dynamics" she had for so long talked about but, until then, not shown. "Conventional 2-D graphic designers use all kinds of tricks to create a sense of dynamics. We've got the dynamics. All those stuffed shirts were just brought to their knees."

• • •

Listening to the tapes after Cooper's death, I found myself laughing out loud again at the impish humor of this gentle, gray-haired lady in baggy black sweater and pants, paisley blouse, and blue-rimmed spectacles — a wardrobe that had changed in pattern but not palette when we met again the following week. And I could

easily picture her — black-and-white ankle-socked feet up on her desk — giving long, meditative responses to my questions between bites on a hand-held chicken bone (her take-out version of that day's Sponsors' Lunch) while Suki, her omnipresent black poodle, settled in the kennel under a literature-encrusted desk.

"I have a profound disdain for answers," she told me, early on, winning my instant empathy. This would be no express ride via predigested sound bites along that gleaming mirage known as the Information Highway. "We do a lot of groping here," she said. "I don't think there are answers. I think there are thoughts."

We first met at the end of the week in which SIGCHI (Special Interest Group on Computer Human Interaction of the Association for Computing Machines) had just held its annual conference in Boston. The Media Lab, being tech-Mecca, still resembled Grand Central Station on Thanksgiving Eve, awash in international visitors for corporations and academe. Things were, thankfully, a little calmer when we met again the next week to talk further about the goals of the VLW, its evolution, the delicate but obviously rewarding relationship with sponsors, and the excitement of current research. "This year has been a good one," she said. "We're on the threshold of some very, very interesting ideas."

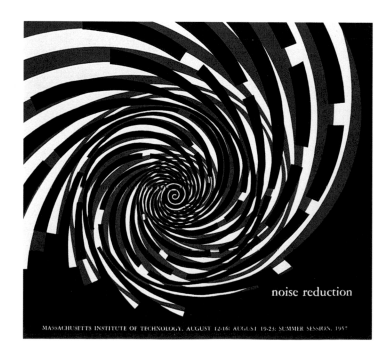

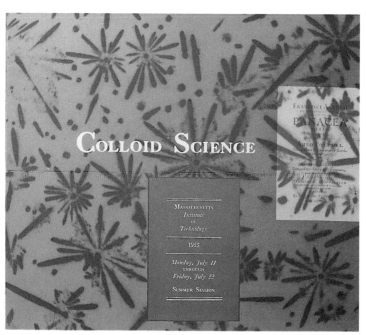

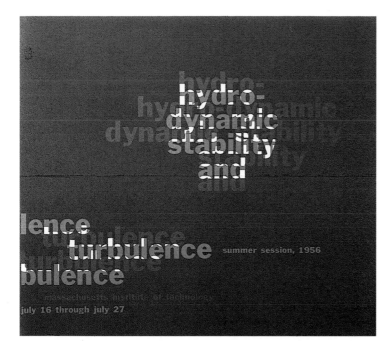

hydro-
dynamic
stability
and

turbulence
bulence

summer session, 1956

massachusetts institute of technology
july 16 through july 27

JULY 22 — AUGUST 2, SUMMER SESSION 1957 — MASSACHUSETTS INSTITUTE OF TECHNOLOGY

$15.00

Innovation in New Communities

Brown Miller,
Neil J. Pinney,
and
William S. Saslow

M.I.T. Press (paper)

This timely study of innovative potentials in new communities—defined in the context of this study as "projects involving the creation of an urban environment rather than the development of limited-use projects in predetermined (or existing) urban patterns"—represents a solid and wide-ranging contribution to the literature on town and city building. At a moment when national and urban growth strategy is crystalizing into a major policy thrust, the authors present abundant and persuasive evidence that new communities can be planned and developed in a manner that accommodates changing technologies and social requirements more efficiently than existing communities.

The book provides a résumé of the fundamental opportunities in new communities, a summary of pertinent social trends, and an unusually illuminating list of innovations. It also addresses issues of population distribution and growth, goals of new communities, and possible future way-of-life scenarios. Drawing on extensive research of progress in both public and private sectors and on authoritative technological forecasting sources, the study succinctly describes a wealth of promising systems—in transportation, communications, energy, and waste management, and in public service programs such as health, education, and institutional control.

Following a survey of current public policy and legislation, the authors construct a financial model to test the feasibility of introducing public service innovations at various stages of community development. The principles and planning determinants derived from this investigation are being applied to the design of a 6000-acre site in eastern Massachusetts.

The final part of the book examines taxonomies of community macroforms and of the smaller-scale service areas manifested in many of the more influential recent new towns and cities. Six informative appendices buttress the main body of work. These range from a description of multiservice cable communication capacities to macroform prototypes and comparative community analties.

Annals of the IQSY

Volume 1
Geophysical Measurements

Techniques
Observational Schedules
and Treatment of Data

Survey Research on Comparative Social Change: A Bibliography

Edited by Frederick W. Frey with Peter Stephenson and Katherine Archer Smith

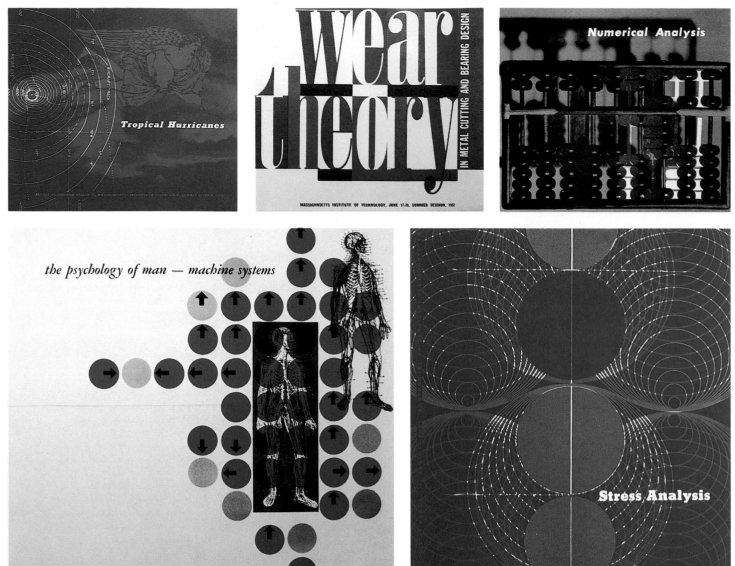

the psychology of man — machine systems

Tropical Hurricanes

Numerical Analysis

Stress Analysis

Massachusetts Institute of Technology, July 8 through July 12, Summer Session, 1957

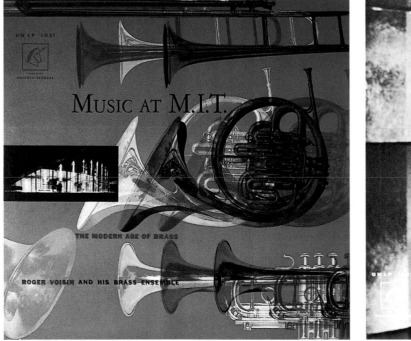

Music at M.I.T.

THE MODERN AGE OF BRASS

ROGER VOISIN AND HIS BRASS ENSEMBLE

MUSIC at M.I.T.

LAWRENCE MOE, ORGANIST

PROF. KLAUS LIEPMANN

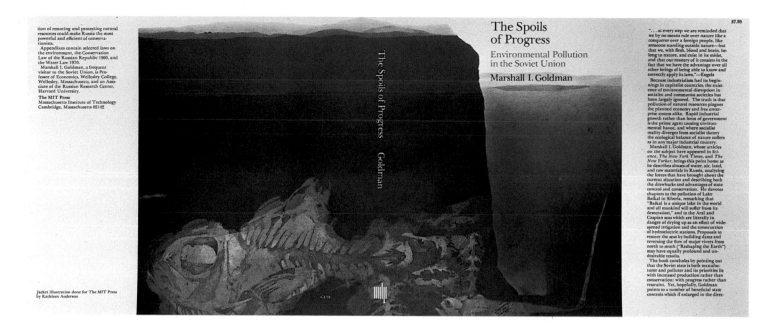

Opposite page, top
and center: MIT Summer
Session brochures
(1959-60). Bottom: MIT
Symphony and Unicorn
Brass Ensemble album
covers (1959). This page:
Book jacket, *The Spoils
of Progress* (MIT Press,
1968).

• • •

Part of the challenge of writing about the
VLW (and about the Media Lab in general,
as Stewart Brand also found) is that the
pioneers of this new technological frontier
speak fluently in a coded language replete
with terms like "anti-aliased," "band-
width," "territory," "assertion rules," and
"double precision floating point numbers,"
to name but a few. The uninitiated visitor
sits before the screens in the penumbral
workshop, watching hypnotized as words
stretch, yawn, and flex, simultaneously
emitting a baby's nursery yowl, or some
other perfectly synchronized sound; as
interpenetrating planes of financial data
revolve and zoom in Star Trek-style
deep space; as freestanding lines of type
hover in this velvety-black computer uni-
verse, then come closer, revealing behind
them a fuzzy colored mass that proves
(on further zooming) to be another chunk
of text...scarcely in focus when yet another
typographic nebula looms into view in
the infinite beyond.

The elegance and apparent effortless-
ness of these demonstrations are easy to
take for granted. But the more one learns,
the more complicated it gets. Only when
one catches a VLW graduate student
switching back and forth on-screen between
the demo and its underlying "code" —
those hieroglyphic knitting patterns that
make things actually happen on a
$250,000 Silicon Graphics Inc. Onyx com-

puter with two SGI Reality Engines
attached, or a 16,000 microprocessor
Connection Machine II — does one begin
to appreciate the effort that goes into
producing these visual feats. That process
— making lucid what has hitherto been
conceptually and visually opaque — is very
much at the heart of the VLW's work.

• • •

It would be easy to see Muriel Cooper's
career as having been divided into two
parts: the conventional print-based graphic
designer, followed by the computer graphics
cartographer. Certainly, by the time she
took up the computer at age fifty-two,
Cooper had established a distinguished rep-
utation as a print designer. Among many
awards, she received the second AIGA
Design Leadership Award for design excel-
lence at MIT, where she worked from 1952
to 1958 and then from 1966 to 1994.
There she founded the MIT Office of Publi-
cations (now Design Services), and was
the first Design and Media Director of the
MIT Press, for which she designed more
than 500 books. She also created the classic
MIT Press logo — an abstract play on the
vertical strokes of the initial letters — in
1963, while running her own design studio.

But rather than a change of course,
Cooper's shift toward computers can be
seen as the continuing pursuit, via new
technology, of an abiding interest: the rela-
tionship of dynamic to static media. She

was, as she recalled, "always trying to push some more spatial and dynamic issues into a recalcitrant medium," namely print. Having designed the epic Bauhaus book for the MIT Press (published in 1969), she later made a film version that attempted a visual speed-reading of the material to escape the sluggishness of the printed page. And in recent work at the VLW, she was beginning to grapple with the converse: how to translate an interactive experience with a computer onto paper, "without just dumping" — an area known technically as "transcoding." In other words: how to turn time into space.

"Electronic is malleable. Print is rigid," she told me, then backtracked in characteristic fashion. "I guess I'm never sure that print is truly linear: it's more a simultaneous medium. Designers know a lot about how to control perception, how to present information in some way that helps you find what you need, or what it is they think you need. Information is only useful when it can be understood."

The primary mission of the VLW is to develop devices and design strategies for manipulating information under constantly changing conditions. Underlying many of these "computationally expressive tools" (to quote the somewhat cumbersome VLW-speak) are the concepts of transparency, adaptability, and blur. Translated into everyday language, these terms imply, respectively, that 1) you can see right through the data, as if it were printed on glass, to sequential layers behind; 2) that if there's a change in background color in a dynamic environment, the type "knows" to adjust its own hue so as to remain legible against it; and 3) that fuzzy fields of information come into focus, and therefore become readable, as you approach them.

The nursery sound I "saw" is just one prototype of a typographical tool that opens up a whole new area of design: the conjunction of image and sound. Using this tool, the shape, size, color, and translucency of type can be made to change in correspondence with a given sound and its tem-

The
Responsive
House

edited by
Edward Allen

DO YOUR OWN THING

A Significance for A&P Parking Lots, or Learning from Las Vegas. Commercial Values and Commercial Methods. Billboards Are Almost All Right. Architecture as Space. Architecture as Symbol. Symbol in Space before Form in Space: Las Vegas as a Communication System. The Architecture of Persuasion. Vast Space in the Historical Tradition and at the A&P. From Rome to Las Vegas. Maps of Las Vegas. Las Vegas as a Pattern of Activities. Main Street and the Strip. System and Order on the Strip, and "Twin Phenomena." Change and Permanence on the

Stone Shelters
Edward Allen

THE NEW TELEVISION:
ESSAYS, STATEMENTS, AND VIDEOTAPES BY VITO ACCONCI, JOHN BALDESSARI, GREGORY BATTCOCK, STEPHEN BECK, WOLFGANG BECKER, RENE BERGER, RUSSELL CONNOR, DOUGLAS DAVIS, ED EMSHWILLER, HANS MAGNUS ENZENSBERGER, VILEM FLUSSER, HOLLIS FRAMPTON, FRANK GILLETTE, JORGE GLUSBERG, WULF HERZOGENRATH, JOAN JONAS, ALLAN KAPROW,
A PUBLIC/PRIVATE ART
DAVID KATZIVE, HOWARD KLEIN, SHIGEKO KUBOTA, BRUCE KURTZ, JANE LIVINGSTON, BARBARA LONDON, EDWARD LUCIE-SMITH, TOSHIO MATSUMOTO, JOHN MCHALE, GERALD O'GRADY, NAM JUNE PAIK, ROBERT PINCUS-WITTEN, DAVID ROSS, PIERRE SCHAEFFER, RICHARD SERRA, ALLISON SIMMONS, GERD STERN, PAUL STITELMAN, HARALD SZEEMAN, STAN VANDERBEEK, EVELYN WEISS.

BAUHAUS BAUHAUS

FILE UNDER ARCHITECTURE

FILE UNDER ARCHITECTURE
Herbert Muschamp

DOXIADIS
Architectural Space in Ancient Greece

Top: Students pulling proofs from an offset press in a Visible Language Workshop (1977). Bottom: Progressive proofs created in the VLW "Creative Seeing" course (1977).

poral duration. A very fast set of algorithms is used to create the number of sizes required for the type to expand and contract, or what Cooper called "on-the-fly scaling." Meanwhile, under the rubric of "behavioral graphics," the VLW has developed a species of "intelligent" type, endowed with its own inherent, but adjustable, physical attributes, such as gravity and bounce, for animation purposes; and "paper" whose "fibers" have differential rates of pigment absorption, allowing variable diffusion of color across its surface — physical characteristics that the computer can model, but that cannot actually be physically produced in the "real world."

A lifelong animation enthusiast, Cooper regarded this technique as a "key component to an overall set of communication vocabularies. Not as in video, not as in scientific visualization or computer animation. Just animation." Asked what is so compelling about it, she began by stating the obvious: "It moves, it tells you much more. I'm more interested in motion than character animation, though that is important as well. Did I love Disney, you mean? Was I turned on by Pinocchio as a child?"

Grinning, she paused for a moment, then revealed a rather different inspiration. "One of the most important animators in my view was Norman McLaren. In the early years of the Canadian film Board, McLaren

Top: Transparencies from the "Books 2000" exhibition celebrating the 2,000 books published by MIT Press (1979). Center row: Visible Language Workshop students (1977). Bottom, students preparing film and color separations at the VLW (1979).

Top: Two computer-generated line drawings and tones produced by VLW graduate students (1980). Center: View of early graphic plotter developed at VLW (1980). Bottom: Two images showing early "blur" on Polaroid format (1981).

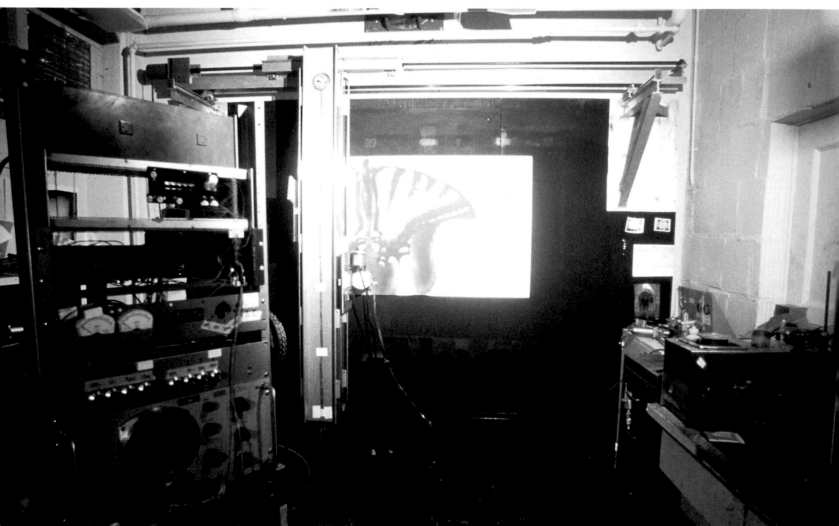

Three self-portraits by a VLW student, using early copy, paste, and distort techniques, recorded with Polaroid (1982).

made images that moved by doing this linear scratching on the cel, among other things. He also did soundtracks. They were quite marvelous."

The work shown at TED5 represented a leap in computer typography, a way of superseding the long-standing cliché of interface design. Instead of having opaque panels of information layered like a deck of cards (the accepted convention of windows-based software), now, with three-dimensional graphics capable of changing size and orientation in real time, the screen turns into a cockpit windshield, admitting onto a landscape of data, navigated with the press of a button. In late 1993, Silicon Graphics Inc. loaned the VLW a Reality Engine, a high-powered machine that propelled Cooper and her team into a new phase of experimentation with type in motion. "On this quarter-of-a-million-dollar computer, you can have a few hundred words on the screen and still do thirty frames per second," says David Small, VLW Research Associate. "If it's that fast, it physically feels three-dimensional. Below that, and you lose the whole visceral feeling."

That feeling, as the TED5 delegates recognized, is just like flying. "Not literal flying," says Small, "but the kind of flying you do in your dreams." Looser, less controlled. A corporeal yet out-of-body experience.

"When Muriel got her hands on a SGI Reality Engine, that really was a turnaround," says professor Steven Benton, head of the Media Lab's Information and Entertainment division, which incorporates the VLW. "She started using it for three-dimensional graphics and the infinity zoom just blew her away. She was absolutely fascinated by being able to zoom in and out by factors of thousands, like some kind of hovercraft. Once somebody showed her what it could do, she didn't stop playing with it."

• • •

Here was a woman, hooked on computers and what they could do, yet she herself could not write "code." "I've tried to learn

to program many, many times, and it frustrates the living hell out of me," she confessed. I asked several people whether it was significant that she was not a code writer. "No. Nor is Marvin Minsky nor is Seymour Papert nor am I," came the emphatic reply from nicholas@hq. media.mit.edu, aka Nicholas Negroponte, referring to two Media Lab colleagues. "Muriel's difference was as a person, not that she was not a computer scientist. She saw things differently. That perspective is worth the world."

"Not only was she not a coder," says Benton, of the Media Lab, "she was not mathematical. All she knew was what she wanted to see, and she couldn't know that until she saw it." Ron MacNeil adds affectionately, "She was a klutz! I was the guy that built the tools, the technical underpinning. She was the design brilliance and administrative muscle. She had learned how to think visually, to create multilayered schemes of possibilities in her head, which is what writing software is. Because she was a completely original thinker, she just refused to learn somebody else's symbology. It was just anathema to her."

Cooper's first encounter with computer programming was a summer course run by Negroponte around 1967, while she was a conventional print designer at the MIT Office of Publications. It was not a promising start. "I nearly died," Cooper said. "We were in this big room with these teletype machines doing Fortran and there was nothing visual about anything. You had to translate any idea you had into this highly codified symbolic language that didn't make any goddamned sense to me, and I was crazy." However frustrating and bewildering that course, Cooper came out of it with "a conviction, naive as it could be, that there lay in computers the possibility of a huge amount of flexibility that the publishing procedure did not have. It was very clear to me that there was a huge potential."

What Cooper brought to the Media Lab was a background not only as a practicing designer, but also as an art school

Views of full-scale
construction of plotter
for billboard-size images
(VLW, 1980).

teacher. The atmosphere of an atelier permeates the VLW: its open-plan physical layout (and hence, social organization) was related to Cooper's idiosyncratic teaching style, as Small recounts. "She was a different kind of teacher: very reluctant to tell you what to do. Once you've started with the assumption that there's no right or wrong way of doing anything, what becomes more important is getting students to think on their own. Muriel set up the right kind of environment for that: the space encourages interaction. Even naming it a workshop, not a lab, was important."

Cooper appreciated the skills of designers and programmers in equal measure, and nurtured a cadre of people possessing both. "My model is very much more an art school, or a design school, where you don't give recipes for things," she said. "But it's not purely a studio, because there's a lot of rigor in making a machine do something you want it to do. The electronic environment seems to me to have significantly different characteristics than any medium

we've communicated in before."

Driving to her house, to fetch tapes she had forgotten to bring in for a colleague, Cooper talked about several epiphanies that changed the direction of her career. There was the spring-cleaning when she went through a closetful of carefully saved pieces of graphics, and realized that she didn't care about any one of them "because they didn't have much content." That propelled her move from graphic design into editorial design, but in time, she grew frustrated by book design as well. "Too often, the role of the designer is to clothe a set of messages they've had no participation in. Here is a book. You didn't write it. You don't change it except insofar as you present the information somebody else has generated. You're not really collaborating, either, because the stuff is there, an accomplished fact. I decided I had to wash that out of my head and impose my own problems."

After several years gestating a text, authors tend to have their own view of what their book should look like, which can

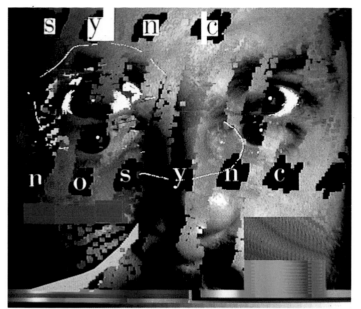
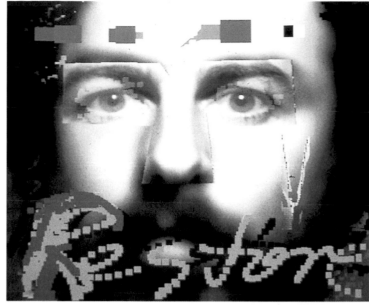

Top: VLW student
project combining photo
images and typography
as "type" and "pixel callig-
raphy" (1980). Center:
Three images of "modeling"
rendered in color (1981).
Bottom: Split-screen
rendering of portrait at
VLW (1982).

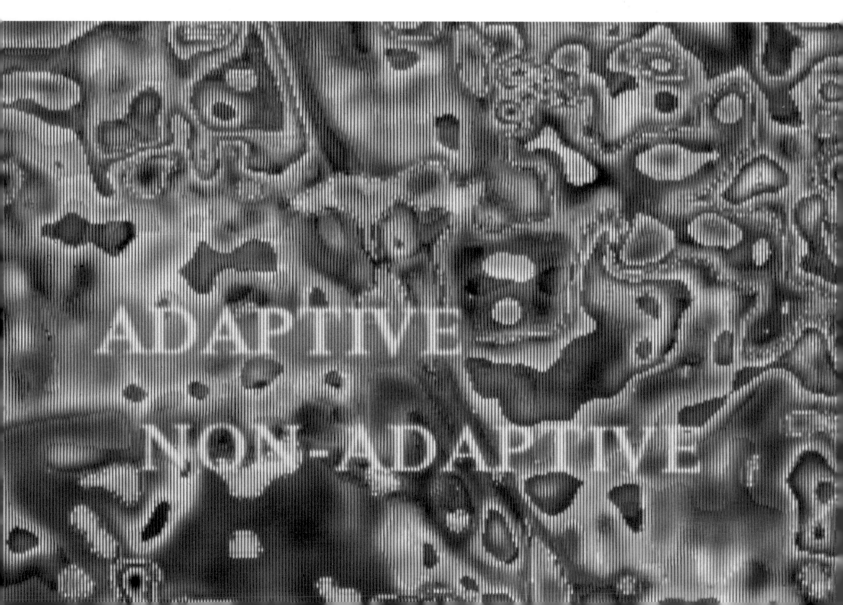

Opposite page: Computer-generated images produced at the Visible Language Workshop during the 1980s, showing (clockwise from top): stacked and distorted type, animation stills, and type combined with blurred and distorted color. This page: Additional computer-generated images from the VLW (1988-89).

lead to some interesting battles of wits. "I had that experience in spades with Denise Scott Brown and Robert Venturi." Cooper recalled, speaking of the original edition of *Learning From Las Vegas*, published by MIT Press in 1972. Cooper even proposed a bubble-wrap cover, in homage to Las Vegas's glitz — a suggestion the authors firmly rejected. "What they wanted most was a Duck, not a Decorated Shed. I gave them a Duck." Cooper went on, referring to the dichotomy between two types of symbolic architecture posited in the book, the former being a literal representation of its function. "I thought: 'God, this is wonderful material. I'm not gonna let them screw it.' Hah! You should have seen it! Well, they hated it! I loved it."

I wondered whether Cooper had writing ambitions of her own. "Yes, I would like to write a book. I always use Gyorgy Kepes's *The Language of Vision* as a model." What would it take for her to write

the book? Without missing a beat, she answered with another question: "A brain transplant?"

On the way back to the lab, Cooper reminisced about early teaching at the Massachusetts College of Art, where the students "froze" when faced with unfamiliar technology, but sprang to life in a class doing interactive printmaking — rotating the plates, changing the fonts and the inks as it moved through. That experience clearly catalyzed her belief in using technology as "a partner in the creative process." She also talked, hesitantly, about what it was like to be a woman in what is still predominantly a man's world.

"I think that's been something of a problem in the Media Lab, though it's changed a lot. You start a meeting and — unless you're much stronger than I am — the conversation almost inevitably dissipates into equipment discussion. And they couldn't be happier. But I'm a terrible

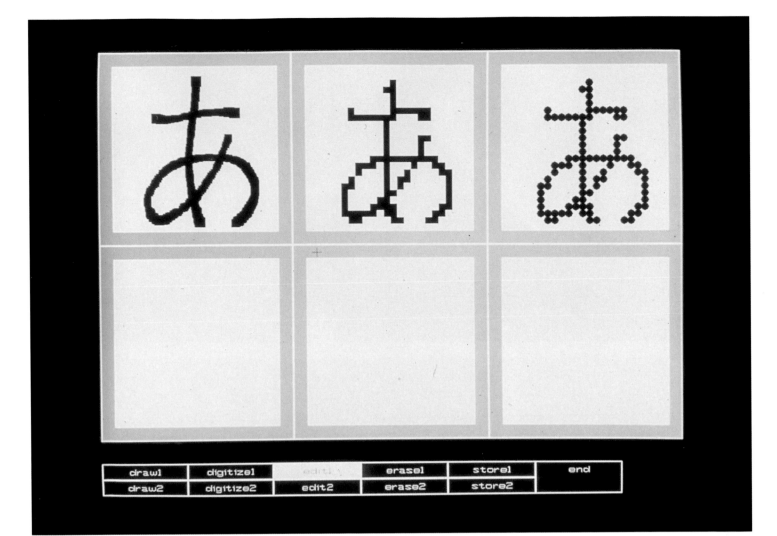

toy freak, too. I love little computers, lots of audiovisual equipment, you name it. As one of my old friends used to say, 'Remember, there's no depression so deep that it cannot be solved by a new piece of equipment.'"

At one point I asked if she minded telling me her age. "No. Sixty-eight. Much to my surprise."

How old did she feel? "About thirteen. I don't know. I'll walk down the street and look at myself off chance in a reflection in a mirror or someplace, and I'll think, 'Oh, my Jesus, who is that person?' It has very little relation to how I feel. Most of the time." She suddenly grew pensive. "Does it matter? I don't know." She paused. "Do I have to have this in the article?"

I said it was up to her.

"Well, I'm a little superstitious. In the sense that there is an awful lot I'd like to do. The worst thing about age, never mind the small indignities of wrinkles and bone loss and possible glaucoma, is that" — and here she raised her voice to a clarion call, addressed to herself — "you damn well better get going. Because you don't know what's going to happen."

Did she consider herself a success?

"On occasion. Has it made a difference? Some days I think it might have. Other days, I think not at all. There's a lot to be accomplished."

This essay is abridged from the original version, published in I.D. Magazine, *September-October 1994. Text copyright © Janet Abrams, 1994 (original version), 1996 (abridged for* Graphic Design USA: 17*).*

Composite comparison of calligraphy at three resolution levels (VLW, 1990).

Top: Muriel Cooper's
signature, used as a title
for a retrospective of her
work designed by family
members for her 1994
memorial service. Center:
MIT Media Lab rendered
as "soft type" (1990).
Bottom: Muriel Cooper
using an SX-70 for a self-
portrait; video imaging
at VLW (1977).

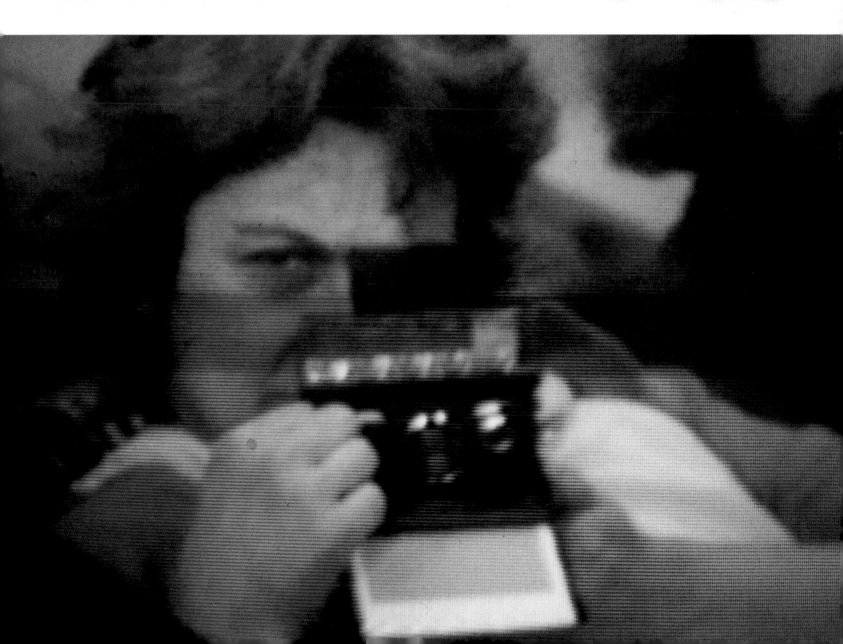

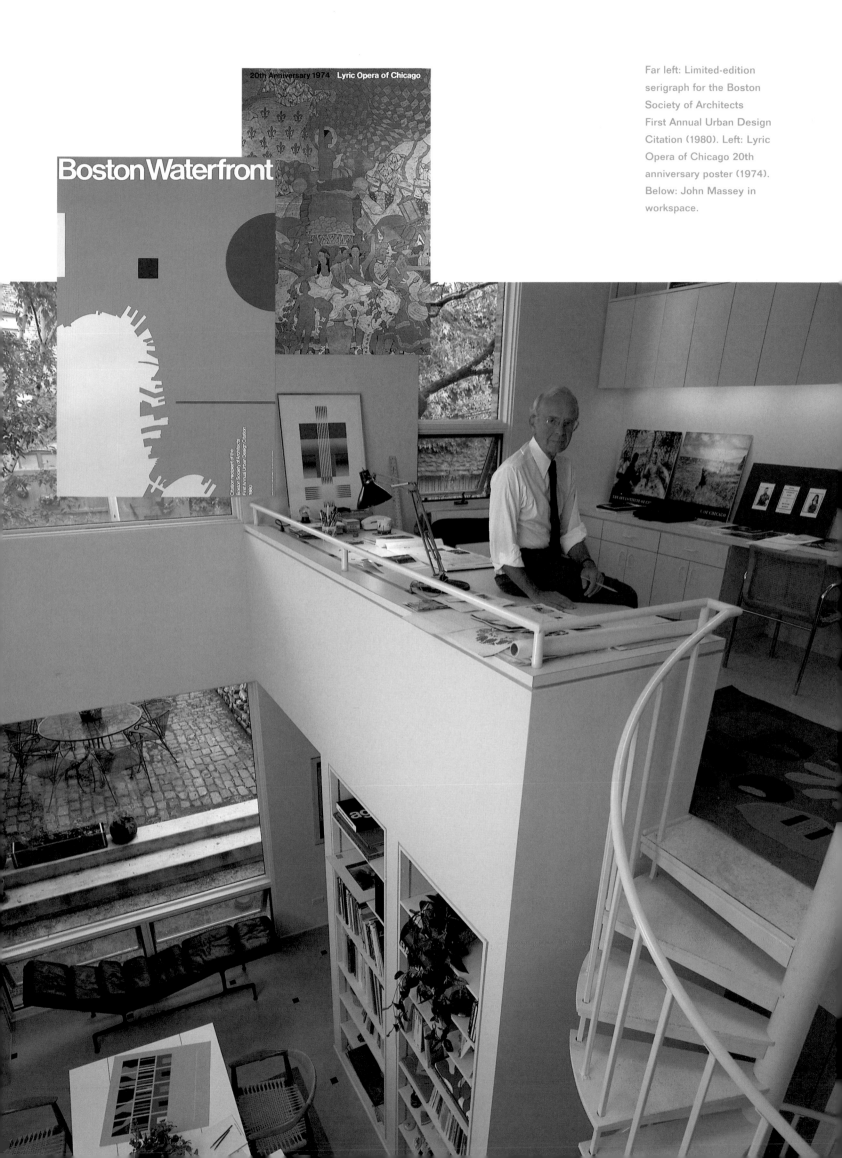

Boston Waterfront

20th Anniversary 1974 Lyric Opera of Chicago

Citation recipient of the
Boston Society of Architects
First Annual Urban Design Citation
1980

Far left: Limited-edition serigraph for the Boston Society of Architects First Annual Urban Design Citation (1980). Left: Lyric Opera of Chicago 20th anniversary poster (1974). Below: John Massey in workspace.

by Philip B. Meggs

G

Student interns received free admission to the fledgling International Design Conference in Aspen in 1953; in exchange, they escorted foreign speakers between the airport, hotel, and auditorium, helped with audiovisual equipment, ran errands, and generally made themselves useful. One student intern from the University of Illinois at Urbana-Champaign was the young John Massey. He was assigned to help two designers from Switzerland whom he had never heard of before: Armin Hofmann from Basel and Josef Müller-Brockmann of Zurich. This experience proved to be one of the major revelations of Massey's life.

Massey vividly remembers picking up the two Swiss designers at the Hotel Jerome and taking them, along with their projector and slides, to the Wheeler Opera House to rehearse their presentations. Over forty years later, Massey recalls watching slides of their incredible Swiss posters and recounts how they changed his whole life. He was mesmerized by the order, color, selectivity of imagery, and the overall aura and spirit of their work. He yearned "to be inside that work, to have it inside of him." From that day forward, he abandoned his dreams of becoming an editorial cartoonist and sought

a higher level of aesthetic and communicative expression. He embraced Hofmann and Müller-Brockmann as role models and did everything possible to educate himself about advanced design thinking.

Massey's fascination with visual imagery dates from age six or seven, when he pored over illustrations, cartoons, and photographs

«Contemporary Ideas of Man»
One of a Series
Container Corporation of America
The Packaging Side of Mercer

Open up, Pandora.

Tear off that cover that shields you from the people, the things around you.

Expose the Black Box that is your soul, your very *power* and relate Pandora

Participate.

—*Washington University Student Year Book 1970*

Right: Container Corporation of America, "Contemporary Ideas of Man" program, acrylic on canvas (1975).

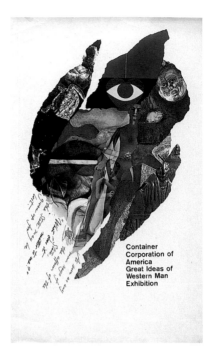

Container Corporation of America Great Ideas of Western Man Exhibition

Above: Container Corporation of America (CCA) "Great Ideas" program poster and catalogue cover (1968). Below left: CCA "Great Ideas" program (1979). Artist: Agnes Dennis. Below right: (CCA) "Great Ideas" program (1978). Artist: Ken Josephson.

in magazines like *The Saturday Evening Post* and decided he wanted to be a cartoonist. He was interested in how artists interpreted things, and his involvement in art and drawing has continued without interruption from early youth.

Massey was the official illustrator for his high school yearbook. While in his senior year in high school, Massey broke his leg in three places playing baseball. He studied fine art at Trinity College in Hartford, but had to leave school during his freshman year for additional surgery on the broken leg.

During a year of convalescence, Massey studied editorial cartooning at the Chicago Academy of Fine Arts under Ed Holland of the *Chicago Tribune*, then enrolled in the University of Illinois at Champaign-Urbana. At the university, he was the editorial and sports cartoonist for the *Daily Illini* and also the editorial cartoonist for the two local newspapers, *The Champaign News-Gazette* and *The Urbana Courier*. Massey's major was advertising design, but he was clueless about what exactly design was until his senior year, when he went to that early

Aspen design conference. His education was centered on traditional training such as figure drawing and anatomy and did not seem especially relevant to his interests. After graduation in 1954, Massey's part-time job as book designer for the University of Illinois Press became full time. Massey worked for Ralph Eckerstrom, design director of the press. Eckerstrom proved to be a dynamic, intelligent man with a great sense of humor and an outgoing personality. From him, Massey learned the relationship between type and paper and cultivated a love of books. Massey still relishes the experience of receiving a book he has designed: holding it, turning the pages, smelling the ink. Eckerstrom's positive attitude and interpersonal relationships offered equally valuable lessons. His impressive presentation skills inspired Massey's own remarkable abilities in that regard.

Massey became art director of the University of Illinois Press in 1957, after Eckerstrom left to join the Container Corporation of America in Chicago. Before the year was out, Eckerstrom invited Massey

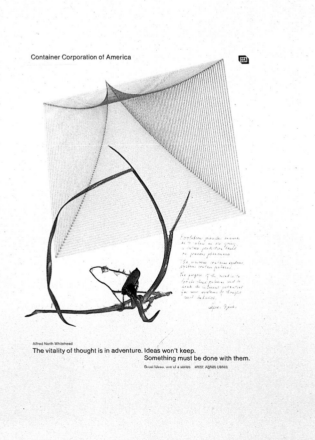

Container Corporation of America

Alfred North Whitehead
The vitality of thought is in adventure. Ideas won't keep.
Something must be done with them.

Great Ideas, one of a series artist: Agnès Denes

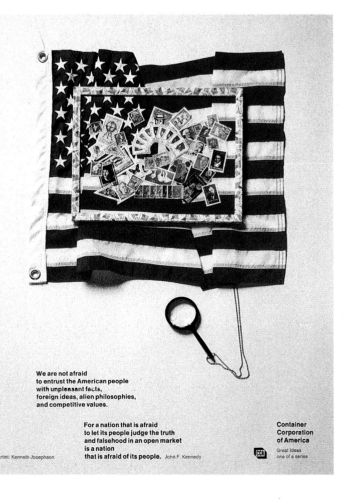

We are not afraid
to entrust the American people
with unpleasant facts,
foreign ideas, alien philosophies,
and competitive values.

For a nation that is afraid
to let its people judge the truth
and falsehood in an open market
is a nation
artist: Kenneth Josephson that is afraid of its people. John F. Kennedy

Container
Corporation
of America

Great Ideas
one of a series

t e n sion

Herman Miller has a healthy respect for tension

as if it were necessarily undesirable,
when the truth is that we couldn't live
without it. Without tension there could
be no balance either in nature or in
mechanical design.
 A tension headache is a symptom,
but of what? Probably of tension in-
appropriately applied. But tension
itself is one of the essentials of
life. When Charles Atlas first addressed
masculine fantasies with the terrifying

which is why some things are better
left unsaid. Sins of omission may
be grave indeed---as in buildings
that omit amenities for the people
who live and work in them---but
omission is often a virtue in design.
"Less is more," Mies said, and he
was right---more or less. Yet, when
you consider that both Samuel Goldwyn
and John Keats were concerned with

omissi n

Herman Miller leaves some things to be desired

**Above left and right:
Series of Herman Miller,
Inc., booklets and posters
based on notes and
thoughts of Ralph Caplan
(1984).**

to become a graphic designer in Container's corporate design office at company headquarters. Shortly after joining Container, Massey met Container's design consultant, Herbert Bayer, who held the title Chairman of the Design Department from 1956 until 1965. Each month Bayer chaired a meeting to review and discuss all design projects and issues within the company. Massey's perspectives were broadened, helping him to achieve an international viewpoint. Bayer articulated the relationship between art, design, life, and business. The connection between art, total reality, and human thought was discussed.

Massey's office was seven or eight doors down from the office of Container's founder and chairman, Walter Paepcke, who built Container into one of America's most admired corporations and was venerated for his support of art and the humanities. Paepcke taught Massey the logic of integrating art and design into industry, for the benefit of society as well as those involved in the enterprise. Paepcke was also a great advocate of continuing education for adults and inspired this love in Massey. Paepcke's employees were encouraged to study the

humanities, so they could understand how their work within the corporation related to the larger human community. Massey believes Paepcke and the philosophy he developed for Container were genuinely idealistic, yet pragmatic. Paepcke believed businesses affected society for better or worse. Container's renowned "Great Ideas of Western Man" ads became one of the most famous advertising campaigns in history. It was inspired by a desire to propagate the important concepts of Western civilization.

From 1958 until 1964, Ralph Eckerstrom served as director of the Department of Advertising and Public Relations. Massey enjoyed a close and cordial working relationship with him, then became manager of design after Eckerstrom left Container in 1964. With Container's full knowledge and approval, Massey had operated an independent design office in Chicago. When he replaced Eckerstrom, it did not seem appropriate for a top executive to run a separate business, so in 1964 Container converted Massey's studio into one of its divisions, called the Center for Advanced Research in Design (CARD). CARD enabled Massey to

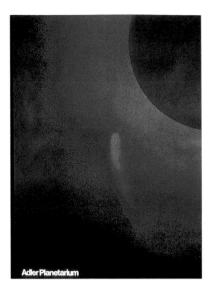

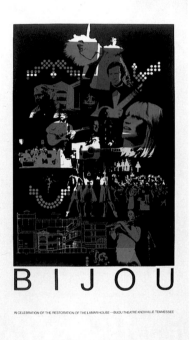

conceive and direct design programs for other organizations, including Atlantic Richfield Company, Inland Steel, and the U.S. Department of Labor.

Advertising was added to Massey's portfolio, and he then became director of communications with responsibility for all of Container's communications activities in North America, Latin America, and Europe. Massey places great value on becoming knowledgeable and involved in the entirety of the corporate structure; this enables designers to integrate design into the totality of the company. The communications program, offices, architecture, transportation, products, and packaging were all guided by Massey as he made design an organic entity in Container's culture. Understanding that whoever controlled budgets had ultimate decision-making authority, he acquired this authority within the firm. From 1964 until its demise, Massey oversaw the continuation of Container's "Great Ideas of Western Man" institutional advertising. It took Massey five years to fully understand the integral relationship between the Great Ideas advertisements and Container's corporate mission. From a pragmatic point of view, the package relates to the world by becoming a bearer of messages about its contents. The "Great Ideas" campaign bears messages with broad ramifications for society. This campaign became a parallel process and metaphor for the processes and purposes of Paepcke's company. Making paper and packages are both arts and sciences. A solid is converted to a ninety-percent liquid, then reconstituted into paper. This new solid is then reformed to make packages. These packages protect, ship, and inform people about the contents.

For a remarkable two decades after Paepcke's death in 1962, his vision and philosophy remained an influence at Container via his employees, even through changes in corporate ownership. Naturally, new owners and managers altered its course as time passed.

A whole community of designers emerged from CCA and CARD. Between the two offices, as many as two dozen designers worked under Massey at a given time.

Prominent Chicago designer Bart Crosby, who worked at CARD before launching his own firm, says CARD was "a scary place to work because the pressure to do great designs was so intense." Massey told him the keys to a design office's success were to "keep the overhead low and do famous work." Once Massey thought Crosby's designs for Herman Miller could be improved and told him, "There are two ways to do things; exactly as I told you, or better."

"The environment was so creative and stimulating," Crosby remembers, "that there was nowhere else to go except to start your own firm."

Joseph Michael Essex, another well-known Chicago studio head who worked for Massey early in his career, says, "John was the buoy who defined where a designer could go. He once told me, 'Be classical or extraordinary; nothing else is acceptable.'" Essex says Massey had a way of letting people work with him, not for him. He mentored from a distance, giving staff designers as much freedom as they could handle.

In 1983, Massey left Container and established an independent design consultancy, John Massey, Inc. Clients have included the Tribune Company in Chicago, FSC Paper Company (one of the largest manufacturers of 100 percent post-consumer recycled paper in the country), The Chicago Community Trust, American Library Association, American Planning Association, and Herman Miller, among others.

Massey began teaching at the University of Illinois at Chicago in 1984 and was appointed full professor in 1986. Teaching has enabled him to share his experiences and insights with an emerging generation of designers. He operates a course for seniors, who must submit their portfolios to him for admission. Each semester they design a comprehensive project for a public or private sector client, as Massey leads the team through the process of data collection, analysis, design development, and ongoing work sessions with the client throughout the semester. The course culminates in a final presentation to the client's management group or board. Massey

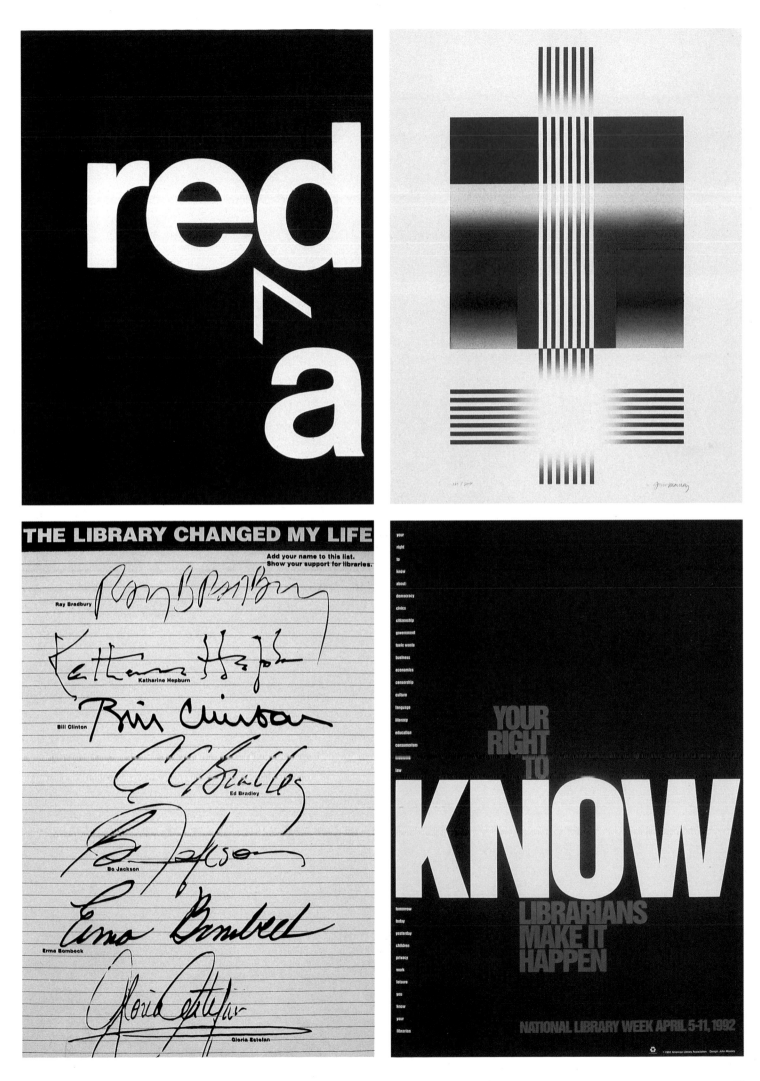

delights in his work with students, and confesses to never knowing how the project will turn out as the design process involving his interaction with students proceeds.

Massey is fascinated with order and the potential for expression through orderly systems. On a recent trip to Egypt with his wife, Barbara, Massey entered tombs 3,000 to 5,000 years old. Sections of some of the wall murals were incomplete and a red grid marking system had been applied to the walls in modules approximately a half-inch in size. Vast wall murals of hieroglyphics and images were all based on this system. Massey is fascinated by the order in earlier art, the order in the universe, and the order within chaos. His art and design are always based on a system, often a grid but sometimes an unstated system in his mind's eye. Massey believes even elementary systems contain the potential for unlimited possibilities.

For Massey, color is one of the most powerful vehicles for experiencing andexpressing thought and emotion. "We understand our environment in terms of the juxtaposition of color," he says. "Planes, proportion, and space are defined by where one color ends and another begins. Hope, fear, space, our physical and natural environment are all defined by color. The act of placing one color next to another is the most difficult thing an artist can do."

Massey is a classical typographer. Order, clarity, and legibility are paramount goals. His typographic palette is limited to great faces that have stood the test of time, such as Bauer Bodoni, Garamond, Helvetica, and Univers. "Assembling letters into words, which are easily recognizable symbols," he notes, "is the essence of typography." He muses that much typographic work today has more to do with decoration and self-expression than with typography.

Massey has been involved in painting, printmaking, and photography throughout his career, and sees very little difference between his fine- and applied-art activity. He says, "A graphic design must satisfy the problem it was conceived and planned to solve, but it can achieve a life of its own, transcending the assignment. This autonomous life is achieved because the creator imbues it with a spirit." Massey cultivates this spirit through his prints and paintings. He believes those who attempt to meld art and design should understand when it is appropriate to join them or separate them.

"John really is an artist who is a designer," says Bart Crosby. "He believes in cosmic energy — being in tune with the cosmos. He has a spiritual philosophy about design and how you create it." Crosby says Massey became a spiritual creative force for a generation of designers; he can "create abstract images to communicate with people."

"John Massey's approach to graphic design is very comprehensive," adds William Clarkson, former chairman and CEO of Graphic Controls Corporation and a Massey client at CARD, then at John Massey, Inc. "He steps back and assesses the total situation before starting to design. By understanding the total context, he could tune into the organization, its culture, its needs ... then reflect them in his work. Or, if he senses problems, he addresses the philosophy and direction.

"John is soft-spoken and an exceptional listener with outstanding interpersonal skills; he builds excellent relationships with clients. His presentation skills are masterful. With so many professional lawyers, architects, and graphic designers, one feels like the clock is ticking, ticking, ticking. With John, after the fee is established one knows he is going to work on the problem until it's right."

John Massey is a generous and honest person, known for personal modesty and uncompromising standards of excellence. True to character, when I interviewed him for this essay, he talked more about his influences, employees, and clients than himself. He has helped his clients to understand the role of art and design within a company, and how it can help a company in achieving its mission. He has been the catalyst for observable changes in management attitudes about the integration of art and corporate life.

Ethics, aesthetics, creativity, and hard work characterize John Massey and have enabled him to establish a paradigm of the graphic designer as a vital force in contemporary life.

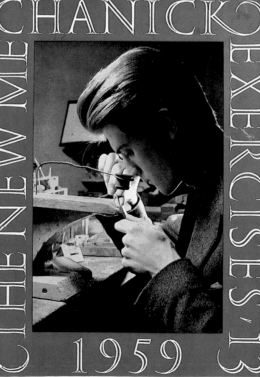

AABCDEE FF
GHIIJKK
LMMNOPQRR
STTUVWXX
YZ & ÆŒ
123467890 5
$£¥ƒ.,:.;-!?□□
+−×=±÷∼⌐‹›
AO©←→‹›«»*†‡
ÅÅÇÉÏJÑÔÔØÙ
¶§ΔΠΣΩ

by J. Abbott Miller

Matthew Carter: Gentleman Typographer

With head bent and fingers delicately poised with his graver, Matthew Carter is gazing through a lens with the cool intensity of an accomplished surgeon. But because he is wearing a suit and tie and his hair is carefully combed, one senses that this is not an offhand snapshot, but a rigorously composed portrait of the artist as a young man. The image graces the cover of a 1959 typographic journal called *The New Mechanick Exercises*. In an essay on what was even then a vanishing art, Carter is shown — deliberately, devotedly, anachronistically — punchcutting. The article speculates that Carter would "eventually achieve the same renown as...Eric Gill." [1]

Carter's life has the contours of a manifest destiny toward typography. His father, Harry Carter, was a respected typographer and authority on the history of typefounding and punchcutting techniques. At the age of twenty, fresh out of school, Matthew spent a year learning to cut punches by hand through an internship program at the famous Enschedé printing house in Haarlem. Having passed his exams to begin at Oxford, he realized he couldn't face three years at university after having tasted a year out in the world. He had "vaguely bookish plans" to pursue at Oxford, but was not excited by the prospect of studying there:

"English at Oxford was all Beowulf, nothing modern." Expecting his father to contest his decision, Matthew was surprised to find him very supportive. A distinguished typophile, Harry Carter introduced his son to important people and helped set him on his chosen path.

Carter has the privilege of having retraced the technological development of typography in the course of his own training. After his immersion at Enschedé, he spent six years as a freelance type and lettering designer in London. He then moved into phototypesetting technology as a typographical adviser to Crosfield Electronics. In 1965 he decided to move to the United States to take a position at Mergenthaler Linotype in New York, where he designed Snell Roundhand, Helvetica Compressed, and Greek and Korean faces, among others. Six years later, Carter crossed the Atlantic again, returning to London but preserving his link with Linotype. He designed Galliard, the font that is perhaps most closely identified with his name, during this period, as well as Bell Centennial, a beautiful space-saving font created for use in American telephone directories. Alongside these classics, he created Hebrew, Greek, and Devanagari fonts, as well as Shelley Script. Crowning, metaphorically but also

Opposite page:
Bell Centennial, an
elegant, space-saving
font designed for
use in American
telephone directories.

somewhat literally, this prolific period, Carter was named Typographical Adviser to Her Majesty's Stationery Office, the British government printer, from 1980 to 1984, and was elected a Royal Designer for Industry in 1982. In the midst of this professional recognition, Carter became interested in the entrepreneurial implications of the digital type revolution. In 1981 he was one of four co-founders of Bitstream Inc., a digital type foundry based in Cambridge, Massachusetts. Bitstream was among the first of the independent font foundries. More than a decade later, two of the founding partners, Carter and Cherie Cone, established a new, smaller company called Carter & Cone Type Inc. With the diminution in scale and staff, Carter was relieved of some of the administrative and financial burdens to be found in larger organizations.

Carter's typographic achievements over the last five years have proven the wisdom of his move into smaller quarters: some of his finest works — the fonts Elephant, Mantinia, Sophia, Big Caslon, Alisal, and Walker — were created during this period. While many of Carter's typefaces have responded to pragmatically defined needs, the Carter & Cone fonts have tended to be of a more speculative nature, pursued as inspiration struck. Mantinia, for example, is based on the lettering that mesmerized Carter when he saw a major retrospective of Andrea Mantegna's work: "I think he is the best letterer of any painter.... I had this feeling that, historically speaking, Mantegna had been very important in opening people's eyes to the beauty of the classical letterforms." [2] Another font that responds to a historical precedent is Sophia, based on the highly mixed lettering found in Constantinople around the sixth century, when that area of the world was extremely cosmopolitan. In designing Sophia, an important resource for Carter was a silver chalice from the Museum of Fine Arts in Boston whose lettering provided a particularly interesting example of this hybrid style.

Carter's reputation is one built on both good type and good words: his contributions to the formal vocabulary of typography must be seen against the backdrop of his intellec-

tual gifts. He is an articulate commentator on typography, an amused observer of its public life, sprinkling lectures with puns and aphorisms that betray the life of a mind obsessed with type (e.g., "movable type is now mutable type."). What is obvious, in the visual evidence of his type design as well as in his lectures and writings, is a generosity of spirit, a constantly calibrated measure of restraint and flourish in his visual and verbal talents.

His thoughts on design are not worn with the armor-plated sureness of the veteran practitioner: he is instead perceptive, fluid, and gracious in the face of the enormous changes that have swept typographic technology in the last forty years. He does not offer a creed or a manifesto, but has rather issued kernels of wisdom, warning against the orthodoxies of technological determinism, or overarching theories of truth-to-materials in type design. When he states that "technology changes faster than design," he is arguing, gently, for the preservation of typographic ideals; when he says he is "not an absolutist," he is advocating tolerance of the experimentation of younger type designers. Not only does Carter welcome graphic designers who are undertaking their own type design, he is excited by the radical democratization of type made possible by the personal computer. He is not, however, an uncritical pluralist. In response to the recent flood of typographic activity, he says, in characteristic understatement, "The results are not always wonderful, but ... you cannot champion the demystification of something and then protest that the results are mystifying!" [3]

Within Carter's oeuvre there is no sense of a recurrent aesthetic. He has been a problem solver (Snell Roundhand, Bell Centennial), a historian (Big Caslon), a synthesizer (Sophia), and a radical (Walker). He designed Snell Roundhand not because he has a fondness for scripts, but because photo-composing machines made joining scripts possible. Thus his influential design of Snell was a celebration of a kind of technical liberation from the constraints of metal typecasting rather than

DISTRICT OF COLUMBIA

11359 c The Chesapeake And Potomac
Telephone Company 1979

Watkins Anthony E MD—
 Ofc 106 Irving St NW - - - - - - - - - - - - - - - 726-7474
 If No Answer Call - - - - - - - - - - - - - - - - - - 462-6711
Watkins Anthony S 1364 Kenyon St NW - - - - 265-2546
Watkins Archie B 843 Longfellow NW - - - - - 723-6902
Watkins Arminta M Mrs 2210 1st St NW - - - - 483-5009
Watkins Artis L 3703 4th St SE - - - - - - - - - 561-5726
Watkins Ashley 1140 N Cap St - - - - - - - - - - 289-6946
Watkins Audrey E 113 R St NE - - - - - - - - - - 832-7603
Watkins Barry B Jr Howard Univ - - - - - - - - 636-0954
Watkins Benj O Jr DDS ofc 3326 Ga Av NW - - 726-8383
 Res 1644 Roxanna Rd NW - - - - - - - - - - - 829-6168
Watkins Berry Howard Univ - - - - - - - - - - - 636-0777
Watkins Berta G Mrs 431 11th St NE - - - - - - 546-0921
Watkins Beulah Mrs 1710 Euclid NE - - - - - - 667-3493
Watkins Blanton I 133 35th NE - - - - - - - - - 396-8641
Watkins Booker T 57 O NW - - - - - - - - - - - - 462-0831

WATKINS-BURDETTE MOTOR CO
 1820 Rosemont Av
 Fredrck - - - - - - - - - - - Rockville Tel No - 948-0992
Watkins C Mrs 700 Jefrsn St NW - - - - - - - - 723-2174
Watkins C A 1674 Beekman Pl NW - - - - - - - 667-0677
Watkins C E 1336 Mo Av NW - - - - - - - - - - 722-0863
Watkins Calvin S 1530 Mass Av SE - - - - - - - 547-2738
Watkins Cameron D 604 Van Buren St NW - - - 726-2618
Watkins Carol 2900 14th St NW - - - - - - - - - 265-8709
Watkins Chas D 1519 41st SE - - - - - - - - - - 582-0685
Watkins Charles E 1731 NH Av NW - - - - - - - 332-9552
Watkins Chas P 32_5 Walnt NE - - - - - - - - - 529-0927
Watkins Clarissa Mrs 91 Sherdn NE - - - - - - 882-2319
Watkins Claude E 1001 Taussig Pl NE - - - - - 526-7442
Watkins Clifton 2325 13th Pl NE - - - - - - - - 526-0539
Watkins Cora R Mrs 5543 Chilum Pl NE - - - - 529-8962
Watkins Corporation
 6849 Old Dominion Dr McLean - - - - - - - - - 893-0740
Watkins D 2420 2nd NE - - - - - - - - - - - - - 832-5954
Watkins Daisy 4801 Ala Av SE - - - - - - - - - 581-6243
Watkins Darlese L Ms 13 K Terr NW - - - - - - 289-8339
Watkins Dewey R Jr 1811 Irving NW - - - - - - 265-8387
Watkins Donnie 27 42nd St NE - - - - - - - - - 398-7608
Watkins Doris 5025 Sheriff Rd NE - - - - - - - 398-4398
Watkins Dorothy C 1409 Ames Pl NE - - - - - - 547-5556
Watkins Dorothy M Mrs 1800 12th NW - - - - 462-5935
Watkins Earl J 609 Consttn Av NE - - - - - - - 546-2377
Watkins Eddie 3128 10th St NE - - - - - - - - - 635-4925
Watkins Edith A Mrs 2120 4th NE - - - - - - - 832-9347
Watkins Elaine 1855 Kendall St NE - - - - - - - 832-8062
Watkins Ernest 5305 Drake Pl SE - - - - - - - - 584-2974
Watkins Ethel 1729 D SE - - - - - - - - - - - - 544-6819
Watkins Eva G Mrs 1812 Vernn NW - - - - - - 265-3376

WATKINS F L CO INC
 5701 George N Palmer Hwy
 Seat Pleasant Md
 Washington Area Tel No - - 396-6300
Watkins Floyd L 1912 T St SE - - - - - - - - - 678-5367
Watkins Foreman D 1431 Whitier Pl NW - - - - 726-2913
Watkins Francis 1365 Kendy St NW - - - - - - 723-2306
Watkins Francis 1435 Newton St NW - - - - - - 234-0808
Watkins Fred 1371 Spring Rd NW - - - - - - - 726-3621
Watkins Gladys M Mrs 1444 Oglthrpe NW - - - 291-3696
Watkins Gretna 901 RI Av NW - - - - - - - - - 265-3021
Watkins Harry 1440 Meridn Pl NW - - - - - - - 797-8994
Watkins Harry 3802 14th St NW - - - - - - - - 291-4229
Watkins Irene Battle 509 Powhatn Pl NW - - - 726-3069
Watkins Irene J 5408 D St SE - - - - - - - - - - 582-8893
Watkins Ivey T 2301 11th NW - - - - - - - - - 332-9035

Watkins Nellie Mrs 80 O NE - - - - - - - - - - 667-4680
Watkins Nellie Mrs 1216 44th Pl SE - - - - - - 584-0916
Watkins Otha Mrs 4402 Falls Ter SE - - - - - - 582-1905
Watkins Queen Isabel 1515 F St NE - - - - - - 398-2365
Watkins Queen V Mrs 1239 Perry NE - - - - - 526-6089
Watkins R 2401 Calvert St NW - - - - - - - - - 332-8265
Watkins Ralph James 1601 18th St NW - - - - 265-1729
Watkins Randy 1385 Nichlsn St NW - - - - - - 726-8253
Watkins Ransom 2306 2d NE - - - - - - - - - - 832-7682
Watkins Reginald D 1800 Birch Dr NW - - - - 723-5029
Watkins Richard 1277 Simms Pl NE - - - - - - 399-5679
Watkins Robert P Iwyr 839 17th St NW - - - - 331-5077
 7944 Orchid St NW - - - - - - - - - - - - - - - 829-5780
Watkins Roger R 3601 Wisc Av NW - - - - - - 362-0916
Watkins Ronald 54 T St NW - - - - - - - - - - - 483-6388
Watkins Ronald E 1445 Fla Av NW - - - - - - - 387-4979
Watkins Ronald W 3352 Baker St NE - - - - - - 397-6329
Watkins Rosa Bell 4003 13th NE - - - - - - - - 832-4535
Watkins Rose 1748 Benng Rd NE - - - - - - - - 396-0086
Watkins Rosser D 34 U NW - - - - - - - - - - - 387-3576
Watkins Roy 3005 Bladnsbrg Rd NE - - - - - - 529-8666
Watkins Ruby L Mrs 113 RI Av NW - - - - - - 483-5323
Watkins-Rummel Studio 930 F St NW - - - - - 347-3533
Watkins Russell W 729 Atlntc SE - - - - - - - - 562-5926
Watkins S 2300 Good Hope Rd SE - - - - - - - 678-9343
Watkins Salt Co Phila Rd White Marsh Md 301 335-7300
Watkins Sarah E Mrs 2900 Newton NE - - - - 832-2097
Watkins Sarah F 4262 E Cap St - - - - - - - - - 398-2669
Watkins Sarita B Howard Univ - - - - - - - - - 636-1748
Watkins Stephen B 3431 Oakwd Terr NW - - - 667-5311
Watkins Steve 4927 G St SE - - - - - - - - - - - 581-1770
Watkins T L 2159 30th St NE - - - - - - - - - - 635-7787
Watkins Theodore L 1210 V St NW - - - - - - 387-6165
Watkins Theresa 27 42nd St NE - - - - - - - - 398-7608
Watkins Thomas J 256 56th Pl NE - - - - - - - 396-4132
Watkins Tobbie 5449-A Randolph Cir SW - - - 562-2337
Watkins Vera W Miss 1338 Corbin Pl NE - - - 547-7329
Watkins Veronica D 2506 Pomeroy Rd SE - - - 678-7463
Watkins Virgie 2721 Shipley Terr SE - - - - - - 678-0682
Watkins Vivian E Mrs 1016 11th NE - - - - - - 397-4377
Watkins Walter L 3978 E Cap - - - - - - - - - - 396-3046
Watkins Walter R 91 Sherdn NE - - - - - - - - 882-2319
Watkins Wes Hon 110 Md Av NE - - - - - - - - 547-0696
Watkins Wesley 115 4th St SE - - - - - - - - - 547-3717
Watkins Wm 1830 R St NW - - - - - - - - - - - 667-5092
Watkins William 3511 13th St NW - - - - - - - 232-3723
Watkins William 2445 15th St NW - - - - - - - 667-8398
Watkins William A 1730 Willard St NW - - - - 265-0353
Watkins Wm Henry 3210 Quesada NW - - - - - 362-2668
Watkins William P Catholic Univ - - - - - - - - 635-6221
Watkins Wm P 7408 Eastrn Av NW - - - - - - 723-5187
Watkins Willie P 2480 16th St NW - - - - - - - 265-2631
Watkinson H H Sqdn Ldr 2844 Wis Av NW - - - 966-4604
Watkis D J 1740 Euclid St NW - - - - - - - - - 232-2654
Watkis Kevin 758 Girard St NW - - - - - - - - 797-7247
Watlington Charles O 2527 Q St NW - - - - - - 338-5567
Watlington Janet B 4705 Asbury Pl NW - - - - 363-4353
Watlington R A 4633 Ellicott St NW - - - - - - 244-5958
Watnik Joy American Univ - - - - - - - - - - - 537-5921
Watriss Whitney 3416 Porter St NW - - - - - - 244-0472
Watriss Whitney 3318 14th St NE - - - - - - - 526-7971
Watrous Geo D Jr 5031 Reno Rd NW - - - - - - 363-4745
Watrous Woodworth A 1500 Mass Av NW - - - 659-1715
Watson A 5547 SD Av NE - - - - - - - - - - - - 635-0377
Watson Albert 843 Decatr NW - - - - - - - - - 829-3617
Watson Albert 11 61st St NE - - - - - - - - - - 398-5833

This page: Big Caslon and Mantinia, two of the fonts Carter has designed at Carter & Cone Type, Inc. Opposite page: Type compositions by Matt Eller, Design Director, Walker Art Center.

Big Caslon

72 pt. THE CONCERT room had both an organ and a harpsichord, refreshments on a sideboard, and excellent home-brewed ale. Guests left at twelve, to walk 60 pt. safely home under a full moon. This picture of Caslon's comfortable and cultured domestic life is reflected in his types, or rather in the harmonious smaller sizes it is.

MANTINIA

CAPS & SUPERIORS
SHIFT KEYS · UNSHIFT KEYS

AABBCCDD
EEFFGGHHIIJJ
KKLLMMNNOOPPQQ
RRSSTTUUVVWWXX
YY&&ZZÆÆŒŒ
07 · so' · o' · soq · oq

FIGURES
ON FIGURE KEYS

1234567890

SMALL CAPS

HACEHIORSTUWYZH
02 · oj · o5 · sok · sob · so8 · or · os · o; · o= · ow · og · oz

INTERPOINTS
08 · 06 · so9

TALL CAPITALS
TO AN OVERLAPPING COMBINATION LIKE THIS IS AUTOMATICALLY POSITIONED BY THE KERNING TABLE

HIHThLHYH
so1 · so2 · so5 · so6

LIGATURES

HVCThUPIATTŒ
s · sov · s6 · sor · sop · ol · s3 · so~

TUTWTYMEMPMDMBE
s, · s. · ox · om · op · od · ob · ot

ALTERNATIVES

AOT&YRRQQ
o9 · oo · s2 · so& · ov · s\ · \ · s~

ACCENTS &C
[ACCENTED SUPERIOR CAPITALS ARE IN THE CORRESPONDING LOWERCASE LOCATIONS]

ÀÁÂÄÃÅÇÐÈÉÊËÌÍ
o'A · oeA · oiA · ouA · o'A · ~ · 5 · c-a · o'E · oeE · oiE · ouE · o'I · oeI

ÎÏŁÑÒÓÔÖÕØÞ
oiI · ouI · c-c · onN · o'O · ozO · oiO · ouO · onO · soO · c-k

ŠÙÚÛÜÝŸŽ
c-e · o'U · oeU · oiU · ouU · c-g · ouY · c-n

SET AT 42 POINT, LETTERSPACED

the pursuit of a particular aesthetic. The font Walker, commissioned by the Walker Art Center in 1994, features an unprecedented kind of "snap-on" serif, accessed through alternative keystrokes. The interest in a sans serif with optional serifs grew organically out of discussions with the design staff of the Walker Art Center. It was only afterward that Carter remembered that a functional model for Walker existed in his solution for photo-setting accents in Greek fonts. His solution in the Greek font was to drop the accent on top of a letter with a zero-space key before hitting another character that would advance a letterspace. This method of building composite characters in Greek photo lettering is also used in Walker to build serif characters and linking strokes. Walker's kit-of-parts sensibility represents a paradigm shift in type design that is sure to be influential.

Carter sees two tendencies in type designers: those who have a strong visual personality, and those whose work does not elaborate a signature aesthetic. Carter offered Goudy, Hermann Zapf, and Gerard Unger as examples of designers whose work he admires for its singularity of vision. Carter vividly described their fonts as having "residual, skeletal forms." He sees himself, however, as coming from a different position, attributable to his background in type-founding rather than art or design school. While there may be no recurrent structure from one of Carter's fonts to the next, there is certainly a great deal of structure particular to each one. One of Carter's favorite assessments of his work asserts that the letters he draws have "backbones." This sturdiness of structure is evidence of an analytical rigor that his fonts, writing, and speaking share. His typefaces have the precision, conviction, and distinction of a well-thought argument or clear diction.

When Carter says, "I can't think of a period in typography that I would rather be working in," one realizes that he has grasped the implications of his own talent in its intersection with history. When asked what sustains his interest in typography, he offers this: "A font is always a struggle between the alphabetic nature of the letter-form, the 'A-ness' of the A, and your desire to put some of yourself into the letterform. It's a struggle between representing something (you cannot take endless liberties with a letterform) and trying to find some iota of yourself in it." With characteristic modesty, Carter speaks of finding oneself in the letter as opposed to merely putting oneself in it. The statement is a beautiful evocation of the tension between expression and restraint that animates the work of Matthew Carter.

1. Ellic Howe (editor), "From Moxon to Carter: Concerning the Art of Punchcutting," *The New Mechanick Exercises* (no. 13, 1959), p. 8.

2. Janet Waegel, "The Undead," *X-height* (vol. 2, no. 1, Spring 1993), pp. 6, 7.

3. Matthew Carter, "The Future for Fonts," *Ampersand* (vol. 13, no. 1, 1993), p. 9.

All statements not footnoted are taken from an interview with Matthew Carter by J. Abbott Miller, June 11, 1996.

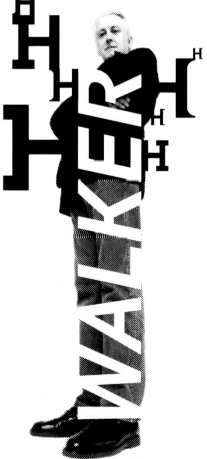

MATTHEW CARTER

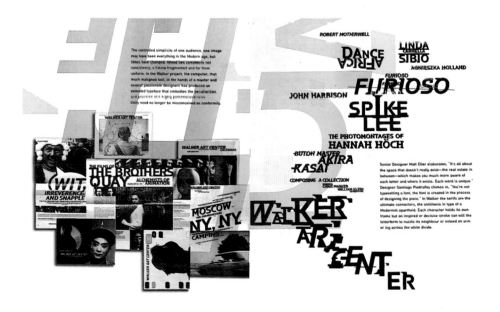

WALKER ART CENTER

Above: Stan Richards.
Below left: Magazine
spread for the Catfish
Institute (1992). Below
right: Newspaper ad for
Neiman Marcus (1994).
Opposite page: Poster
for Optique (1994).

by **Ellen Shapiro**

Stan Richards: Creative Guy

Hi, this is Tom Bodett for Motel 6. Oh sure, it'll be rough to survive one night without avocado body balm or French-milled soap, but maybe the money you save'll help you get over it. It always works for me.

POOR VISION IS NO EXCUSE FOR PICKING OUT AN UGLY PAIR OF GLASSES.

And this is Stan Richards, 1995 AIGA Medalist. A designer who says he's most proud of his twangy radio spots for a no-frills motel chain. Stan is the ad man in the rarefied world of graphic design, the slick Easterner among the straight-shootin' Texans. He defies easy characterization. "Just call me a creative guy," he says.

People call him all sorts of things. Pentagram partner Woody Pirtle has called him "the ideal businessman, salesman, teacher, and mentor." Rex Peteet of Sibley/Peteet has called him "my cheerleader, my muse, my conscience, my dad, my friend, my critic, my enemy — all in the same day." He's been favorably or unfavorably compared by various Richards Group "alumni" — all now highly successfully entrepreneurs in their own design and advertising businesses — to Leonardo da Vinci, Midas, Machiavelli, Hemingway, E.F. Hutton, Michael Jackson, and God.

Stan Richards, founder and head of the Dallas-based Richards Group, is the quintessential advertising agency executive. In fact, his agency is the only one that's been named "agency of the year" four times by *Adweek* magazine. He's also the quintessential graphic designer, principal of Richards, Brock, Miller, Mitchell & Associates (RBMM), one of America's premier design firms, winner of too many major design awards to count. And as head of various entities that create and produce print advertising, television commercials, radio spots, film titles, annual reports, corporate logos, public relations, sales promotion, and marketing communications of all kinds, he is perhaps above all the consummate businessman, named "entrepreneur of the year" by *Inc.* magazine in 1995. How many entities he runs and how much money they all make is a bit of a mystery. "A bunch" is all Stan will say, admitting that he has 315 employees, $300 million in annual billings, two buildings in the north end of Dallas, and clients from San Francisco to Yarmouth, Maine.

Stan was born in 1932 in West Oak Lane, Philadelphia, a typical suburban

Note: Stan Richards art-directed the projects illustrated on the following pages, collaborating with a number of designers.

Above: Poster for Tabu
Lingerie (1994).

neighborhood. His father was a bartender and his mother a hostess at restaurants and social director at hotels. When he was in high school, the family moved to the New Jersey shore and Stan played basketball for Atlantic City High, where he "drew better than anybody else." "Everybody's mother thinks they can draw better than the other kids in school," he says. "My mom thought I could draw better than anybody else in the *whole world*." This constant familial encouragement, coupled with the "real" feedback of always being chosen poster contest winner, brought him to the Philadelphia Museum School and then to Pratt Institute, where he came under the tutelage of the legendary Hershel Levitt, the teacher who has been credited with being the most significant influence on the careers of Gene Federico, Steve Frankfurt, Len Sirowitz, and other advertising luminaries who, along with Stan, learned the ropes at Pratt's Brooklyn campus in the late '40s and '50s. "It was a terrific program," recalls Stan. "The best school in the country. Extraordinarily broad-based. We learned 2-D, 3-D, color theory, illustration, lettering, how to make great ads, and more important, how to make good judgments." Unlike many of his classmates, though, Stan didn't stay in New York. Inspired by the work of Saul Bass ("one of my heroes") and the Office of Charles and Ray Eames, he decided to take off for L.A. after graduation to do the kind of work for which Doyle Dane Bernbach was starting to get famous. For some reason he decided to stop in Dallas on the way there, and spotted an opportunity that nobody else could see at the time. "I was one of the better kids out of Pratt," says Stan, "with a highly advanced portfolio. Dallas was a cow town. I mean, it was a *retarded* advertising community. But I saw that Texas was going to grow and flourish. Good work was going to be really difficult to sell. But if I could stick to it, I could become the predominant designer. It took a lot of years, but we did it."

It's interesting that he doesn't say, "I did it." From the beginning, Stan was a "we" kind of guy, a team builder. The

Richards Group/RBMM may be the only creative organization in the country that has something akin to an alumni association, having nurtured the careers of, in addition to Pirtle and Peteet, such important design firm principals as Jack Summerford, Don Sibley, Cap Panell, Arthur Eisenberg, Jerry Herring, and Mark Perkins. And then there are the ones who stayed, including Dick Mitchell, Steve Miller, Ed Brock, Brian Boyd, and Kenny Garrison. Some of Stan's partners and colleagues have been with him for more than twenty years.

Stan started his Dallas career by taking a job with the Bloom Agency. "I hated it," he says. "I hated the politics and the bureaucracy, but I figured you owed an employer at least a year." In 1953 he and his wife, Betty, began selling freelance design services to agencies that were looking for outstanding creative. And soon there was a milestone month when they billed $135. They spent their time looking for the best clients, putting together the best-run shop in town, finding the best people, and getting them to do their best work. Looking back on those years, Stan says, "I made a point of seeing every kid who wanted to see me. I hired the most immensely talented people. I taught them how to run a highly disciplined organization, and how to run it profitably. I taught them how to fight very hard for doing things right. It took a while, but soon we dominated the local awards shows. And then my competitive instincts ran nationally."

They still do. Today, Stan crisscrosses the country in his private jet, moving from client to client, from briefing to presentation, from mission to accomplished.

Although he may be most proud of his work for Motel 6, he deserves equal acclaim for — among many other achievements — developing the theme annual report (over twenty-five years of outstanding reports for Lomas Financial Corporation, which celebrate the American home and family); for using graphic design to help transform TGI Fridays from a single restaurant to a $.5 billion, 400-strong chain; for designing

THERE'S A SIGN

HANGING AROUND

YOUR NECK.

DOES IT SAY THAT

YOU'RE DULL AND

UNIMAGINATIVE?

MCQUEENEY
100% HAND-DYED SILK

Top: Magazine spread for
McQueeney Ties (1994).
Center left: Poster for
Harley-Davidson Motor
Clothes (1993). Center
right: Poster for Lombardo
Custom Apparel (1994).
Right: Logo, Aubrey Hair.

Top right: Outdoor board for Mustang Jeans (Haggar) (1993). Center: Poster for St. Louis Microbrew and Blues Festival (1996). Bottom: Poster for Hummer (1996).

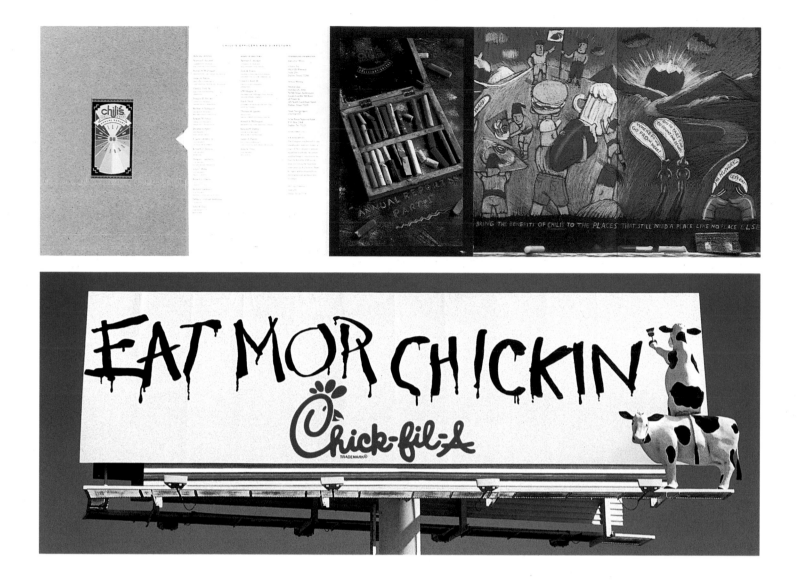

the title sequence for *Butch Cassidy and the Sundance Kid* (Saul Bass must have been pleased); and for orchestrating multifaceted marketing campaigns that launched and ensured the success of Rouse Company real estate projects nationwide.

"Why categorize yourself?" he asks rhetorically. "I want my clients to say, 'I've got a good creative guy.' Some clients who see me as an advertising guy don't even know I'm a graphic designer. And don't care. The difference is the business relationship. Being a designer is a project-based relationship; you're purely focused on one aspect of the work, the design of it. In advertising, it's a long-term, overarching business relationship, which can take place over many, many years. You do anything and all things to enhance the client's business. It could be TV, print, radio. I write headlines, theme lines, come up with ideas for campaigns, do thumbnails."

A typical workday in the life of Stan Richards finds him up at five in the morning, taking a four-mile run with "a couple of buddies," maybe a CFO type and a young art director. Then it's in the office by 7:45 a.m. and "endless meetings," sometimes twenty meetings a day. Some last a few hours and others take three or four minutes, if, as Stan puts it, "That's all the time you need to sit down with top creatives and go over what they've been doing. When you have good, strong people turning out terrific work, sometimes all you have to say is, 'That's great, let's go.'" After a morning of meetings he might be off to a lunch presentation in San Antonio, then a meeting with a CEO in Orlando, then back to the office before leaving for home — rarely later than 6:30 p.m. "I've always been very committed to family," he says, "real attentive to being home in the evenings. From the beginning I was not going to be the kind of person who was not there for dinner." Stan and Betty have been married

Above: Logo, Mercantile
Bank. Below: Logo, USA
Film Festival.

for almost forty years. Grant, their older son, is a creative director in San Francisco; Brad is a clinical psychologist at Harvard Medical School.

A typical non-work day in the life of Stan Richards is something else again. He's into cars, fishing, and music — each in a typically big, Richards kind of way. In cars, he's "won lots of trophies" rallying and racing, and thinks he may be better known to more people in the car world than the ad world. Fishing means chasing blue marlin around the Gulf of Mexico. And music used to be the way he earned his living before people in the oil, financial, health care, and real estate businesses in Texas and around the country got wind of his other talents. In the late '50s he had a live television show on Dallas's CBS affiliate in which he played the five-string banjo, sang, and interviewed local celebrities. "I played professionally in bars through school and in the first years when selling design was a real struggle," he says.

Although the struggle has long been over and Stan's legacy as designer and ad man is cast in our profession's equivalent of Mount Rushmore, perhaps he'll always be thought of foremost in the mentor role. At the 1992 AIGA National Conference in Chicago, Woody Pirtle honored Stan with a visual tribute of slides, quotes, and remembrances. "He expected each of us to enjoy the kind of autonomy that his office

thrived on and to do it all," Pirtle recalled. "Concept, design, writing, illustrating, handling production, and finally billing the job. It was as close to running one's own business as is possible while working for someone else. And in the end, your success or failure was always judged by the strength of the central conceptual platform. We quickly learned that if the concept wasn't there, the rest wasn't worth doing."

While Stan's clients, such as Jess Hay, CEO of Lomas Financial Corporation, consistently express appreciation for the positive effects his work has had on their businesses, a generation of designers has chosen him to receive the AIGA Medal as a symbol of their admiration and thanks — even though their feelings about him may be still sometimes mixed with frustration and even a little envy.

In tones sounding a bit like Motel 6's laconic Tom Bodett, all those Richards Group alumni have just about the same thing to say about him:

"Like my dad, he was tough."

"Nothing was ever quite good enough."

"He thought I could have always done it better."

"But I could have never made it without him."

Right: Logo, Dallas Zoo.
Below top: Cover and
spread from Lomas &
Nettleton Annual Report
(1979). Below bottom:
Cover and spread from
Lomas & Nettleton Annual
Report (1986).

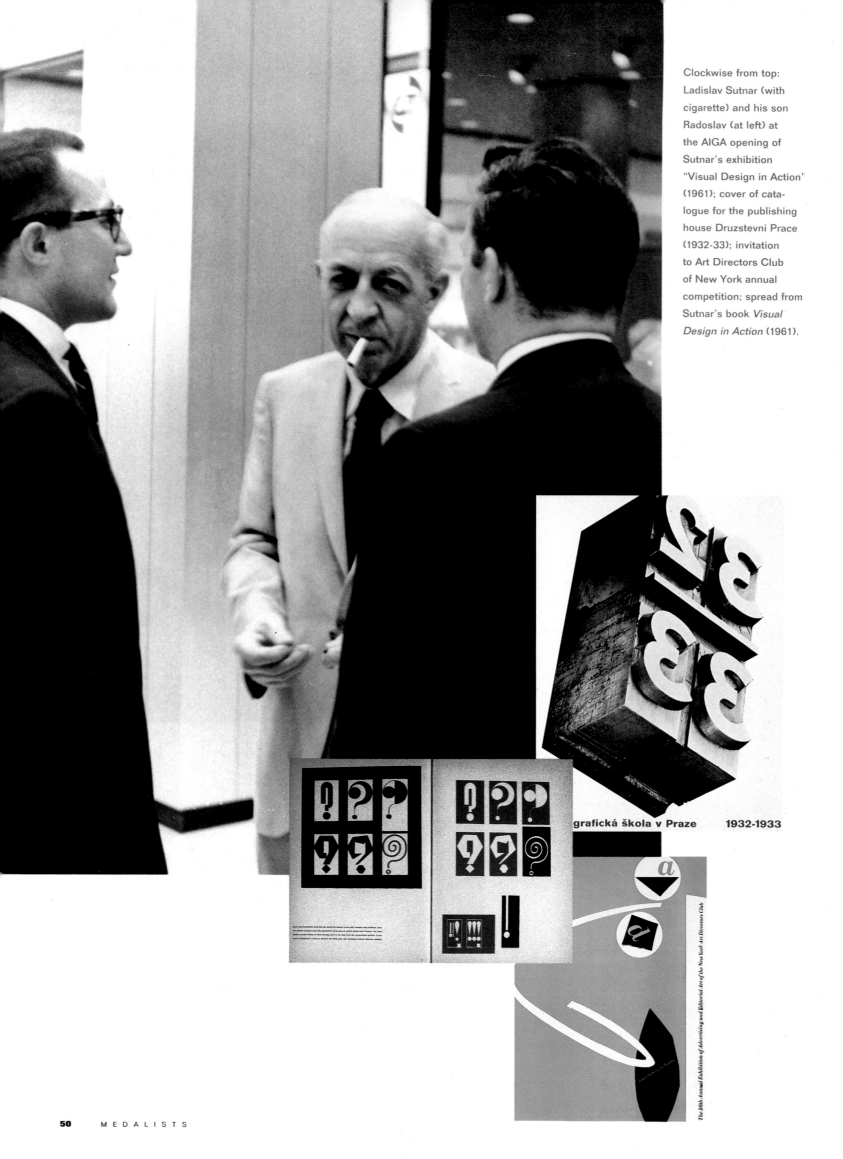

Clockwise from top:
Ladislav Sutnar (with
cigarette) and his son
Radoslav (at left) at
the AIGA opening of
Sutnar's exhibition
"Visual Design in Action"
(1961); cover of cata-
logue for the publishing
house Druzstevni Prace
(1932-33); invitation
to Art Directors Club
of New York annual
competition; spread from
Sutnar's book *Visual
Design in Action* (1961).

grafická škola v Praze 1932-1933

The 39th Annual Exhibition of Advertising and Editorial Art of the New York Art Directors Club.

by Steven Heller

Ladislav Sutnar: Pioneer of Information Design

adislav Sutnar was a progenitor of the current practice of information graphics, the lighter of a torch that is carried today by Edward Tufte and Richard Saul Wurman, among others. For a wide range of American businesses, Sutnar developed graphic systems that clarified vast amounts of complex information, transforming business data into digestible units. He was the man responsible for putting the parentheses around American telephone area-code numbers when they were first introduced.

The English author Anthony Trollope, who held a day job as a postal employee, is not remembered for "designing" the British postal box in 1852. Likewise, Sutnar has not been credited for the American area code, which was so integral to the design of the new calling system that it was instantly adopted into the language. The functional typography and iconography that he developed as part of various design programs for the Bell System in the late 1950s and early '60s made public access to both emergency and normal services considerably easier, while giving America's telecommunications monopoly a distinctive graphic identity. Yet the Bell System denied him credit, considering graphic designers as

transparent as the functional graphics they designed. Nonetheless, Sutnar's unheralded contributions to information architecture remain milestones, not only of graphic design history but of design for the public good.

As impersonal as the area-code design might appear, the parentheses were actually among Sutnar's signature devices, one of many he used to distinguish and highlight information. As the art director, from 1941 to 1960, of F.W. Dodge's Sweet's Catalog Service, America's leading distributor and producer of trade and manufacturing catalogues, Sutnar developed various typographic and iconographic navigational devices that allowed users to efficiently traverse seas of data. His icons are analogous to the friendly computer symbols used today.

In addition to grid and tab systems, Sutnar made common punctuation, such as

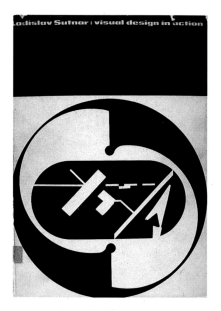

commas, colons, and exclamation points, into linguistic traffic signs by enlarging and repeating them. Although he professed universality, he nevertheless possessed a graphic personality that was so distinctive from others practicing the International Style that his work did not even require a credit line, although he almost always took one.

"The lack of discipline in our present-day urban industrial environment has produced a visual condition, characterized by clutter, confusion, and chaos," wrote Allon Schoener, the curator of the exhibition *Ladislav Sutnar: Visual Design in Action*, which originated at the Contemporary Arts Center in Cincinnati in 1961. "There is an urgent need for communication based upon precision and clarity. This is the area in which Ladislav Sutnar excels."

Like Jan Tschichold, Sutnar synthesized European avant-gardisms, which he said "provided the base for further extension of new design vocabulary and new design means," into a functional commercial lexicon

that eschewed formalistic rules or art for art's sake. While he modified aspects of the New Typography, he did not compromise its integrity in the same way that elements of Swiss Neue Grafik became mediocre through mindless usage over time. "He made Constructivism playful and used geometry to create the dynamics of organization," says Noel Martin, who was a member of Sutnar's small circle of friends in the 1950s.

Consistency reigned within an established framework, such as limited type and color choices as well as strict layout preferences, but within those parameters a variety of options existed in relation to different kinds of projects, including catalogs, books, magazines, and exhibitions.

Although Sutnar's spoken English was fettered by a heavy Czech accent and marred by grammatical deficiencies, he was nevertheless a prolific writer who articulated his professional standards in essays and books that were both philosophical and practical. *Visual Design in Action*

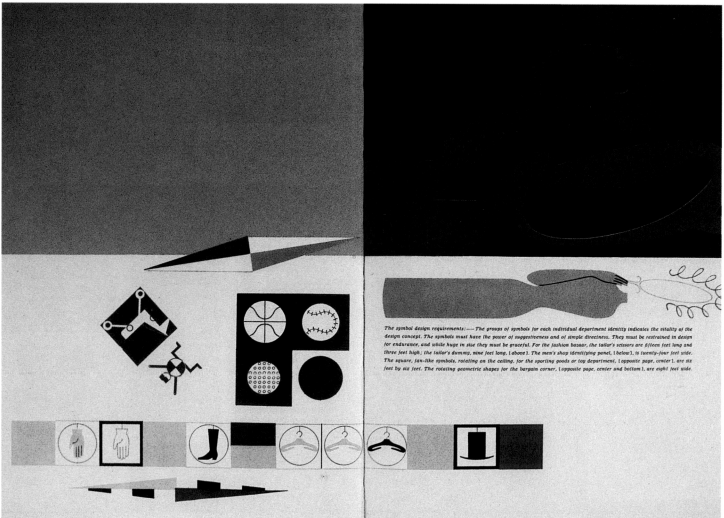

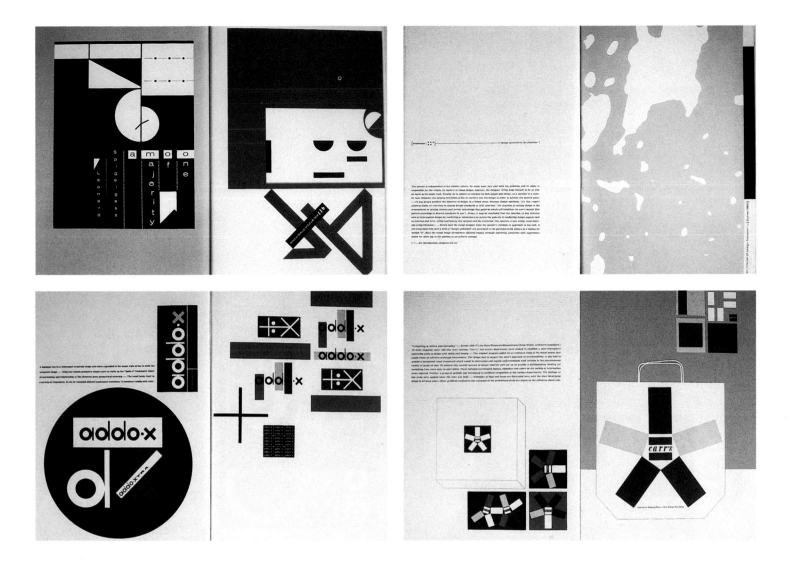

argues for future advances in graphic design and defines design in relation to a variety of dynamic methodologies. It is arguably the most intellectually stimulating Modern design book since Tschichold's *Die Neue Typographie*.

Sutnar's difficulties with spoken English as a second language do much to explain why his design was so straightforward. Indeed, information of the kind presented in the Sweet's catalogs, which included everything from plumbing supplies to hydroelectric generators, were the equivalent of second or even third languages to many of its users. So if verbal or written language could not efficiently communicate or mediate information in the age of mass production, then, Sutnar reasoned, visual language needed to be more direct.

One of his favorite comments was: "Without efficient typography, the jet plane pilot cannot read his instrument panel fast enough to survive. [So] new means had to come to meet the quickening tempo of industry. Graphic design was forced to develop higher standards of performance to speed up the transmission of information. [And] the watchword of today is 'faster, faster'; produce faster, distribute faster, communicate faster."

Even before the advent of the Information Age, there was information — masses of it, begging to be organized into accessible and retrievable packages. In the 1930s American industry made an attempt to introduce strict design systems to business, but the Great Depression demanded that the focus turn to retooling factories and improving products, which spawned a new breed of professional: the industrial designer. In Europe, the prototypical industrial designer had already established himself, and the graphic design arm of the Modern movement was already concerned with access to information as a function of making the world a better place. The mission to modernize antiquated aspects of European life led directly to efficient communica-

design and paper

line for indication

So simple a tool as a line may, in the designer's hands, record the most complex movements and relationships. A few common examples of the use of line quickly suggest its numerous everyday applications. In the first example shown above, line is used to trace a fighter plane's course, illustrating the acrobatic techniques employed in combat. In the diagram of a specific play in a football game, each line serves to indicate a player's move through men of the opposing team. On the opposite page, which consists of part of an advertisement, lines are drawn so as to suggest chaotic conditions in the field of marketing. Thus, despite the extreme economy of line, it can be used to great advantage even in conveying an idea.

shape, line and color—just for fun

Sometimes the use of shape, line, and color departs so far from the utilitarian that, in the case of an artist painting abstractions, it seems he has been painting just for fun. Or an imaginative designer indulges his feeling for shape, line, and color in designs for toys—and a child has fun with building blocks. In more everyday matters, a man's whim for a bit of brightness in his attire may explain "that loud tie." Woman, more fortunate, may adorn her body (and head) with shapes, lines and colors which draw eyes—sometimes just for fun, it seems. So much do fun and purpose intermingle in life that the amusing bit of design in paper, the valentine, can even serve to release the arrow in Cupid's bow.

tions expressed through typographic purity. Sutnar led the charge in Czechoslovakia years before emigrating to the United States.

In the early 1920s Sutnar, who was born in Pilsen in 1897 and finished his studies concurrently at the Prague School of Decorative Arts, Charles University, and Czech Technical University, was already a devout Modernist. In 1923 he was made a professor of design at the State School of Graphic Arts in Prague. From 1932 to 1946 he was its director, and kept the title even in absentia after emigrating to the United States in 1939. Le Corbusier's purism influenced his exhibition design, and he developed his own personality as a textile, product, glassware, porcelain, and educational toy designer. From 1929 to 1939 he was art editor on the staff of Prague's largest publishing house, Drustevní Prace (Cooperative Works), where he created playful photomontage covers that are still remarkably fresh today. For magazines like the Socialist arts journal *Zijeme* (We Live) and *VÝytvarnÈ snahy* (Fine Arts Endeavors) and jackets for books by Upton Sinclair and George Bernard Shaw, Sutnar's asymmetrical type and image compositions offered the reader additional levels of visual experience.

Overshadowed by two contemporaries, El Lissitsky and Moholy-Nagy, Sutnar is a relatively unsung leader of Modern objective typography. Yet he was a household name in Prague. "To be a Sutnar in Czechoslovakia was to be a prince," recalls his younger son Radoslav Sutnar, who today is a real estate developer and consultant in Los Angeles. In Prague they lived in a classically modern home in Baba, a residential district known for its avant-garde artists. As evidence of his father's fame, a 1934 exhibition (which is still intact) entitled *Ladislav Sutnar and the New Typography* earned considerable praise.

By 1938 Sutnar had earned many international awards, including a silver medal at the 1925 International Exhibition in Paris; a gold medal at the World Exhibition, Barcelona, 1929; the Grand Prix, Triennale, Milan, 1936; and fourteen Grand Prix and gold medals at the 1937 International Exhibition in Paris. Sutnar was then awarded a commission to design the Czech exhibition at the 1939 New York World's Fair: "The World of Tomorrow." However, Hitler's partitioning of Czechoslovakia forced the pavilion to open with material already on hand. Sutnar, who was sent to New York by the German government to liquidate the exhibit and bring its treasures back to occupied Czechoslovakia, decided not to return home. And since he did not send the materials back to the German authorities, he was suspended by the Education Ministry, thereby

This page and opposite right: covers of *Zijeme* (1931) that introduced Constructivism and the New Typography to Czechoslovakia. Opposite left: Book cover for George Bernard Shaw, revealing a Constructivist ethos.

becoming a marked man. So in 1939, while his wife and two sons remained in Prague, he established residence on 52nd Street in the heart of New York's Jazz district.

During his first year in New York Sutnar worked briefly with Norman Bel Geddes, one of the key designers of the World's Fair, and later at Coty cosmetics for Grover Whalen, the former World's Fair president. He also worked for the Czech government in exile, which allotted him some funds for unspecified purposes. He renewed his contacts with other émigré designers, such as the architects Serge Chermayeff, Marcel Breuer, Walter Gropius, and graphiste Herbert Matter. Through John Heduk, who founded the School of Architecture at Columbia University, he was a frequent guest at dinners for the Congress of International Modern Architecture, where he met the director of information research for Sweet's Catalog Service, K. (Knud) Löndberg-Holm, who instantly arranged for Sutnar to become his art director.

It is said that Löndberg-Holm was the other half of Sutnar's brain when it came to information. They were the Rogers and Hammerstein of information design. Together they composed and wrote *Catalog Design* (1944) and *Catalog Design Progress* (1950). Löndberg-Holm introduced a variety of systematic departures in catalog design, while Sutnar fine-tuned those models to show how complex information could be organized and retrieved.

Sweet's Catalog Service was a facilitator for countless trade and manufacturing publications that were collected in huge binders and distributed to businesses throughout the United States. Before Sutnar began its major redesign around 1941, the only organizational device was the overall binder. Löndberg-Holm had convinced Chauncey Williams, the president of F.W. Dodge, to order an entire reevaluation, from the logo (which Sutnar transformed from a nineteenth-century swashed word, Sweets, to a bold "S" dropped out of a black circle), to the fundamental structure of the binder (including the introduction of tabular aids),

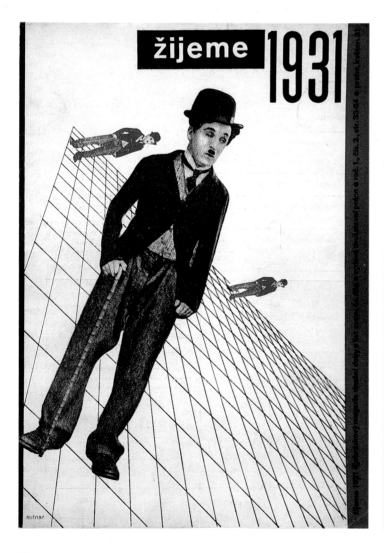

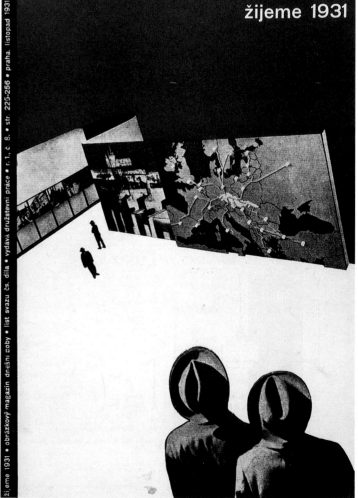

to the redesign of individual catalogues (some of which were designed by Sweets' in-house art department under Sutnar's direction). Together they introduced the three-way index system (by company name, production service, and trade name) to facilitate information retrieval.

Perhaps the most significant of Sutnar's innovations was the use of spreads. He was one of the first designers to design double spreads rather than single pages. A casual perusal of Sutnar's designs for everything from catalogues to brochures from 1941 on, with the logical exception of covers, reveals a preponderance of spreads, on which his signature navigational devices force the viewer to go from one level of information to the next. Through spreads, Sutnar was able to inject visual excitement into even the most routine material without impinging upon accessibility.

For almost twenty years Sutnar had an arrangement whereby he worked for Sweet's in the morning and did freelance in the afternoon. At first he worked out of a

small studio; next he opened an office near Wall Street originally called Sutnar, Flint and Hall. Flint sold ads to newspapers, and Thelma Hall, whom Sutnar had met at Sweet's, ran the studio. After a year Flint left, so the office was moved and renamed Sutnar + Hall. Sutnar relied on Hall for everything. While he set the style, she would explain it to the board people.

Philip Pearlstein, the realist painter, was Sutnar's assistant for many years. He remembers that Sutnar loved taking things apart to find the right organizing structure and reconstruct it. In this sense he referred to himself as a Constructivist. One of Sutnar's favorite organizational tropes was precise indexing to both avoid misunderstanding and limit unnecessary reading time. By using small images his indices were akin to a visual Dewey Decimal system. However, even though the goal was to save time, Sutnar often introduced design ideas to engender "visual interest" — such as italics as body text — that were initially difficult to navigate, and therefore time

consuming. Sutnar also had the desire to introduce aesthetics into everyday life. "If the catalogue looked good, the user might think about why it looked good," reports Pearlstein, "which in addition to being utopian idealism was also a snobbishness on his part."

Sutnar was a snob when it came to design. Like other pioneer Modernists, he believed that he had the right answers and everyone else was wrong. His fundamental thesis is found in these words: "Good visual design is serious in purpose. Its aim is not to attain popular success by going back to the nostalgia of the past, or by sinking to the infantile level of a mythical public taste. It aspires to uplift the public to an expert design level. To inspire improvement and progress demands that the designer perform to the fullest limits of his ability. The designer must think first, work later."

Radoslav Sutnar recalls that his father came on strong: "Some clients loved him; others thought he was crazy. In fact, people

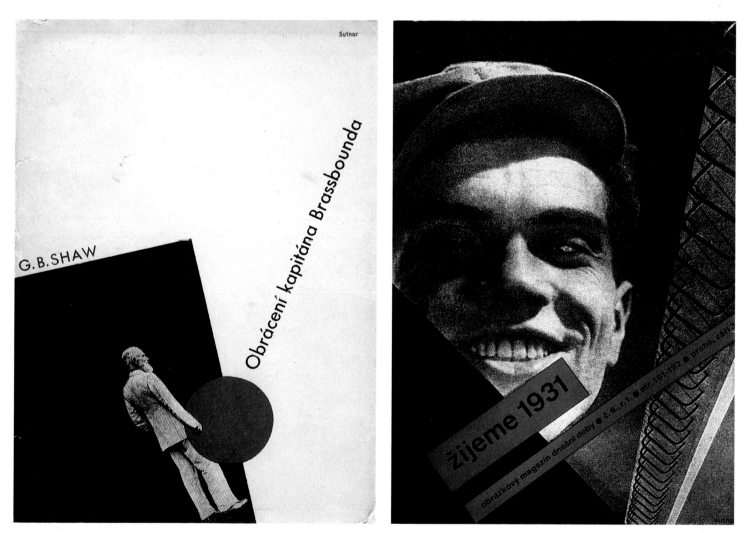

▶the name "addo-x" [pronounced add—oh—ex]

▶stands for precision-built adding machines

in the United States were often skeptical of the radical ideas he proposed. He was just so methodical, he had to do things his own way. When he hit it right, it was a thousand percent; when he did it wrong, it was curiously crude."

While the term "crude" doesn't jive with the meticulous typography that was Sutnar's recognized trademark, judging from the evidence in his archive at the Cooper-Hewitt, National Design Museum in New York, he did produce a large amount of aesthetically questionable material. Whether it was the result of too many compromises or just poor judgment, there is a curious pattern to his crudity. It usually occurred when he used excessively large type or oversimplified an information graphic. Even so, his most flawed work was on a higher plane than most.

As he once wrote, "Design is evaluated as a process culminating in an entity which intensifies comprehension," and clients benefited from his unswerving commitment to this idea. In addition to the Bell System program, which was only partially instituted, he developed Modern systems for a variety of businesses, most notably advertising and identity campaigns for Vera scarves (which despite the mass market appeal of the product, were masterpieces of Constructivist sophistication); graphic and environmental systems for Carr's shopping plaza in New Jersey (for whom he developed a lexicon of icons, pictographs, and glyphs which were the quintessential application of rapid identifiers and symbols); and identity, advertisements, and exhibitions for Addo-X, a Swedish business machine company that was competing with Olivetti in the United States. The Addo-X identity was predicated on geometric forms and is rooted in graphics that are beguilingly simple and unmistakably unique (a bold sans serif iconographic X exhibited power that could be likened to the cross and swastika).

Despite such milestones, Sutnar's client base was eroding by the early 1960s. He lost his job with Sweet's because the systems in place obviated the need for

a full-time art director and information research department. At a particularly difficult time, Sutnar's friends banded together to inform the business community about his work. The result was the traveling exhibition *Ladislav Sutnar: Visual Design in Action*, which was curated by Allon Schoener but meticulously designed by Sutnar himself. The exhibition was the basis for the book of the same name, which, because he could not find a publisher who would pay the high production costs, Sutnar financed out of his own pocket and sold for the hefty price of $15. Sutnar had previously edited *Design for Point of Sale* (1952) and *Package Design* (1953), which showcased exemplary work by others, but *Visual Design in Action* featured his own work as a model on which to base contemporary design. Sales were not very brisk, although today the book is a rare treasure.

Through the 1960s commissions disappeared. Disheartened by the lack of interest in his work, he turned his attention to painting what he called "joy-art," essentially a collection of geometrically constructed nudes that resembled, though in fact prefigured, paintings by Tom Wesselman. In the late '60s and early '70s he continued to haunt the New York Art Director's Club, where a younger generation was relatively oblivious to his achievements. In the mid-seventies he was diagnosed with cancer and died in 1976.

Sutnar left a legacy of work and writing that prove his vitality as a designer and his passion for design. Many designers can claim to have one or more pieces in the pantheon, but few can claim, as Sutnar can, that these works are as viable today as they were when first conceived. Many design students — knowingly or not — have borrowed and applied his signature graphics to a post-Modern style. Sutnar, however, would loathe being appreciated as a nostalgic figure. "There is just one lesson from the past that should be learned for the benefit of the present," he wrote in 1959, as if preempting this kind of superficial epitaph. "It is that painstaking, refined craftsmanship appears to be dying out."

Opposite page:
Advertisements for Addo-X
(c. 1954), a Swedish
business machine compa-
ny. This page, top: Logo
for Golden Griffin Books,
1950. Middle left: Cover
for *Catalog Design
Progress* (1950), the sec-
ond in a series on efficient
graphic design for busi-
ness. Middle right: Cover
for *Package Design: A
Force of Visual Selling*
(1953). Below: Cover bind-
ing and title page of *The
Green and the Red* (1950).

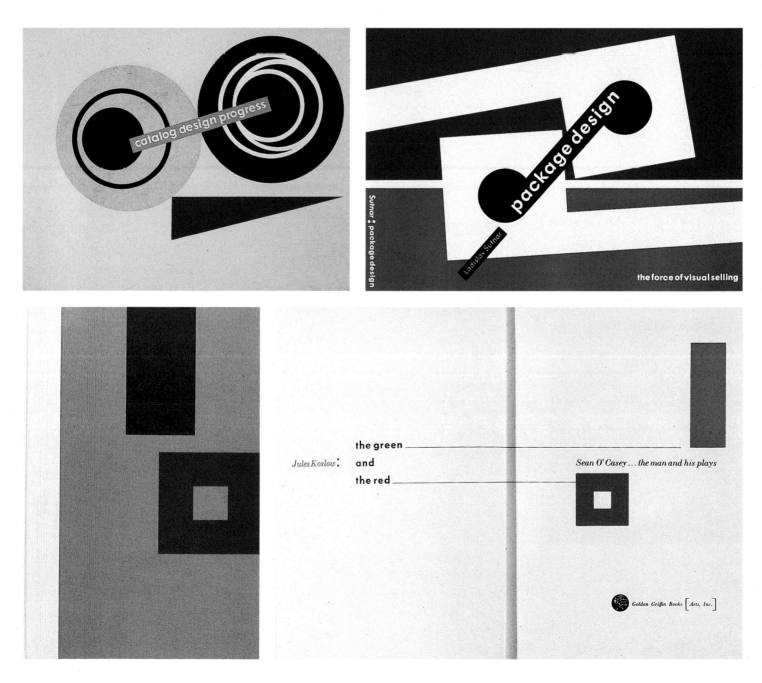

Jan van Krimpen
and the Splendid Book

by Moira Cullen

In the fall of 1995, a discreet historical display made its way to the mezzanine of the AIGA's national gallery. The exhibition's arrival collided with current discourse (ongoing and often overheated) on the demise of type, demonstrating that whatever the cut of the font or the cult surrounding the designer, the world of typography has long borne the imprint of controversy.

Thirty-seven years after his death, Jan van Krimpen, the self-taught Dutch calligrapher, typographer, and aficionado of the broad-pen, who later designed books, bindings, and commemorative stamps, was the honored subject of an intercontinental liaison between the AIGA and the Museum of the Book (The Hague). The Dutch museum curated this critical retrospective of van Krimpen, who is "as well known inside the world of type and design as he is anonymous outside it," (Ton Brandenberg, Director, Museum of the Book).

Swashes of calligraphy on parchment, compact gilt-edged volumes bound in goatskin replete with marbled pebble boards and wispy flyleaves provided rare glimpses of the evolution of a designer and his work over time. Hand-drawn letterforms pencil sketched and mounted under glass — smudged graphite renderings by turns sensual and severe — summoned an intimate immediacy seldom (if ever) experienced on today's bitmapped screen.

On view was van Krimpen's first typeface — the *gran prix* winning Lutetia — commissioned by the director of

J. Enschedé & Sons, a 300-year-old type foundry in Haarlem. Lutetia was named after the Roman designation for Paris, which was the site of the font's début at the 1925 international design fair. Also on view were extended families of type (Romulus) and fully resolved solutions that graced labels for Amstel beer, jubilee stamps for the Dutch post office (PTT), and a Bible set in van Krimpen's custom 7-point font (Sheldon) for optimal legibility. Van Krimpen's disdain for the commercial domain did little to discourage the broad distribution of his work.

A purist whose pursuit of an unadorned ideal led him to abandon personal projects he judged overly elaborate and juvenile, van Krimpen pared his decorative impulses as he advanced his career to hone instead a harmony of the highest (unaffected) standards of quality and clarity. Yet despite his austerity, van Krimpen remained true to an enduring belief that the craft of letterform design lay in the utilitarian yet emblematic art of handwriting — an idiosyncratic and decidedly personal form.

Jan van Krimpen and the Splendid Book was exhibited at the AIGA from November 2 to December 15, 1995. The exhibition was produced by the Museum of the Book/Museum Meermano Westreenianum, the Netherlands, and was designed by Stephen Doyle, Drenttel Doyle Partners. Exhibition photographs courtesy of Drenttel Doyle Partners.

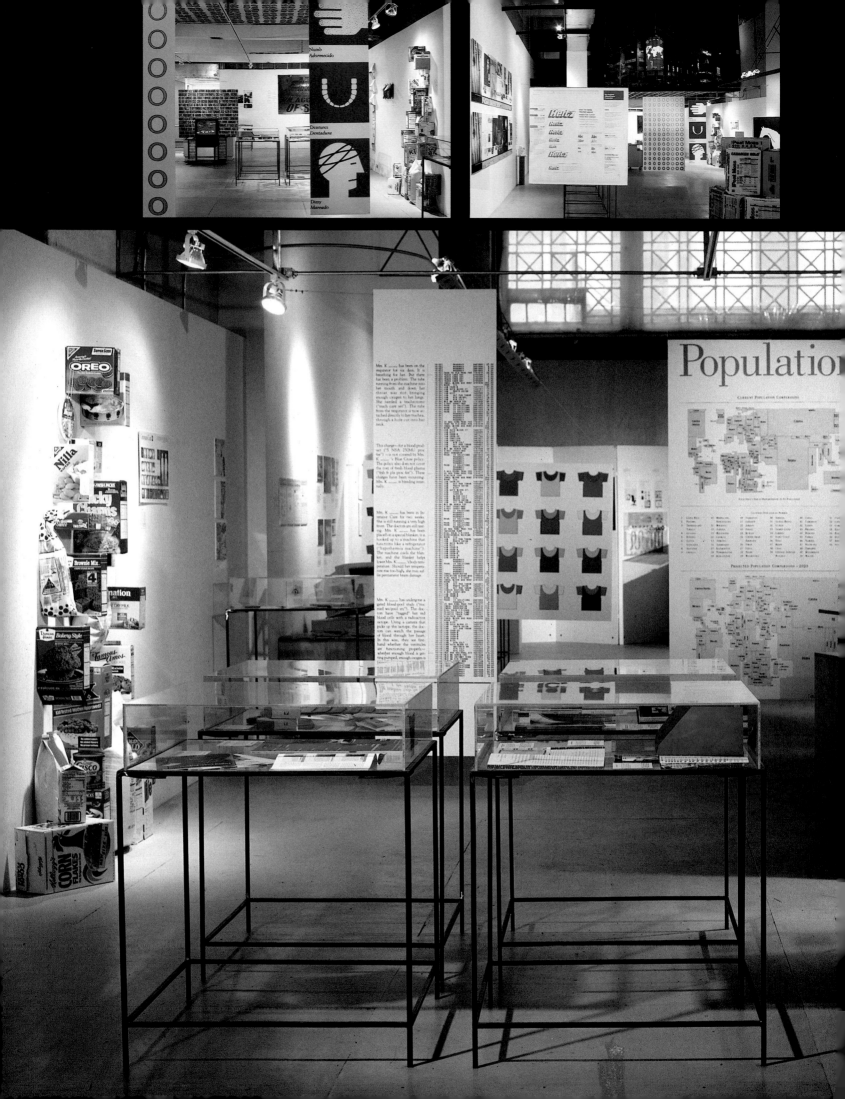

This is not a beauty contest. *Richard Saul Wurman*

Information Graphics

Design of Understanding

Today's graphic design profession developed from two important legacies. First, the role of book designer, typographer, and printer during the early years of the century. Then, mid-century, the graphic designer developed corporate identities and strong visual communications. The first dealt with literacy and the second communication.

The competition *Information Graphics: Design of Understanding* and its subsequent exhibition are at the heart of the next epoch for graphic designers, and it draws from the quest for both literacy and visual impact.

Graphic design today is not just about creative visual images. It is about addressing the challenges of visual communication and context. Graphic design is a form of problem solving that requires a talented and perceptive professional. Yet the profession's strength has been challenged by the wide distribution of the technology and tools for well-executed design. The graphic designer must be seen as essential to society and business to succeed and survive in today's economic environment.

The consistent contribution of the graphic designer today, regardless of his or her style, technique, technology, or medium, involves mediating between information and understanding. While the artist's challenge during this decade has been to prove relevance — never mind garnering appreciation — the graphic designer who is committed to improving communication is immediately crucial. During no other period of this century has there been so much information and so little understanding. The need for improved understanding will never diminish. So this role for the designer remains both relevant and vital well into the millenium. This year's *Design of Understanding* is the first of what will become an annual competition and exhibition. As long as the graphic designer plays a central role in "making the complex clear," there will be the opportunity for a vital graphic design profession.

This exhibition (on view from January 10 to March 6, 1996) was organized and designed by Maddocks & Company NY/LA. Exhibition photographs by Scott Frances. The AIGA gratefully acknowledges Maddocks & Company as well as its other Partners in Design:

Helene Jackson Berger
Canadian Spaghnum Peat Moss Association
Engraph Screen Group,
 Ariston Division (Allen Shanosky)

Sally Geier
Saba Ghazi-Ameen
Massachusetts College of Art
Massachusetts Institute of
 Technology Media Laboratory
The MIT Press
Susan Rogers
Speed Graphics, Inc.
Tom Wong

1 Print *poster, ...*
2 Print system *catalogues, books 4 pages & more*
3 Electronic *video, infomercials, TV*
4 Electronic Interactive
5 Exhibits, Exhibitions, 3D

How to submit entries

Entries larger than 40" will be accepted...

For magazine and newspaper design, ads and editorials, please submit complete tear-sheet...

...aphics: Design of
There is a new breed
...signer, exhibition
...strator & photograph...
...assion is to make the
...ear. •This competition is
...tion to those among us
interested in the design of
...tanding, who care about
good, not just looking good,
care about essential communi-
...ion between human beings.
...dgeable & rigorous in what they
do •how they think. This competi-
tion has been a long time coming. It
represents to me a new vitality in
the AIGA. It represents, quite sim-
ply, two factors that make things
happen: ❶A need-palpable, visible,
describable. ❷An economy poised
to address the business. There's
standing. Translated: There's
money in it. •As there is both a
need & work for pay, we now find
increasing numbers of extraordi-
nary projects by the most talented
creative people. •Please send your
best & brightest to make this idea,
competition, exhibition & publica-
tion have power & visibility.

ENTRY FEES

Entry fees for AIGA members are $23 per single entry and $55 per series (limited to five pieces in the series). For non-members, the entry fee is $30 per single entry; and $65 per series (limited to five pieces in the series). Entries must be accompanied by a check made payable to AIGA Information Graphics: Design of Understanding for the exact amount in U.S. dollars. Brokerage and custom fees on Canadian entries must be prepaid. Please note, the AIGA will disqualify all entries received without payment or sent collect.

PUBLICATION FEES

A publication fee of $65 per winning entry will be charged to the entrant upon notification of their acceptance into the show. The AIGA charges no hanging fee for the exhibition.

SEND ENTRIES TO:

AIGA Information Graphics, 164 5th Ave., New York, NY 10010. You will be informed of the jury's decision only if you enclose a self-addressed, unsealed, stamped business-size (#10) envelope. You may enclose your completed Master Form and check in this unsealed envelope.

DEADLINE: 1 November 1995

EXHIBITION

The Information Graphics: Design of Understanding exhibition will open in the Fall of 1995 at the AIGA's National Gallery in New York City. Duplicate shows will travel to selected AIGA Chapters, museums, university and corporate galleries throughout the U.S. and Canada for one year. The complete exhibition will be documented, including juror and designer comments, in a subsequent publication.

Master Registration Form

Enclosed are _____ pieces to be judged in
Information Graphics: Design of Understanding.

Enclosed is a check for the amount of US $ _____
(All entries must be accompanied by this form.)

MR./MS.
COMPANY
ADDRESS
CITY
TELEPHONE NUMBER
FAX NUMBER
E-MAIL ADDRESS
MEMBER OF AIGA?

Categories

☐ Print *poster, ...* 4 pages & more

Entry Form

Please fill out the following form (or facsimile) and tape it to the back of each entry, face down. We urge you to make sure that this information is accurate and complete, since corrections cannot be made after approval.

MR./MS.
COMPANY
ADDRESS STATE ZIP CODE
CITY
TELEPHONE NUMBER
FAX NUMBER
E-MAIL ADDRESS
TITLE
CATEGORY
ART DIRECTOR
DESIGNER
COPYWRITER
TYPOGRAPHER
ILLUSTRATOR
PHOTOGRAPHER
SOFTWARE DESIGN/ENGINEERING
PRINTER
PAPER

**Information Graphics:
Design of Understanding
There is a new breed
of graphic designer,
exhibition designer, illus-
trator & photographer,
whose passion is to
make the complex clear.**

Information Graphics

Awards

The term "graphic design" has not found its way into the dictionary and the same can be said for "information graphics," "information architect," and certainly the descriptive term "the design of understanding." Yet the profession of graphic design exists — the AIGA has represented it in the United States and Canada for the last eighty-two years.

The heroes of the AIGA have historically been typographers, illustrators, designers, and others who have served the gods of fine arts, aesthetics, and communication. The goal has been to produce work that looks good and communicates a clear message.

There is now a new area of design — the design of understanding — whose origins can be traced back to the same root of communication. Explosive changes in data storage and transmission have occurred in the last decade. What has not kept pace with this overflow of bits and bytes is our artful ability to arrange and transform the pieces — those bits and bytes — into a form that allows for the ready comprehension of data. The pattern of civilized learning is the transformation of data into information, information into knowledge, and knowledge into wisdom. As elegant as the end goal of wisdom sounds, the crisis in communication is actually occurring at the first step of data translation. Here is where we need the recipes to organize data: how to strain, sift, and mix it to rise into a cake of clarity and understanding.

The AIGA has invited designers to send in their best examples of information graphics, this new parallel branch of graphic design, which serves clarity without sacrificing aesthetics, which is handsome — not pretty, not clever, not shocking, not different for difference's sake — but handsome, as both the Willys Jeep and the Ferrari are.

This show is not large but is important, as the first step is always so important in the beginning of a journey. There exist many people who produce a large body of work not represented in this show, who I hope will participate in future years, as this show becomes a perennial.

Richard Saul Wurman

Chair

Call for Entry

Designers
Richard Saul Wurman,
Nancye Green, Nigel Holmes,
David Macaulay, and
Clement Mok

Printing
Daniels Printing

Paper
Crown Vantage,
Curtis Fine Papers, Graphika
100 Text, Basis 60

J U

Richard Saul Wurman
Red Burns
Nancye Green
Nigel Holmes
David Macaulay
Clement Mok

Richard Saul Wurman FAIA, is an architect, cartographer, and the author and designer of more than sixty books. He has received Guggenheim, Graham, Chandler, and NEA fellowships, the 1991 Kevin Lynch Award from MIT, and in 1993 was appointed Visiting Scholar at the MIT Media Lab. He became a fellow of the World Economic Forum in Davos, Switzerland, in 1994. He was awarded a Doctorate of Fine Arts by the University of the Arts in Philadelphia in 1994 and an honorary Doctorate of Humane Letters by the Art Center College of Design in Pasadena in 1995. He is chairman and creative director of the TED Conferences, which focus on the merging and converging of the fields of Technology, Entertainment, and Design, in the service of learning and communications. He is an honorary member of the American Center of Design, a member of AGI, and a board member of the Corporate Design Foundation.

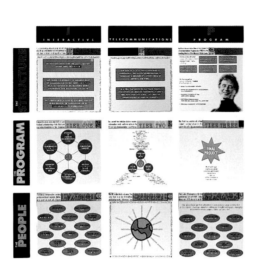

Red Burns is the chair of the Interactive Telecommunications Program in the Tisch School of the Arts at New York University, a pioneering graduate center for the study and design of new communications, media forms, and applications. The program emphasizes the user's creativity rather than the machine. She founded the Alternate Media Center in 1971. During the 70s and 80s she was Director of Implementation for a series of projects, including two-way television for senior citizens, telecommunications applications for the developmentally disabled, and one of the first field trials of Teletext in the United States. This work led to the development of the Interactive Telecommunications program in 1979. Professor Burns's current projects include a CD-ROM on chaos theory and an interactive cable/telephone experiment, The Electronic Neighborhood. She teaches in the graduate program, has served on many committees, consulted with non-profit groups, and spoken publicly on new communication technologies.

Nancye Green graduated from Tulane University in 1968 with honors in political science. In 1973, she graduated cum laude in environmental design from the Parsons School of Design. She is a partner in Donovan and Green, a company designed to solve integrated communications problems. Founded in 1974, it is a reflection of the partners' interest in employing the broadest array of media in shaping experiences that inform, entertain, educate, and sell. In her work, she leads teams of architects, designers, writers, and media producers on projects that have included the Liberty Science Center and the Ronald Reagan Presidential Library. Some projects have required the invention and definition of new formats, such as location-based entertainment environments for Sony, a cruise ship for Celebrity Cruises, and new retail formats for Hallmark, where she is on the board of directors. She is past president of both the AIGA and the International Design Conference in Aspen. She lectures extensively across the country.

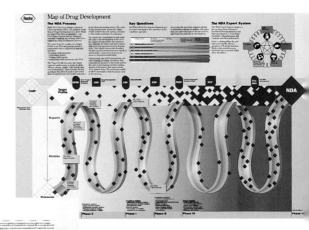

Nigel Holmes graduated from the Royal College of Art, London, in 1966 with an MA in illustration. Until 1978 he worked in London; then he joined *Time* magazine in New York and stayed for seventeen years. His graphic style there was widely imitated. Since then, he has curtailed the more illustrative aspects of his work, while remaining committed to the power of a picture to help readers understand abstract concepts. In 1982 he was the chairman of the fist AIGA competition devoted to information graphics. He has won gold and silver medals from British and American design organizations. In 1994 he formed his own information design company. He has lectured in India, Japan, Brazil, and Singapore, all over Europe and the U.S., often including "performances" of information. He has written four books on information design, and is currently working with Stephen Kosslyn, professor of psychology at Harvard, on a book that probes readers' understanding and presentation of numbers from the twin viewpoints of science and design.

David Macaulay was eleven when his family moved from England to the U.S. His fascination with simple technology and the way things worked, combined with a love of model-making and drawing, ultimately led him to study architecture at the Rhode Island School of Design. He received his degree in 1969. The first of his internationally acclaimed books was *Cathedral* (1973). *City* (a Roman one), *Pyramid*, *Castle*, *Underground*, and *Unbuilding* (of the Empire State Building) followed. Other works include *Great Moments in Architecture*, *Motel of the Mysteries*, *Mill*, *Baaa*, and *Why the Chicken Crossed the Road* (the riddle is answered). He is probably best known for a very thick book called *The Way Things Work* (1988), an exhaustively researched compendium of the hows and whys of almost anything that functions. He won the 1991 Caldecott medal for *Black and White*, a considerably slimmer volume that offers four separate little stories which can also be read as one. His latest book is *Ship* (a Spanish Caravel), in which two stories are told, one leading to the other.

Clement Mok, his work and his agency, are perhaps best described as "media agnostic." Creating meaningful connections between people, ideas, art, and technology is the focus of many design and consulting projects he is involved with —- everything from cyberspace theme parks to expert publishing systems to major identity programs. His work has been published internationally and he has received hundreds of awards and citations from professional organizations. His designs have also been exhibited in museums and galleries in Europe and the Far East. He lectures about technology, identity, and intellectual rights at industry conferences and seminars. He has served on the AIGA National Board of Directors and is a charter member of the New Media Centers. He recently edited a book on interactive media for Graphis Books and wrote a book on identity and information design for Adobe Press.

Ergo Measure Tool

Workers have long been at a loss to improve their individual work areas without relying on experts. Using information graphics, the ergo measure tool offers a way to optimize the ergonomic relationships between the computer, the work surface, and the work chair to support an individual's body size and shape. Key graphics measurements from the current ANSI standards on the back of the ergo-measure tape guide users through a series of ergonomic adjustments. An accompanying booklet explains how to use the level on the face of the tool and the mirror on the back to position the computer screen correctly. The smart tool ultimately transfers ergonomic adjustment into the hands of the individual.

Art Director/Graphic Designer **Yang Kim**
Illustrator **Yang Kim**
Writers **Laurel Hamalainen and Clark Malcolm**
Client **Herman Miller, Inc.**
Typographer **Dana Imaging**
Printers **Dana Printers, F&S Carton**
Paper **Weyerhaeuser Cougar**

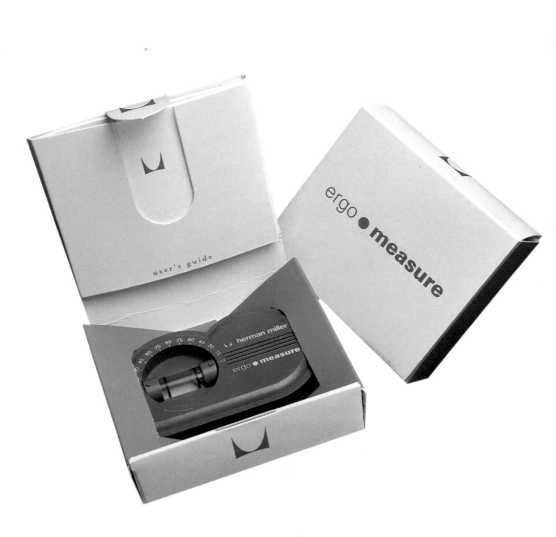

Crane's Global Guide

This guide was conceived as a reference tool for designers who handle international correspondence. Using full-size stationery diagrams, conversion tables, and comparison rulers in both metric and U.S. standard measurement systems, the guide dispenses much-needed technical information for global paper-based communication.

Design Firm **Chermayeff & Geismar Inc., New York, NY**
Art Director **Steff Geissbuhler**
Graphic Designer **James D. McKibben**
Writer **Lisa Friedman**
Client **Crane & Co.**
Printer **Milocraft**
Paper **Crane's Cover, Crane's Crest Writing**

Crane's Post-Perfect Resource Kit

This self-promoting but functional kit was created to
help designers understand the enigmatic postal regula-
tions affecting the design of business envelopes. The
postal guidelines checklist was culled from complex
federal handouts while the see-through template provides
an easy test for regulations compliance. The assorted
sample envelopes and sheet of "postage stamps"
promote the value of Crane paper.

Design Firm **Chermayeff & Geismar Inc., New York, NY**
Art Director **Steff Geissbuhler**
Graphic Designer **James D. McKibben**
Writer **Rose DeNeve**
Client **Crane & Co.**
Printer **Excelsior Printing**
Paper **Crane's Cover**

Early Minimalism

Two Columns distills Morris's first performance, in which a human-sized column occupied a stage for three and one-half minutes and then fell over and lay prone for three and one-half minutes. Abstracting a single bodily gesture, it demonstrates Minimalism's initial connection to performance. Formed of plywood, the work displays Minimalism's commitment to ordinary materials, factorylike assembly, and the repetition of simple shapes.

Anti-Form

Working with unorthodox materials, Morris turned in the late 1960s to what he called "anti-form." The resulting works extend the idea he proposed in his "open centers" that a work of art should be formed by its emergence into its physical context; it should not be preformed in the artist's mind or in terms of an internal armature.

Open Centers

Many of Morris's Minimalist sculptures are conceived as open perimeters with empty centers, and many are assembled from rearrangeable units. Emptiness is important for Morris, who wants to describe the human organism as taking its shape and meanings from its connection to the world it occupies, a connection articulated on its surface rather than at its center.

Conceptual Self-Portraits

By means of a group of conceptual works (for example, I-Box) that explore language, memory, thought, and "personal" feelings, Morris critiqued traditional attitudes about these mental states. Many works pay tribute to Marcel Duchamp, who had not only worked with language but had invented the "readymade"—an ordinary object that becomes art by being selected and signed by an artist.

Bodily Experience

The connection between Morris's performances and his art objects can be traced in the relationship between the dancers in Waterman Switch, bodies pressed together in a prolonged enactment of two surfaces touching, and the folds and pleats of the Felts he began in the late 1960s. Felt increasingly took on erotic connotations until, in a work like House of the Vetti (1983), the press of the material against itself alludes to the innermost recesses of bodily experience.

Drawing Blindfolded

In his four series of Blind Time drawings, made with eyes shut, Morris performed set tasks, such as creating a shape and repeating it. In Blind Time IV, the tasks, relating to issues raised by philosopher Donald Davidson, led Morris to an inquiry of his motives for working blindfolded, which leads to a question: can we ever determine the "intention" behind a work?

Techno-Catastrophe

By the late 1970s, Morris became obsessed by the destructive potential of modern technology turned toward the forces of war. The Firestorm drawings (1982) arose from an image that haunted Morris: a section of seared concrete onto which the "shadow" of a body, vaporized by the heat of the nuclear blast at Hiroshima, had been cast at the split second of the body's disappearance.

"Hearing"

The inquisition carried out aurally on the stage of Hearing is part trial, part psychoanalysis; the "hearing" has to do both with external political events and those "events" that make up the artist's persona. The sound track is a text collage assembled by Morris from authors such as Noam Chomsky, Michel Foucault, and Ludwig Wittgenstein.

clockwise from top left:
Two Columns, 1993 refabrication of a 1961 original. Painted plywood, two units, each 243.8 x 61 x 61 cm.
Untitled, 1970. Felt, overall dimensions variable. Solomon R. Guggenheim Museum, Panza Collection. Photo by David Heald.
Untitled (Ring with Light), 1965–66. Fiberglass with gel-coat, wood, and fluorescent light, two units, each 61 cm high, 35.6 cm deep; overall diameter 246.4 cm. Dallas Museum of Art, General Acquisitions Fund and a matching grant from the National Endowment for the Arts. Photo by Rudolph Burckhardt, courtesy Leo Castelli Gallery.
I-Box, 1962 (closed view). Painted plywood cabinet covered with Sculptmetal, containing photograph, 48.3 x 32.4 x 3.5 cm. Collection Leo Castelli. Photo © Dorothy Zeidman.
Waterman Switch, 1965. Morris and Yvonne Rainer in performance. Photo © 1965 Peter Moore.
Blind Time IV (Drawing with Davidson), 1991. Graphite on paper, 96.5 x 127 cm. Collection of the artist. Photo by John Berens, courtesy Leo Castelli Gallery.
Untitled (Firestorm), 1982. Ink, charcoal, graphite, aardvark, and pigments on rag paper. 1.95 x 5.08 m. The Museum of Modern Art, New York, Gift of Mr. and Mrs. S. I. Newhouse, Jr. Photo © 1993 The Museum of Modern Art, New York.
Hearing, 1972. Mixed-media installation. Williams College Museum of Art, Williamstown, Massachusetts.
Untitled (Portland Mirrors), 1977. Four mirrors, each 182.9 x 243.8 cm, with 30.5 cm² fir timbers of varying lengths.

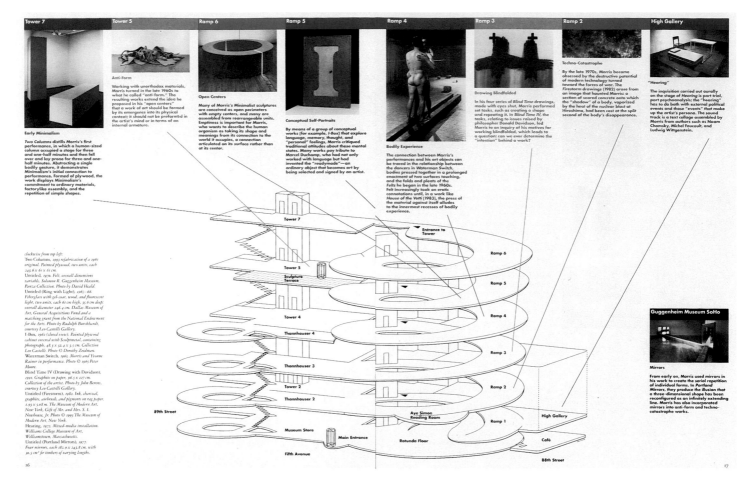

Guggenheim Museum SoHo

Mirrors

From early on, Morris used mirrors in his work to create the serial repetition of individual forms. In Portland Mirrors, they produce the illusion that a three-dimensional shape has been reconfigured as an infinitely extending line. Morris has also incorporated mirrors into anti-form and techno-catastrophe works.

Diagram labels: Tower 7 · Tower 5 · Sculpture Terrace · Tower 4 · Thannhauser 4 · Thannhauser 3 · Tower 2 · Thannhauser 2 · Museum Store · 89th Street · Fifth Avenue · Main Entrance · Rotunda Floor · Aye Simon Reading Room · Café · 88th Street · High Gallery · Entrance to Tower · Ramp 1 · Ramp 2 · Ramp 3 · Ramp 4 · Ramp 5 · Ramp 6

16 17

Guggenheim *Magazine* Spring/Summer 1994

▲

Guggenheim Magazine, Spring/Summer 1994

The magazine was created to inform visitors about the museum's current exhibitions. The design delivers information in strong, basic layouts that are dramatic and uncomplicated. The designers enhanced the text's ability to inform by using font sizes and color for for visual impact, while paying attention to sequence as a means to suggest movement and vitality.

Design Firm **Vignelli Associates, New York, NY**
Art Director **Massimo Vignelli**
Graphic Designers **Dani Piderman and Massimo Vignelli**
Client/Publisher **Guggenheim Museum Publications/ Anthony Calneck**

Sundial

Not only does this simple piece of cardboard inform you about the correct time, it enhances your understanding of the earth's relationship to the sun. The postcard folds into a working sundial with an accuracy rate of plus or minus five minutes a day. Although the dial's angle adjusts for most American cities, you're likely to be late on a cloudy day.

Firm **Sagmeister Inc., New York, NY**
Art Director **Stefan Sagmeister**
Graphic Designers **Veronica Oh and Stefan Sagmeister**
Illustrator **Veronica Oh**
Client **Stefan Sagmeister Inc.**
Printer/Fabricator **Robert Kushner**
Paper **80# Dull Text, mounted on 12 pt. chipboard**

The Arts: See, Hear and Do

This low-budget publication, published with the support of two local newspapers, was created to help regional arts organizations promote their programming. The information design is immediate, direct, and easy to understand. Categories and daily listings are presented so that finding an event of interest is as easy as choosing a favorite TV show. Said the designers, "When we hear that people put up the At-a-Glance spread on their refrigerator, we feel successful. We've assisted the end user in identifying the arts as accessible, which implies a call to action."

Design Firm **Michael Orr & Associates, Corning, NY**
Art Director **Michael R. Orr**
Graphic Designer **Gregory Duell**
Photographers **Various**
Client **The Arts of the Southern Finger Lakes**
Publishers **The Leader, The Star Gazette**

Herman Miller Seating Hang Tags

These instructions are designed to help the user of
the chair make whatever adjustments are necessary
for customized comfort.

Art Directors **Michael Barile and Kathy Stanton**
Graphic Designers **Michael Barile,**
Kevin Budelmann, and Kathy Stanton
Illustrators **Technical Marketing, Inc./The W Group**
Writers **Dick Holm, Lois Maassen,**
and Nancy Nordstrom
Client **Herman Miller, Inc.**
Printer **Dana Printers**
Paper **Weyerhaeuser Cougar 65# Cover**

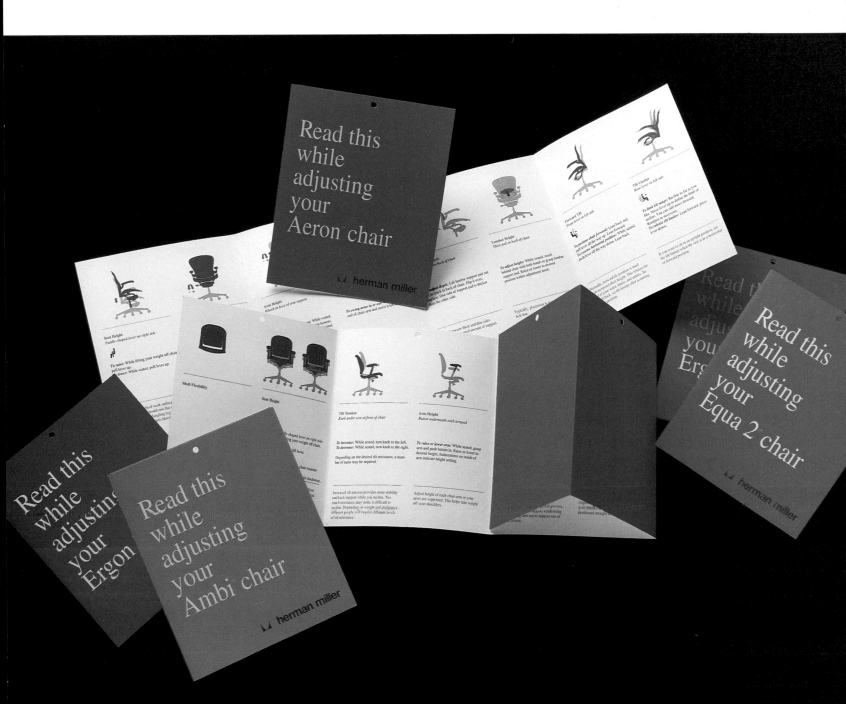

Seat Height

Paddle-shaped lever on right side

To raise: While lifting your weight off chair, pull lever up.
To lower: While seated, pull lever up.

Adjust to fit height of work surface or keyboard, if possible. Feet should rest flat on floor or footrest. Avoid dangling legs, which puts pressure on and restricts blood flow in the back of thighs.

Seat Height

Seat height is the distance from the floor to the back of the user's knees and should be the first adjustment a user makes. Aeron's pneumatic height adjustment gives the A-size chair a height range of 14 3/8" to 19 1/2"; B- and C-size chairs adjust from 15" to 20 7/8".

It is essential that the seat height adjusts in order to reduce exposure to contact pressure on the back of the leg or back strain from an unsupported spine. The user's feet should rest flat on the floor and his or her thighs should be approximately parallel to the floor. Other workstation adjustments, such as computer monitor distance, height, and tilt, keyboard height, footrest height, lighting, and/or worksurface height, may further help to make the workstation fit the user's body.

Even of the Aeron's pneumatic height adjustment lets workers change height as often as they wish. Remember that moving around and varying one's posture is encouraged and that the Aeron chair accommodates individual preferences for forward, upright, and reclined sitting as well as different activities such as keyboarding, reaching, or relaxing when reading or talking.

Also consider the following when adjusting seat height:

- Users should adjust chair height while their backs rest comfortably against the chair's back.
- Users who prefer sitting forward in their seats might prefer a higher seat height. Conversely, those who tend to recline in their seats might consider lowering their seat height.
- Users who needs a seat height of less than 15" should use an A-size Aeron chair or a footrest as a temporary assist.
- Seated eye height should allow users to maintain a comfortable monitor viewing angle to the monitor screen.

Seat height is adjusted so that feet are flat on the floor, wrists are straight, and the neck does not bend to view the monitor. Note that an adjustable keyboard tray and work surface assist in establishing a comfortable work posture.

Tilt Tension

Long stem on right side with knob

To increase tension: While seated, turn knob forward (clockwise, toward + sign).
To decrease tension: While seated, turn knob backward (counterclockwise, toward – sign).

Depending on desired tilt resistance, a number of turns may be required.

Increased tilt tension provides more stability and back support while reclining. Too much resistance makes the chair feel stiff. Depending on weight and preference, different people will require different levels of tilt resistance.

Tilt Tension

Next to seat height, tilt tension is the most important adjustment to make. While chair height is based on the user's height, tilt tension should accommodate the user's weight and maintain a comfortable and stable torso position while performing various office tasks. All Aeron chairs come with a tilt tension control that eases or resists reclining; however, because tilt tension is a "user fit" preference, it usually does not require frequent adjustment.

Also consider the following when adjusting tilt tension:

- Users who prefer sitting forward in their chairs should consider a tighter tilt tension to reduce the "give" in the seat's back; those who prefer to recline can loosen the tilt tension.
- Lighter weight workers should loosen the tension so they needn't push back on the chair or exert force on the floor to recline; heavier workers should tighten tilt tension to increase stability.

The Aeron Chair:

User Adjustments and
Ergonomic Guide

Read this while adjusting your Aeron™ chair

herman miller

◄

Aeron Chair Hang Tag Series

This complex chair has three audiences, each of which needs simple instruction. First is the person who sits in the chair. Second is the person who teaches people to use office furniture or purchases the furniture. Third is a combined audience composed of the first two groups from around the world. The chair's features are complex, but information on each page is presented in as non-intimidating a way as possible. Adjustments are explained (in English and in a four-language international version) in a consistent format using illustrations and text that help readers locate information quickly and grasp the chair's innovative customizing possibilities.

Art Director **Michael Barile**
Graphic Designers **Michael Barile,**
Kevin Budelmann, and Adam Smith
Illustrator **The W Group**
Copywriter **Dick Holm**
Client **Herman Miller, Inc.**
Paper **Weyerhaeuser Cougar 100# Text**
and 65# Cover

Ansel Edmont Work Gloves Packaging

Choosing the right glove for the job is as important as choosing the right tool. The designers created a packaging/display system to support the consumer launch of "Tools for Hands," a line of industrial gloves. A solid yellow background unifies the brand, creating a block of brand color that is consistent regardless of the size of the display. Color bands with "pull-down menus" for specific tasks identify six categories keyed to home use, while large descriptive product names guide users through the range of applications. The glove's construction is exposed in a cutaway illustration readable even with your left hand in the glove.

Design Firm **Fitch Inc., Boston, MA**
Art Director **Mike Mooney**
Graphic Designer **Eric Weissinger**
Photographer **Mark Steele**
Writer **Mike Mooney**

Performance Profile
The Stripping Glove™

Developed to protect workers in demanding industrial settings, applicable for jobs at work, home or in the yard.

The Ansell Edmont Story

Ansell Edmont, a pioneer in making gloves for industrial safety, is the world's largest manufacturer of latex products. Long known for high quality products that meet strict performance demands, Ansell Edmont produces gloves available for use on the job and at home.

INDUSTRIAL USES	APPLICATIONS
• petrochemicals	• paint removers
• degreasing	• varnish removers
• refining	• thinners
• electronics	• turpentine
• exposure to many oils	• mineral spirits
• exposure to many acids	• stains
• exposure to many caustics	• shellacs
• exposure to many alcohols	• varnish
• exposure to many solvents	• polyurethane
	• paint prep
	• naval jelly
	• linseed oil

COATING	DUTY	LINING
Neoprene	Heavy	Lined
Nitrile	Medium	Unlined
PVC	Light	
PVC/Nitrile		**GRIP**
Rubber		Textured
		Smooth

See CAUTION statements on the inside panel for additional chemical resistance information.

STRONG enough to resist many strippers and removers. Tough enough for abrasive stripping conditions.

OUTPERFORMS ordinary household rubber and refinishing gloves in paint and varnish stripping applications.

IMPORTANT
This glove is not recommended for all applications. For prolonged use or extra protection when using extremely harsh stripping agents, we suggest the Ansell Edmont Home Chem Glove.

© 1990
Ansell Edmont
Consumer Products Division
Eatontown, NJ 07724

0 76490 86915 1

T-434

Made in Malaysia

KROMEKOTE
SEVEN · SUBJECTIVE REASONING

▼

Subjective Reasoning #7:
Notes on the Ottoman Legacy

The seventh issue of *Subjective Reasoning* — a promotional campaign for Champion International Paper — reviews the conflict in Bosnia and its roots through the rise and fall of the Ottoman Empire. A chronology of war, displayed on the inside covers, depicts the region's enduring legacy of conflict while a detailed essay, supported by a series of historical maps, traces radical shifts in the empire's geographical boundaries.

Design Firm **Pentagram Design, New York, NY**
Series Art Directors **Paula Scher and William Drenttel**
Art Director **Michael Gericke**
Graphic Designers **Michael Gericke, Sharon Harel,**
and Donna Ching
Maps **Hammond, Inc.**
Photographer **Christopher Morris/Black Star**
Writers **David Rieff (Text) and**
Nan Gatewood (Captions)
Client **Champion International Paper**
Printer **Van Dyke/Columbia Printing Co.**
Paper **Champion Kromekote Recycled 1S Cover,**
12 pt., and 2S Cover, 6 pt.

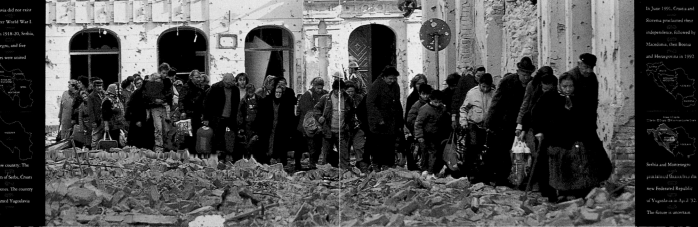

Yugoslavia did not exist until after World War I. Between 1918–20, Serbia, Montenegro, and five territories were united into a new country: The Kingdom of Serbs, Croats and Slovenes. The country was renamed Yugoslavia in 1929.

In June 1991, Croatia and Slovenia proclaimed their independence, followed by Macedonia, then Bosnia and Herzegovina in 1992.

Serbia and Montenegro proclaimed themselves the new Federated Republic of Yugoslavia in April '92. The future is uncertain.

But to make the system work, the Sultan imported men of talent, who often turned out to be Christian slaves from the Balkans, and, particularly, from Bosnia. There was even the custom of what in the Balkans would come to be known as 'Boy Tribute.' This was a tax, but one that required payment in people not money or goods. More commonly the Sultans left their affairs, whether, military, administrative, or commercial, to aliens—Jews, Balkan Christians, Armenians. The Ottoman empire in its dotage was further obliged to rely on loans from the great powers of Europe, and, by the beginning of the twentieth century, the empire was bankrupt. All that remained to it were its holdings in the Middle East, which it would lose at the end of the First World War.

The Europeans were not just exerting the victor's privilege of arrogating the holdings of the losing side. As Lord Curzon, one of Britain's representatives at the Versailles Conference in 1919, put it succinctly, the Turks had for centuries been "a source of distraction, intrigue and corruption...of unmitigated evil to everybody concerned." Had Curzon gotten his way at Versailles, the Turks would have lost Constantinople and the Straits of the Dardanelles as well as Mesopotamia. As it was, they were left with a finger of land around Edirne on the European side of the Bosphorous, as ever, in the words of the English historian, Perry Anderson, "camped in the continent without ever becoming naturalized into its social or political system." In a sense, the Bosnian war reflects the degree to which the successor states to the Ottoman empire—Serbia, despite all the talk of 'Serbdom' being far more than Bosnia a perfect example of this socio-

and the quicker the better. In any case, they tell you, the question of who was in the majority a couple of years ago is of no importance. Before the Turkish conquest, Serbs were in the majority. Besides, who knows what the population distribution would have been if Serbs had not taken so many casualties during the Second World War? Perhaps Zvornik—Zvonik—would always have been majority Serb. Anyhow, it doesn't matter. Our boys did a good job at the very beginning of the war. "We gave the Turks a hiding," one soldier said, smiling at the memory, "and drove them away once and for all. They won't be back any time soon, whatever it says in the Vance-Owen peace plan."

THE NAMES

Bihac. Cazin. Velika Kladusa. Banja Luka.
Prijedor. Sanski Most. Bosanski Brod. Zvornik.
Cerska. Tuzla. Srebrenica. Zepa. Foca. Gorazde.
Bijeljina. Mostar. Jablanica. Prozor. Breza.
Zenica. Travnik. Vares. Vitez. Lukovac. Brcko.
Doboj. Maglaj. Visoko. Grude. Bugojno. Jajce.
Visegrad. Gradacac. Rogatica. Sarajevo.

Amtrak Graphic Signage Standards Manual

Each day, customers, employees, and the public form impressions about the products and services they use. This leading transportation provider considers consistency in signage design, fabrication, and installation a vital expression of its marketplace identity. The *Amtrak Graphic Signage Standards Manual* is a corporate identity program created to establish a national wayfinding system that is recognizable from station to station. Developed for Amtrak's corporate users, field employees, and members of the architecture and design community involved in station design and renovation, the guide complies with the Americans with Disabilities Act, which mandates that all public accommodations and facilities be accessible to all people, including those with disabilities.

Design Firm **McCulley Design Group, Inc.,**
San Diego, CA
Art Director **John Riley McCulley**
Graphic Designers **Diana Duque and**
Nicholas A. Grohe
Client **Amtrak National Railroad Passenger Corp.**
Printers **Milton Art Press and French Bray**
Fabricator **Architectural Graphics, Inc.**
Paper **Potlatch Vintage Velvet Dull 100# Text**
and Vintage Gloss 10pt. Cover

6) Amtrak
Thruway Bus*

12) Information*

19) Buses*

20) Taxis*

21) Buses
and Taxis*

22) Trains*

26) Telephone(s)*

34) Women*

35) Men*

36) Restroom(s)*

Electronic Signage

8.4

Next Agent
Available System
E1 Sign Type

Mounting Option

ACL Model 1525
Director with Beacon
without Ticket Agent
Numbers

Semi-automatic
Operation
Includes a director with chime, 12 volt power pack and a beacon with remote switch control at each position.

Agent Activated
When activated by a server, the beacon light flashes and director changes from "Please Wait" to "Agent Available" with appropriate directional arrow. Beacon light turns off and the director reverts to "Please Wait" when remote switch control is turned off by the agent.

Plan View

6"x6" Tri-Beacon
Indicating "Agent
Available Position"

E1 Sign Type

8.5

Electronic Signage

Next Agent
Available System
E1 Sign Type

Mounting Option

ACL Model 1725
Director with Beacon
with Ticket Agent
Position Numbers

Semi-automatic
Operation
Includes a numbered director with chime, 12 volt power pack, and a numbered beacon with remote switch control at each position.

Agent Activated
When activated by a server, the numbered beacon light flashes and the director changes from "Please Wait" to "Agent Available" with appropriate directional arrow and position number. Beacon light turns off and the Director reverts to "Please Wait" when remote switch control is turned off by the agent.

Plan View

6"x6" Tri-Beacon
Indicating "Agent
Available Position"

E1 Sign Type

Hertz Worldwide Collateral Program

Corporate communication standards instruct chiefly through graphic explanations rather than through text. This program is designed so that all producers of the company's collateral — some of whom are talented designers, but many with little training in graphic design — can create print ads, signage, brochures, forms, and other identity applications that consistently support the worldwide expression of Hertz. Simple pictograms and step-by-step examples demonstrate the program's flexibility and precision, set the desired corporate tone and spirit, and specify criteria for color selection and picture usage.

Design Firms **Landor Associates, New York, NY, and Don Kline Co., New York, NY**
Art Director **Don Kline**
Graphic Designers **Michael Farish and Don Kline**
Photographer **Dorothee Ahrens**
Writers **Michael Farish and Don Kline**
Client **Hertz Corporation/Hertz Europe Ltd.**
Typographer **Michael Farish**
Printer **Hennegan Company**
Paper **Quintessence 100# Cover, Dull Coated**

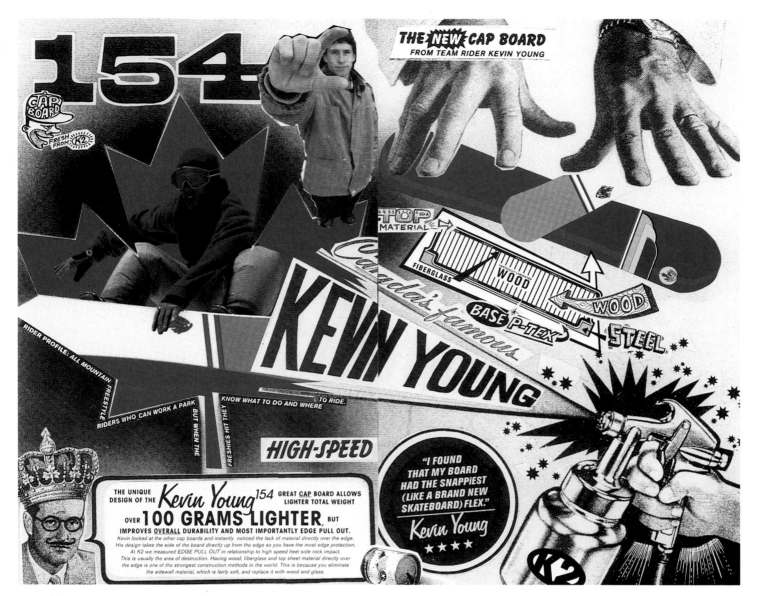

154

CAP BOARD
FRESH FROM K2

TOP MATERIAL
FIBERGLASS
WOOD
BASE P-TEX
WOOD + STEEL

Canada's famous
KEVIN YOUNG

RIDER PROFILE: ALL MOUNTAIN FREESTYLE
RIDERS WHO CAN WORK A PARK BUT WHEN THE FRESHIES HIT THEY KNOW WHAT TO DO AND WHERE TO RIDE.

HIGH-SPEED

"I FOUND THAT MY BOARD HAD THE SNAPPIEST (LIKE A BRAND NEW SKATEBOARD) FLEX."
Kevin Young
★★★★

THE UNIQUE DESIGN OF THE Kevin Young 154 GREAT CAP BOARD ALLOWS LIGHTER TOTAL WEIGHT
OVER 100 GRAMS LIGHTER, BUT IMPROVES OVERALL DURABILITY AND MOST IMPORTANTLY EDGE PULL OUT.
Kevin looked at the other cap boards and instantly noticed the lack of material directly over the edge. His design takes the side of the board directly up from the edge so you have the most edge protection. At K2 we measured EDGE PULL OUT in relationship to high speed heel side rock impact. This is usually the area of destruction. Having wood, fiberglass and top sheet material directly over the edge is one of the strongest construction methods in the world. This is because you eliminate the sidewall material, which is fairly soft, and replace it with wood and glass.

K2

SNOWBOARDS 95 96

▲

1995-96 K-2 Snowboards Catalogue

How would a snowboarder who is inherently interested in snowboards present dry product specs and other technical information in a catalogue? The designers thought it would be fun to put themselves in the consumer's shoes. They cut spec charts out of a more conservatively designed catalog and hand-pasted them in a collage. Hand-lettering and illustration loosen things up, while hidden graphic surprises entice the reader to look again and again.

Design Firm **Modern Dog, Seattle, WA**
Art Directors **Modern Dog Staff and K-2 Snowboards**
Graphic Designers/Illustrators **Vittorio Costarella, George Estrada, Robynne Raye, and Michael Strassburger**
Photographers **Eric Berger, Jimmy Clarke, Jeff Curtes, Aarron Sedway, Reuben Sanchez**
Client **K-2 Snowboards**
Printer **Valco**
Paper **Simpson Evergreen**

Go Hard or Go Home

In-line skating streaked into popular culture with a blur.
As a market, the sport's early enthusiasts typically were
of a generation not easily defined. But the designers
of this catalog spoke the "blader's" stylized language,
which they used to establish a brand character for a
major in-line manufacturer.

Design Firm **Visual Marketing Associates, Dayton, OH**
Art Director **Christopher Barcelona**
Graphic Designer **Christopher Barcelona**
Photographer **AGI Photographic Imaging**
Writers **Christopher Barcelona, Steve Goubeaux,**
and Canstar
Client **Canstar Sports**
Printer **Central Printing**
Paper **French Dur-o-Tone Butcher**

JBL EON Manual

This multilingual user guide was designed to provide operating instructions and detailed technical information for seven products in a pre-packaged professional audio system. The designers consolidated more than 100 pages of technical and user information into 28 pages. The cover doubles as a table of contents for main product sections, which are designed to provide all necessary information to begin using the product. Cross-references lead to related sections, including troubleshooting guides and a glossary.

Design Firm **Fitch, Inc., Boston, MA**
Art Director **Jeff Pacione**
Graphic Designers **Ellen Hartshorne,**
Ben Segal, and Art Tran
Photographer **Mark Steele**
Writer **Mike Mooney**
Client **JBL Professional**

JBL EON SoundEffects Packaging

A market leader in the consumer electronics industry developed a "surround sound" home theater system based on consumer preference for smaller, more versatile wireless components. The designers created a user-friendly, retailer-friendly, and environmentally sensitive packaging system in which individual boxes were given "personalities" and iconographic identities to signify separate product functions. Simple product names need no translation for international marketing; a colored-coded/numbering system categorizes and differentiates between products; and a sequence of opening "cues" on the package flaps guides the assembly of ensemble purchases.

Design Firm **Fitch, Inc., Boston, MA**
Art Director **Ann Gildea**
Graphic Designers **Kate Murphy and**
Beth Novitsky
Illustrator **Hal Mayforth**
Photographer **Peter Rice**
Writer **Mike Mooney**
Client **Harman International**
Fabricator **Empire Container**

The Italian Metamorphosis

A recent Whitney Museum exhibition on the evolution of Italian design is reinterpreted as a dynamic book using the interactive medium of CD-ROM. The clean, spare interface allows the viewer to access and interact with a variety of historical, pictorial, and biographical information framed in the appropriate Italian Modernist graphic style.

Design Firm **Vignelli Associates, New York, NY**
Art Director **Massimo Vignelli**
Graphic Designers **Dani Piderman, Rocco Piscatello, and Massimo Vignelli**
Client **ENEL and the Guggenheim Museum**
Programmer **Infobyte**

A Passion for Art: Renoir, Cézanne, Matisse, and Dr. Barnes

The designers and producers of this CD-ROM set out to re-create the experience of visiting an art gallery. Using an on-screen navigational device, the user moves through the physical space as works of art are presented in context with other works in their natural setting. Viewing the artwork on the walls further affords a sense of scale that is often missing from conventional static representations.

Title **A Passion for Art: Renoir, Cézanne, Matisse, and Dr. Barnes**
Creative Director/Producer **Curtis G. Wong**
Interface Designer/Art Director **Pei-Lin Nee**
Developer **James C. Gallant**
Graphic Designers **Cecil Juanarena and Pei-Lin Nee**
Photographers **Dennis Brack, Nicholas King, Edward Owen, Tess Steinkolk, and Gradon Wood**
Writers **Various**
Sound Editors **Ella Brackett, Eileen H. Monti, and Curtis Wong**
Editor **Lorna Price**

American Visions: Twentieth-Century Art from The Roy R. Neuberger Collection

This CD-ROM affords the viewer a unique, accessible way to experience one of the world's great collections of modern art. A personal tour guide reveals the stories behind the artist, paints a portrait of the times, and provides educational guidance for each work of art. The CD-ROM user can meet the collector, encounter nearly 130 of America's finest artists, listen as they discuss their creations, and view more than 185 of their works.

Design Firm (CD-ROM) **Eden Interactive, San Francisco, CA**
Art Director/Graphic Designer **Eden Interactive**
Illustrator/Animator **Eden Interactive**
Photographers **Various**
Producer **Eden Interactive**
Publisher **Chronicle Books**
Printer/Fabricator **Mandarin**
Package Design **Aufuldish & Warinner**
Package Art Directors **Jill Jacobson and Michael Carabetta**

**"Paintings From the Collection
of Joseph H. Hazen" CD-ROM Catalogue**

Creating a CD-ROM catalog for a collection of
paintings is a challenging task: how to create a subtle,
compelling environment for fourteen paintings that is
sensitive to the conventional representation of artwork
yet exploits technology's potential for multiple perspec-
tives. The designers activated the screen according
to hierarchy and function, creating a clean, legible
interface with a consistent navigational map that allows
the viewer to focus on content and enjoy the many
presentation options available in the medium free from
technical distractions.

Design Firm **Tsang Seymour Design, New York, NY**
Creative Directors **Patrick Seymour and**
Catarina Tsang
Graphic Designers/Illustrators **Patrick Seymour**
and Catarina Tsang
Writer **Augustine Hope**
Client **Runtime, Inc.**
Typographer **Patrick Seymour**
Programmer **Stuart Hunt**
Sound Editor **Miles Green**

Passage to Vietnam

Many Americans still regard Vietnam as a war rather than a country. The designers of this CD-ROM wanted viewers to experience the country through the eyes of the 70 photographers who were asked to document modern Vietnam for a week. The interface was designed as a series of invitations activated by a 3-D Quebe™, a multifaceted navigational device. The photographers' voices and video histories personalized the experience, while background Vietnamese music transports the viewer into a faraway world.

Design Firm/Producers **Against All Odds Productions, Sausalito, CA**
Art Director **Megan Wheeler**
Graphic/Interface Designer **Megan Wheeler**
Illustrator/Animator **Megan Wheeler**
Photographers **Various**
Developer **Ad Hoc Interactive**
Publisher **Against All Odds Productions/ Internal Research**
Digital Video Producer **E-Motion Studios/Stonysoft**
Programmer **Shawn McKee**
Sound Editor **Aaron Singer**

How It Works

From the outset, this series was conceived as an informational graphic. Diagrams and illustrations drive the text, layout, and overall construction of the piece so that the reader can move freely from image to words and back again. By simplifying and explaining the complicated and the unfamiliar, the design offers the reader a broad view of an entire process — laying a foundation that makes it easier to absorb specific information or to understand related subjects.

Design Director **Dennis McLeod**
Designer **Leslie Barton**
Art Director **Kent Tayenaka**
Graphic Designer **Arne Hurty**
Writer **Lon Poole**
Editor **Galen Gruman**
Client **Macworld Magazine**

Inside the New Classic

A classic cutaway-style photo-illustration highlights the unique features of Apple's new computer model. The innovative organization of the computer's internal components is the central focus of the graphic. Captions support the illustration by referring to other significant features.

Design Director **Dennis McLeod**
Art Director **Kent Tayenaka**
Graphic Designer/Illustrator **Arne Hurty**
Photographer **Luis Delgato**
Writer/Editor **Galen Gruman**
Client **Macworld Magazine**

FIRST IN A THREE-PART SERIES

Inside the Processor

The phone rings. You pick it up without stopping to think. A computer doesn't have that luxury. Its "brains"—the central processor—must calculate every step needed for any action. People learn to perform complex actions without identifying the steps involved. By contrast, computers must string together a simple vocabulary consisting of two "words"—*on* and *off*—to handle complex actions. It comes down to intelligence versus brute force.

An Ever Smaller World As it sits on the computer's logic board, a processor looks rather dull—a dark gray block with a bit of gold for the wiring and black for the label. But if you peer under that drab cover, you glimpse what looks like a city seen from an airplane window. Thin strips of wire (called *traces*)—made of aluminum and so incredibly fine that you'd have to stack up 60 traces from a Motorola 68040 processor to equal the thickness of this page—crisscross the chip, connecting all of its many tiny parts.

Zoom in a little closer, and the processor takes on distinct patterns, one area looking as empty as a city's warehouse district, another as crowded as its downtown. Zoom in even further and you can see the individual regions—the processor's "buildings" that handle computations.

By zooming in closer yet, you can see the transistors—the basic components that do the processor's actual work. The 68000 processor, first introduced by Motorola in 1979 and still used today in the Macintosh Classic, has about 68,000 transistors (thus its name). The 68030 used in many Macintosh models has more than 300,000 transistors. There are more than 1.2 *million* transistors in the 68040 found in Apple's most powerful computers, the Quadras. And the next generation of processors may have tens of millions.

A World of Simple Choices Transistors do a very simple thing: turn on and off. Yet, they control everything that happens in the processor. It's as if stoplights controlled everything that goes on in a city.

A transistor either lets electricity flow (the *on* state) or prevents it from flowing (the *off* state). A series of transistors is called a *circuit*. Electricity flows through the circuit—the exact path that the electricity follows is determined by the on and off patterns formed by the transistors. The vast number of possible paths that electricity can take—each with its own meaning—coupled with the fast speed at which the transistor can move data along those paths lets the processor handle complex computations.

A transistor is made from silicon, which normally blocks electricity but can be forced to let electricity through (that's why silicon is called a *semiconductor*). In a transistor, an aluminum trace comes in at one side; a second trace comes out at the other. A strip of sili-

by Lon Poole

A Motorola 68040 chip at the actual size.

Engineers at Motorola discuss a pathway of the 68040 chip's mask, which is a road map of its circuitry.

Inside the New Classic

The microphone circuitry, shown here, supports the new Classic's built-in microphone, which is located on the computer's front panel.

The deflection portion of the Classic's color picture tube is technically called a saddle saddle yoke for low magnetic radiation. The yoke's coils are positioned as closely as possible to the display portion of the tube to reduce the amount of energy used and thus lower the ELF/VLF emissions that the yoke generates.

LC PDS slot

3 1/2-inch hard drive

The computer's feet give it some height and place the monitor in a slightly better position for viewing. But their real purpose is to give the Classic a distinctive new look.

The analog board contains two independent power supplies: one for the display, the other for the CPU. Power supplies are traditionally located on the main logic board, but here the goal was to design a logic board that could easily—and safely—be removed by owners.

The speaker is housed within a specially designed plastic box. The box is secured to the computer's chassis using a high-quality, Velcro-like material (generically known as a hook-and-loop fastener), which reduces sound vibrations.

The logic board slides in and out of the computer chassis along tracks.

1.4MB SuperDrive

The case holds the fan (not shown). This is mounted with rubber to minimize sounds and vibrations.

How to Produce a CD

This informational graphic demystifies the process of manufacturing a compact disk. The process, which is fairly simple but new to many, is broken into several distinct steps. Text follows each section as the illustrations leap from a macro perspective in the introduction to a micro view during the greater part of the description, jumping back for a final macro presentation when the process is complete.

Design Director **Dennis McLeod**
Graphic Designer/Illustrator **Arne Hurty**
Writer/Editor **Liza Weiman**
Client **Macworld Magazine**

Three Color Printing Technologies

This piece explains three viable print technologies by displaying them side-by-side. The text is formatted to guide the reader through pertinent comparisons without the need for introductory captions. Illustrations are stylized and greatly exaggerated to emphasize distinctions between the three printers and and demonstrate clearly how each works.

Design Director **Dennis McLeod**
Graphic Designer/Illustrator **Arne Hurty**
Writer/Editor **Charlie Piller**
Client **Macworld Magazine**

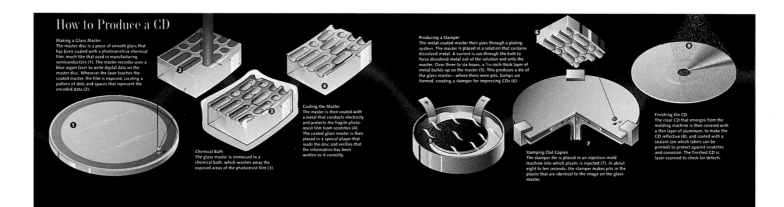

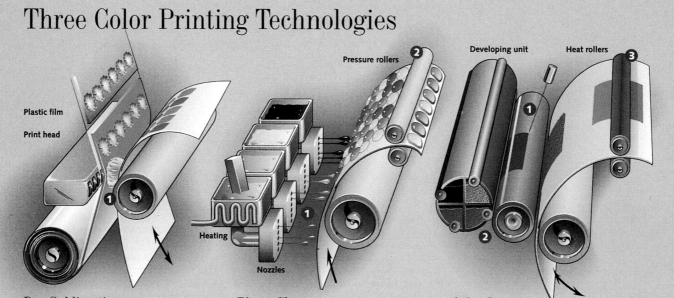

Three Color Printing Technologies

Dye Sublimation

Dye-sublimation printers pass plastic film coated with cyan, magenta, yellow, and black (C, M, Y, and K) dye across a print head containing about 2400 heating elements. This dye goes from solid to gaseous form when heated **(1)**. Coated paper, designed to absorb the gaseous dye on contact, passes across the film four times (once per color) as it contacts the print head. Each heating element can produce 255 different temperatures—the hotter, the more dye is transferred. This variable dye density produces continuous-tone images.

Phase Change

Phase-change printers melt blocks of C-, M-, Y-, and K-color wax in ink reservoirs. The melted ink is sprayed onto the page through tiny perforations in print-head nozzles **(1)**, in a single pass, as with typical ink-jet printers. Unlike the water-based inks used in typical ink jets, the wax-based inks in solid-ink printers solidify on the page very quickly, inhibiting absorption that can reduce image sharpness. This allows solid-ink printers to use relatively absorbent plain paper. High-pressure rollers then flatten the dots and fuse them to the page **(2)**.

Color Laser

Color laser printers use a four-chamber developing unit that holds colored (C, M, Y, and K) plastic toner powder. After a light source exposes an image on a photosensitive drum **(1)**, exposed portions of the drum take on an electrical charge that attracts toner as the drum rotates past the developing unit **(2)**. This process is repeated four times, once for each color. After each exposure, the paper passes across the toner-coated drum. When the four passes are completed, heated rollers fuse the toner to the page **(3)**.

How Liquid Crystal Displays Work

Liquid crystal displays use crystals and polarizing filters to selectively block light shining from the back of the display. Blocked light creates dark pixels; unblocked light creates light pixels. In the PowerBooks, images are formed by dark pixels on a light background. Both the 100 and 140 use the passive matrix super-twist display illustrated here. A two-pixel area of the screen is shown in detail.

A polarizing filter allows only a small portion of the available light, traveling at specified angles, to pass through **A** .

A Dark Pixel: The crystals, suspended in an oily fluid, naturally orient themselves in a helix **B** . Microgrooves on the inner surface of the surrounding glass plates control the beginning rotation of these spirals **C** . As the light beam travels through this helix, its angle is redirected, thereby preventing the light from passing through the second polarizing filter **D** . A dark pixel is created on the face of the screen **E** .

A Light Pixel: To allow filtered light to pass all the way through the display, a charge is applied to the crystals by passing a current from a vertical electrode **F** to a horizontal electrode **G** . This charge reorients the crystals. Instead of forming a helix, most of them straighten out parallel to the light beam **H** . Without a helix to pass through, the light's angle is unchanged and the light passes through the second polarizing filter **D** . A light pixel is created on the face of the screen **I** .

Area of detail

▲

How Liquid Crystal Displays Work

New technology is demystified in this informational graphic. A stylized micro view of the process shows how liquid crystals used in conjunction with other components activate an LCD display.

Design Director **Dennis McLeod**
Graphic Designer/Illustrator **Arne Hurty**
Writer **Galen Gruman**
Editor **Liza Weiman**
Client **Macworld Magazine**

How Digital and Film Cameras Compare

Often a new technology is best understood by contrasting it with an existing process. Here, graphic images introduce digital photography by way of a camera-to-camera comparison with a familiar film-based counterpart. A consistent format for diagrams emphasizes the differences and allows readers to make fundamental comparisons.

Design Director **Dennis McLeod**
Graphic Designer/Illustrator **Arne Hurty**
Writers **Arne Hurty and Kate Ulrich**
Editor **Jim Martin**
Client **Macworld Magazine**

How Apple Makes Quicktime VR Feel Real

The jargon and hype surrounding the introduction of this new technology were tremendous. Here, images replace text as a way to demonstrate the process, step-by-step, so that readers can better understand the technology's use and its varied applications. Compartmentalized pictures tell the story so that the accompanying written captions could provide shorter, more direct explanations.

Design Director **Dennis McLeod**
Graphic Designer/Writer **Arne Hurty**
Editor **Charlie Piller**
Client **Macworld Magazine**

How Digital and Film Cameras Compare

Digital cameras bring photography into the computer age, yet they operate on the same basic principles as traditional cameras. Some key differences make digital cameras better suited for electronic publishing. Below, we show the two image-capture methods at the moment light enters the camera.

The medium is the difference
The two cameras use very different media to capture an image. In a traditional camera the medium is **film**; in a digital camera it's a **charge-coupled device (CCD)**.

Most of the parts are the same
1a and 1b) Because both cameras are based on the same principles, they share many of the same components: **lenses** focus incoming light; an **aperture** contols the amount of light entering the camera; a **shutter** controls the length of time that light comes through the aperture; and a photosensitive medium captures an image. But the similarities end here.

2a) Film is made of multiple layers: outside protective layers and inner **emulsion layers**. (The emulsion is a gelatin filled with light-sensitive crystals.) Color film pairs three emulsion layers—each sensitive to one of the primary colors (cyan, magenta, or yellow)—with three **dye layers**, which color the emulsion. The image forms on the emulsion layer.

2b) A CCD is a multilayered silicon chip. In one layer, a grid of **electrodes** divides the surface into pixels. Each electrode is connected to **leads**, which carry a voltage. A **color filter layer** determines which primary color (in this case red, green, or blue) each pixel senses. The image forms on a layer of **silicon substrate**.

Image resolution in film is determined at the crystal level and is very high. Film can respond to a broader range of lighting conditions than a CCD, but it must be developed after exposure. Scanning adds yet another step for electronic publishers. In a CCD, image resolution is determined at the pixel level and is much lower than in film, but images captured by a CCD are immediately ready for use in electronic publishing.

What happens when light strikes
The medium's job is to record the various levels of light in the scene being photographed.
3a) Film reacts to light chemically. The crystals in the emulsion contain **silver** and **bromide ions**. When light particles strike a **crystal**, they free electrons (not shown) from the bromide ions. The freed electrons attach to **impurities** in the crystal, giving them a negative charge. The charged impurities attract submicroscopic clusters of positively charged silver ions. The stronger the light, the bigger the cluster. In exposed film these differences are too subtle to see. The development process (not shown) exaggerates the differences by enlarging the clusters, which determine how light or dark each point of the image becomes.
3b) A CCD reacts to light electromagnetically. Light particles pass through the CCD, freeing **electrons** in the silicon substrate. A voltage applied to the electrodes draws freed electrons together in special areas (called **photo sites**) in the silicon substrate. The stronger the light, the greater the number of electrons drawn together at that site. The CCD transfers captured electrons, one by one, to an analog-to-digital converter, which assigns each site a digital value corresponding to the number of electrons the site holds. In this form the image is saved to disk and is ready for use in electronic publishing. The number of electrons in a photo site determines how light or dark each pixel in the image is.

FILM CAMERA

Crystal
Bromide ion
Impurity
Silver ion
Emulsion layer
Dye layer
Film
Shutter
Aperture
Lenses

DIGITAL CAMERA

Electrons
Photo site
Electrode
Lead
Silicon substrate
Electrode layer
Color filter layer
CCD
Shutter
Aperture
Lenses

HOW APPLE MAKES QUICKTIME VR FEEL REAL

Apple's latest foray into you-are-there technology, the QuickTime VR movie, sets you in the midst of a navigable, 360-degree scene and lets you explore the virtual environment. Apple's VR approach overcomes various problems inherent in patching together a series of flat images and projecting them onto a cylinder to create a three-dimensional feel. While competing technologies require the use of special, expensive, panoramic cameras, VR developers can use an ordinary camera to capture a scene that surrounds you and lets you pan up, down, and side to side.

Capturing the Scene

You capture a scene by shooting a series of overlapping photos. Mounting the camera on a tripod lets you keep the same center point as you swivel the camera; the tripod also keeps the whole series on a level plane, ensuring that the first and last shots in the sequence will line up.

Making the Movie

You might think you could create a scene by simply butting pictures taken with a conventional camera up against each other (**A**). But unless taken with a panoramic camera, the pictures won't normally match up. QuickTime VR compensates for misalignment by distorting or warping (**B**) each image so that it appears as if it were taken by a panoramic camera. Once warped, images will match when they overlap (**C**). QuickTime VR then analyzes the areas of overlap and blends, or stitches the images together (**D**).

Once all the images, including the first and last, are stitched together into a virtual cylinder, the panorama is complete (**E**). Because QuickTime VR treats the scene as a single image wrapped inside a cylinder, you can pan around the image (instead of sliding along it as you would when it's flat). You can even pan up and down and continuously from side to side in either direction.

Objects don't line up

Objects line up · Stitching gets rid of seams

Why QuickTime VR Emulates Panoramic Photography

A conventional camera exposes a whole rectangle of film all at once, and only the center of the frame faces the scene straight on. Toward the sides, the scene is exposed at an increasingly oblique angle, creating distortion. A high-end panoramic camera pans around a scene, exposing the film through a narrow slit. At any given moment, the camera captures a thin slice at the center of the camera's view, and the incoming light for each exposure hits the film straight on and without distortion.

Cameras viewed from above
Conventional camera · Panoramic camera
Film · Lens · Film · Lens

Viewing the Scene

Now that you're done making the movie, you'll want to view it on a flat medium. As you might suspect, simply projecting a series of slices from the cylindrical image onto your monitor won't create a realistic view. To compensate for distortion caused by warping, and to heighten the realism, QuickTime VR manipulates the image, instantaneously, as you pan around the movie.

QuickTime VR compresses the image in the center. This compression makes objects increase in size as they move toward the edge of a view, giving side-to-side panning a more realistic feel.

Face of monitor

To increase the realism of a vertical pan, QuickTime VR brings data in from the sides of the image at the top (as you pan up) or bottom (as you pan down). This simulates the sensation that your field of vision broadens as you look up or down, as it does in real life.

Face of monitor

How Pointing Devices Work

This graphic was produced just as new pointing devices were being introduced to the market. Key features of each technology are explained visually so that prospective consumers can be more aggressive with their inquiries and better informed when purchasing products.

Design Director **Dennis McLeod**
Graphic Designer/Illustrator **Arne Hurty**
Writer/Editor **Cathey Abes**
Client **Macworld Magazine**

Waiting on Death Row

Numbers tell a chilling story. A single symbol represents twenty inmates serving time on death row. An instant visual picture reveals the ratio of executions per inmate and exposes the number of executions per state.

Design Firm/Client **Newsweek Magazine, New York, NY**
Art Director **Lynn Staley**
Graphic Designer **Bonnie Scranton**

How Pointing Devices Work

Mechanical Mouse

In an Apple mouse, a rubber ball touches two capstans, which are connected to slotted wheels sandwiched between two light-source-and-photosensor pairs (**A** and **B**). When the ball rolls, the capstans turn the wheels, whose slots interrupt the light. Each interruption is interpreted by the Mac as one increment of movement. The sensors are offset slightly so that, as the wheels turn, they produce a pair of signals with a pause between. The direction a wheel turns is indicated by which sensor, **A** or **B**, produces the first signal in each pair. Trackballs work similarly, except only the ball (not the entire housing) moves.

Optical Mouse

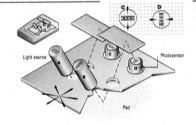

In an optical mouse, light from two light sources (**A** and **B**) reflects off a pad covered with a fine grid of dots. The image of the grid is projected onto two separate photosensors. One senses vertical movement (**C**) and the other horizontal movement (**D**). As the reflection of the grid passes over the sensors, circuitry within the mouse counts the dots to determine the distance the mouse has moved in either direction.

Tablet with Stylus

In a graphics tablet, a drawing stylus or cursor exchanges minute radio signals with the tablet through a grid of wires that crisscross the drawing area. The tablet determines the location of the stylus and transmits the location information to the Macintosh. The stylus doesn't need to touch the tablet surface itself; this means you can trace a drawing, even through several pages of a book.

Waiting on Death Row

Since 1976, there have been 290 executions in the United States—a third of them in Texas alone.

Green states have no death penalty*

† number of inmates executed since 1976
‡ currently on death row

*ALASKA AND HAWAII HAVE NO DEATH PENALTY
SOURCE: DEATH PENALTY INFORMATION CENTER

342. Yet for each of the last 19 years—ever since the U.S. Supreme Court allowed states to resume capital punishment—no more than about 2 percent of the death-row total has ever been executed (map). In 1994, the number was 31; this year, the figure might reach 50. Spending a reported annual $90 million on capital cases, California has managed to gas just two inmates—and one of them waived all his appeals.

Capital punishment in America is a paper tiger. Despite tough political bluster and overwhelming poll numbers, the nation is ambivalent about the ultimate penalty. For many years, legislators, governors, judges and victims'-rights activists have vowed to finally get on with it—to bar endless appeals, sanction mollycoddling defense lawyers, root out office bleeding-heart governors. Congress passed reforms and cut funding for defense lawyers, the U.S. Supreme Court cracked down, and leaders like New York Gov. Mario Cuomo were voted out. The press, NEWSWEEK included, proclaimed in various aqueous illusions that the floodgates would soon open or that the logjam was about to be broken.

It's never happened. State prosecutors' offices remain understaffed and overwhelmed, courts have hopelessly long backlogs (assuming they can find lawyers for the defendants in the first place) and juries in most states enthusiastically continue to send killers to death row. For every inmate to die, though, there are five new ones to take his (or, in the rare case, her) cell. To clean up the backlog, states would have to execute a killer a day (Christmas and Easter included) through 2021. Even Texas—far and away the nation's death-penalty capital, with a third of all executions since 1976—manages to dispatch only about one in eight condemned inmates.

At the water cooler and in the streets of Union, S.C., people argue about what fate the Susan Smiths of the world deserve. And race and poverty have never gone away in the vexing national debate over the death penalty. But those moral and ideological questions have now been overshadowed by a simpler fact: people sentenced to death nonetheless live on in prison. What's the most frequent cause of death for death-row inmates? As of 1992, according to the U.S. Bureau of Justice Statistics, electrocution and lethal in-

jection were mere runner-ups. The No. 1 killer: "Natural Causes." What becomes of a penal policy that on its face is a sham?

Ask Alex Kozinski, one of the country's most outspoken and conservative federal judges who almost always upholds death sentences. "We have constructed a machine that is extremely expensive, chokes our legal institutions, visits repeated trauma on victims' families and ultimately produces nothing like the benefits we would expect from an effective system of capital punishment," he wrote in a recent, controversial op-ed article in The New York Times. "This is surely the worst of all worlds."

The systemic ambivalence about the death penalty is reflected in virtually all the 38 states that have death chambers open for business. During his election campaign last year, South Carolina's new attorney general, Charlie Condon, was so taken with a triple execution in Arkansas that he proposed doing away with his state's electric chair. His reform? An "electric sofa," to juice several inmates at a time. South Carolina's death-row population is 59; its last execution was in 1991. Ambivalence there

Pyramids Gatefold

Pyramids were the economic engines of ancient Egypt. To illustrate this perspective, the designers created a layered map that links pyramid sites with surrounding trade routes and mineral deposits. Above this image, in the same perspective, is a telescopic view of the Nile river valley as it might have appeared in ancient times. Above that, another telescopic view shows the pyramid-studded Giza plateau and harbor, which was the center of economic activity. Zooming in further, the viewer enters the interior of the largest built pyramid. Sidebar illustrations identify key elements of a pyramid complex and trace the evolution of pyramids over time.

Design Firm/Client **National Geographic Magazine, Washington, D.C.**

Art Director **Chris Sloan**

Graphic Designer **Carolyn Summerville**

Illustrator **Chuck Carter**

Writer **Bill Newcott**

Researcher **Karen Gibbs**

Publisher **National Geographic Society**

Printer **Ringier America, Inc.**

Life on a Wharf Piling

Biodiversity exists in the depths of exotic rain forests, but few people are aware of the presence of hidden realms in more familiar, mundane habitats. A wharf piling in the lower Chesapeake Bay teems with many life forms, which are graphically exposed here to show how each adapts to its own intertidal niche and how all are linked in a web of interrelationships.

Design Firm/Client **National Geographic Magazine, Washington, D.C.**
Art Director **Mark Holmes**
Graphic Designer **Carol Ann Smallwood**
Illustrator **Christopher A. Klein**
Writers **Cassandra Franklin-Barbajosa and George Grall**
Researcher **Hillel Hoffmann**
Publisher **National Geographic Society**
Printer **Ringier America, Inc.**

Layers of Life

The rainforest canopy represents an abundance of life, but photographs rarely show more than a tangled riot of green. By categorizing the kinds of plants and animals found on a typical tree branch, the designers not only sorted the jumble into understandable fragments, but made sense of the canopy's varied ecological relationships and survival strategies.

Design Firm/Client **National Geographic Magazine, Washington, D.C.**
Art Director **Nicholas Kirillof**
Illustrator **John D. Dawson**
Writer **Cliff Tarpy**
Researcher **Hillel Hoffmann**
Publisher **National Geographic Society**
Printer **Ringier America, Inc.**

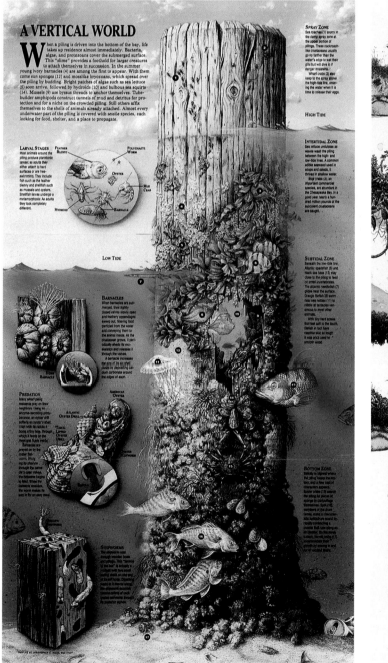

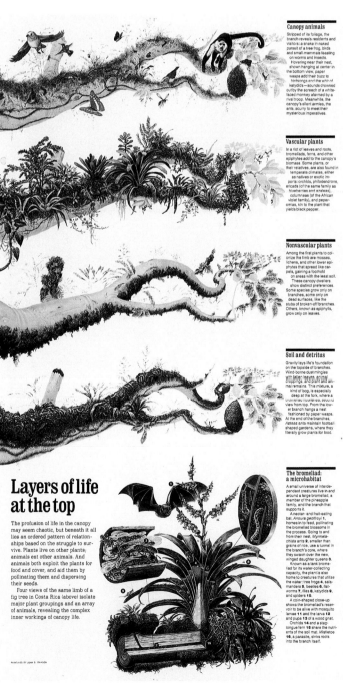

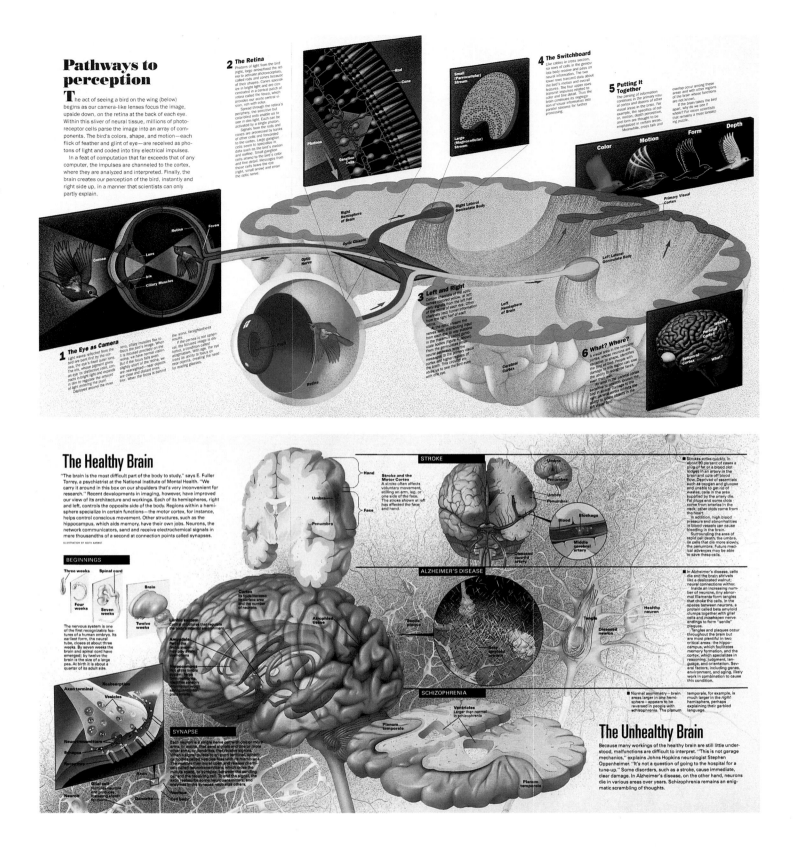

Pathways to perception

The act of seeing a bird on the wing (below) begins as our camera-like lenses focus the image, upside down, on the retina at the back of each eye. Within this sliver of neural tissue, millions of photoreceptor cells parse the image into an array of components. The bird's colors, shape, and motion—each flick of feather and glint of eye—are received as photons of light and coded into tiny electrical impulses.

In a feat of computation that far exceeds that of any computer, the impulses are channeled to the cortex, where they are analyzed and interpreted. Finally, the brain creates our perception of the bird, instantly and right side up, in a manner that scientists can only partly explain.

2 The Retina

4 The Switchboard

5 Putting It Together

1 The Eye as Camera

3 Left and Right

6 What? Where?

Color Motion Form Depth

Primary Visual Cortex

The Healthy Brain

"The brain is the most difficult part of the body to study," says E. Fuller Torrey, a psychiatrist at the National Institute of Mental Health. "We carry it around in this box on our shoulders that's very inconvenient for research." Recent developments in imaging, however, have improved our view of its architecture and workings. Each of its hemispheres, right and left, controls the opposite side of the body. Regions within a hemisphere specialize in certain functions—the motor cortex, for instance, helps control conscious movement. Other structures, such as the hippocampus, which aids memory, have their own jobs. Neurons, the network communicators, send and receive electrochemical signals in mere thousandths of a second at connection points called synapses.

ILLUSTRATION BY KEITH KASNOT

BEGINNINGS

Three weeks Spinal cord
Four weeks Seven weeks
Twelve weeks Brain

The nervous system is one of the first recognizable features of a human embryo. Its earliest form, the neural tube, closes at about three weeks. By seven weeks the brain and spinal cord have emerged; by twelve the brain is the size of a large pea. At birth it is about a quarter of its adult size.

SYNAPSE

STROKE

ALZHEIMER'S DISEASE

SCHIZOPHRENIA

The Unhealthy Brain

Because many workings of the healthy brain are still little understood, malfunctions are difficult to interpret. "This is not garage mechanics," explains Johns Hopkins neurologist Stephen Oppenheimer. "It's not a question of going to the hospital for a tune-up." Some disorders, such as a stroke, cause immediate, clear damage. In Alzheimer's disease, on the other hand, neurons die in various areas over years. Schizophrenia remains an enigmatic scrambling of thoughts.

Life Sense of Sight

Many diagrams have been published showing how
the eye works in a mechanical sense. But little effort
has been made to illustrate the remarkable sequence
that begins when photons stream through our pupils
and ends — a fraction of a second later — when the
mind recognizes a familiar object. This nearly instanta-
neous process is fantastically complex, and parts of
it are still poorly understood. This design gives readers
a new appreciation for the mind's subtle sophistication
by graphically describing the pathways information
takes as it is transmuted by the nervous system into
perception.

Design Firm/Client **National Geographic Magazine,**
Washington, D.C.
Art Director **Allen Carroll**
Graphic Designer **Mark Holmes**
Illustrator **Edward S. Gazsi**
Writers **Ann Williams and Bill Newcott**
Researcher **Hillel Hoffmann**
Publisher **National Geographic Society**
Printer **Ringier America, Inc.**

Healthy Brain/Unhealthy Brain

Diagrams can barely tap the mystery of the brain,
an object of endless wonder. After extensive consulta-
tions with leading neurologists, the designers opted
to suggest the brain's mystique on both side of a maga-
zine gatefold. The folded flap displays a healthy brain's
anatomy, summarizes its growth, and describes how
neurons and synapses work. In contrast, the open
gatefold illustrates the causes and physiological effects
of three common brain diseases.

Design Firm/Client **National Geographic Magazine,**
Washington, D.C.
Art Director **Mark Holmes**
Graphic Designer **Carolyn Summerville**
Illustrator **Keith Kasnot**
Writer **Ann Williams**
Researcher **Hillel Hoffmann**
Publisher **National Geographic Society**
Printer **Ringier America, Inc.**

Equine Parasite Protection

Most horse owners understand that parasitic
worms pose a serious threat to the health of their
animals, but few understand that different kinds
of worms do damage at different life-cycle stages.
This brochure, developed for veterinarians, was
designed to explain the use and limitations of various
classes of de-wormers. A flip chart shows what
each parasite looks like during its life cycle, where
it damages the horse, and which parasiticides are
effective at which stage of the parasite's development.

Design Firm **Warhaftig Associates, Inc.,**
New York, NY
Art Director **Reiner Lubge**
Illustrator **Richard A. Botto**
Photographers **Todd Buchanan (Cover) and Various**
Writer **Jon Hughes**
Client **Merck & Company, Inc.**
Typographer **Warhaftig Associates, Inc.**
Printer **Panorama**
Paper **S.D. Warren 100# Dull Cover**

▼

The Ballistics of Assassination

In an appendix to Gerald Posner's 1993 book *Case Closed*, the author argues that the Warren Commission was correct: Lee Harvey Oswald, acting alone, killed John F. Kennedy. For this graphic analysis, the assassination was divided into four main areas. Evidence is brought together — including startling computer projections — that trace the bullet's trajectories back to their origins. The author, section editor, researcher, and graphic artist worked together closely to decide which elements of the report warranted visual explanation and how they could be best displayed.

Illustrator **John Grimwade**
Writer **Gerald Posner**
Editor **Clive Irving**
Researcher **Joyce Pendola**
Publisher **Random House**

Reading the Ice

Designed to accompany a feature story on the effects of global warming on the world's glaciers, this graphic serves as a general primer on glacier mechanics. It explains how glacier ice contains thousands of years' worth of information about vegetation and climate.

Design Director **Diana LaGuardia**
Graphic Designer **Christin Gangi**
Illustrator **John Grimwade**
Publisher **Condé Nast Traveler**

Pieces of the Problem

Condé Nast Traveler has a reputation for covering important air-travel issues and often uses graphics to help explain the details. Serious, but not sensationalist, the magazine's visual approach is deliberately restrained.

Design Director **Diana LaGuardia**
Graphic Designer **Michael Powers**
Illustrator **John Grimwade**
Publisher **Condé Nast Traveler**

The Earth's Ice Crown

Part map, diagram, and illustration, this image was designed to support and expand an accompanying feature story that described a voyage to the North Pole on a Russian icebreaker.

Design Director **Diana LaGuardia**
Graphic Designer **Stephen Orr**
Illustrator **John Grimwade**
Publisher **Condé Nast Traveler**

X Ray: A Century of Medical Radiology: 1895-1995

These posters were developed to meet the need for an informative, widely accessible, and inexpensive display to mark the centennial of the invention of the X ray. Designed for display in lobbies and exhibit areas in hospitals, medical centers, medical and technical schools, radiology practices, and public libraries, the posters offer professional and lay audiences a lively interpretation of radiology's medical history. The designers organized archival material and an interpretive script provided by the client into a graphic hierarchy of zones, layers, and timelines that could be scanned, read casually, or studied in depth.

Design Firm **Dearborn, Geyman & Company, Reston, VA**

Art Director/Graphic Designer **Nan Dearborn**

Photo Researcher/Writer **Nancy Knight**

Print Coordinator **Becky Haines**

Client **Radiology Centennial, Inc.**

Prepress **Aurora Color**

Printer **Custom Print, Inc.**

Paper **Mohawk**

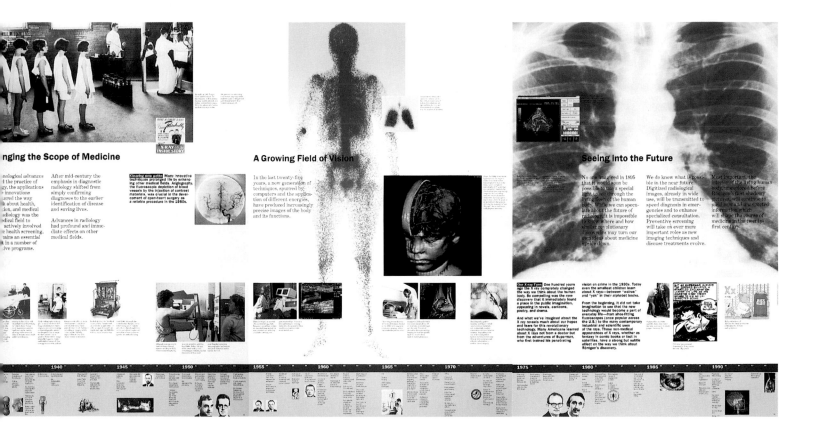

nging the Scope of Medicine

...nological advances ...d the practice of ...gy, the applications ...e innovations ...ered the way ...about health, ...ion, and medical ...diology was the ...edical field to ...tively involved ...e health screening, ...nains an essential ...t in a number of ...ive programs.

After mid-century the emphasis in diagnostic radiology shifted from simply confirming diagnoses to the earlier identification of disease and saving lives.

Advances in radiology had profound and immediate effects on other medical fields.

Clearing new paths Many innovative techniques prolonged life by enhancing other medical fields. Angiography, the fluoroscopic depiction of blood vessels by the injection of contrast materials, was crucial in the development of open-heart surgery as a reliable procedure in the 1950s.

A Growing Field of Vision

In the last twenty-five years, a new generation of specialists, spurred by computers and the application of different energies, have produced increasingly precise images of the body and its functions.

Seeing into the Future

No one imagined in 1895 that it would soon be possible to use a special light to see through the living flesh of the human body. While we can speculate about the future of radiology, it is impossible to know where and how similar revolutionary discoveries may turn our own ideas about medicine upside down.

We do know what is possible in the near future. Digitized radiological images, already in wide use, will be transmitted to speed diagnosis in emergencies and to enhance specialized consultation. Preventive screening will take on ever more important roles as new imaging techniques and disease treatments evolve.

Most important, the interior of the living human body, unexplored before Röntgen's first shadowy pictures, will continue to yield new and unexpected information which will shape the course of medicine in the twenty-first century.

Our X-ray Eyes One hundred years ago the X ray completely changed the way we think about the human body. So compelling was the new discovery that it immediately found a place in the public imagination, appearing in novels, cartoons, poetry, and drama.

And what we've imagined about the X ray reveals much about our hopes and fears for this revolutionary technology. Many Americans learned about X rays not from a doctor but from the adventures of Superman, who first trained his penetrating vision on crime in the 1930s. Today even the smallest children learn "X rays—between 'walrus' and 'yak'" in their alphabet books.

From the beginning, it did not take imagination to see that this new technology would become a part of everyday life—from shoe-fitting fluoroscopes (once popular across the U.S.) to the many contemporary industrial and scientific uses of the rays. These non-medical appearances of X rays, whether as fantasy in comic books or fact in satellites, have a strong but subtle effect on the way we think about Röntgen's discovery.

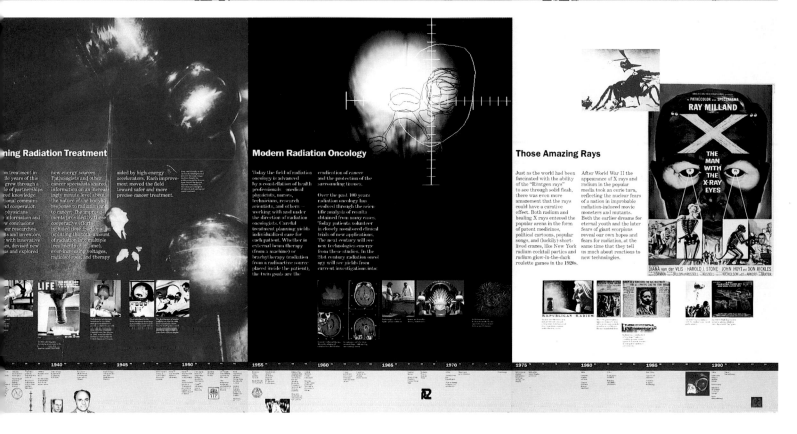

...ning Radiation Treatment

...on treatment in ...le years of this ...grew through a ...te of partnerships ...ved knowledge, ...tional communi- ...nd cooperation ...physicians ...ir researches. ...s and inventors, ...with innovative ...es, devised new ...us and explored

new energy sources. Pathologists and other cancer specialists shared information on an increasingly minute level about the nature of the body's response to radiation and to cancer. The improvements provided by these cooperative efforts included dose fractionation (splitting the total amount of radiation into multiple treatments over time), ever-increasing voltages, radioisotopes, and therapy

aided by high-energy accelerators. Each improvement moved the field toward safer and more precise cancer treatment.

Modern Radiation Oncology

Today the field of radiation oncology is advanced by a constellation of health professionals—medical physicists, nurses, technicians, research scientists, and others—working with and under the direction of radiation oncologists. Careful treatment planning yields individualized care for each patient. Whether in external beam therapy (from a machine) or brachytherapy (radiation from a radioactive source placed inside the patient), the twin goals are the

eradication of cancer and the protection of the surrounding tissues.

Over the past 100 years radiation oncology has evolved through the trial-and-error analysis of results obtained from many cases. Today patients volunteer in closely monitored clinical trials of new applications. The next century will see new technologies emerge from these studies. In the 21st century radiation oncology will see yields from current investigations into...

Those Amazing Rays

Just as the world had been fascinated with the ability of the "Röntgen rays" to see through solid flesh, there was even more amazement that the rays could have a curative effect. Both radium and healing X rays entered the popular arena in the form of patent medicines, political cartoons, popular songs, and (luckily) short-lived crazes, like New York radium cocktail parties and radium glow-in-the-dark roulette games in the 1920s.

After World War II the appearance of X rays and radium in the popular media took an eerie turn, reflecting the nuclear fears of a nation in improbable radiation-induced movie monsters and mutants. Both the earlier dreams for eternal youth and the later fears of giant scorpions reveal our own hopes and fears for radiation, at the same time that they tell us much about reactions to new technologies.

Do It! Guidebook Series

Each booklet in the series contains step-by-step instructions for a single household task, such as stripping a floor or fixing a bicycle. Designed for distinct purposes, the guides also work together as an eye-catching store display.

Design Firm **Pentagram Design, New York, NY**
Art Director **Michael Bierut**
Graphic Designer **Agnethe Glatved**
Illustrator **Nicholas Fasciano**
Photographer **John Paul Endress**
Publisher **Redefinition Books/Chronicle Books**

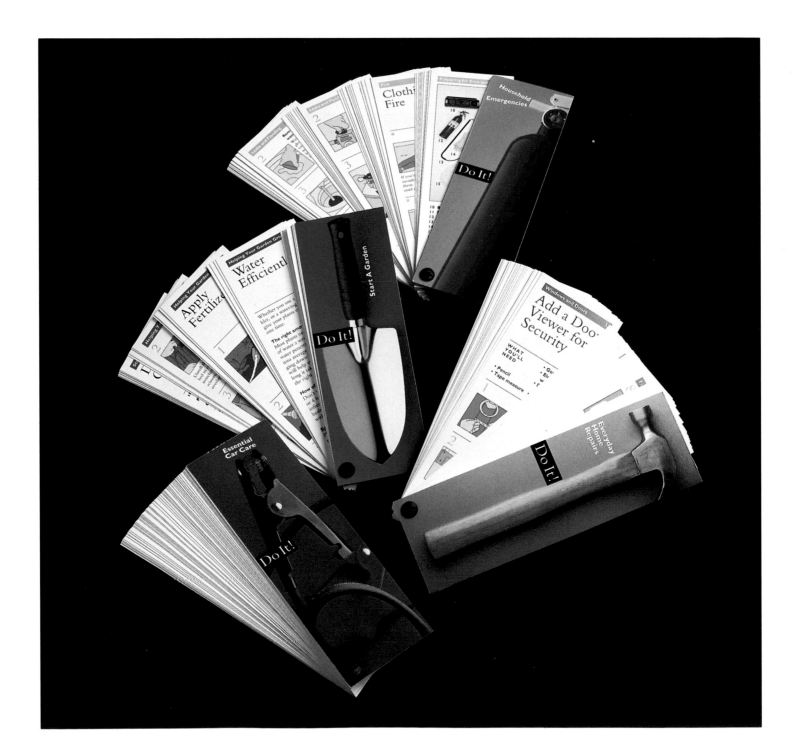

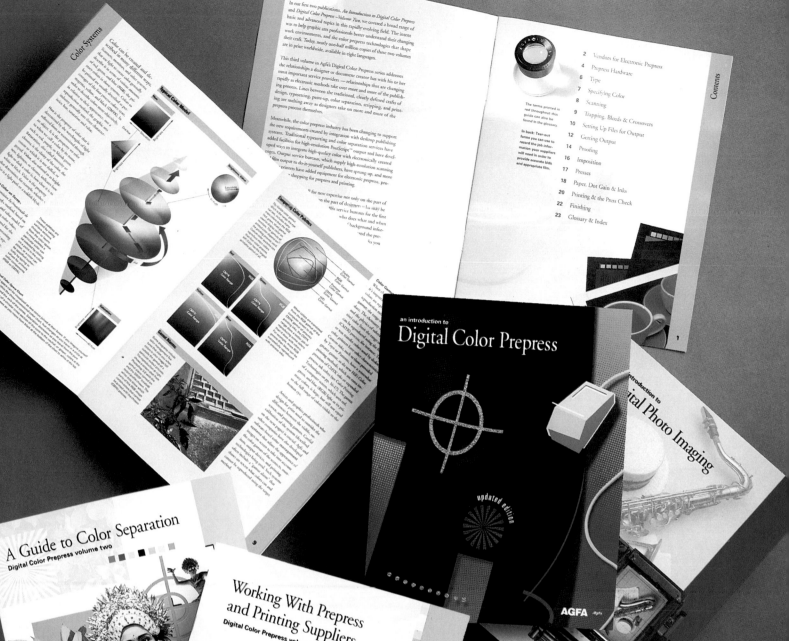

Digital Color Prepress Series

This series was conceived in 1990, when the challenge of desktop publishing had just begun and information on new technology was scarce. Produced by a major vendor of digital prepress equipment, visual guides were created in seven languages for designers, print buyers, desktop publishers, and others involved in color prepress. Topics are explained graphically with brief explanatory text on single pages or double-page spreads so that readers can access information randomly, as well as sequentially. Although writers and illustrators often chafed at the strict one- or two-page architecture, its clear structure and effectiveness outweighed the creative frustration.

Design Firm **YO, San Francisco, CA**
Creative Directors **Maria Guidice and Lynne Stiles**
Illustrators **Arne Hurty and Steve McGuire**
Photographers **Various**
Writers **Various**
Client **AGFA**
Prepress Suppliers **Digital Prepress International, Anderson Lithograph**
Printers **Fong & Fong, Anderson Lithograph**
Paper **Centura Dull Coated**

Myriad Multiple Master

Recent advances in technology and innovations in type-
face design spawned the concept of a "multiple master
typeface" that generates fonts of unlimited weights and
widths. Myriad, the first of of these type mutants, was
introduced to the design community in this book, which
displays the typeface in settings of varied sizes, along
with sample art that demonstrates how multiple master
technology solves design problems.

Design Firm/Client **Adobe Systems, Inc.,**
Mountain View, CA
Art Director **Laurie Szujewska**
Graphic Designers **Laurie Szujewska**
and James Young
Photographer **Dennis Hearne**
Writer **E. M. Ginger**
Publisher **Adobe Systems, Inc.**
Typographers **Laurie Szujewska and James Young**
Printer **West Coast Lithography**
Paper **Mohawk Superfine**

Minion Multiple Master

Minion was the first multiple master typeface with
three flexible design axes — weight, width, and size.
This book demonstrates this technology's ability to
generate unlimited variations, especially the size
axis, which optically customizes the typeface design
according to point size. Sample art and specimen
settings also showcase the beauty of the typeface
in its varied sizes, weights, and widths.

Design Firm/Client **Adobe Systems, Inc.,**
Mountain View, CA
Art Director **Laurie Szujewska**
Graphic Designers **Margery Cantor,**
Laurie Szujewska, and James Young
Photographer **Dennis Hearne**
Writer **Tanya Wendling**
Publisher **Adobe Systems, Inc.**
Typographers **Laurie Szujewska and James Young**
Printer **West Coast Lithography**
Paper **Mohawk Superfine**

Poetica

Poetica is a digital typeface modeled on formal
chancery scripts developed during the Renaissance.
This specimen book showcases all 21 character
sets, alternative characters, ligatures, and ornamental
designs, and demonstrates how individual characters
are used in context. The design locates each
character on the keyboard and facilitates character
by character comparisons. In addition to a brief
history of chancery scripts, the book includes sample
settings of the basic font in assorted sizes along
with contemporary illustrations that display the beauty
of the typeface in use.

Design Firm/Client **Adobe Systems, Inc.,**
Mountain View, CA
Art Director **Laurie Szujewska**
Graphic Designers **Laurie Szujewska**
and James Young
Photographer **Dennis Hearne**
Writer **E. M. Ginger**
Client/Publisher **Adobe Systems, Inc.**
Typographers **Margery Cantor, Laurie Szujewska,**
and James Young
Printer **West Coast Lithography**
Paper **Mohawk Superfine**

Census 2000

The Census Bureau has long been concerned with low rates of return and the expenses associated with soliciting each decade's responses. The designers reorganized, simplified, and redesigned the instructions so that the experience of receiving, completing, and returning the material would be as easy as possible. The form was reformatted to facilitate input by people instead of processing by machines. Primary, patriotic colors were chosen for their ability to stand out in the mail and look contemporary in the year 2000. A typeface was selected for its legibility and data recognition by optical scanning machines. Of the three similar designs submitted, the Census Bureau chose these two versions for further development.

Design Firm **Two Twelve Associates, New York, NY**
Creative Director **Sylvia Harris Woodard**
Art Director **Julie Marable**
Illustrator **David Flaherty**
Designers/Typographers **Ellen Conant and Courtney Howell**
Writers **Sylvia Harris Woodard and Julie Marable**
Client **U.S. Department of Commerce**
Printer **Rochester Institute of Technology**

Path Station Maps

Three-dimensional color images map multilevel pathways in a complex urban transportation center, helping passengers to visualize their path from the platform to the street.

Design Firm **Louis Nelson Associates, Inc., New York, NY**
Art Director **Louis Nelson**
Graphic Designer **Jennifer Stoller**
Client **Port Authority/Port Authority Trans Hudson**

Communi-Card 2

This visual tool facilitates interaction between emergency service and cardiac care staff and non-English-speaking patients or those with communication problems. Colorful pictograms illustrate symptoms, while a simplified human figure targets the symptom's location. Basic questions in English and a second language along with an alphabet on the back of the card allow users to spell out messages.

Firm **Richard Poulin Design Group Inc., New York, NY**
Art Director **Richard Poulin**
Graphic Designers **J. Graham Hanson and Richard Poulin**
Client **Mount Sinai Medical Center**
Printer **Colahan-Saunders Corporation**
Paper **Warren Lustro Offset Enamel**

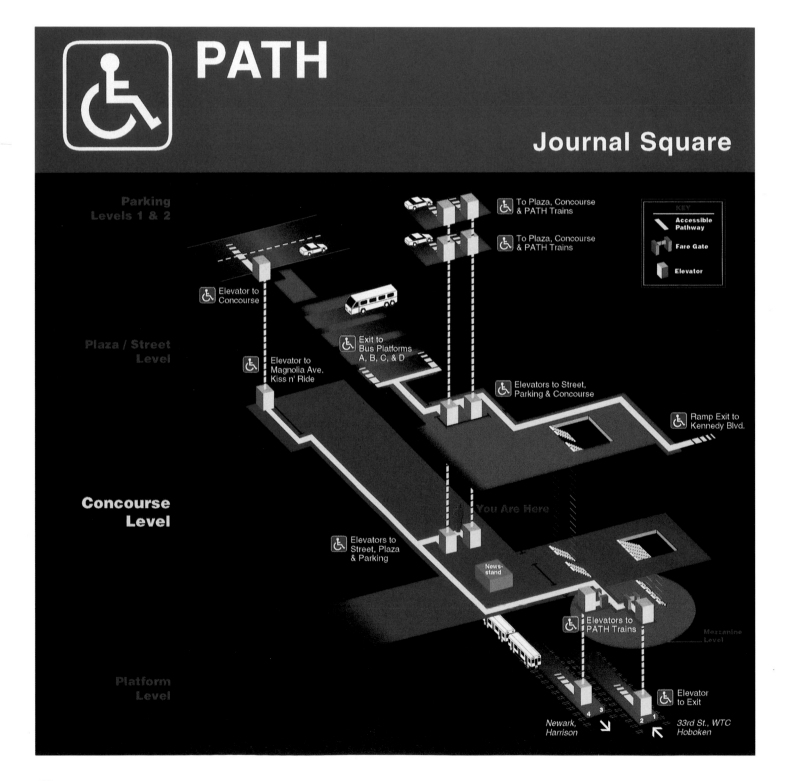

Communi-Card **2**

This card has been prepared to assist you in communicating with hospital staff in the emergency area and special care units.

Esta tarjeta ha sido preparada para ayudarle a comunicarse con el personal en la sala de emergencia y en la unidad de cuidado intensivo.

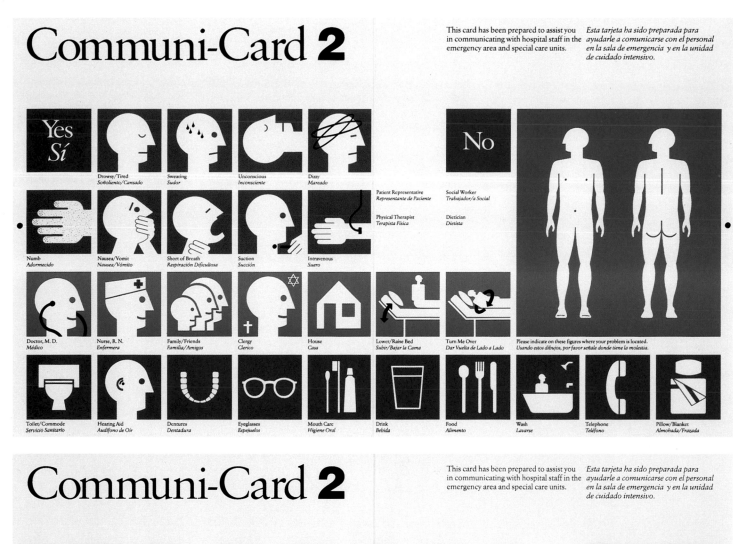

Yes *Sí*

Drowsy/Tired — *Soñoliento/Cansado*
Sweating — *Sudor*
Unconscious — *Inconsciente*
Dizzy — *Mareado*

Numb — *Adormecido*
Nausea/Vomit — *Nausea/Vómito*
Short of Breath — *Respiración Dificultosa*
Suction — *Succión*
Intravenous — *Suero*

Patient Representative — *Representante de Paciente*
Social Worker — *Trabajador/a Social*
Physical Therapist — *Terapista Física*
Dietician — *Dietista*

Doctor, M. D. — *Médico*
Nurse, R. N. — *Enfermera*
Family/Friends — *Familia/Amigos*
Clergy — *Clerico*
House — *Casa*
Lower/Raise Bed — *Subir/Bajar la Cama*
Turn Me Over — *Dar Vuelta de Lado a Lado*

No

Please indicate on these figures where your problem is located.
Usando estos dibujos, por favor señale donde tiene la molestia.

Toilet/Commode — *Servicio Sanitario*
Hearing Aid — *Audífono de Oir*
Dentures — *Dentadura*
Eyeglasses — *Espejuelos*
Mouth Care — *Higiene Oral*
Drink — *Bebida*
Food — *Alimento*
Wash — *Lavarse*
Telephone — *Teléfono*
Pillow/Blanket — *Almohada/Frazada*

Communi-Card **2**

This card has been prepared to assist you in communicating with hospital staff in the emergency area and special care units.

Esta tarjeta ha sido preparada para ayudarle a comunicarse con el personal en la sala de emergencia y en la unidad de cuidado intensivo.

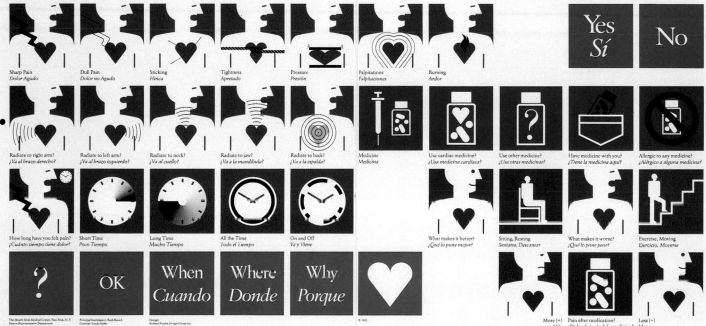

Sharp Pain — *Dolor Agudo*
Dull Pain — *Dolor no Agudo*
Sticking — *Hinca*
Tightness — *Apretado*
Pressure — *Presión*
Palpitations — *Palpitaciones*
Burning — *Ardor*

Yes *Sí*
No

Radiate to right arm? — *¿Va al brazo derecho?*
Radiate to left arm? — *¿Va al brazo izquierdo?*
Radiate to neck? — *¿Va al cuello?*
Radiate to jaw? — *¿Va a la mandíbula?*
Radiate to back? — *¿Va a la espalda?*
Medicine — *Medicina*

Use cardiac medicine? — *¿Usa medicina cardíaca?*
Use other medicine? — *¿Usa otras medicinas?*
Have medicine with you? — *¿Tiene la medicina aquí?*
Allergic to any medicine? — *¿Alérgico a alguna medicina?*

How long have you felt pain? — *¿Cuánto tiempo tiene dolor?*
Short Time — *Poco Tiempo*
Long Time — *Mucho Tiempo*
All the Time — *Todo el Tiempo*
On and Off — *Va y Viene*

What makes it better? — *¿Qué lo pone mejor?*
Sitting, Resting — *Sentarse, Descansar*
What makes it worse? — *¿Qué lo pone peor?*
Exercise, Moving — *Ejercicio, Moverse*

?
OK
When *Cuando*
Where *Donde*
Why *Porque*

The Mount Sinai Medical Center, New York, N.Y. Patient Representative Department
Principal Investigator: Ruth Ravich Concept: Linda Marks
Design: Richard Poulin Design Group Inc.
© 1992

More (+) — *Más*
Pain after medication? — *¿Dolor después de la medicina?*
Less (−) — *Menos*

Price Tag

This stand-alone graphic series, which ran in a fixed space on the consumer page of *The New York Times*, offered cost comparisons on a broad range of consumer goods and services. The designer delivered a quantity of financial and statistical data in a visual package within tight time and space constraints. Her first priority was information. After tracking down the most recent figures on varied subjects from available databases, she shaped the data (layers of numbers, text, and pictures) in an artful way that invited readers to wander through its design. "The playful feel was intentional," she said. "Okay, we're talking about money and numbers, but if we can relax and poke fun at the subject (and ourselves), there's no harm done to the data."

Design Firm/Client **The New York Times,**
New York, NY

Graphic Designer **Megan Jaegerman**

Publisher **The New York Times**

How the Bridge Fared
on a Previous Inspection

During New York City's fiscal crisis, the Manhattan Bridge suffered a lack of maintenance and repairs. By the end of 1990, two sets of subway tracks were shut down to avoid overtaxing the weakened structure, which was inspected inch by inch over the following summer. The designer obtained the Department of Transportation log and sorted detailed locations of the corroded and cracked areas. By stacking the total number of dangerous "spots" over each roadway panel, the resulting diagram conveyed the location of the worst damage, emphasizing the cumulative number of problems by the degree of vertical stacking. The diagram was completed in July 1992, just as inspectors found a hole in a support beam which forced a shutdown of the entire bridge.

Design Firm/Client **The New York Times,**
New York, NY

Graphic Designer **Anne Cronin**

Publisher **The New York Times**

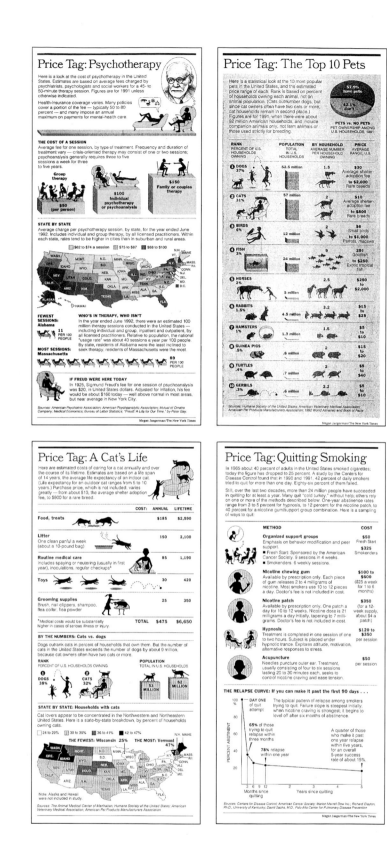

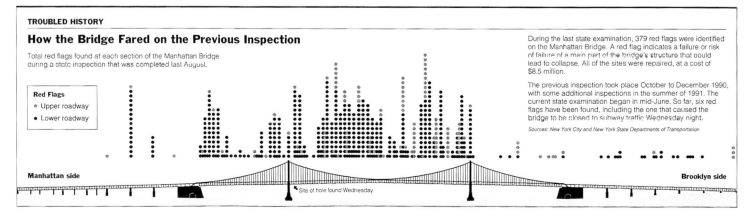

Loops and Whorls into Bits and Bytes: How One System Matches Prints

Thanks to recent technological advances, fingerprints no longer have to be manually recorded with ink and then laboriously compared against actual files of other prints. Prints can now be captured in a flash with optical scanners linked to personal computers, and then compared to millions of records in a fraction of the time previously required. To illustrate how one version of the new technology works, the graphic designer superimposed angle and distance formulas over an actual fingerprint, highlighting the specific areas of minutiae that are tracked for identification. When the beginning and end points of ridges on each set of prints are plotted and multiplied, these formulas generate a unique numeric code that is easily matched by computer.

Design Firm/Client **The New York Times,
New York, NY**
Art Director **Nancy Kent**
Graphic Designer **Anne Cronin**
Publisher **The New York Times**

Shooting in the Subway

Created in time to meet a press deadline within hours of the incident, this graphic depicts a complex accidental shooting of a police officer by his colleague following a chase in a New York City subway station. Mindful of the episode's sensitive political nature, the designer used six separate text blocks to present the facts without bias or commentary.

Design Firm/Client **The New York Times,
New York, NY**
Art Director **Carl Lavin**
Graphic Designer/Illustrator **Newman Huh**
Writers **John Haskins and Newman Huh**
Publisher **The New York Times**

Shrinking Snippets of Campaign Speech

The designer deemed Julius Caesar, whom he considered "a semi-poet laureate," as appropriate as any current head of state in this graphic for *The New York Times*. Television sets from each era lend a contemporary flavor, while the use of the Lithos font adds a Roman feeling to the text. Said the designer, who considers this piece (the result of a week's work) one of his best, "I can safely say that that was the first, last, and only time that font was used in the paper."

Design Firm/Client **The New York Times,
New York, NY**
Designer **Ty Ahmad-Taylor**
Publisher **The New York Times**

Loops and Whorls Into Bits and Bytes: How One System Matches Prints

Digitalized fingerprints have made regular searches of millions of print files possible. Here is how one version, the NEC Technologies Automated Fingerprint Identification System, works.

Old Way
Fingerprints used to be filed by Henry Classification, a method like the Dewey decimal system, that grouped prints by whorls, arches, etc., and counted print ridges. Fingerprints had to be checked manually against those it might resemble within its classification. In a large city, this could mean tens of thousands of prints. Without specifics, like a crime suspect's name, it was nearly impossible to make a match against a single crime-scene print.

New Way
The relationship of minutiae, or places at which fingerprint ridges end or split, are entered into a computer. This allows searches to be done electronically. The Los Angeles Police Department, for example, can now compare one print from a crime scene to every one of the almost 2 million sets of prints in their files in about an hour. If more information is available, (e.g. race, sex), this information can be used to narrow down the search and make it faster.

How It Works
The fingerprint is scanned into a computer and digitalized. Each minutia, or place at which ridge lines end or split into two, is noted and categorized by its type (end or split), by location, and ridge direction. Then four neighboring minutiae are also examined. The ridges between the minutiae are counted. That information is entered into a matrix. Blurred areas of the fingerprint are ignored.

Type of Minutia
Whether it is an end or a split.

Relative Position
Counted on a 512-pixel-per-inch scale from landmarks like the core. Pixels are the dots that make up computer images.

Relationship
The number of ridges between one minutia and the closest four minutiae.

Location and Angle
The point at which the minutia hits the X and Y axis and the angle at which it extends from that point.

Accuracy
The computer scores how closely a potential match comes to the search print and ranks the top contenders in descending order. With one good-quality print, the system is accurate better than 97 percent of the time.

Source: NEC Technologies, Inc.

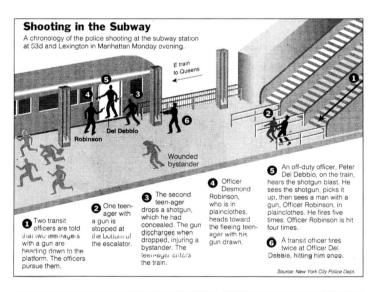

Shooting in the Subway
A chronology of the police shooting at the subway station at 53d and Lexington in Manhattan Monday evening.

E train to Queens

Del Debbio
Robinson
Wounded bystander

1 Two transit officers are told that two teen-agers with a gun are heading down to the platform. The officers pursue them.

2 One teen-ager with a gun is stopped at the bottom of the escalator.

3 The second teen-ager drops a shotgun, which he had concealed. The gun discharges when dropped, injuring a bystander. The teen-ager enters the train.

4 Officer Desmond Robinson, who is in plainclothes, heads toward the fleeing teen-ager with his gun drawn.

5 An off-duty officer, Peter Del Debbio, on the train, hears the shotgun blast. He sees the shotgun, picks it up, then sees a man with a gun, Officer Robinson, in plainclothes. He fires five times. Officer Robinson is hit four times.

6 A transit officer fires twice at Officer Del Debbio, hitting him once.

Source: New York City Police Dept.

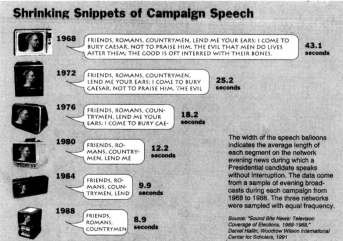

Shrinking Snippets of Campaign Speech

1968 FRIENDS, ROMANS, COUNTRYMEN, LEND ME YOUR EARS: I COME TO BURY CAESAR, NOT TO PRAISE HIM. THE EVIL THAT MEN DO LIVES AFTER THEM; THE GOOD IS OFT INTERRED WITH THEIR BONES. **43.1** seconds

1972 FRIENDS, ROMANS, COUNTRYMEN, LEND ME YOUR EARS; I COME TO BURY CAESAR, NOT TO PRAISE HIM. THE EVIL **25.2** seconds

1976 FRIENDS, ROMANS, COUNTRYMEN, LEND ME YOUR EARS; I COME TO BURY CAE- **18.2** seconds

1980 FRIENDS, RO-MANS, COUNTRY-MEN, LEND ME **12.2** seconds

1984 FRIENDS, RO-MANS, COUN-TRYMEN, LEND **9.9** seconds

1988 FRIENDS, ROMANS, COUNTRYMEN **8.9** seconds

The width of the speech balloons indicates the average length of each segment on the network evening news during which a Presidential candidate speaks without interruption. The data come from a sample of evening broadcasts during each campaign from 1968 to 1988. The three networks were sampled with equal frequency.

Source: "Sound Bite News: Television Coverage of Elections, 1968-1988," Daniel Hallin, Woodrow Wilson International Center for Scholars, 1991

Nutrition Facts

Serving Size 1/2 cup (114g)

Servings Per Container 4

Amount Per Serving

Calories 260 Calories from Fat 120

	% Daily Value*
Total Fat 13g	**20%**
Saturated Fat 5g	**25%**
Cholesterol 30mg	**10%**
Sodium 660mg	**28%**
Total Carbohydrate 31g	**11%**
Dietary Fiber 0g	**0%**
Sugars 5g	
Protein 5g	

Vitamin A 4%	•	Vitamin C 2%
Calcium 15%	•	Iron 4%

Warren Idea Exchange

A large international manufacturer of coated free-sheet
paper chose a paperless medium to communicate in
an innovative way with its customers. As a resource,
the Warren Idea Exchange had existed for decades.
The designers expanded its meaning and scope in a
16-color online application — a home page on the World
Wide Web — where the graphic arts community could
exchange ideas and have access to 700 pages of
information on printing, design, photography, and the
environment.

Design Firm **Siegel & Gale, Inc., New York, NY**
Creative Director **Cheryl Heller**
Project Manager **Evan Orensten**
Design Director **Patrick O'Flaherty**
Graphic Designers **Tony Hahn and Alex Hu**
Illustrator **Barnes Tilney**
Software Design **Kathleen Dolan, Tom Elia,**
Andrew Zolli
Client **S.D. Warren**

◄ BELOW
Nutrition Facts

In 1990, new legislation charged the FDA to develop
a labeling program that consumers could use to inform
their dietary decisions. Three constraints governed label
development. First, complex information had to be con-
veyed simply, in a way consumers of low-level literacy
could understand. Second, poor printing quality demand-
ed simple letterforms and graphic styling: sophisticated
graphic devices and color could not be used. Finally,
space was at a premium. Manufacturers who jealously
guard valuable label space lobbied to have the required
nutritional chart occupy the smallest possible portion
of the total food label.

Design Firm **Greenfield/Belser Ltd., Washington, D.C.**
Art Director **Burkey Belser**
Graphic Designers **Burkey Belser and Joe Kayser**
Client **Food and Drug Administration**

Canadian Sphagnum Peat Moss Packaging

Can packaging in two languages create broad consumer
awareness of a generic item and brand the individual
products of associated manufacturers? Designers
devised an "educational billboard" for a flexible packag-
ing system that established a uniform appearance for
bags of varied sizes and formats, and met the specific
branding needs of individual members of the Canadian
Sphagnum Peat Moss Association. The system is based
on three shared information units: an introduction to
product features and benefits for gardening and land-
scaping; two data matrices for specific seasonal applica-
tion instructions; and cross-referenced coverage
requirements and bag capacity to help consumers esti-
mate the size and number of bags required.

Design Firm **Fitch, Inc., Boston, MA**
Art Director **Mike Mooney**
Graphic Designers **Beth Novitsky and Carolina Senior**
Writer **Mike Mooney**
Client **Canadian Sphagnum Peat Moss Association**

◄

Siemens Intermail Icons

All unnecessary detail was removed and objects
were reduced to their essential form in order to create
a system of simple identity icons that is recognizable
in both monochromatic and color applications.

Design Firm **Infogram, New York, NY**
Art Director/Graphic Designer **Ronnie Peters**
Client **Siemens Nixdorf**

▼

Diagram (Cost, Activity, Time)

Is it possible to integrate disparate elements in one
cohesive environment using simple three-dimensional
shapes, forms, and color? The designer created a
diagram that combined the number, location, and cost
of one week's worth of student activities as part of
a class project while studying at the Rhode Island
School of Design.

Design Firm **Infogram, New York, NY**
Art Director/Graphic Designer **Ronnie Peters**
Client (School Project) **Rhode Island School of Design**

▲
Animated Maps

WGBH, Boston's public television network, developed
a six-hour documentary that relied heavily on mapping
to depict the voyages of Columbus and the subsequent
explorers who circumnavigated the globe. This sequence
describes Columbus's second voyage to the West
Indies, which was then thought to be the edge of Asia.
Rich, fluid 3-D computer animation articulates the adven-
turer's path through the island chain and reinforces a
global perspective while breaking with the pre-Columbian
flat earth paradigm.

Design Firm **WGBH, Boston, MA**
Art Director **Chris Pullman**
Graphic Designer **Chris Pullman**
Project Director **Bob Born**
Animator **Lamb & Company**
Writers **Various**
Executive Producer **Zvi Dor-Ner**

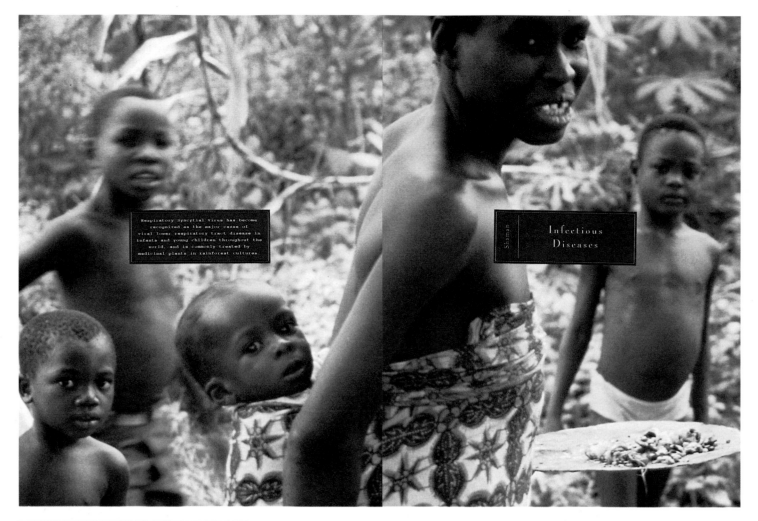

Respiratory Syncytial Virus has become
recognized as the major cause of
viral lower respiratory tract disease in
infants and young children throughout the
world, and is commonly treated by
medicinal plants in rainforest cultures.

Shaman | Infectious
Diseases

SHAMAN
Pharmaceuticals
1994
Annual Report

▲

**Shaman Pharmaceuticals
1994 Annual Report**

The map on the cover of this annual report for an
ethno-botany-based drug company immediately draws
the reader into the world of a shaman scientist. Aerial
photography and a journal entry handwritten by a field
scientist convey the company's scientific approach,
in which plants used by native healers in the rainforest
are screened for medicinal use. The text is formatted
as chapters in a book, while the combination of sequen-
tial field photography, scientific data, and descriptive
captions provides additional information about the com-
pany's unique approach to modern therapeutics.

Design Firm **Cahan & Associates, San Francisco, CA**
Art Director **Bill Cahan**
Graphic Designer **Sharrie Brooks**
Photographers **Bill McLeod and Various**
Writer **Shari Annes**
Client **Shaman Pharmaceuticals, Inc.**
Printer **Alan Lithograph**
Paper **Cougar**

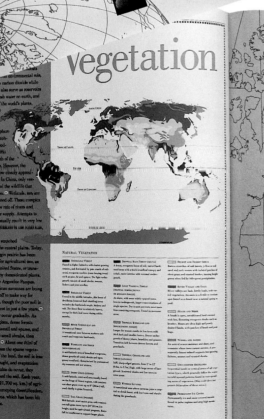

Hammond Atlas of the World

This atlas is the result of an ambitious five-year effort that combined designers, mathematicians, cartographers, editors, and advances in digital technology. Using a new formula based on fractal geometry, maps were created by plotting the Earth's latitude and longitude in a giant database. Because experimental departures from cartographic tradition would have obscured the information and undermined the maps' credibility, the designers developed a strict system for type and color usage. They gave information graphic form in the front sections, which describe the world's languages, religions, and environmental concerns.

Design Firm **Pentagram Design, New York, NY**
Art Director **Michael Gericke**
Graphic Designers **Donna Ching and Sharon Harel**
Maps **Hammond, Inc.**
Writer **Frederick Shamlian**
Publisher **Hammond, Inc.**

OUR TIMES
The Illustrated History of
THE 20TH CENTURY

▲

Our Times: The Illustrated History of the Twentieth Century

This massive volume enables general readers to comprehend the pivotal events of the present century and prepare for the yet-to-be-imagined challenges of the next. Considered the most comprehensive and ambitious visual and textual account of our century, the book was the result of the collaborative efforts of editors, writers, and graphic designers, who melded an authoritive text with over 2,500 illustrations — including archival photographs, paintings, and specially commissioned maps, diagrams, and charts.

Design Firm **Century Books, New York, NY**
Art Director **Linda Root**
Design Directors **Walter Bernard and Milton Glaser**
Illustrators **Nigel Holmes, Mirko Ilic, and Various**
Photographers **Various**
Writers **Various**
Publisher **Turner Publishing**
Printers **R.R. Donnelley (Text),**
McQuiddy Printing (Jacket)
Paper **Westvaco 70# Sterling Gloss**

Where Purchased Styling Product Last

1987 | 1995

	1987	1995
Department Store	14%	13%
Large Discount Chain	20%	28%
Cosmetic Supply/Drug Store	36%	28%
Beauty Salon	23%	27%
Mail Order/800-Number	N/A	1%*
Other	7%	7%

*Unstable; reported for consistency only

THIRTY 6

51% Total Respondents

GLAMOUR Readers

Index

Bought a fragrance as a result of trying a scent strip in a magazine

▼

Glamour 1995 Beauty Survey

In 1995, *Glamour* magazine conducted and produced a survey for beauty market advertisers to support the magazine's position as a beauty authority. The designers devised a structured foundation to maintain a consistent presentation for charts and information, which was counterbalanced with free-form images and a generous use of negative space. In each section, colorful informative graphics were created with beauty images to offset the density of the charts.

Design Firm **Michael Orr & Associates, New York, NY**
Creative Director **Sheila Sullivan**
Art Directors **Elizabeth Baldwin and Christine Licata**
Client **Glamour Promotion/Condé Nast Inc.**
Printer **Sieple Lithograph Company**
Paper **12 pt. Silver Mirricard C1S Cover, 17# UV Ultra II Vellum Bond, 80# Vintage Velvet Text**

Fragrance

I wear the same fragrance most of the time	44%
I wear different fragrances depending on the event or where I'm going	42%
I wear fragrance to feel sexy or attract a man	39%
The fragrance I wear reflects or expresses my mood at the moment	34%
I wear fragrance all the time, around the clock	28%
I wear a lighter fragrance to work than I do in the evening	27%
The fragrance I wear is chosen to express the way I would like to feel	18%
I try to match my fragrance to what I'm wearing	17%
I wear fragrance only for dating or special occasions	16%
I seldom wear fragrance to work	15%

The cosmetic supply and drug stores are losing share to the large discount chains, while the department stores remain on top — increasing their share by three points.

Fragrance: Where Purchased Last	1987	1995
Department store	60%	63%
Large discount chain	7%	13%
Cosmetic supply/drug store	19%	11%
Mail order/800-number	N/A	3%*
Other	14%	13%

*Unstable; reported for consistency only

Non-retail venues have made some headway in the fragrance market, perhaps due to the increasing popularity of scent strips. Whether because of new technology that offers a truer sample of the fragrance without seepage or just the fact that women have grown accustomed to them, scent strips increased 55% in their effectiveness at getting women to buy a fragrance. Over half of respondents (51%) said that they had purchased a fragrance after sampling it via scent strip vs. only 33% in 1987.

purchasing patterns

Nearly two-thirds of respondents (65%) had played some role in the purchase of fragrance as a gift for a man. Over half had purchased the scent themselves, and 31% had made the fragrance choice themselves for the gift they were buying or for someone else. Only 11% were told which scent to purchase by the man receiving the gift.

Women have very different motivations for using fragrance and different attitudes about that usage

More than two out of every five (44%) prefer to wear the same fragrance most of the time. It is a part of who they are, their signature scent. Yet almost as many women (42%) said they prefer to vary their scent depending on the occasion or place. Life in the Comfort Zone means that almost as many women can wear fragrance to fit their mood as to attract a man (34% and 39%, respectively). Fragrance is part of everyday life for over one in four respondents who claimed to wear scent "around the clock," as compared with only 16% who wore fragrance exclusively for special occasions. Fully 85% of women regularly wear fragrance to work; just over one-quarter prefer a lighter scent for the office than for evening.

Which of the following have you done in the past 12 months?

Chosen a fragrance as a gift for a man — 31%

Purchased a fragrance as a gift for a man — 51%

Purchased a fragrance which a man chose as a gift for himself — 14%

Fragrance is a part of **everyday life**

THIRTY 4

HANNAH WILKE

Words on Paper.

An encyclopedia.

Champion **Carnival** Text and Cover

j 24

jog
to shake a stack of papers, either on a machine or by hand, so that the edges line up. Printers jog the paper to get rid of any dust or particles, and to ensure proper feeding into the press.

kraft paper
a paper manufactured using kraft pulp, usually noted for its strength. In the kraft pulping process, fiber is separated from lignin by cooking wood chips with steam and pressure.
see also bleached kraft, lignin, pulping wood

Kraft paper is a material strong enough to withstand the rigors of postal handling.

laid finish
a paper with a translucent pattern of lines running both parallel to, and across the grain. Laid finished paper like Champion Mystique® is created by dropping a patterned dandy roll onto the paper machine while the paper is still wet.
see also dandy roll, finish

laser compatible
paper that performs on a laser printer or copier. Laser compatible paper has good dimensional stability that keeps it from curling, changing shape, and causing paper jams in printers and copiers. All of the premium writing grades that Champion manufactures are laser compatible.
see also dimensional stability, xerography

letterpress
a relief printing method. Printing is done using cast metal type or plates on which the image or printing areas are raised above the nonprinting areas. Ink rollers touch only the top surface of the raised areas; the nonprinting areas are lower and do not receive ink. The inked image is transferred directly to the page, resulting in type or images that may actually be depressed or debossed into the paper by the pressure of the press.
see also printing methods, relief

The concept of letterpress
Letterpress was the earliest process used for printing.

lignin
the natural, glue-like substance that holds together the cellulose fibers of wood plants. Lignin that is left in pulp causes paper to age and yellow over time.
see also acid-free, cellulose fiber, groundwood paper

like-sided
paper that has the same appearance and characteristics on both sides (the opposite of two-sided).
see also twin-wire machine, two-sidedness

linen finish
a paper finish that is similar to the texture of linen fabric, such as Champion Carnival Linen. Linen finishes are embossed after the paper comes off the paper machine.
see also embossing, finish

lines per inch
the number of lines in an inch, as found on the screens that create halftones and four-color process images (for example, "printed 175-line screen"). The more lines per inch, the more detailed the printed image will be. With the demand for computer-generated imagery, the term "dots per inch" (which refers to the resolution of the output), is replacing the term "lines per inch."
see also dpi, four-color process, halftone, screen

Lottery tickets dated May 6, 1782
In early America, money was often raised by lottery for the establishment of paper mills.

litho
short for lithography or offset lithography.

lithography
a printing process using flat surface planographic plates (originally stone) that is based on the principle that oil and water don't mix. The image to be lithographed is created on the plate with greasy material that repels water. Water is run over the plate, and the non-image areas absorb it. When the oily ink hits the plate, it's attracted to the similarly greasy image, and repelled by the rest of the wet plate. When paper is pressed onto the plate, it picks up the ink (and a bit of the water). This process is now used primarily for limited-edition art prints.
see also offset, planographic, plate, printing process

The concept of lithography
Lithography (li-thog'-ra-foe) literally means stone writing.

Invented in the late 1700's and made popular by Currier and Ives in the 1800's, lithography is the most frequently used printing method.

A winter country scene, Currier and Ives

M weight
the weight in pounds of 1,000 sheets (or two standard 500-sheet reams) of paper. On the label of a paper ream, the M weight is often given after the dimensions of the paper in the ream: for example, 23" x 29"-42M. The capital letter M, like the Roman numeral M, designates 1,000; the 42 indicates that the 1,000 sheets weigh 42 lbs.
see also basis weight, ream weight, weight

machine coated
paper that is coated on the papermaking machine.
see also coated paper

machine finish
a paper texture or finish imparted onto the paper while it's still

l 25

Intra Venus

Hannah Wilke was a pioneering body artist and feminist sculptor who used photographs and other media to address personal and universal themes. In this catalogue, the designer chose to remain true to the classic calm and directness of the artist's expression, constructing a dramatic performance that invites the viewer to experience Wilke's artistic process. Ultimately, the piece portrays the human, dignified way in which she lived life and confronted death.

Design Firm **Lisa Feldman Design, Scarsdale, NY**
Art Director/Graphic Designer **Lisa Feldman**
Photographers **Dennis Cowley, Christopher Giercke, and Donald Goddard**
Writers **Donald Goddard, Amelia Jones, Robert McKaskell, Renny Pritikin, and Marsie Scharlatt**
Client **The Estate of Hannah Wilke**
Publisher **Ronald Feldman Fine Arts**
Typographer **Lisa Feldman**
Printer **Virginia Lithograph**
Paper **Vintage Velvet White 100# Text and Cover**

◄ BELOW

Words on Paper: An Encyclopedia

Paper remains one of communication design's most pervasive tools, yet its history, terminology, and place in our culture remain relatively obscure, even to designers. Champion International created this educational tool to inform designers of paper's intrinsic value (while reminding them to use the company's products).

Design Firm **Crosby Associates, Inc., Chicago, IL**
Art Director **Bart Crosby**
Graphic Designer **Angela Norwood**
Illustrator **Kent Ijichi**
Photographer **Peter Bosy**
Writers **Nancy Garfinkel and Elizabeth Shepard**
Client **Champion International Corporation**
Printer **Active Graphics**
Paper **Champion Carnival Vellum 80# Cover and Text**

Cultural Connections

Most books about art, culture, or history consist of text supported by random illustrations or illustrations accompanied by brief or insubstantial captions. The design structure of this book supports the notion that collections are built, not born, and that the way artifacts are acquired, organized, and displayed reflects a culture's values, ideas, and preoccupations at a given point in time. Here, text, art, and captions that refer to artifacts in Philadelphia collections are treated as complete thoughts in a series of spreads so that the reader can immediately grasp the connections.

Design Firm **Joel Katz Design Associates, Philadelphia, PA**
Design Director **Joel Katz**
Graphic Designers **Jerome Cloud and Joel Katz**
Cartography **Joel Katz**
Photographers **Various**
Writer **Morris J. Vogel**
Client/Publisher **Temple University Press**
Typesetter **Duke and Company**
Printer **Nissha Printing Company**
Paper **Mitsubishi Super Matt Art**

Envisioning Information

The book's design was meant to be self-exemplifying, demonstrating the very ideas about information design that it contains.

Art Director **Edward R. Tufte**
Graphic Designer **Howard I. Gralla**
Illustrator **Nora Hillman Goeler**
Photographers **Richard Benson, Richard Caspole, Robert Hennessey, and Gus Kayafas**
Writer/Publisher **Edward R. Tufte**
Typesetter **Bixler Press & Letterfoundry**
Printer **Franklin Graphics**
Bookbinding **Acme Bookbinding Company**
Paper **Monadock Dulcet 100# Smooth Finish Text**

Architectour Japan 95:
An Inspiring Architectural Journey

An invitation directed at American architects took the form of a timeline view of 129 sites, seminars, and events offered in a two-week tour of Japan. The designers communicated this complex information with simplicity in a style appropriate to a creative but often aesthetically critical audience. Portraits, short bios, and project photos of nine notable Japanese architects connected by linear graphic elements give prospective attendees a flavor of the tour, and allow them to construct their personal itinerary.

Design Firm **Design Associates, Pasadena, CA**
Art Director **James Cross**
Graphic Designers **Lisa Ashworth, James Cross, and Agustin Garza**
Writer **Maxwell Arnold**
Client **Architects Abroad, Inc.**
Typographer **Lisa Ashworth**

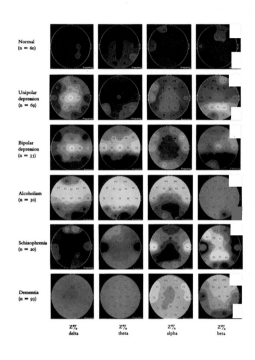

Jacob Leupold, *Theatrum Arithmetico-Geometricum* (Leipzig, 1727), section 4, tab. I.

4 Small Multiples 67

IN this splendid 1659 drawing by Christiaan Huygens, the inner ellipse traces Earth's yearly journey around the Sun; the larger ellipse shows Saturn's orbit, viewed from the heavens. The outermost images depict Saturn as seen through telescopes located on Earth. All told, we have 32 Saturns, at different locations in three-space and from the perspective of two different observers—a superior *small multiple* design.

At the heart of quantitative reasoning is a single question: *Compared to what?* Small multiple designs, multivariate and data bountiful, answer directly by visually enforcing comparisons of changes, of the differences among objects, of the scope of alternatives. For a wide range of problems in data presentation, small multiples are the best design solution.

Illustrations of postage-stamp size are indexed by category or a label, sequenced over time like the frames of a movie, or ordered by a quantitative variable not used in the single image itself. Information slices are positioned within the eyespan, so that viewers make comparisons at a glance—uninterrupted visual reasoning. Constancy of design puts the emphasis on changes in data, not changes in data frames.

Christiaan Huygens, *Systema Saturnium* (The Hague, 1659), p. 55.

A. Ghizzo, B. Izrar, P. Betrand, E. Fijalkow, M. R. Feix, and M. Shoucri, "Stability of Bernstein-Greene-Kruskal Plasma Equilibria: Numerical Experiments Over a Long Time," *Physics of Fluids*, 31 (January 1988), 72–82. Viewing these illustrations upside down turns the mountains into valleys. Note also the two-space contour plots to the right of the three-space perspectives.

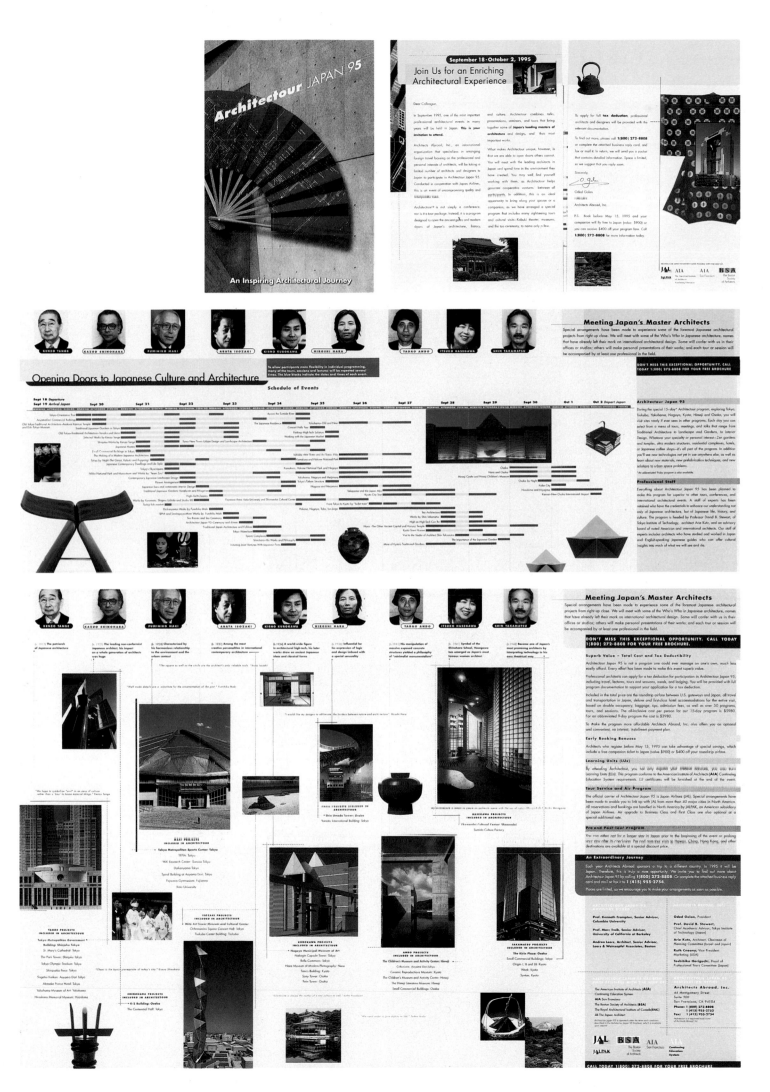

Philadelphia Architecture

A Guide to the City

Second Edition

A publication of the Foundation for Architecture
Philadelphia, Pennsylvania

Philadelphia's Best Buildings

In [and Near] Center City

Includes four walking tours

A publication of the Foundation for Architecture
Philadelphia, Pennsylvania

City Hall Tour

Center Square was one of the five squares set aside for public use in William Penn's original plan for Philadelphia. When the decision was made to locate the new City Hall in Center Square in 1870, the surrounding area became the focus of commercial development. At the time, Center Square was on the edge of the developed area of the city. There were several civic institutions along Broad Street and a few houses built by prominent citizens. All that changed as department stores, office buildings and banks surrounded City Hall. The importance of the area was strengthened when the Pennsylvania and Reading railroads located their stations west and east of City Hall.

In the past few decades, the railroad stations have provided the focus for even greater commercial and retail growth. During the 1950s, the Pennsylvania Railroad's Broad Street Station was demolished to create the Penn Center office complex. Retail development remained east of City Hall, where a new shopping mall, the Gallery, has been constructed adjacent to the Reading Terminal. More recently, the City Hall area has been transformed by some of the city's largest construction projects, including the Pennsylvania Convention Center and four tall office buildings, all of which exceed the traditional height limit of the City Hall Tower.

20

City Hall
1871–1901
John McArthur, Jr.,
architect, with
Thomas U. Walter
Open to the public

Reading Terminal
1891–93
The Wilson Brothers
Open to the public

T

he tour begins at City Hall and then proceeds through the older portions of the area along Market and Broad streets. The tour returns to City Hall after passing through the office sector to the west and along the beautiful Benjamin Franklin Parkway.

The first building on the tour is **(1) City Hall** (1871–1901), Broad and Market streets.

City Hall is the largest municipal building in the country and the finest example of the Second Empire style. It contains 14 ½ acres of floor space, occupied by city and county offices, courtrooms and several ornately detailed public spaces.

The building is organized around a central public courtyard which is reached through monumental arched portals on all four sides. Second Empire motifs are combined with an abundance of sculpture to give the exterior a rich yet intimately scaled appearance. Solid granite, 22 feet thick in some portions, forms the first floor and supports a brick structure faced with white marble.

Alexander Milne Calder created all the sculpture on the building. Calder also designed the 27-ton cast-iron statue of William Penn atop the tower, which is the largest single piece of sculpture on any building in the world. The 548-foot high tower is the world's tallest masonry structure without a steel frame. It is granite up to the clock, then cast iron painted to look like stone.

Public spaces within the building are among the most lavish in the city. The City Council chamber is ornately detailed and uses such expensive materials as alabaster on the walls. The Mayor's Reception Room is extremely handsome; it has a blue and gold ceiling, beautiful woodwork and red Egyptian marble columns. Conversation Hall, restored to its original elegance in 1982 by Day and Zimmermann Associates, is dominated by a magnificent chandelier. John Ord, chief architect from 1890–94, is thought to have been responsible for much of the interior detailing. The tower is open to the public and affords a wonderful view of the city.

Leave City Hall by the east portico and walk along Market Street to 12th Street to the **(2) Reading Terminal** (1891–93) *and Pennsylvania Convention Center* (1993–94).

When steam locomotives eliminated the fear of fire from wood-burning engines, the Reading Railroad built a inner-city terminal on the site occupied by the Franklin Farmers' Market since 1860. The market, now known as the Reading Terminal Market, was given space under the train shed where it remains to this day.

The Head House on Market Street originally contained waiting rooms and offices. It is constructed of wrought- and cast-iron columns, wrought-iron and steel beams and brick floors. The structural system was designed by the Wilson Brothers, as was the train shed, but the Italian Renaissance exterior of the Head House was applied over the structural system by a consulting architect, Frank Kimball of New York.

The train shed is the only surviving single-span arched train shed in the country. It was the largest single-span structure

21

1697
America's first stone
bridge at the "Pennepacka"
Creek

1709
First private mental
institution founded by
Quakers

1712
First ocean-going vessel
launched on Delaware

107

108

107 B,J *OP*
Christ Church, 1727–44
2nd and Market Sts.
Dr. John Kearsley, supervisor

Although Penn founded Philadelphia to provide a refuge for Quakers, he extended freedom of worship to all religions. One of the first groups to exercise this right was the Anglicans of the Church of England, whose interests had also been protected by Charles II in his charter to Penn.

When the Anglicans outgrew the wooden church built in 1697, they modeled their new church on the work of Sir Christopher Wren, the English architect who rebuilt fifty-two churches in London after the Great Fire. Construction was supervised by John Kearsley, a physician, who probably was responsible for the design. He was the first of many gentlemen-architects who designed important civic buildings.

Christ Church is symmetrical in plan and elevation. The decoration on the facade is classical. Two-story brick pilasters alternate rhythmically with round arch windows. The cornice is decorated with modillions, and a balustrade hides the vertical slope of the roof. On the east end, a large Palladian window provides light for the chancel. The classical forms are made more dramatic by the strong curving lines of fat scrolls on the east pediment and by the robust curves of the roof urns, capped by carved flames.

Christ Church was the most sumptuous building in the colonies. It was the most sophisticated example of Georgian design in spite of a few awkward details. One of the most noticeable is the failure of the cornice on the side to match the cornice line of the projecting pavilion on the east end.

Robert Smith, the most prominent master carpenter of the time, worked on the steeple, which was added in 1751–54. It also was designed with classical details: round arch windows, pilasters and pediments over circular windows. The brick tower was finished quickly, but it took three lotteries, sponsored by Benjamin Franklin, to raise enough money to add the wooden part. The 196-foot steeple, probably the tallest in the colonies, was a prominent landmark on the early Philadelphia skyline.

108 K *OP*
Stenton, 1728
Courtland and 18th Sts.

Stenton was built on a 500-acre estate by James Logan, William Penn's personal representative in the early years of the colony. Logan was a fur trader and iron merchant. He served as mayor of Philadelphia and chief justice of Pennsylvania.

Stenton is a magnificent example of an early Georgian country house. The facade is formal and symmetrically balanced. Simple brick pilasters mark the principal divisions and provide a strong accent at the corners. Modillions along the cornice provide ornament under the eaves of the hipped roof. Logan was a Quaker, and his manor house

The Georgian Style

The rebuilding of London after the Great Fire of 1666 provided a unique opportunity to introduce new architectural ideas. Many of the new buildings were influenced by the recently discovered classical architecture of the 16th-century Italian Renaissance. The work of the Italian architect Andrea Palladio was the dominant influence in London after 1715. Publications such as Campbell's Vitruvius Britannicus and Gibb's Book of Architecture made Palladio's work available throughout England and the colonies.

The Palladian style incorporates classical columns, pilasters, cornices and other decorative elements over the traditional brick building shell. These elements may be seen in elaborate doorways, heavy cornice lines, window treatment and brick detailing. The most prominent exterior feature is the Palladian window, a large, three-part window with an arched central bay.

The Palladian style is known as Georgian in the colonies. It was the dominant style for homes of the well to do, churches and civic buildings prior to the Revolutionary War.

reflects the influence of Quaker plainness on the Georgian style, particularly in the restrained use of ornament.

Inside, a generous staircase and fireplace fill the center hall, which was used as another room in the house. It is believed that the large front room on the second floor was Logan's library, which was the most distinguished in the colonies.

109 A,B,J *OP*
State House
(Independence Hall), 1732–48
See page 24.

110 K
Glen Fern, 1733–39
Livezey Lane, Fairmount Park

While Georgian houses were being built with classical ornament, the Shoemaker family of Germantown built a simple farmhouse with doors and windows spaced irregularly on a plain rubble facade. The house was later purchased by Thomas Livezey, who added a second story to the original one-and-a-half-story structure. In the 1850s, the kitchen and dining room were added laterally in the main block, resulting in a long, rambling structure typical of many country houses.

At its prime, the Livezey estate was self-sufficient. It included a grist mill, a forge, a shop for making barrels, a bridge across the Wissahickon Creek and a smokehouse. By the middle of the 19th century, steam-powered machines made water-powered mills obsolete. The mill was abandoned, and all that remains is the farmhouse and a dam with its mill race.

22

23

Philadelphia Architecture:
A Guide to the City

Philadelphia's Best Buildings
In or Near Center City

These two books were conceived and designed for audiences with varied interests, time commitments, and information needs — from the tourist to the scholar. *Philadelphia Architecture* (the second, updated version of the original 1984 edition) tracks the city's cultural, historical, and artistic development. A clear cross-referencing system moves the reader between a chronologically (rather than geographically) organized catalogue of 200 buildings and styles, with a section of walking and driving tours and maps linked to public transit. *Best Buildings* presents similar infomation geographically, with less detail, serving as an alternative architectural guide for readers whose time is limited or whose principal focus is the city's most notable historic structures.

Design Firm **Joel Katz Design Associates, Philadelphia, PA**
Design Director **Joel Katz**
Graphic Designers **Jerome Cloud, Joel Katz, and Kim Mollo**
Illustrator **David Schpok (Cover)**
Cartography **Joel Katz**
Photographer **Peter B. Olson**
Publishers **Group for Environmental Education/Foundation for Architecture**
Typesetter **Duke and Company**
Printer **Strine Printing Company**
Paper **Cham Tenero Dull**

Wright Brothers Official Map and Guide

History was made in December 1914 amid the dunes of North Carolina's Outer Banks. The brochure communicates the essence of this legendary story and the significance of the site, which today is part of the National Parks system. Based on a Unigrid format developed in 1977 by Massimo Vignelli, the design enhances the delivery of visitor information and speeds the brochure's concurrent development as well as updates undertaken by writers, photo researchers, designers, art directors, illustrators, and other specialized collaborators.

Design Firm **National Park Service, Interpretive Design Center, Harpers Ferry, WV**
Art Director **Nick Kirilloff**
Graphic Designer **Bruce Geyman**
Illustrator **Richard Schlecht**
Writer **Bill Gordon**
Production **Elizabeth Ehrlich**
Client **National Park Service**
Typesetter **Harlowe Inc.**
Printer **Art Litho Inc.**

Heritage Trails New York

This graphic system orients and informs visitors to Lower Manhattan. Interpretive kiosks and an interactive video orientation center give visitors free, convenient street access to historical and contemporary data. Four color-coded trails delineate pathways between major landmarks and locate the East and Hudson rivers, while maps point to major streets, subways, and local facilities.

Design Firm **Chermayeff & Geismar Inc.,**
New York, NY
Art Directors **Ivan Chermayeff,**
John Grady, and Keith Helmetag
Map **Van Dam**
Photographers **Various**
Client **The J. M. Kaplan Fund**
Printer **Dollco**
Fabricator **Scotchprint: Ariston**
Paper **Strathmore**
Digital Video Producer **Graf/x**
Programmer **Tom Walker**

60 Minutes in the Vatican

Great museums can be very intimidating. This guide, which was designed as one in a series of pocket-size booklets inserted into *Condé Nast Traveler* magazine, puts the reader in control by offering an optimum route through the Vatican museum recommended by the publication's writer. The text is brief, expert, and humorous and the graphics mark critical twists and turns so that all essential sights are taken in.

Design Director **Diana LaGuardia**
Graphic Designer **Michael Powers**
Illustrator **John Grimwade**
Writer **Manuela Hoelterhoff**
Publisher **Condé Nast Traveler**

Chesapeake and Ohio Canal Official National Park Handbook

National park guides tell stories to visitors using a variety of media — from outdoor signage to visitor center exhibits, audiovisual presentations, printed materials, and oral presentations by park personnel. A handbook was found to be the best way to communicate a complex story like that of the Chesapeake and Ohio Canal.

Design Firm **National Park Service Interpretive**
Design Center, Harpers Ferry, WV
Art Director **Nick Kirilloff**
Graphic Designer **Bruce Geyman**
Illustrators **Donald Demers, Steven Patricia,**
Richard Schlecht, Patricia Topper, Lloyd Townsend,
and John Louis Wellington
Maps **Nancy Morbeck Haack, Meagan Kealy,**
and Lori A. Simmons
Photographers **Greg Beaumont,**
David Guiney, Elizabeth Kytle, Robert Lautman,
and Michael Wiltshire
Writers **Bill Gordon and Ed Zahniser**
Client **National Park Service**
Production **Elizabeth Ehrlich**
Typesetter **Harlowe Inc.**
Printer **Ameriprint, Inc.**

HERITAGE TRAILS NEW YORK

Downtown at your feet!

GREEN TRAIL

New York Stock Exchange
8-18 Broad Street
George B. Post, architect, 1901-03
Dow Jones averages, bulls and bears, the great crash, the S&P 500, trusts and trust busters, buy, sell, futures, derivatives — here it is, the beating heart of the world's financial markets, housed in grandiose imitation ancient Roman style at the corner of Wall and Broad streets, the international temple of finance. Brokers have been trading shares on Wall Street since 1792, when they started meeting informally under an old buttonwood tree on the sidewalk outside 68 Wall. Their descendants, operating as the New York Stock Exchange, opened on the current site in 1865, and in 1903 built this new home with two great temple fronts, one on Broad and one on New Street. The huge sculpted scene in the pediment above the colossal columns on Broad Street shows "Integrity Protecting the Works of Man," with figures representing Motive Power, Scientific and Mechanical Appliances, Agriculture and Mining. Behind the columns is the frenzied trading floor, where approximately eleven billion dollars' worth of financial instruments change hands every day. The historic trading stations have been replaced with computers, but the action is still live and in person, and you can see it on the daily tours.

J.P. Morgan & Co. Incorporated
23 Wall Street
Trowbridge & Livingston, architects, 1913
At the corner of Wall and Broad streets, the financial crossroads of the world, sits the "House of Morgan", financier to industrial America. J. Pierpont Morgan, the capitalist's capitalist, founded the bank in 1861 when he was just twenty-three. In 1913, the year he died, the company built its new home on one of Wall Street's most expensive sites. With skyscrapers rising on all sides, and land values skyrocketing, Morgan displayed its fabulous wealth by building its headquarters only four stories tall. Luxurious but unmarked, like a prestigious private club, it was nevertheless so well known that when in 1920 a wagon exploded across the street, killing 38 people, it was simply assumed — though never proven — that an anarchist bomb had been aimed at the bank. You can still walk up to the bank's Wall Street facade and put your finger in the pockmarks from the explosion, deliberately left unrepaired.

G1 Federal Hall National Memorial
26 Wall Street
Town & Davis, architects, 1833-42
A majestic statue of George Washington stands on the front steps of Federal Hall in memory of Washington's inauguration as the country's first president — which happened on this spot in 1789. The current building is named for the original Federal Hall, perhaps the most historic site in the entire country, where Congress first met when New York was the nation's first capital. This new Federal Hall, originally built as the city's Custom House in the 1830s, is one of the few buildings surviving from a time when Wall Street was lined with new American banks pretending to be old Greek temples. Outside, its row of columns suggests a reverence for Greek democracy; inside, its Pantheon-like dome brings to mind the economic power of the Roman empire — a thoroughly mixed message about 19th century American ideals. Today, Federal Hall serves as a museum operated by the National Park Service, and as hub and visitor information center for the Heritage Trails New York program.

Condé Nast Traveler

60 minutes in the Vatican

A Traveler's File Special Section April 1992

Much walking; many tourists are ahead. We'll avoid a few of them anyway by taking the Vatican bus, reaching the entrance via a pleasant, short ride through the Vatican Gardens, whose horticultural elegance is usually enjoyable by special appointment only.

Most people, of course, come here to see the Sistine Chapel, and are they ever annoyed that this is achieved only by walking through some of the longest corridors and halls in Christendom. There is no direct route. Of the four

color-coded tours Vatican authorities have devised to torture visitors, we will partly adhere to the green C and yellow D itineraries, with a few shortcuts and additions. Start by taking a left immediately after surrendering your ticket.

You are now in the Cortile delle Corazze (Courtyard of the Cuirasses), dominated by the granite base of the **Antoninus Pius column 1**. It was erected shortly after his death in A.D. 161 and

honors the Roman emperor and his wife, Faustina, who both rise to the heavens tucked aboard the wings of an angellike genius. As his name suggests, Antoninus was one of Rome's less venal and vicious emperors; Edward Gibbon, the chronicler of Rome's decline and fall, gave him a gold star. But all that goodness didn't help the cause of art, which was slowly degenerating into sclerotic stiffness, just like the Empire; you can see this in the stumpy soldiers with their interchangeable faces.

Do not follow the crowds up the Simonetti staircase; proceed instead into the vast Cortile della Pigna—the great big bronze pinecone left over from a Roman fountain. In medieval times the pinecone aroused great wonderment among the locals, who thought it must be a thing of magic. We will take a left at the pinecone's mysterious, modern companion, that bronze applelike thing cluttering up the court's center, and head into the Chiaramonti Museum. The **marble head 2** by the door shows the idealized (and enlarged) features of Augustus Caesar, of whom we are about to

'see a more human-size representation. This is the famous **Augustus of Prima Porta 3**, which stands in the Braccio Nuovo, or New Wing, built in the nineteenth century and just down the hall on our right. The light-flooded gallery alone is worth a visit—a lavishly marmoreal, faintly funereal space so chilly to behold that it takes your temperature down a few degrees, never mind the broiling heat outside. Here the emperor stands, raising the arm that once held a lance, on his breastplate a crisp report of a battle won against the Parthians. The statue, found in 1863, takes its name from the estate of the odious Livia, Augustus's wife.

Ignoring countless portraits of the misshapen bullies, psychotics, and mass murderers who followed

Augustus to the throne, we come upon friendly **Father Nile 4**, resting from his labors on a sphinx and a cornucopia. The babies crawling on his body further the image of fertility.

1 Antoninus Pius column

3 Augustus of Prima Porta

4 Father Nile awaiting the flood

Condé Nast TRAVELER

134

Chesapeake and Ohio Canal

The Race West

From the start the C&O had unwelcome company in its reach for western markets. On July 4, 1828, the day the canal was inaugurated, ground was broken for the Baltimore and Ohio Railroad, the first profit-making railroad in America. The B&O reached Cumberland and the lucrative coal-carrying trade 8 years before the canal. The competition lasted for almost 60 years, with the railroad always a step ahead. The ancient canal technology was destined to lose in the end to the symbol of the new industrial age. When the canal company was devastated by the 1889 flood, control passed to the principal bondholder: its old adversary, the B&O Railroad.

"The Rivals" shows canal horse spooked by a locomotive. Below: A B&O train passes a C&O boat near Harpers Ferry, West Virginia, 1920.

America's first canal was built in 1786, its earliest revenue-producing railroad in 1830. Before the first locomotive rolled, there were 1,200 miles of canals. Despite the canals' 44-year head start, by mid-century there were twice as many miles of railroad track. Canal abandonments were exceeding construction. Why

did railroads so quickly displace canals? They were faster and, with consolidation, less expensive and more efficient. But it was dependability that gave railroads the upper hand. They kept rolling year round, while ice, drought, and floods closed the canals. By the Civil War the railroads had won the western markets.

Railroad system in 1850

Canal system in 1850

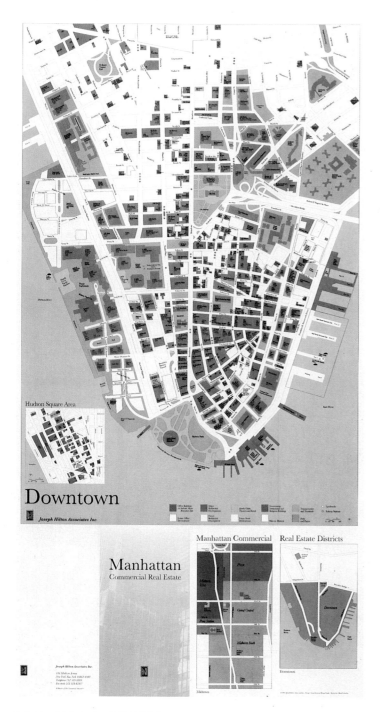

Downtown

Joseph Hilton Associates Inc.

Manhattan
Commercial Real Estate

Joseph Hilton Associates Inc.

Manhattan Commercial | Real Estate Districts

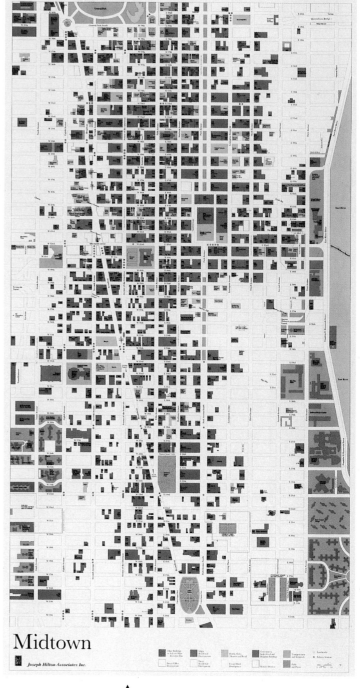

Midtown

Joseph Hilton Associates Inc.

Manhattan
Commercial Real Estate

Manhattan Commercial Real Estate Map

Designing a map that describes the commercial
real estate districts of Manhattan requires a critical
appreciation of scale, ease of use, and graphic as
well as textual legibility. The principal communication
device became color. Key colors are linked to prime
available areas, while typographic fonts and sizes
distinguish between various categories. The design
fulfilled the client's request that the map serve a dual
purpose as a functional tool and a framed image.

Design Firm **Tsang Seymour Design, New York, NY**
Creative Directors **Patrick Seymour and**
Catarina Tsang
Graphic Designers **Patrick Seymour and**
Catarina Tsang
Illustrator **Microcolor**
Photographer **Patrick Seymour**
Client **Joseph Hilton Associates, Inc.**
Printer **Tanagraphics, Inc.**
Paper **Mohawk**

The Official Map and Guide to Alcatraz

Alcatraz Island is visited by more than three million people each year. This guide bridges the gap between throw-away brochures and expensive souvenir books, providing visitors with enough visual information (including a bird's-eye view of the island and cellhouse) for a self-guided tour. It also includes accurate, concise information and photographs that describe both the island's colorful history and its role today.

Design Firm **Reineck & Reineck, San Francisco, CA**
Art Directors **Jack Reineck and Gay Reineck**
Graphic Designers/Illustrators **Jack Reineck**
and Gay Reineck
Photographers **Various**
Writer **Greg Moore**
Publisher **Rufus Graphics**
Typographer **Omnicomp**
Printer **Fong & Fong**
Paper **Simpson Sequoia 70# Matte Book**

Map and Guide to Tuolumne Meadows

·The high country of Tuolumne Meadows is often under snow for eight months of the year. This guide offers visitors an aerial glimpse of the mountainous landscape and trails, which are invisible from the meadow below. Concise text combined with images affords an overview of what to see and do during the short summer season in this breathtaking locale.

Design Firm **Reineck & Reineck, San Francisco, CA**
Art Directors **Jack Reineck and Gay Reineck**
Graphic Designers/Illustrators **Jack Reineck**
and Gay Reineck
Photographers **Various**
Writer **Steven P. Medley**
Publisher **Rufus Graphics**
Imagesetting **Proscan**
Printer **Fong & Fong**
Paper **Simpson Sequoia 70# Matte Book**

▼

Map and Guide to Fisherman's Wharf

"Where is the nearest ATM? How do I get to Alcatraz? Where is Ghirardelli Square?" By combining the first-ever bird's-eye view of the San Francisco's popular waterfront area with concise text and images, the visitor is given a new way of experiencing the diverse environment of Fisherman's Wharf.

Design Firm **Reineck & Reineck, San Francisco, CA**
Art Directors **Jack Reineck and Gay Reineck**
Graphic Designers/Illustrators **Jack Reineck**
and Gay Reineck
Photographers **Various**
Writer **Hazel White**
Publisher **Rufus Graphics**
Imagesetting **Focus 4**
Printer **Dome Printing**
Paper **#70 Shasta Dull**
Paper **Mohawk**

▼

Map and Guide to Yosemite Valley

The first in a series of guides to Yosemite National Park, this informative brochure features text, graphic images — including an aerial view of the valley from the south rim — plus descriptions of most frequently visited sites.

Design Firm **Reineck & Reineck, San Francisco, CA**
Art Directors **Jack Reineck and Gay Reineck**
Graphic Designers/Illustrators **Jack Reineck**
and Gay Reineck
Photographers **Reineck & Reineck, Dean Shenk,**
National Park Service Yosemite Collection
Writers **Marla La Cass and Dean Shenk**
Editor **Hazel White**
Publisher **Rufus Graphics**
Imagesetting **Proscan**
Printer **Fong & Fong**
Paper **Simpson Sequoia #70 Matte Book**
Paper **Mohawk**

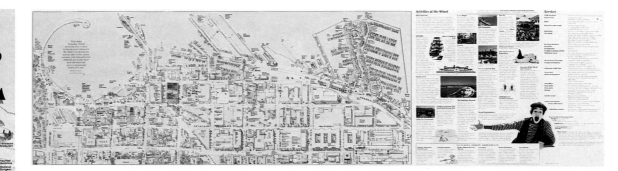

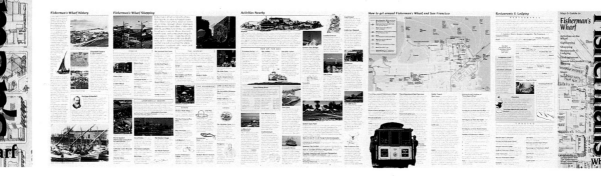

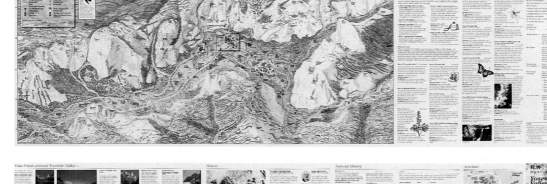

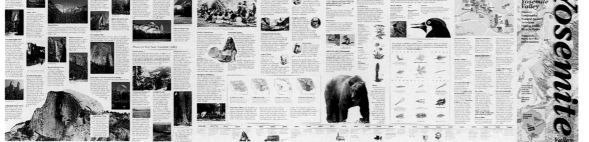

▲

**The Official Map and Guide
to the Presidio of San Francisco**

Timed to coincide with the transfer of San Francisco's famous Presidio from the Army to the National Park Service, this guide provides a colorful map and a concise but thorough introduction to the Presidio's past and future. Since it is entirely digital, it is designed for periodic updating.

Design Firm **Reineck & Reineck, San Francisco, CA**
Art Directors **Jack Reineck and Gay Reineck**
Graphic Designers/Illustrators **Jack Reineck
and Gay Reineck**
Photographers **Regis Lefebre and Various**
Writer **John Martini**
Editor **Nora Deans**
Publisher **Golden Gate National Park Association**
Imagesetting **Focus 4**
Printer **Dome Printing**
Paper **Simpson Sequoia #70 Matte Book**
Paper **Mohawk**

▲

Morgan Stanley Headquarters
Information Supergraphics

Morgan Stanley's purchase of a 42-story office tower
in New York City's redeveloped Time Square district
came with strict new zoning regulations specifying that
the building's exterior carry large-scale kinetic signs.
The result is one of the largest information displays
in the Times Square area: two 44-foot-high backlit
cylindrical world maps highlighting the cities where the
brokerage house has offices worldwide. Digital clocks
display the corresponding times. Directly above, three
140-foot-long stacked electronic LED ticker boards
transmit "real time" information — news bulletins on
one board and stock market quotes on the other two.
At either end of this display, two 30x60-foot inform-
ation panels flash charts, graphic images, and related
financial information.

Design Firm **Richard Poulin Design Group Inc.,
New York, NY**
Art Directors **Douglas Morris and Richard Poulin**
Graphic Designers **Douglas Morris and
Richard Poulin**
Client **Morgan Stanley**
Fabricator **The Artkraft Strauss Corporation**
Architect **Gwathmey Siegel & Associates**

▶ A B O V E

XIX Amendment Installation

The objective of this installation was to increase aware-
ness of the seventy-fifth anniversary of the Nineteenth
Amendment. The budget was small and the space
that was to house the installation enormous. By enlarg-
ing the text to fill the room, the designers confronted
passersby with the monumental one-sentence amend-
ment itself — twenty-eight revolutionary words that
were wrestled with and fought over for more than sev-
enty years. The "tower" presents historical references
that enlighten the history of the struggle for suffrage, its
leaders, and their public and private dramas.

Design Firm **Drenttel Doyle Projects, New York, NY**
Creative Directors **Stephen Doyle, William Drenttel,
and Miguel Oks**
Architect **Miguel Oks**
Architectural Designer **James Hicks**
Project Coordinator **Cameron Manning**
Photographer **Scott Frances**
Client **New York State Division for Women**
Digital Imagery **Duggal**
Fabricators **Bart Von Praag (Tower) and
Vomella (Floor Text)**
Material **3M Scotchguard Floor Graphics**

▶

Super Graphics for the Changing Gallery
at the Denver Art Museum

This graphic system helps guide museum visitors
through a maze of visual stimuli and fragmented gallery
spaces to convey a comprehensible organizational
scheme. Informative signs attract visitors to an often-
overlooked exhibition in a seven-story museum; give a
unified visual identity to meandering mezzanine areas;
create an illusion of spaciousness; and provide a hierar-
chical and integrated architectural aesthetic.

Design Firm/Client **Denver Art Museum, Denver, CO**
Art Director **R. Craig Miller**
Graphic Designer **Mary H. Junda**
Writer **R. Craig Miller**
Fabricator **Manhattan Sign**

Science City

This museum without walls invites passersby to learn about New York City's infrastructure and how its water, electricity, sewage, trash, steam, and telephone systems work. Pedestrians peer through telescopes and look into periscopes to interact with various displays that convey information and scientific principles.

Design Firm **Chermayeff & Geismar Inc., New York, NY**
Art Directors **Jonathan Alger, John Grady, and Keith Helmetag**
Illustrator **Robert Zimmerman**
Client **New York Hall of Science/ National Science Foundation**
Printer **Scotchprint: Ariston**
Fabricator **Dimensional Communications Inc.**
Digital Video Producers **Outpost Video Productions and C&G Promotional Tape**

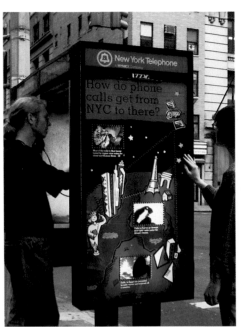

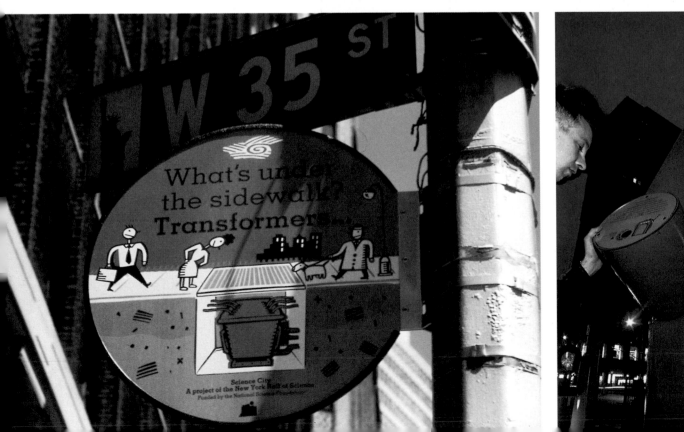

The Minnesota Children's Museum

An identity system designed for a children's museum communicates using words and symbols in a "sign language" signage system based on children's gestures.

Design Firm **Pentagram Design, New York, NY**
Art Director **Michael Beirut**
Graphic Designers **Michael Beirut and Tracy Cameron**
Architect **Tracy Cameron**
Photographers **Jeffrey Grosscup, July Olausen, Michael O'Neill, and Don Wong**
Client **The Minnesota Children's Museum**
Fabrication **Cornelius Architectural Products**

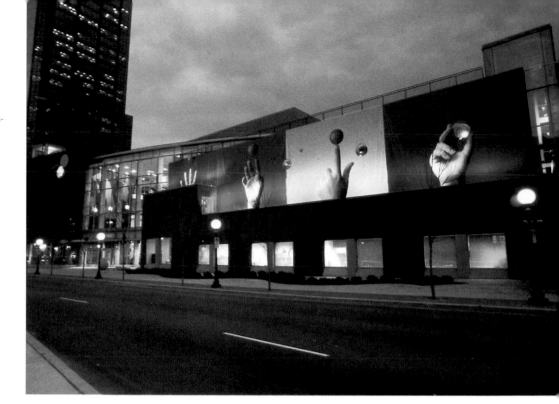

Philips Competence Centre, the Netherlands

Exhibition and graphic designers teamed up with writers and researchers to develop a communication system that would project to visitors the core competencies of this international corporation. Linked interactive exhibits demonstrate how technical competence in optics, materials, software, and other areas contributes to innovations in nine product divisions. A circular competency diagram that mirrors the actual physical exhibition space lists the menu of options and acts as a road map for all exhibits.

Design Firm **The Burdick Group, San Francisco, CA**
Creative Directors **Bruce Burdick and Susan Burdick**
Graphic Designers **Christoph Oppermann and Cindy Steinberg**
Exhibition Designers **Jon Betthauser, Johnson Chow, Jerome Goh, Cameron Imani, Bruce Lightbody, and Jeff Walker**
Photographer **Herman De Winter**
Writers/Researchers **Aaron Caplan and William Smock**
Client **Philips**
Typographer **Eurotype**
Silkscreener **Gielissen BV**
Fabricators **Carlton Benbow Contracts, Ltd., and Gielissen BV**

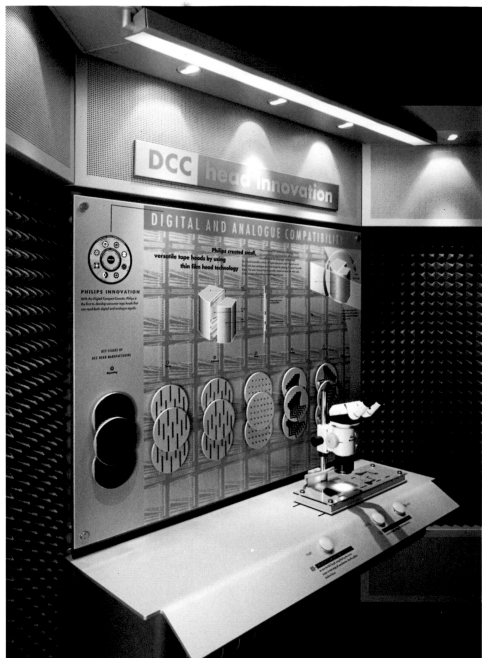

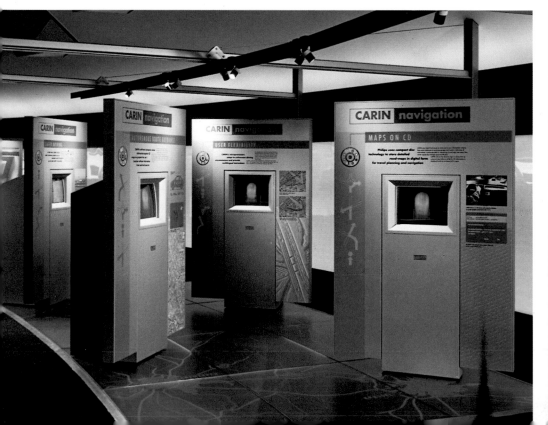

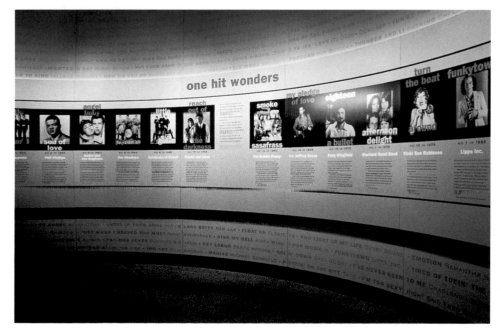

Rock and Roll Hall of Fame and Museum

The designers wanted to create an environment that expressed the energy of this rebellious form of communication. Using sound, video, graphic imagery, and lighting effects, the designers layered exhibition graphics in a typographic grid designed to accommodate a diverse range of text and images. Graphic imagery is set in striking assortments of color palettes against dark or neutral metallic backgrounds that accentuate their luminosity and evoke the spirit of a live performance.

Design Firm **The Burdick Group, San Francisco, CA**
Creative Directors **Bruce Burdick and Susan Burdick**
Graphic Designer **Stuart McKee**
Interface Designers **Christian Anthony
and Jerome Goh**
Exhibition Designers **Johnson Chow, Bruce Lightbody,
and Jeff Walker**
Photographer **Timothy Hursley**
Writers **Aaron Caplan and Various**
Client **Rock and Roll Hall of Fame and Museum**
Typographer **Eurotype**
Printer **Screen America for Design & Production**
Fabricators **Design & Production (exhibition
and graphics), Turner Construction Company
(exhibition interiors)**

The Avant-Garde
Letterhead

Aletterhead can be staid or extravagant, traditional or inventive, ordinary or outlandish. From the paper it is printed on to the arrangement of words and symbols on the page, the design of a letterhead opens the conversation between writer and reader, offering a firm handshake, a warm hello, or an intimate kiss. A letterhead's design provides a second signature for its user, framing the written text with a visual personality.

In the spring of 1996, the Cooper-Hewitt, National Design Museum presented an exhibition of letterheads and other business ephemera in collaboration with the American Institute of Graphic Arts. *The Avant-Garde Letterhead* featured over one hundred examples of writing paper, business cards, envelopes, postcards, and other ephemera created by Modern artists and designers during the first half of the twentieth century.

Avant-garde movements in Europe and the United States used printed stationery to project public identities to an international community. F.T. Marinetti, Kurt Schwitters, Herbert Bayer, El Lissitsky, Mies van der Rohe, Jan Tschichold, Ladislav Sutnar, Piet Zwart, Laszlo Moholy-Nagy, Lester Beall, and many others used dramatic stationery to convey their artistic philosophies visually. These letterheads are typographic self-portraits of some of the most fascinating people and institutions in the development of Modernism. The exhibition showed how designers and artists disseminated their ideas around the globe via the postal service.

The objects featured in *The Avant-Garde Letterhead* are drawn from the collection of Elaine Lustig Cohen, an artist, designer, and collector who has assembled a unique body of European and American letterheads from the early and mid twentieth century. This collection tells the history

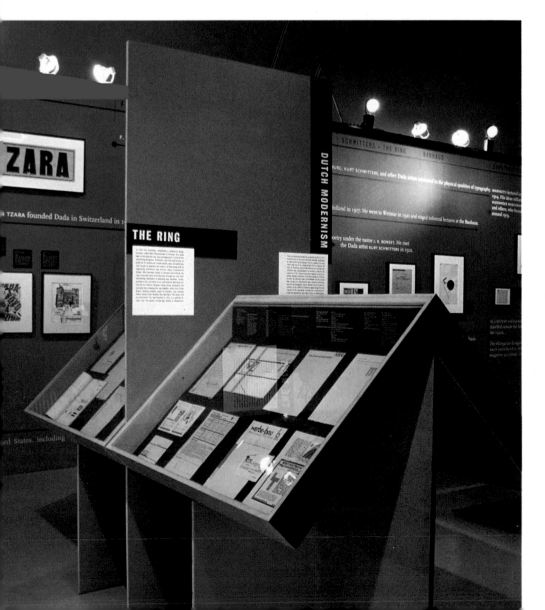

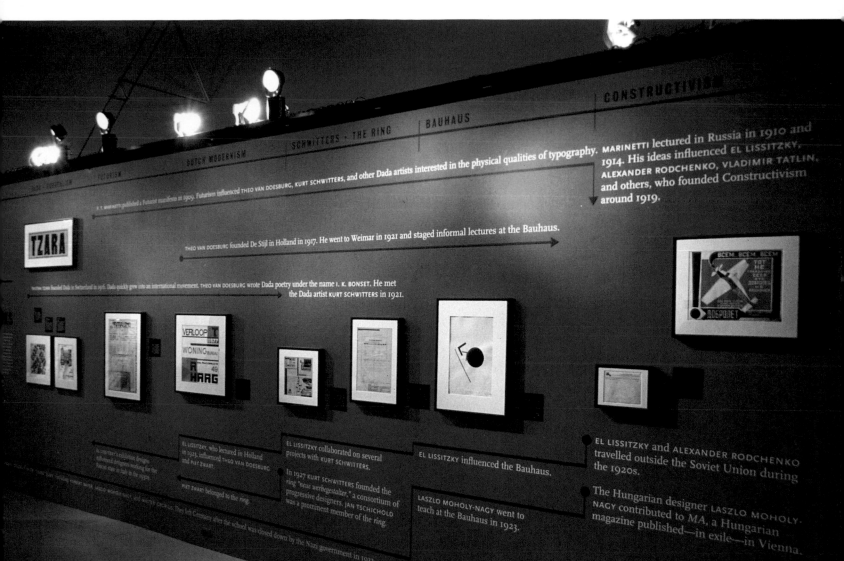

Within the exhibition image:

CONSTRUCTIVISM

SCHWITTERS · THE RING | BAUHAUS

DUTCH MODERNISM

FUTURISM

MARINETTI lectured in Russia in 1910 and 1914. His ideas influenced EL LISSITZKY, ALEXANDER RODCHENKO, VLADIMIR TATLIN, and others, who founded Constructivism around 1919.

F. T. Marinetti published a Futurist manifesto in 1909. Futurism influenced THEO VAN DOESBURG, KURT SCHWITTERS, and other Dada artists interested in the physical qualities of typography.

THEO VAN DOESBURG founded De Stijl in Holland in 1917. He went to Weimar in 1921 and staged informal lectures at the Bauhaus.

Tristan Tzara founded Dada in Switzerland in 1916. Dada quickly grew into an international movement. THEO VAN DOESBURG wrote Dada poetry under the name I. K. BONSET. He met the Dada artist KURT SCHWITTERS in 1921.

EL LISSITZKY, who lectured in Holland in 1923, influenced THEO VAN DOESBURG and PIET ZWART.

EL LISSITZKY collaborated on several projects with KURT SCHWITTERS.

EL LISSITZKY influenced the Bauhaus.

EL LISSITZKY and ALEXANDER RODCHENKO travelled outside the Soviet Union during the 1920s.

PIET ZWART belonged to the ring.

In 1927 KURT SCHWITTERS founded the ring "neue werbegestalter," a consortium of progressive designers. JAN TSCHICHOLD was a prominent member of the ring.

LASZLO MOHOLY-NAGY went to teach at the Bauhaus in 1923.

The Hungarian designer LASZLO MOHOLY-NAGY contributed to MA, a Hungarian magazine published—in exile—in Vienna.

of Modern art and design through a familiar genre of communication.

The exhibition, which was on view from March 13 through May 8, 1996, at the AIGA's national gallery, was made possible by Crane & Company. The show was organized by Elaine Lustig Cohen and Ellen Lupton, the National Design Museum's curator of contemporary design. Lupton and Cohen co-authored the book *Letters from the Avant-Garde,* published in spring 1996 by Kiosk, an imprint of Princeton Architectural Press. Exhibition photographs by Josh McHugh.

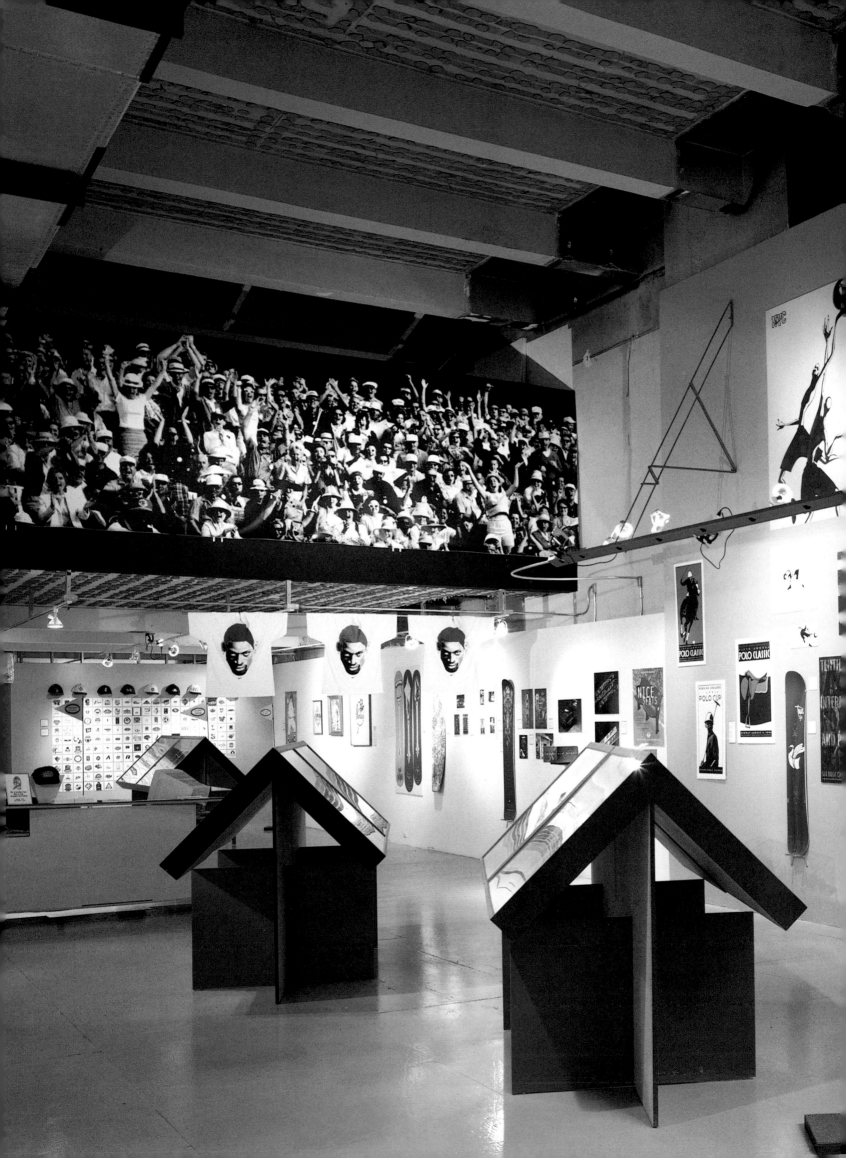

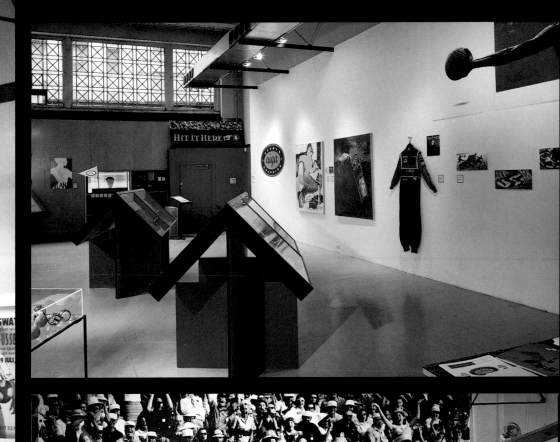

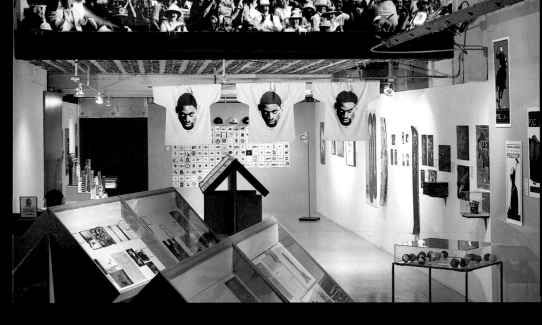

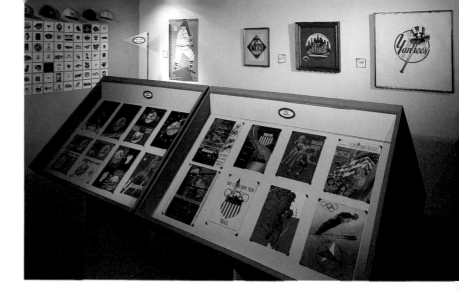

by Moira Cullen

Sports Graphics

Design is a capitalist tool with populist appeal. Why is its relation to sports so, well, complex?

Not that long ago, sports were sport, and design was design; studio and stadium were worlds apart as both camps practiced their chosen game. Each played on the margins, at opposite ends of the field — grooming champions prized for their enduring aesthetics or faultless physiques. But regardless how inspired or invigorating these efforts were (for them or their fans), by and large their impact on the commercial mainstream was limited, and fleeting.

Then came television — big networks whose economies collapsed distance and pumped up visual media so that what once was local became national, then global. Players became personalities, contests became events. Design was scouted (and soon under contract) to package the experience, sell the spectacle, boost ratings, and above all, please sponsors, marketers, and the public alike.

Suddenly those whose professional paths rarely, if ever crossed (except on weekends or at the gym), were teamed up in service to the marketing gods. Their union was potent. Slap a logo on a T-shirt, a jacket, or a cap and it flew out the door. Was this easy money, or what? In fact, so powerful was design when applied to common goods, it sparked violence among some who prized certain emblems more than life.

Design equals added value, equaling increased profit: the numbers were there. So when the time came to conceive an AIGA competition based on a popular cultural theme, I thought: sports, of course. After all, the sports industry had grown at record speed: to $50 billion by the end of the 1980s when more than 400 corporations had established budget lines for "marketing/sports." Today, annual revenues in sports apparel and active wear alone exceed $39 billion, of which 37 percent belongs to Nike, whose founder recently proclaimed

sports (surpassing music) to be the coveted currency of mass communication. Competition is fierce. Global is now the range of the games. And design, in all media, is ammunition in the battle for market share.

Given today's fascination (some might say obsession) with performance in all fields, why not stage a contest for those who design communications that inspire others to compete? Sports graphics: the aesthetic branding of triumph over life's obstacles and trials.

So a jury — a pro-team of four designers with track records uniquely their own — convened and all eyes were soon on the contest at hand. A quick survey of entries confirmed that — amateur, professional, traditional, and extreme — design had duly marketed products, personalities, events, and attitude. Based on variety alone, there would be ample work to celebrate. Or so I thought.

Then I watched as jurors passed over logo after logo, package after poster with cool remove. I followed the trail of their finely honed critique as they picked through the piles. What, all head and no heart? Was design excellence the reserved domain of an aestheticized elite? Remember context, I cried. These entries were meant to rouse passions, bind allegiance, provoke participation, push limits (not excluding taste), and incite bawdy, rowdy, undisciplined fun. In their search for the perfect, would these experts overlook what common eyes considered good?

Granted, sports is a tricky market composed of fans whose tailgate parties serve up everything from Bud and Nathan's to Sevruga and Cristal. There's even a hierarchy for games played on driveways and fairways, on playgrounds and backlots, and country club courts. Still, the equestrian's velvet cap stands unadorned. Was this disconnect between design and sports a question of taste, or a matter of class?

Most likely the real issue is mass. Commercial mainstream design is a high-stakes game, one that historically many designers (including many AIGA members) have disdained to play. Why? Many find the products too mundane, the clients too bureaucratic, the design briefs too repressive, and the creative solutions too anonymous to suit their artistic training and temperaments. Besides (common thinking maintains), broad audiences are supremely ignorant of good design. Are they? One has only to follow the wide swath of the "swoosh" to see that the public rallies behind excellence when offered a choice between competing aesthetic styles.

Herein lies the designer's challenge: excellence in sports graphics is as difficult to evaluate as the genre is to execute. Tens of hundreds of thousands, even millions, of client dollars ride on decisions that support marketing strategies, corporate identities, brand equities, product categories, competitive activities, production necessities, and consumer proclivities. Design that on the surface seems simplistic (even to trained eyes), is but one (albeit critical) part of the marketer's detailed game plan.

For, like their corporate counterparts (identity systems and logos), sports graphics require a considered evaluation of context and demand that designers respect parameters that too often are misconstrued as creative constraints.

The Sports Graphics exhibition (on view from May 22 to July 31, 1996), was designed by Alternatives Design, NY. Exhibition photography by Jennifer Krogh Photography, New York, NY. The AIGA also gratefully acknowledges the following Partners in Design:

AIGA/Atlanta
American Needle, IL
Atlanta College of Art
Copeland Hirthler Design
 & Communications, Atlanta
Free Advertising, NY
The Kingsley Group, NY
Kurt Keller, Jay Keller, and Lonna Keller
 Heffington (Lon Keller Estate)
NFL Properties, NY
Pearl Paint, NY
Speed Graphics, NY
Sussman/Prejza & Co. Inc., LA
Swatch USA, NY
Vomella System Graphics/
 3M Scotch Print, St. Paul, NY

What's the payoff? Impact and visibility: audiences, for the most part, are huge.

Inevitably, a designer's dreams of intricate six-color insignias are dashed, replaced by sturdier two-color versions that pass embroidery tests and meet network specs. But does this make for better design? These are tough calls. In theory, aesthetic standards should not vary — niche or mass — so long as judgment is not passed on looks alone. Excellence, like design, is context specific. And design, conceptually or stylistically, is no monolithic practice but an art applied to functional forms that are best evaluated not by execution or aesthetics alone but in consideration of how, for whom, and to what end the designer's expertise is exercised.

In the wide world of sports (and other mainstream) graphics, the field is open for more designers to shed their suits of scorn, step up to the plate, and challenge the level of play by using their toned aesthetic skills to shape a broader public language for design. If only the ball were bigger, the bar lower, the fence a little closer, this would indeed be a different game. But the creative challenge lies in repeated heroic efforts; while success is gauged by degrees of difficulty in beating seemingly impossible odds.

Today's Olympic games track back to the ancient Greeks, who believed frequent contests cultivated the athlete's ability and the public's taste as well. In 3,000 B.C., the story goes, Odysseus defeated Ajax for the shield of the slain Achilles. That must have been some logo. Who designed it? But would a mark that moved mortal gods survive the judgment of design's pantheon?

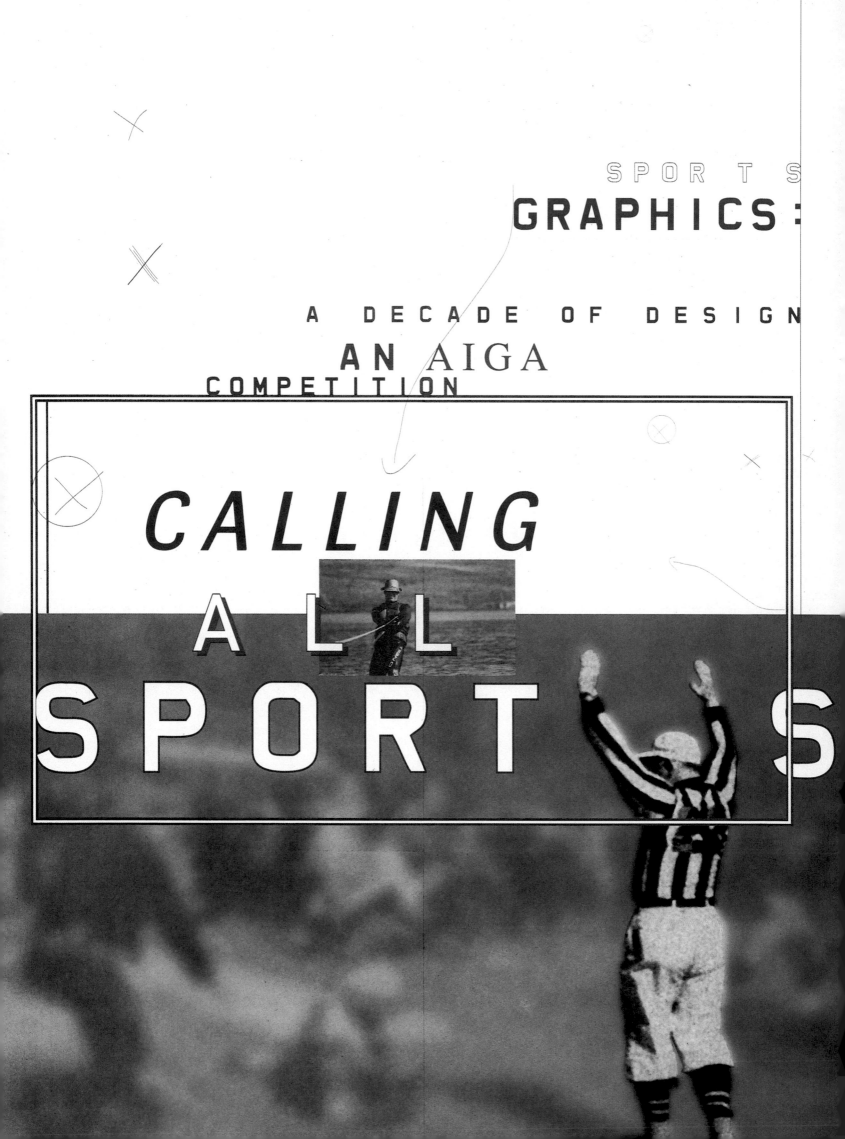

SPORTS
GRAPHICS:

A DECADE OF DESIGN

AN AIGA
COMPETITION

CALLING

ALL

SPORTS

Sports
Graphics

Awards

Sports graphics — like packaging, branding, and all forms of marketing communication — is charged with making people respond. From athletic equipment, sports nutrition stores, and boxes of tennis balls to televised sporting events, open competitions, the Internet, and print advertisements, sports graphics needs to engage the interest of the right audience, get the message through, and win a commitment in dollars, participation, or attention. In identifying the submissions that would be included in this exhibition, our primary challenge as a jury was to determine a set of unbiased, non-anticipatory judging criteria, and then apply those criteria retrospectively to assorted sports graphics of the past ten years.

Initially, in calling for a decade's worth of entries, our scope may have been a bit too ambitious. What was popular ten years ago will not necessarily obtain the same response today. Identifying the best sports graphics from the past year would have been a much easier task —- but this exhibition had to perform the dual function of showing a retrospective of sports graphics and showing quality as well.

Then the question of marketing arose. We were faced with balancing the AIGA's high standards of graphic excellence with the marketing excellence of any given entry. Are these two factors one and the same? Often not. How could we know how well any of these pieces were marketed — and should we care?

A high standard for clear and memorable graphic expression should be applied across the board in the judging of any subject area. Sports at first appears to offer an enticing potential for graphic expression because of the inherent dynamics of the field, but it possesses a variety of target audiences commanding higher or lower levels of visual sophistication. The main issue in selecting these works was clear and accurate communication for an effective response. Nonetheless, *Sports Graphics* was the most difficult of all the shows I have judged. In the end, the final approval must go to those lucky candidates whose work is beautiful to behold, both for its visual power and for its marketing success.

Primo Angeli
Chair

Call for Entry

Design
David Carson Design

Printer
Applied Graphics
Technologies – Fleetwood

Printing
Judy Salmon, NFL Properties
Advertising and Design

Photograph
David Wagner

Paper
Simpson Evergreen,
Hickory, 70# Text

Primo Angeli
Bruce Burke
Cheryl Heller
Robynne Raye

Primo Angeli Since establishing his own firm in 1967, Primo Angeli has built an international reputation for his work in packaging, corporate identity, environmental graphics, and poster design. Angeli and his creative group have received over 350 awards for design, and have worked with clients ranging from Coca-Cola, Nestle, and Miller Brewing to Xerox, AT&T, Levi Strauss, and Banana Republic. In early 1994, Primo Angeli Inc. was selected from nearly 500 applicant firms to join the design team for the Atlanta Committee for the Olympic Games in 1996.

Bruce Burke is Vice President, Creative Director, for the National Football League in New York. He is responsible, with his nineteen-person staff, for the development and execution of all NFL advertising and design, television and print advertising, and multimedia presentations. Prior to joining the NFL, he worked for the Harrison Design Group in San Francisco and for Edwin, Bird, Wilson Advertising in New York. His work has been recognized by the Art Directors Club and the Society of Illustrators, among others.

Punch out the shoe, put it together, fill it with Wheaties. And it'll weigh about what the new Converse football shoe weighs.

Converse got the lead out.

Cheryl Heller is a creative director for Siegel & Gale, whose clients include Reebok and Converse. Prior to working for Siegel & Gale, she was Executive Vice President and Creative Director at Frankfurt Balkind Partners, where her clients included Avon, E&E, Pantone, Inc., and the Department of Education. Heller has also worked as Executive Vice President, Group Creative Director, for Wells, Rich, Green, where she was responsible for creative direction on the Ford Motor Company, ITT, Philip Morris, and S.D. Warren accounts, among others. Her work has been recognized internationally and collected by the Library of Congress.

Robynne Raye was a very serious woman who felt quite solemn about the extreme gravity of her craft. Upon graduation from the Totally Math-Oriented Institute of Linear Design, she embarked upon a fabulously exciting career designing invoices and annual reports for the accounting firm of Snell and Bingham. Her work

was applauded by the National Organization of Career CPAs and several regional chapters of the Elks Club. She was also a guest lecturer at the Harvard School of Fussbudgets. And then one day, Robynne said, "Let's start Modern Dog." Mike Strassburger happened to be standing nearby, and was into it, and there you have it.

Brooks for Women (1986)

Packaging for the Brooks for Women shoe was aimed at active young women in search of a sports shoe for aerobics, tennis, running, and walking. Because many of the consumers wore the Brooks for Women shoe when commuting, the packaging was also designed to transport the wearer's office shoes during the commute to work. The package cleverly became a mobile 3-D billboard that helped introduced the brand identity to the marketplace in the mid-1980s.

Design Firm **Duffy Design, Minneapolis, MN**
Art Director **Joe Duffy**
Graphic Designer **Charles Spencer Anderson**
Illustrator **Lynn Schulte**
Client **Brooks for Women**

Artists' Baseballs (1994)

These "designer" baseballs were created expressly for sale in the Guggenheim Museum's gift shops. The designer's intent was to create graphics that referred to contemporary art styles, but because the graphics were silk-screened, repeated use on the playing field soon wreaked havoc on the decoration. In practice, reality triumphed over lofty intention.

Design Firm **Greenberg Kingsley, Inc., New York, NY**
Graphic Designers **Karen Greenberg and**
D. Mark Kingsley
Client **Guggenheim Museum**
Fabricator **Promotion By Design**

▲

Newman-Haas Racing Team Uniform (1990)

As the first fashion designer involved in professional sports, Alexander Julian was invited to design driving suits and pit crew uniforms for the Newman Haas Racing Team, owned by Carl Haas and Paul Newman. Julian's inspiration was Colours, his casual menswear collection, featuring his artful sense of color — using brilliant bands of red-violet and his signature teal — impeccable placement, and unconventional detail. He created a look that emphasized important sponsor names, yet unified the team as a whole. In addition to designing the driving and pit crew uniforms for Mario Andretti and Nigel Mansell, Julian has designed for the Charlotte Hornets, UNC's men's and women's basketball teams, and the Charlotte Knights baseball team and stadium.

Design Firm **Alexander Julian, Inc., Ridgefield, CT**

K2 Skis (1992–1994)

Increasingly, graphics are a key factor in the successful marketing of skis. Years ago, ski manufacturers employed similar design strategies, using black, blue or red accents on a white ski base. In recent years, as the demographic shifted toward the high energy of a younger market, European fashion trends increasingly influenced the look of the slopes. K2 was one of the first companies to change its graphics to fit the times. To capture a greater market share, graphics are keyed to specific audiences and niche markets. Each season begins with a color study as a various colorways and graphics are developed for American, Japanese, and European markets.

Design Firm **Hornall Anderson Design Works, Inc., Seattle, WA**
Art Director **Jack Anderson**
Graphic Designers **Jack Anderson, David Bates, Mary Hermes, Jani Drewfs, and Leo Raymundo**
Client **K2 Corporation**

Giro Helmets and Packaging (1992)

To reinforce its position as an industry leader, Giro sought to attract the bicycle consumer's attention in the retail environment by blending fashion and technology in packaging design. To distinguish Giro merchandise at the point of sale, designers developed a colorful packaging program linking various helmet models and styles to target consumers: racers or road bikers, mountain bike enthusiasts, and recreational cyclists.

Design Firm **Hornall Anderson Design Works, Inc., Seattle, WA**
Art Director **Jack Anderson**
Graphic Designers **Jack Anderson, David Bates, and Lian Ng**
Client **Giro Sport Design, Inc.**
Typographer **Hornall Anderson Design Works, Inc.**
Printer **Giro Sport Design, Inc. (Helmets) and Georgia Pacific (Packaging)**
Paper **Laminated E-Flute Cardboard (Packaging)**

Kemper Snowboards
Martin Gallant Board (1994)

Manufactured according to pro rider Martin Gallant's specifications, this specialty snowboard is mass produced to satisfy fan's "give me what my hero uses" consumer mentality. At Gallant's suggestion, the board graphics carry the image of a gargoyle inspired by architectural ornaments and traditional stone faces. The designer's customized typography name pushes the grotesque, edgy feel of the intimidating gargoyle art.

Design Firm **Margo Chase Design, Los Angeles, CA**
Art Director **Margo Chase**
Graphic Designer **Margo Chase**
Client **California Pro/Kemper Snowboards**

Gatta Snowboards Silverware,
Appliances, Disaster Series (1995)

This series of three directional concepts for a new line of graphite snowboards was presented to a Japanese manufacturer known for their golf and tennis equipment. The designers named the brand "Gatta," Japanese slang for "Gotta," and created board graphics that would convey a California aura — edgy but not too extreme — to a Japanese audience. Outrageously proportioned Western-style eating utensils, old-fashioned chrome appliances, and an LA disaster scenario complete with fire, smog, and earthquake put a whimsical, slightly disturbing spin on American iconography. Of the three proposals, the client mass produced the silverware series to rave reviews and better-than-expected sales.

Design Firm **Margo Chase Design, Los Angeles, CA**
Art Director **Margo Chase**
Graphic Designer **Wendy Ferris-Emery**
Client **Yonex Co., Ltd.**

Burton Twin 44 (1996)

Board graphics must have an immediate global appeal to riders of all ages. The Twin 44 model is lightweight to allow the freedom of motion necessary for doing airs and spinning tricks. The board's graphics — four silkscreened spot colors — generate the appropriate individuality, motion, and freedom.

Design Firm **Jager Di Paola Kemp Design, Burlington, VT**
Creative Director **Michael Jager**
Art Director **David Covell**
Graphic Designer **Dan Sharp**
Client **Burton Snowboards**
Printer **BMC Printers**

Jobe Psycho Wakeboard (1995)

The wakeboard market covers all ages from youth to adult, so the designers took a "something for everyone" approach when creating this board graphic, based on clip art images assembled from their collection. The more you look, the more you find, especially when using the accompanying 3-D Chroma-depth glasses. Then you can see everything — which is more than the client saw of the final design. The designers literally handed the mechanical to the printer, craftily dodging the prospect of creative censorship.

Design Firm **Sheehan Design, Seattle, WA**
Art Directors **Art Chantry and Jamie Sheehan**
Graphic Designers **Art Chantry and Jamie Sheehan**
Client **Ascend Sports/Jobe Waterskis**
Printer **Color Craft**
Fabricator **HO Sports**
Material **Aluminum**

▶ Above

Kemper Snowboards Griffin Logo (1994)

An iconic logo derived from a Teutonic gothic coat of arms works with existing corporate typography to differentiate this high performance "pro" snowboard line from the manufacturer's other product categories. The griffin, valued for its mythic domination of earth and sky — the domains of the snowboarder — also symbolizes the strength and industry of Germany, where the snowboards are manufactured.

Design Firm **Margo Chase Design, Los Angeles, CA**
Art Director **Margo Chase**
Graphic Designer **Margo Chase**
Client **California Pro/Kemper Snowboards**

▶ Left

Burton Brushie Fish Snowboard (1993)

The trout on a Pro Model board becomes a visual pun on the "Stale Fish," a trick made famous by Vermont's pro-rider Jeff Brushie. When this board was designed, snowboard graphics were typically unsophisticated or ski-influenced. With its narrative appeal, bold layout, and high-quality detailing, this board graphic signaled a creative departure in the industry.

Design Firm **Jager Di Paola Kemp Design, Burlington, VT**
Creative Director **Michael Jager**
Graphic Designers **David Covell, Michael Jager, and George Mench**
Client **Burton Snowboards**
Printer **BMC Printers**

▶ Right

Burton Ouija Board (1994)

This board graphic marks a pivotal point in the development of the snowboard industry, when sampling and the use of appropriated images became vital to conveying snowboarding's irreverent challenge to traditional sports. The Ouija board game art signals the emergent conflict between riding's good and evil cults and graphically represents "everything a ski can never be."

Design Firm **Jager Di Paola Kemp Design, Burlington, VT**
Creative Director **Michael Jager**
Graphic Designer **Adam Levite**
Client **Burton Snowboards**
Printer **BMC Printing**

Burton Consumer Catalogue (1994)

Similar in style and creative intent to the '94 Burton Marmot Dealer catalogue, this consumer version was translated into five languages and mailed direct to consumers worldwide. Handwritten elements were rewritten in each language and great effort was taken to ensure that the catalogues never looked retro-fitted for each version.

Design Firm **Jager Di Paola Kemp Design, Burlington, VT**
Creative Director **Michael Jager**
Art Director **David Covell**
Graphic Designers **Keith Brown, David Covel, and Dan Sharp**
Photographers **Geoff Fosbrook and Various**
Client **Burton Snowboards**
Printer **Danbury Printing and Litho**

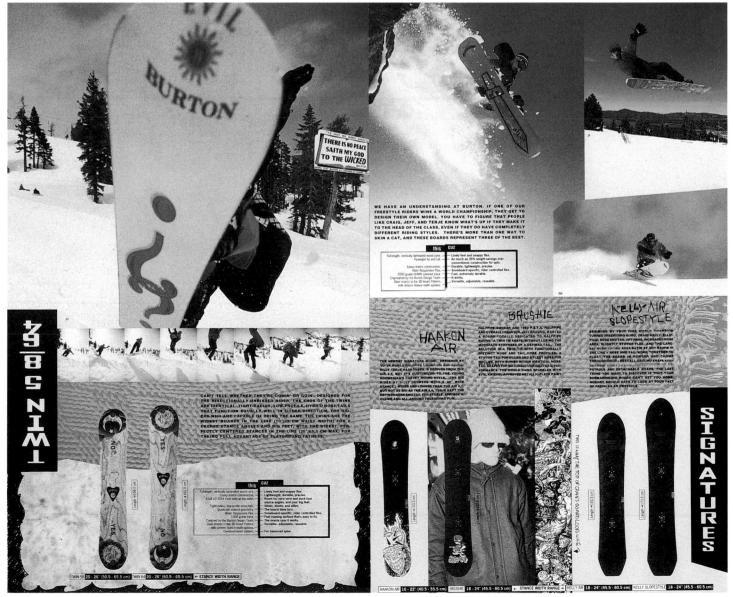

Burton Marmot Dealer Catalogue (1994)

In 1994 the snowboard market was flooded with "upstart" companies armed with the latest computer design tricks and type styles. The designers played up Burton's history of innovation and the company's unique geographical position in rural Vermont. Using hand-rendered type and visual references — from road trips to local flea markets, tourist traps, and deer camps superimposed on a faux riding pedigree — they created a funky, spontaneous home-grown catalogue that showcases an original, well-crafted, hard-core product.

Design Firm **Jager Di Paola Kemp Design, Burlington, VT**
Creative Director **Michael Jager**
Art Director **David Covell**
Graphic Designers **Keith Brown, David Covell, and Dan Sharp**
Photographers **Geoff Fosbrook and Various**
Client **Burton Snowboards**
Printer **Danbury Printing and Litho**

Burton Snowboards Utopian Riding Technology Dealer Catalogue (1995–1996)

In 1995, snowboarding was poised on the brink of mainstream acceptance, as powerful companies lined up to invest in the sport. This catalogue, created to help Burton stake its claim as the technology leader, reflects the environment of 1995, which saw a huge explosion in video game technology, 3-D imagery, and the incessant buzz of the Internet and virtual reality. The catalogue imagery, created after watching a mix of the super-sterile *2001* followed by the super-groovy *Barbarella*, supports Burton's technically savvy position with full-on sonic color, techno diagrams, a custom font named Planivers, and a Burton Robot tour guide.

Design Firm **Jager Di Paola Kemp Design, Burlington, VT**
Creative Director **Michael Jager**
Art Director **David Covell**
Graphic Designers **Jim Anfuso, David Covell, Ken Eiken, John Phemister, Dan Sharp, and Mark Sylvester**
Illustrators **Jim Anfuso and John Churchman**
Photographers **Geoff Fosbrook and Various**
Client **Burton Snowboards**
Printer **DePalma Printing**

► BELOW

Converse Catalogue (1993)

This dealer catalogue was conceived as a travel guide to Generation X. The aim was not merely to present the new fall sneaker collection to dealers (many of whom are far removed from today's youth and attitudes) but to show different market segments for the versatile product line. The designers traveled to L.A., Boston, New York, and Vermont, shooting videos, Polaroids, and 35mm to record the life-styles and mindsets of the people wearing this brand. Their raw footage was used to build this catalogue.

Design Firm **Jager Di Paola Kemp Design, Burlington, VT**
Creative Director **Michael Jager**
Art Director **Steve Farrar**
Graphic Designers **Steve Farrar, Michael Jager, and Dan Sharp**
Illustrator **Zodak**
Photographers **George Covella, Peter Rice (Product), and Aaron Warkov**
Client **Converse**
Printer **W. E. Andrews**
Paper **French 80# Speckletone Kraft (Cover), Vintage Velvet 100# Text**

Burton Science Consumer Catalogue (1993)

This consumer version of the '93 Burton Science
Dealer Catalogue was translated into five languages
and distributed worldwide. The catalogue's digest-size
format was unique in the industry, and its "textbook"
cover allowed riders to sneak it into class.

Design Firm **Jager Di Paola Kemp Design,**
Burlington, VT
Creative Director **Michael Jager**
Graphic Designers **David Covell, Michael Jager,**
and Adam Levite
Photographers **Geoff Fosbrook and Various**
Client **Burton Snowboards**

Koho In-Line Catalogue (1994)

This trade catalogue announced Koho's arrival in the
world of in-line hockey. The catalogue's "Ugly Truth"
positioning drove the industry toward a machine-like
aesthetic that delivered a message of pure, stripped-
down power. The design firm's ability to influence
product and marketing decisions resulted in a catalogue
that injected a new, raw sensibility into the slick,
brightly colored universe of skates and equipment.

Design Firm **Jager Di Paola Kemp Design,**
Burlington, VT
Creative Director **Michael Jager**
Art Director **Steve Farrar**
Graphic Designers **Steve Redmond, Michael Shea,**
and Andrew Szurley
Illustrator **Steve Redmond**
Photographers **White/Packert and Lars Toppleman**
Client **Tropsport International**
Printer **Danbury Printing**
Paper **French Packing Carton (Cover)**
and Potlatch Vintage

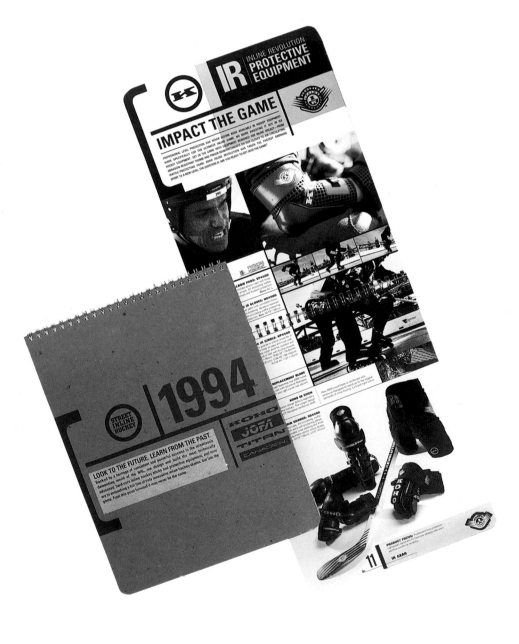

▸

Burton Science Dealer Catalogue (1993)

When this catalogue was designed, snowboarding needed to make the leap from its underground roots to a legitimate sport. The Burton "science book" concept was developed to explain new technical advances with an irreverent, sardonic humor characteristic of snowboarders. The brochure's clear organization sold Burton technology and captured the sport's raw energy, launching a much-copied trend.

Design Firm **Jager Di Paola Kemp Design,
Burlington, VT**
Creative Director **Michael Jager**
Graphic Designers **David Covell, Michael Jager,
and Adam Levite**
Photographers **Geoff Fosbrook and Various**
Client **Burton Snowboards**

▾

Burton Factory Dealer Catalogue (1995)

As Burton Snowboard's primary sales tool worldwide, the dealer catalogue must be accessible, concise, and entertaining. The designers developed separate identities for each product category — boards, boots, bindings, and clothing — and designed a series of different-size books, linked graphically with a manufacturing theme.

Design Firm **Jager Di Paola Kemp Design,
Burlington, VT**
Creative Director **Michael Jager**
Art Director **David Covell**
Graphic Designers **Keith Brown, David Covell,
Ian Factor, and Dan Sharp**
Photographers **Geoff Fosbrook and Various**
Client **Burton Snowboards**
Printer **DePalma Printing**
Paper **Vintage Text, Jersey 100# Cover**

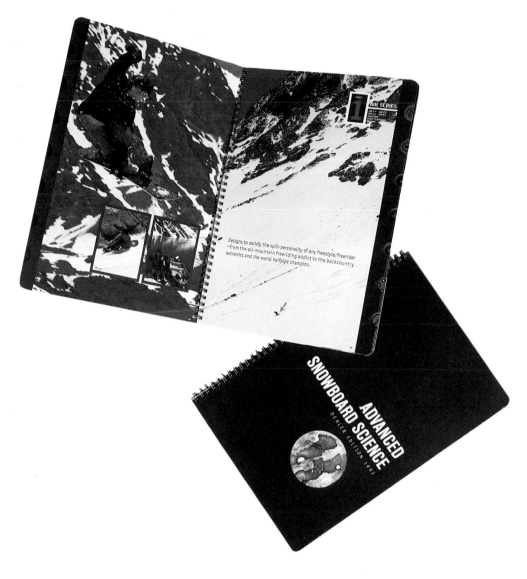

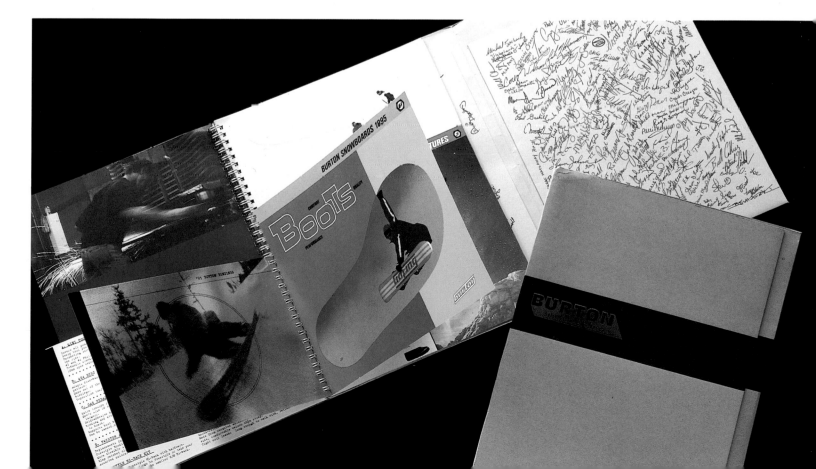

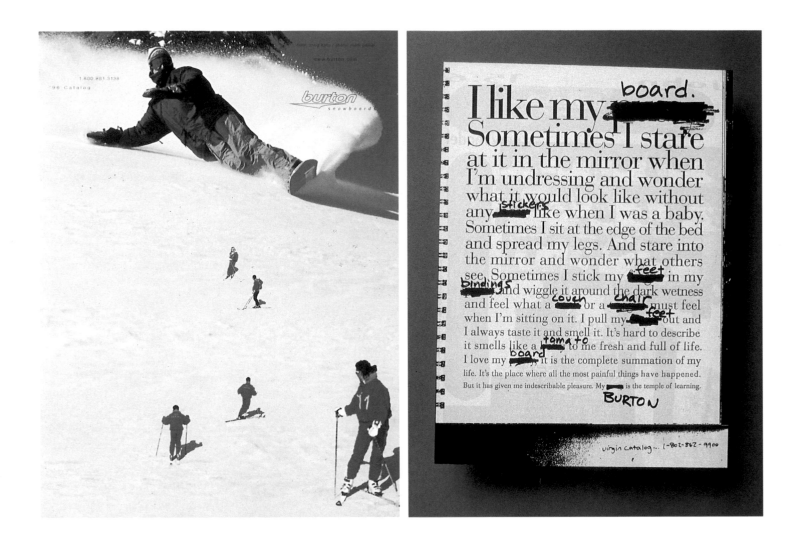

▲ ABOVE LEFT

Burton Craig the Giant (1995–1996)

This humorous advertisement designed for a skiing publication spins the contining feud between skiers and riders in winter mountain sports, with snowboarding depicted as a giant tromping through the traditional skiing industry.

Design Firm **Jager Di Paola Kemp Design,**
Burlington, VT
Creative Director **Michael Jager**
Graphic Designer **Mark Sylvester**
Photographer **Mark Gallup**
Client **Burton Snowboards**

▲ ABOVE RIGHT

Burton Madonna Ad (1994)

Intended for small, regional snowboard publications, this ad soars above the blatant sexism and braggadocio that typify snowboard advertising. The ad outsmarted a culture consumed in one-upmanship with humor and unabashed confidence. By deconstructing the hype surrounding the undisputed Queen of Sleaze, it embraces a hand-made, raw composition that communicates an honest, quality vibe to the company's advantage.

Design Firm **Jager Di Paola Kemp Design,**
Burlington, VT
Creative Director **Michael Jager**
Art Director **David Covell**
Graphic Designer **Keith Brown**
Client **Burton Snowboards**

▲

Soho Training Identity (1993)

This logo was conceived as a "signature" that conveys a sense of place and simultaneously communicates the nature of the company's health and fitness business. Hardworking, legible in small sizes, adaptable to horizontal and vertical configurations and to positive and negative applications, the graphic identity succeeds as a communications tool that stimulates interest and invites participation in this downtown New York health club.

Design Firm **Siegel & Gale, New York, NY**
Art Director **Kenneth R. Cooke**
Graphic Designer **Kenneth R. Cooke**
Illustrator **Kathy Koelzer**
Client **Soho Training**

▶

Burton B.U.R.T.O.N. Logo (1996)

This whimsical image for a Burton dealer catalogue
demonstrates technology's power to make real what
the mind can only imagine.

Design Firm **Jager Di Paola Kemp Design,**
Burlington, VT
Creative Director **Michael Jager**
Art Director **David Covell**
Graphic Designers **Jim Anfuso and David Covell**
Client **Burton Snowboards**
Printer **DePalma Printing**
Paper **Pure White Mohawk Innovations Soft Cover**

▼

Burton Golf Green Ad (1994)

When this series of "construction" ads was created,
Burton's competitors were relying on new computer
technologies to create their slick images. Bucking
the trend, Burton and the designers went junk shopping,
generating and then photographing more than seventy
one-of-kind, hand-crafted collages. Letter by letter,
even some fine-print type was glued in.

Design Firm **Jager Di Paola Kemp Design,**
Burlington, VT
Creative Director **Michael Jager**
Art Director **David Covell**
Graphic Designer **David Covell**
Client **Burton Snowboards**

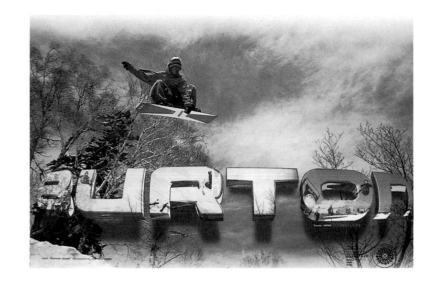

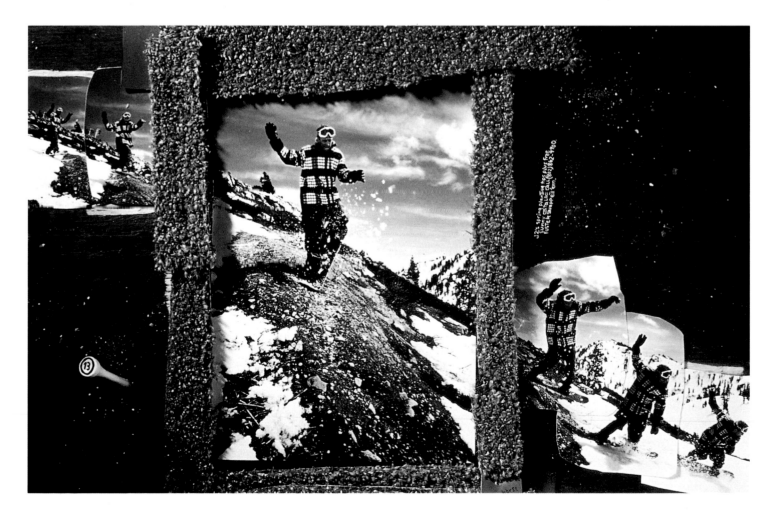

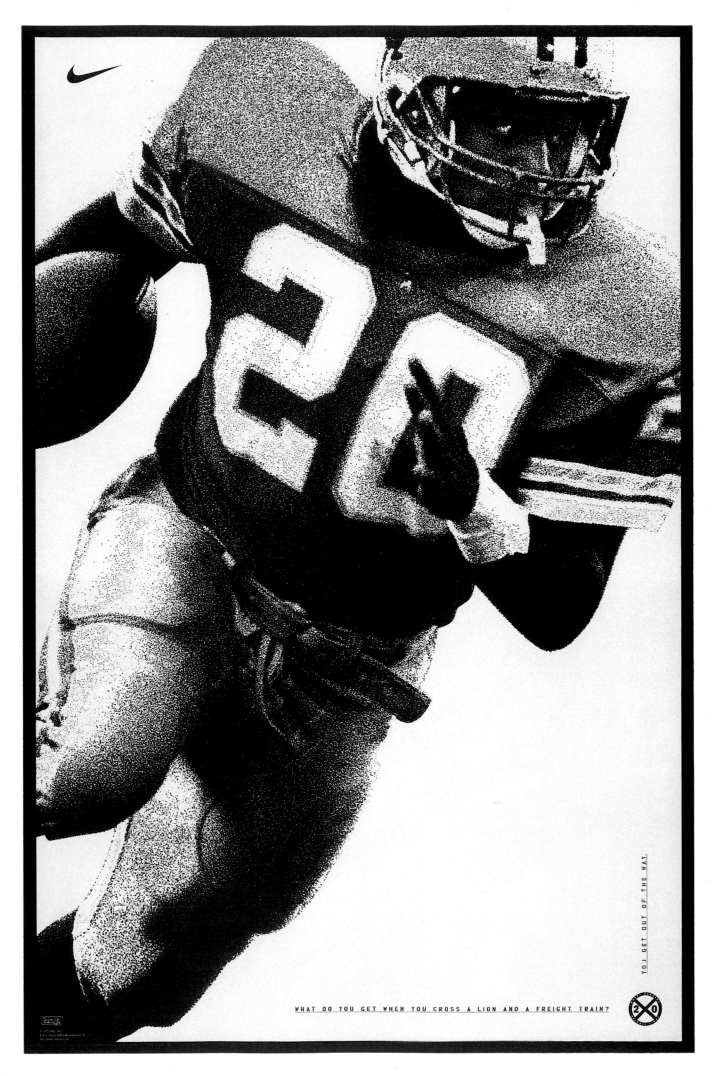

WHAT DO YOU GET WHEN YOU CROSS A LION AND A FREIGHT TRAIN?

YOU GET OUT OF THE WAY.

Barry Sanders Poster (1995)

Lacking a budget for a photoshoot, the designer selected and manipulated a stock photo image. By exaggerating the grain, removing the background, and giving the image a dramatic crop, the designer successfully captured the sport's true grit, power, and grace.

Design Firm **Nike, Inc., Beaverton, OR**
Creative Director **Ron Dumas**
Graphic Designer **Dan Richards**
Client **Nike, Inc.**
Printer **Irwin Hodson**

Nice Seats (1995)

A creative strategy conceived as an in-store promotion for the Dockers brand of casual men's pants offered two Nice Seats at Super Bowl XXX, America's premier sporting event, to a lucky customer. Shifting the focus away from those in the game to those at the game, the designers devised a ballot box that showcased the two coveted seats. Entry blanks printed on acetate kept the prize visible as the contest progressed.

Design Firm **Foote, Cone & Belding Promotion & Design, San Francisco, CA**
Art Directors **George Chadwick and Eric Rindal**
Graphic Designer **Dee Pyshe**
Copywriter **Steve Good**
Client **Dockers**
Printer **G & R Plastic Products (Box) and Leit'n Up (Poster)**
Fabricator **Tolone Studios**
Paper **120# LOE Cover (Poster)**

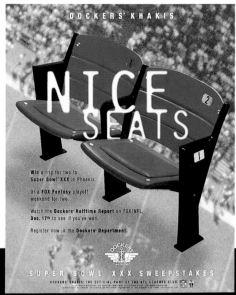

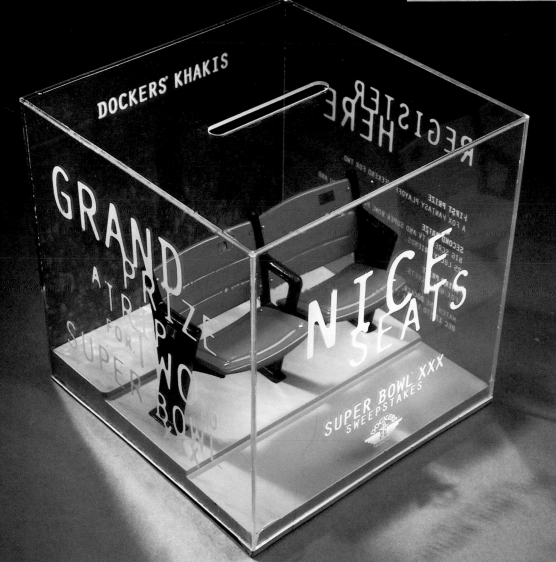

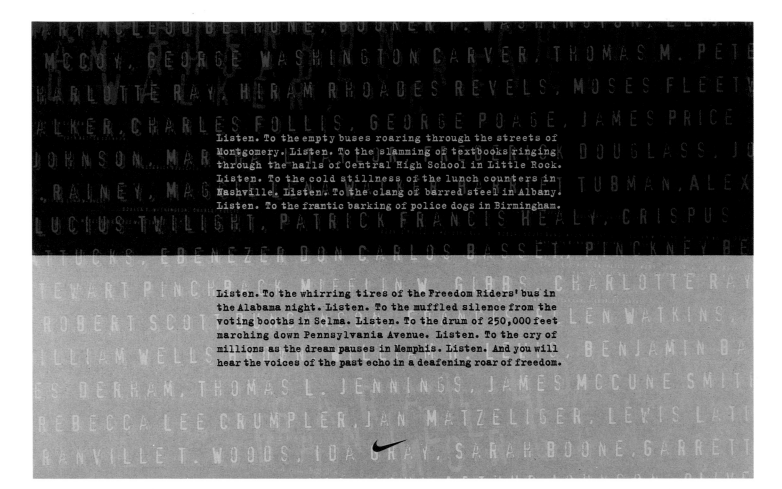

Listen. To the empty buses roaring through the streets of Montgomery. Listen. To the slamming of textbooks ringing through the halls of Central High School in Little Rock. Listen. To the cold stillness of the lunch counters in Nashville. Listen. To the clang of barred steel in Albany. Listen. To the frantic barking of police dogs in Birmingham.

Listen. To the whirring tires of the Freedom Riders' bus in the Alabama night. Listen. To the muffled silence from the voting booths in Selma. Listen. To the drum of 250,000 feet marching down Pennsylvania Avenue. Listen. To the cry of millions as the dream pauses in Memphis. Listen. And you will hear the voices of the past echo in a deafening roar of freedom.

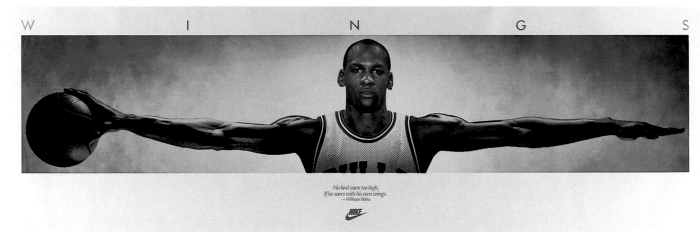

No bird soars too high,
If he soars with his own wings.
—William Blake

▲ ABOVE

Black History Month Poster (1995)

Distributed to schools, black organizations, and publications across the country, this poster was designed to commemorate Black History Month and to celebrate Coretta Scott King's arrival at Nike headquarters. Printed on uncoated kraft paper in overlapping inks, the poster's simplicity focuses the viewer's attention on equality — the mission of the civil rights movement.

Design Firm **Nike Inc., Beaverton, OR**
Art Director **Jeff Weithman**
Graphic Designers **Craig Barez and Jeff Weithman**
Copywriter **Stanley Hainsworth**
Client **Nike, Inc.**
Printer **Graphic Arts Center**
Paper **French Speckletone, Kraft Paper**

▲

Michael Jordan "Wings" Poster (1989)

This was the first black-and-white poster of basketball legend Michael Jordan and was Nike's first oversize poster. It is included in the permanent collection of the Library of Congress and with sales-to-date in excess of one million dollars, it remains one of Nike's top performing posters.

Firm **Nike Inc., Beaverton, OR**
Art Director **Ron Dumas**
Graphic Designer **Ron Dumas**
Photographer **Gary Nolton**
Text **William Blake**
Client **Nike, Inc.**
Typographer **V.I.P.**
Printer **Panel Prints**
Paper **100# Coated Stock**

Century of Basketball Poster (1991)

The designers hoped to evoke sentimental nostalgia for the sport on a monumental scale. Created to celebrate the game's centennial, the poster was distributed nationally to coaches and teams at all levels of the sport.

Design Firm **Nike Inc., Beaverton, OR**
Art Director **John Norman**
Graphic Designer **John Norman**
Illustrators **Anton Kimball and John Norman**
Copywriter **Becky Katson**
Client **Nike, Inc.**
Typographer **Supertype**
Printer **Graphic Arts Center**
Paper **Potlatch Eloquence**

Carolina Panthers Team
Logo and Logotype (1994)

The desigers' challenge was to develop a new logo and logotype that would anticipate the spirit and passion of future fans of the Carolina Panthers, an NFL expansion team. The logo also had to accommodate a variety of applications, from team helmets, uniforms, stationery, print, and video ads to commercial use on a wide range of licensed merchandise. Instantly recognizable yet different from other NFL team logos, the Panthers logo readily became a powerful unifying symbol of Carolina pride.

Design Firm **NFL Properties Advertising & Design Group, New York, NY**
Creative Director **Bruce Burke**
Graphic Designer **Jim Breazeale**
Client **Carolina Panthers Football Organization**
Typographers **Kelly Hume and Kurt Osaki**

Get ready to see Penn racquetballs in action during today's tournament. Of course, they won't be this easy to follow on every shot. But then again, you don't have to follow every rally to realize that our racquet balls take an enormous beating and always bounce back for more. The fact is, Penn racquetballs are backed by the exclusive Double Performance Guarantee: Should any Penn ball fail before the label wears off, Penn will replace it with two new balls. Now that's something only our competition finds difficult to follow. Penn racquetballs. You've seen one. You've seen them all.

"Get Ready ... Racquetball ..." Ad
(1988–1989)

The audience: attendees at North American racquetball tournaments. The purpose: build on brand positioning of Penn's unparalleled consistency as the manufacturerer of top-performance racquetballs. The strategy: create a page that has stopping power; say something quickly without color or lengthy copy. The parameters: produce a full-page ad for tournament programs; print b/w only on inexpensive uncoated papers; no time; little budget. The value: the designer praised the copywriter (it was his idea) and the client's acceptance of something so economical and playful. "It fit the nature of sport. Plus, they let us use a photo of the ball instead of the corporate logotype."

Firm **Rapp Collins Communications, Minneapolis, MN**
Art Director **John Seymour Anderson**
Photographer **Mike Habermann**
Copywriter **Mike Gibbs**
Client **Penn**

Nike LA Seeding Campaign (1995)

The Nike LA campaign was created to recognize basketball's unique heritage of winning in this city. Using billboards and other outdoor media, a specific effort was made to seed this promotional concept in targeted LA neighborhoods.

Design Firm **Wieden & Kennedy, Portland, OR**
Creative Director **Dan Wieden**
Art Director **John Jay**
Graphic Designers **Nicole Misiti and Imin Pao**
Illustrator **Nicole Misiti**
Photographer **Brad Harris**
Copywriter **Jimmy Smith**
Client **Nike**
Printer **International Color Poster**

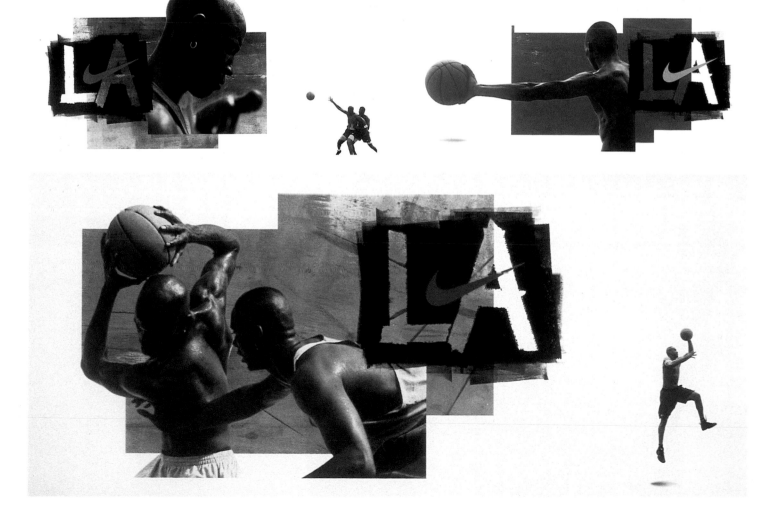

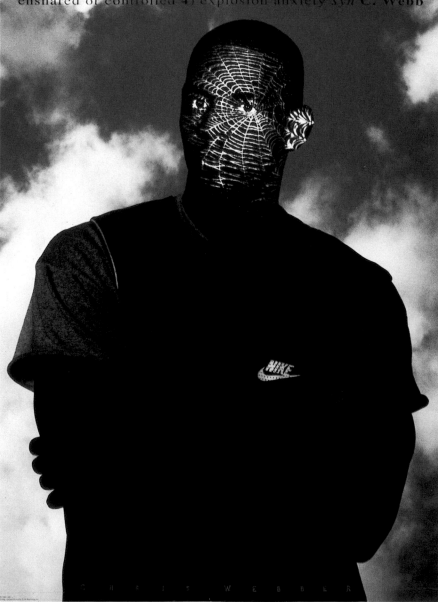

Chris Weber Arachnophobia Poster (1994)

The fear of spiders is an apt visual metaphor for this poster's tribute to fearsome basketball pro Chris Weber, whose name alludes to a spider's web.

Design Firm **Nike Inc., Beaverton, OR**
Art Director **Ron Dumas**
Graphic Designer **Guido Brouwers**
Photographer **Everard Williams, Jr.**
Copywriter **Bob Lambie**
Client **Nike, Inc.**
Printer **Irwin Hodson**
Paper **100# Productolith**

Dortmund Poster (1992)

This poster for the German soccer team Borussia Dortmund breaks the rules of traditional sports team posters. Designed as a game giveaway, the poster conveys the excitement and energy of the game as well as the irreverence of the players. To create a spirit of fun, the designer and photographer showed each player Polaroids of his teammates before photographing him. Each player tried to outdo the last. In the end, each participant experienced the design process at its collaborative best.

Design Firm **Nike Inc., Beaverton, OR**
Art Director **Jeff Weithman**
Graphic Designer/Illustrator **Jeff Weithman**
Photographer **Richard Corman**
Client **Nike, Inc.**
Printer **Henkes Senefelder**
Paper **Arjomarie**

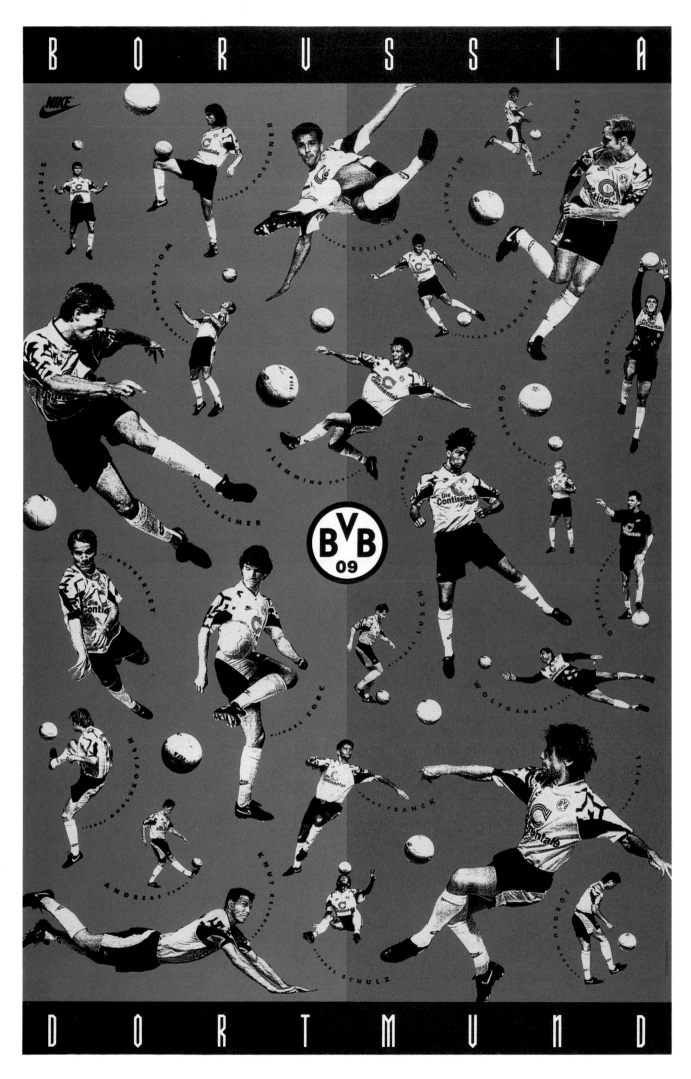

Swatch Euro All Star Fussball

Swatch Maxi Cup (1987)

Swatch Watch is known for building a strong brand image based on eclectic, youthful graphics. Creatives at Swatch suggested looking instead to Swiss history for visual inspiration for a corporate campaign. Swatch loved the concept at the time, but didn't have the budget (they were not the mega-success they are today). The designer took the project on himself.

Design Firm **Spot Design, New York, NY**
Art Director **Drew Hodges**
Illustrator **Drew Hodges**
Copywriters **Drew Hodges and Max Imgroth**
Client **Swatch Watch**

▶ OPPOSITE PAGE, ABOVE

Bay to Bay Poster (1991)

The audience for these posters is sports enthusiasts and college students who participate in rowing and paddling regattas across the United States. This was the first poster created for what eventually became an annual fund-raising event for a local YMCA. Inspired by the fluid strokes made by rowers and paddlers, the designers built an international red, white, and blue brand recognition for the event based on the feeling of strength.

Design Firm **Mires Design, Inc., San Diego, CA**
Art Director **Jose Serrano**
Graphic Designer **Jose Serrano**
Illustrator **Gerald Bustamante**
Client **Peninsula Family YMCA**
Printer **Rush Press**

▶ OPPOSITE PAGE, BELOW

Bay to Bay Poster (1994)

Using an old piece of wood as a "canvas" for the illustration, the designers gave this poster a weathered look reminiscent of older boathouses that have been exposed to years of rain, wind, and sun.

Design Firm **Mires Design, Inc., San Diego, CA**
Art Director **Jose Serrano**
Graphic Designers **Mike Brower and Jose Serrano**
Illustrator **Gerald Bustamante**
Client **Peninsula Family YMCA**
Printer **Rush Press**
Paper **Simpson Vicksburg Starwhite**

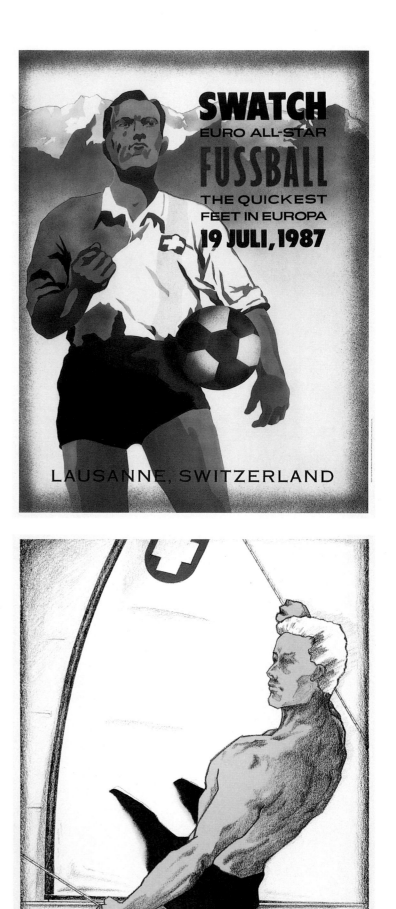

Seventh Annual International Rowing & Paddling Regatta · Mission Bay to San Diego Bay · Peninsula Family YMCA · San Diego, California · April 21, 1991

Run, Bike, Swim (1995)

Run, Bike, Swim, a series of paintings originally created for gallery exhibition, challenges the limitations of the medium and the physique by evoking the athlete's enduring struggle to balance force and finesse.

Design Firm **Groover Design, Atlanta, GA**
Illustrator **Susan Groover**
Client **Art with an Attitude Gallery**

◄ BELOW

Coca-Cola Healthworks (1995)

"Always Balanced," a 24-page booklet for employees of the Coca-Cola Company, provides an overview of company programs and services to help associates get the most out of their workdays and balance work and personal obligations. The booklet uses three full-page illustrations, each done by a different artist, depicting different life-balance programs. The artists' energy and physicality, bold colors, and aggressive brushwork graphically capture the spirit of sports in Coca-Cola's Healthworks program.

Design Firm **Groover Design, Atlanta, GA**
Art Director **Richard Shannon**
Graphic Designer **Richard Shannon**
Illustrators **Susan Groover, Lonni Sue Johnson, and Nina Laden**
Client **The Coca-Cola Company**
Printer **Tucker-Castleberry Printing**
Paper **Mohawk Satin**

▼

Coca-Cola Bike

Design Firm **Groover Design, Atlanta, GA**
Art Director **Richard Shannon**
Graphic Designer **Richard Shannon**
Illustrator **Susan Groover**
Client **The Coca-Cola Company**

POLO RALPH LAUREN AT YOUNG QUINLAN

FIFTH ANNUAL

POLO CLASSIC

SCHWAB

SUNDAY AUGUST 7, 1994
FOR CHILDREN'S HOME SOCIETY OF MINNESOTA

5th Annual Polo Classic Poster,
6th Annual Polo Classic Poster,
11th Annual Polo Cup Poster

The posters in this collectible series were first used
as advertisements and then sold at the event. To reduce
eventual color fading, the image was silkscreened onto
fine paper stock. The designers tried to avoid using
typical "action shots" of galloping horses.

Design Firm **Michael Schwab Studio,**
San Anselmo, CA
Art Director **Bill Merriken**
Graphic Designer **Michael Schwab**
Illustrator **Michael Schwab**
Client **Polo Retail Corporation**
Printer **B+R Screen Printing**

"Rebel with a Cause" Poster (1989)

This parody of the famous James Dean photograph taken in Times Square makes cheeky reference to the film classic *Rebel Without a Cause*. McEnroe plays the irreverent hero whose outlandish on-court antics often threatened to undermine his professional standing. Nonetheless, he became an icon and the sport grew in popular appeal. This poster was such a market success it completely sold out.

Design Firm **Nike Inc., Beaverton, OR**
Art Director **Ron Dumas**
Graphic Designer **Ron Dumas**
Photographer **Bill Sumner**
Copywriter **Ron Dumas**
Client **Nike, Inc.**
Typographer **V.I.P.**
Printer **Irwin Hodson**
Paper **100# Coated Stock**

Just Do It (Braille) Poster (1993)

Blind embossing prints "Just Do It" in Braille in poster, one in a series designed for the handica

Design Firm **Nike Inc., Beaverton, OR**
Art Director **Ron Dumas**
Graphic Designer **Guido Brouwers**
Copywriter **Laura Houston-Emery**
Client **Nike, Inc.**
Fabricator **Creative Paper Crafting**
Paper **Illustro Dull**

I DO MISS ALL THE TIME THAT I'M NOT THERE. They change so much. My little girl, Jasmine, was starting to crawl by the end of the playoffs. I had missed the stages that led up to her actually trying to crawl. I missed the whole stage where she started to stand up, where she tried to move but really couldn't get going. I missed all that.

Rare Air: Michael on Michael (1993)

The book's concept was simple: raise the curtain and provide a first-hand peek at the public and private lives of the late-twentieth-century sports icon Michael Jordan. For the book's designers, Rare Air, Ltd. and publishers Macmillan Associates, this meant nothing short of the highest quality with regard to text, image, paper, and printing. Featuring the work of world-renowned sports photojournalist Walter Iooss, Jr., the finished book stands as a testament to Jordan's power, elegance, and grace on and off the basketball court.

Design Firm **McMillan Associates, West Dundee, IL**
Art Director **Michael McMillan**
Graphic Designer **John Vieceli**
Photographer **Walter Iooss, Jr.**
Writer **Mark Vancil**
Publisher **Collins Publishers**
Printer **Graphic Arts Center**
Paper **LOE**

RareAir Card Set (1994)

The concept: design a sophisticated card set based on the career of superstar Michael Jordan that appeals to novice and professional collectors alike. The parameters: create a groundbreaking product on a minimal budget. The solution: the designer used a simple color palette of red, white, and black (the Bull's team colors), with silver as a highlighting color for selected Jordan quotes. The card design and typography were kept simple to avoid detracting from the photography, and the Jordan mystique prevails throughout. His personal thoughts shine through sheets of vellum on the slip-sleeve, underscoring his farewell to basketball, and giving a sense of the star's proximity to the product.

Design Firm **The Upper Deck Company, Carlsbad, CA**
Art Director **David Lomeli**
Graphic Designer **David Lomeli**
Photographer **Walter Iooss**
Copywriter **Joe Soehn**
Client **The Upper Deck Company**
Typographer **"Rare Air" logotype by**
McMillan Associates
Printers **Container Concepts/Lithocraft**
Fabricator **Advanced Paper Box**

Hummer Brochure (1995)

This brochure, which was used as a launch piece for sales representives and employees, outlines Nike's new corporate identity direction — the swoosh alone. Later supplemented by a CD-ROM, it marks a significant step in the logo's evolution.

Design Firm **Nike Inc., Beaverton, OR**
Art Director **Ron Dumas**
Graphic Designer **Ron Dumas**
Photographers **Tony Dezinno and Various**
Copywriter **Bob Lambie**
Client **Nike, Inc.**
Printer **Irwin Hodson**

Rodman Tee (1995)

Outrageously eccentric basketball renegade Dennis Rodman tattooed on a plain white T-shirt? The designers used minimal graphics, three vivid hair colors, and an intense large-scale portrait to create an immediate visual impression.

Design Firm **Nike Inc., Beaverton, OR**
Art Director **Michael Morrow**
Graphic Designer **Dave McLaughlin**
Client **Nike, Inc.**

Annual Report (1990)

Because 1990 was a record year for Nike, the design-
ers chose to express the corporate spirit in a non-tradi-
tional way. Their plan for the 1990 annual report was
to create a piece that represented Nike employees with
the shoes, clothing, and accessories they created.
The designers secretly set up photo booths at a five-day
international sales meeting so that employees sponta-
neously took their self-portraits. The results were great.

Design Firm **Nike Inc., Beaverton, OR**
Art Director **Ann Schwiebinger**
Graphic Designer **Ann Schwiebinger**
Photographers **Dennis (Cover), Various (Interior)**
Client **Nike, Inc.**
Typographer **V.I.P. Typographers**
Printer **Irwin Hodson**
Paper **Iconolux and Speckletone**

THIS ANNUAL REPORT IS ABOUT THE PEOPLE WHO WORK FOR A UNIQUE COMPANY AND HOW THEY WORK TOGETHER TO PRODUCE OUTSTANDING RESULTS FOR SHAREHOLDERS. TO BORROW A WORD FROM THE WORLD OF ATHLETICS, IT'S ABOUT TEAMWORK. IN MANAGEMENT TEXTBOOKS, IT'S ABOUT PEOPLE WORKING TOGETHER WITHIN A MATRIX ORGANIZATION. IT'S ALSO ABOUT A SPECIAL CORPORATE CULTURE, INSPIRED BY COMPETITIVE SPORTS AND THE DESIRE TO WIN.

BEFORE A PRODUCT IS BORN, NIKE HAS RESEARCHED WHAT ELEMENTS NEED TO BE INCLUDED FOR ENHANCED FIT AND FUNCTION; HOW THIS PRODUCT CAN OFFER MORE THAN ITS PREDECESSOR; HOW IT CAN BE THE NEXT STEP IN THE EVOLUTION OF PERFOR-MANCE FOOTWEAR, APPAREL AND ACCESSORIES. AND ONE OF THE MAJOR REASONS WE ARE ABLE TO ANSWER THESE QUERIES UNLIKE ANY OTHER SPORTS AND FITNESS COMPANY IS THE NIKE SPORT RESEARCH LABORATORY (NSRL). SINCE 1980, THE NSRL HAS CONDUCTED EXTENSIVE STUDIES ON A WIDE VARIETY OF BASIC AND APPLIED RESEARCH PROJECTS, FROM CHILDREN'S FOOT MORPHOLOGY TO THE PROBLEM OF TURF TOE IN FOOTBALL TO APPAREL AERODYNAMICS. NSRL ALSO EVALUATES NEW IDEAS FROM OUR ADVANCE PRODUCT ENGINEERING (APE) DEPARTMENT WHICH WORKS ON LONG-TERM PRODUCT DEVELOPMENTS THAT OFTEN RESULT IN REVOLUTIONARY INNOVATIONS SUCH AS THE NIKE FOOTBRIDGE™ STABILITY DEVICE, INFLATABLE FIT SYSTEMS AND THE 180 NIKE-AIR® CUSHIONING SYSTEM.

The exceptional Air 180, the most cushioned running shoe developed, will be introduced in Spring 1991 as part of the NIKE International Collection.

A young runner once asked Bill Bowerman how to improve his times. Bowerman replied, "Run faster." The answer reveals his humor and minimalist philosophy. The Cortez, made to Bowerman's specifications in 1966, became the best-selling shoe for Blue Ribbon Sports, the forerunner of NIKE. But it was the Waffle® outsole that allowed Bowerman and Knight to launch a distinct product line based on better, lighter, more stable running shoes. The motivation was always the same: Help athletes run faster. Performance *the shoes we wear* remains the cornerstone of every NIKE product. The success of the AIR JORDAN® shoe, now in its ninth year of development, has paralleled the rise of basketball as a global sport and helped NIKE become the undisputed leader in basketball. The Air Trainer® High defined a fitness revolution—cross-training. The Air Mowabb took cross-training outdoors in 1992. Products like these in the industry's largest categories have helped make NIKE the dominant force in athletic footwear. Constant innovation and refinement

▲

Annual Report (1992)

Nike's 1992 annual report was designed to celebrate twenty years of innovation in sports and fitness. The designers decided to take a look at the past without undue nostalgia, while demonstrating Nike's ability to respond creatively to future opportunities. Eight photographers and an illustrator created nine spreads focused on different areas of the company, illustrating Nike's past, present, and future.

Design Firm **Nike Inc., Beaverton, OR**
Art Director **Ann Schwiebinger**
Graphic Designer **Ann Schwiebinger**
Illustrator **Joel Nakamura**
Photographers **Amy Guip, Gary Hush, Geof Kern, Grace Knott, Jose Picayo, Charles Purvis, Maria Robledo, and James Wojcik**
Copywriter **Bob Lambie**
Client **Nike, Inc.**
Typographer **V.I.P. Typographers**
Printer **Irwin Hodson**
Paper **Iconolux and Speckletone**

▼

Brighton Locals

Wig magazine, an eclectic independent publication,
aims to pull the reader into the moment with editorial
features that speak in a personal voice. The designer
of this article wrote, illustrated, and photographed
the story as a personal journal. Her intent was to con-
vey — in word and image — a participatory, emotionally
radical sense of snowboarding as a sport.

Design Firm **Wig Magazine**
Art Director **Dawn Kish**
Graphic Designer **Dawn Kish**
Photographers **Jon Jensen and Dawn Kish**
Client **Wig Magazine**
Printer **Hudson Printing**

iditabike

The Abominable Snow Woman
**Assistant editor Monique Cole mountain bikes her way to personal tri-
umph in Alaska's 160-mile Iditabike**

The howling outside my window one morning last January did not bode well. Nonetheless, I set off into 45-mile-per-hour winds to bike my first century (100 miles), completely alone and without support. My original plan had been to pedal my clunky vintage mountain bike from Boulder, Colorado, northwest (translation: uphill) into the Rockies to Estes Park, then loop back on the Peak-to-Peak Highway. But a mere two miles up the mountain roads, I decided that the head wind blowing off snow-capped peaks and 3,000 feet of elevation gain were a lethal combination. So I retreated to the flatlands, pedaling aimlessly, my goal to clock miles and avoid straying too far from the 7-Eleven's, which served as my aid stations.

I rode north, south, east, west, and never seemed to experience a tailwind. The gusts either blasted me head-on, slowing my pace to a crawl, or side-swiped me, forcing me to ride at a 45-degree angle to keep from blowing over. My ears were filled with roaring and my nostrils with frozen moisture. The gale, like a hormone-crazed teenage boy, managed to force its way through my layers of carefully placed polyester to naked skin. While flipping the bird into the eye of the storm, I muttered to myself, "This is good for your mental toughness." I would need it to complete the race for which this was merely a training ride.

The race was the Iditasport Human-Powered Ultramarathon in the Alaskan bush outside of Anchorage. Here's the punch-line: it's held in February on the Iditarod dog sled trail (translation: cold). Entrants have several choices, they can run or snowshoe 75 miles to the halfway point and fly back in a single-engine bush plane. Or they can do the entire 160-mile lollipop loop on a bike, skis, or a triathlon combination-bike, skis, and feet. Theoretically, snowmobile and dog-sled traffic pack the snow into a surface that can support the weight of a runner or cyclist. This theory does not always ring true.

Iditasport is as much a wilderness survival course as a race, so entrants must carry basic life-support gear—a bivouac sack, sleeping bag, lighting system, stove, and cook pot (for melting snow into drinking water), water in insulated containers, and two days worth of food. Ever present are the dangers of getting frost-bitten, hypothermic, or lost in the maze of snowmobile tracks, which wind through the swamps and scraggy spruce trees. Aid stations—tent camps or rustic fishing lodges—are spaced between 15 and 40 miles apart and offer minimal amenities like relative warmth, drinking water, human companionship, and sometimes hot food.

Even though I had never raced by mountain bike or any other self-propelled means and at best could have been described as a recreational athlete, I decided to enter the '95 "Iditabike." It was an especially strange decision considering that I grew up on the beaches of Hawaii where fitness was a side effect of play—running down the beach to the best surf break and paddling a bodyboard into waves. As a young girl, I had been hit by a car while crossing the highway. This left me with one leg almost an inch longer than the other, which later caused a curve in my spine to develop between my shoulders. Through high school, I used my physical limitations as an excuse to shun land sports. Having spent so much time on crutches, I feared injury and, less consciously, failure.

After moving to Colorado, I dabbled in mountain biking, trail running, and rock climbing. I was gradually chipping away at my self-limitations; Iditabike appeared to be the perfect final blow. I wasn't going into the race blindly. The previous year I had traveled the course by snowmobile while marking the course with reflective tape and later I volunteered at the half way point aid station.

Iditasport founder, Dan Bull, had first brought me to Alaska to help him write a book on Alaskan extreme cycling. My research uncovered inspiring, terrifying, and humorous tales of Iditabike veterans and their 19th-century counterparts: gold prospectors who rode single-speed "safety bicycles" from one strike to the next. If they traveled the frozen "stampede" trails clothed in heavy fur coats on those relics, certainly, I could manage with the benefit of modern technology, I reasoned.

I begged, borrowed, and schmoozed until I acquired a small wardrobe of warm, lightweight clothes, an aluminum Barracuda mountain bike and extra-fat Snowcat wheels. Invented by Alaskans, the Snowcats are wider than normal rims but just narrow enough to fit in a standard mountain bike fork. They help a bike "float" on snow by distributing weight over a larger surface area and are highly recommended for Iditabikers.

After months of training, planning, and spending, I found myself at the Denver Airport, bound for Anchorage. "This the third bike I've checked in for this flight," and the MarkAir employee incredulously. I tried to explain to her that it all made sense, that we were heading for a mountain bike race in Alaska... in February. Later, peering out the tiny airport port-hole at the hugeness that is Alaska, I realized how silly that prospect was. Below us stretched a chaos of untouched peaks looking like a piece of crumpled aluminum foil sprayed with white Christmas flocking. The wilderness was both welcoming and foreboding. "Come explore me," she said, "But remember, I'm a fickle hostess." Proverbial butterflies did acrobatics in my belly.

The butterflies are strangely still when race day dawns in Big Lake—about 30 miles north of Anchorage. I stand at the start line amidst an equal mix of world-class athletes and determined adventurers. There are three other women on bikes; at worst I'll place fourth in my division. I don't care about winning, though. My goal is to have a good time and finish the race before the 72-hour cut-off.

The elation of the start quickly turns to concentration as I learn to maneuver over the punchy trail across the lake. Pedal, sink, dismount, push. Pedal, pedal, sink, dismount, push. I'm doing the Iditabike shuffle as my back wheel gets mired in soft spots. If it isn't soft snow forcing me to push my bike like an over-loaded gypsy wagon, it's these steep, icy stream banks. One is so steep that my friend and fellow Colorado journalist pulls out a pair of ice-climbing crampons to make the ascent. Lacking crampons, I scramble most ungracefully up to within four feet of the top before an Italian racer offers his assistance most chivalrously. Considering the circumstances, I find this gesture laughable rather than insulting male chauvinism. We are after all, in the middle of the toughest mountain bike race ever created, and I ain't no damsel in distress.

Eventually, the playing field disperses and I settle into a pace so unique that it leaves me alone with only a few stragglers behind me. Night falls and I hit a fun roller-coaster section of trail. If Disneyland had an Iditabike ride, this would be it: banked turns and gentle whoop-de-dos flanked by silly spruce trees that resemble Dr. Seuss' trees in "The Lorax." I stop for a drink of water and absorb the silence surrounding me. As I gaze up at the vault of the night sky, the darkness swallows my lead lamp's beam. Millions of stars shine back, mocking the insignificance of my puny light. It strikes me that I am alone in the Alaskan bush, miles away from the nearest road. Instead of feeling frightened, I am exhilarated by a sense of complete confidence in myself.

At midnight I stop at the second checkpoint, Eagle Song Lodge, where I dine on caribou sausage and chili an indulge in an hour of conversation with my fellow laid-back competitors Roman Dial and Chris Kostman, one of the checkpoint volunteers informs me that two women cyclist dropped out of the race at the first checkpoint. I think of them and all those poor suckers who are still riding as I bed down for the night in a warm bunk. The next section of trail is notoriously the worst, a death march of soft, punchy, snow pocked by moose prints. I will attack it in the morning when I'm fresh.

My plan pays off. I ride at a blazing 6 miles per hour over a trail that froze solid in the early morning, but which had been a sloggy mess the night before. Abandoned bikes stood like sentinels along the way, testimony to the racers who had pushed on into the night, only to give into exhaustion. They traded their $100 evacuation fee for a snowmobile ride and plane flight back to civilization, hot showers and cooked food.

Another sentinel basking in the pink light of dawn and dwarfing her neighboring peaks is 23,320-foot Mount McKinley. Ethnocentric Americans named her after a president who had never touched her foothills. Native Alaskans call her Denali, "The Great One," a name I found more suitable. The Great One offers respite from the monotonous bush scenery. I could swear that the same stunted spruce tree and swamp keep passing by like the backdrop of a Roadrunner cartoon. The monotony and perpetual pedaling throw my brain into auto-pilot. I think of nothing save the trail before me, the needs of my body, and the desire to keep moving.

THERE'S A REASON HOOPS ARE 10 FEET OFF THE GROUND. TO MAKE THEM HARD TO REACH

PEOPLE WHO MAKE IT ARE USUALLY STRONGER OR LIGHTER OR BOTH. TAKE THE AIR FORCE MAX

SHOE. GOING UP, THERE IS LESS HEAVY MIDSOLE MATERIAL TO BRING ALONG. AIR MAX

MEANS 35% MORE NIKE-AIR® CUSHIONING. NOT 35% MORE HARD GEL

NOT 35% MORE MOVING PARTS OR SPRINGS OR LEVERS OR SNAKE OIL. AND WHAT'S LIGHT

GOING UP IS HEAVY-DUTY PROTECTION COMING DOWN. BENEFITS THAT RESPOND TO YOUR PLAY

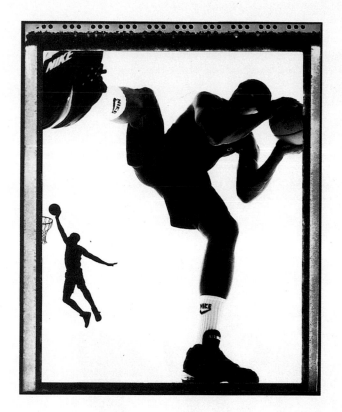

▲

Air Brochure (1992)

This brochure exhibits two of Nike's most important corporate business objectives: innovation and design excellence. The aim was to present the new Nike Air technologies and explain their benefits to Nike sales reps in a fresh way. The layout of the brochure, through its simplicity and generous use of space, reinforces the lightweight "air" message. It juxtaposes a highly technical message with unconventional, yet easy to understand imagery.

Design Firm **Nike Inc., Beaverton, OR**
Art Director **Carol Richards**
Graphic Designer **Carol Richards**
Photographer **Scott Morgan**
Copywriter **Bob Lambie**
Client **Nike, Inc.**
Printer **Diversified Graphics**
Paper **French Speckletone, UV Ultra, Vintage Velvet**

▼ ►

Nike "NYC" Graffiti Figures (1995)

These graffiti-inspired basketball-playing "alien" figures
were created to reflect the flair, fantasy, and flourish
of NYC's streetball players. The figures appeared in an
outdoor advertising campaign, on a court design in
Brooklyn, and were animated in a 90-second film trailer
shown in movie theaters throughout the city.

Design Firm **Wieden & Kennedy, Portland, OR**
Creative Directors **John C. Jay and Dan Wieden**
Art Directors **John C. Jay and Imin Pao**
Illustrator **Javier Michalski**
Copywriter **Jimmy Smith**
Client **Nike, Inc.**

Nike **"NYC" Graffiti Walls** (1995)

Design Firm **Wieden & Kennedy, Portland, OR**
Creative Director **Dan Wieden**
Art Director **John C. Jay**
Copywriter **Jim Riswold**
Designer **Petra Langhammer/Chris Shipman**
Photographer **Stanley Bach**
Client **Nike, Inc.**

▲

Nike "NYC" Trash Talk (1995)

Nike's "NYC Trash Talk" campaign celebrates that
special bravado found on the city's streetball courts.
Designed exclusively for NYC as both an outdoor
and a print campaign, the concept relied on the "talk"
of real ballplayers, past and present, to articulate the
sport's authenticity, elegance, and strength.

Design Firm **Wieden & Kennedy, Portland, OR**
Art Director **John C. Jay**
Creative Director **Dan Wieden**
Graphic Designer **Imin Pao**
Photographer **John Huet**
Copywriter **Jimmy Smith**
Client **Nike, Inc.**

Nike LA Books II campaign (1995)

Basketball in Los Angeles has a proud history of winning and a trove of legendary players. Nike's LA campaign, based on real stories of coaches and heroes, was created for the city's ballplayers as a tribute to their legacy and their iconoclastic style of play.

Design Firm **Wieden & Kennedy, Portland, OR**
Creative Directors **John C. Jay and Dan Wieden**
Art Director **Imin Pao**
Graphic Designer **Jessie Huang**
Photographer **John Huet**
Copywriter **Jimmy Smith**
Client **Nike, Inc.**

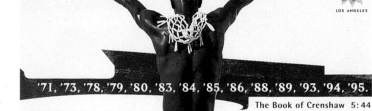

THEY CALLED HIM ALLAH.
The Book of John Williams 1:3

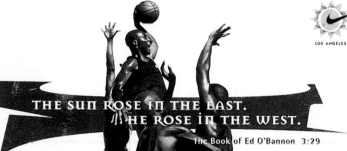

THE SUN ROSE IN THE EAST.
HE ROSE IN THE WEST.
The Book of Ed O'Bannon 3:29

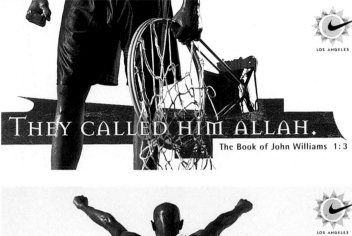

'71, '73, '78, '79, '80, '83, '84, '85, '86, '88, '89, '93, '94, '95.
The Book of Crenshaw 5:44

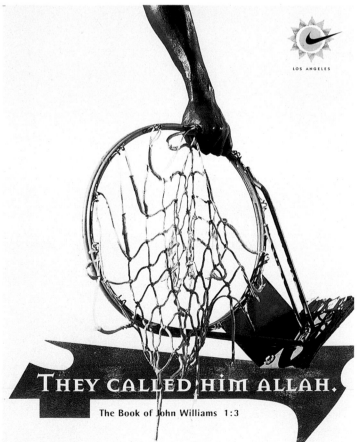

THEY CALLED HIM ALLAH.
The Book of John Williams 1:3

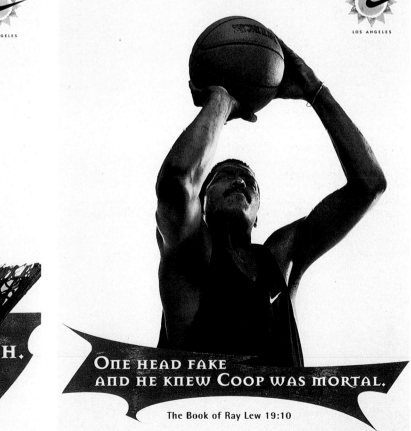

ONE HEAD FAKE
AND HE KNEW COOP WAS MORTAL.
The Book of Ray Lew 19:10

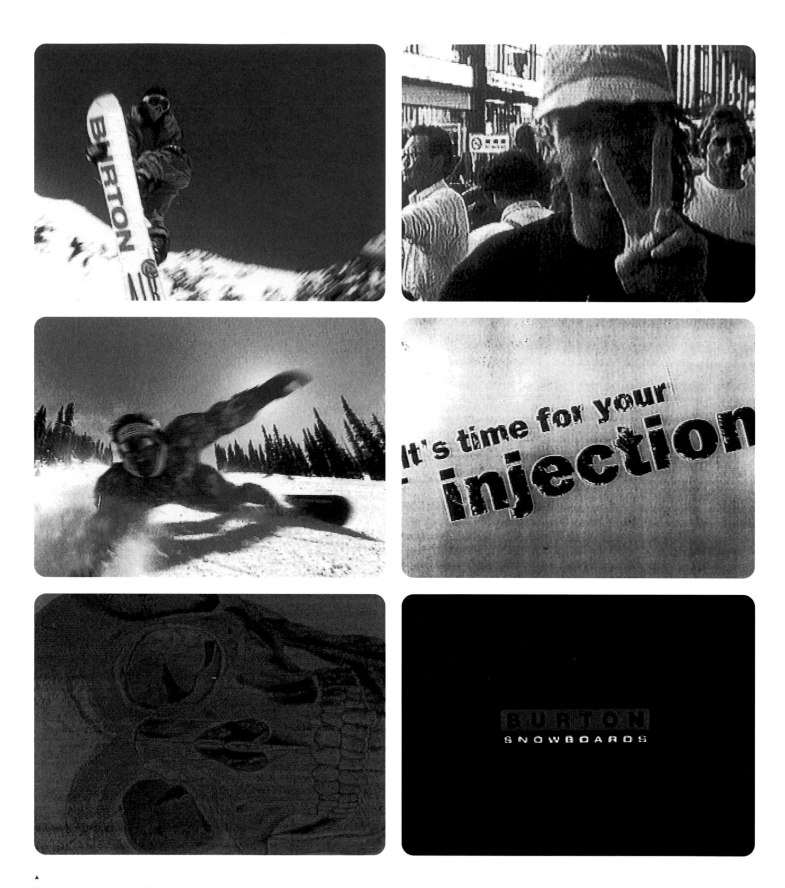

▲

Burton Red Army TV Spot (1993)

This surreal stream-of-consciousness television
spot grew out of a print ad campaign of a similar style.
Odd, seemingly random images mix with snowboards
in a high-energy, aggressive reflection of the sport.

Design Firm **Jager Di Paola Kemp Design,
Burlington, VT**
Creative Director **Michael Jager**
Graphic Designers **David Covell and Michael Jager**
Client **Burton Snowboards**
Video Producer **Resolution**

"All NYC" Animated Film Trailer (1995)

Nike honors basketball heroes, courts, and skills in this animated movie trailer. Shown in theaters throughout New York City, the spot pits two dream teams of the greatest players (including each city's streetball heroes) in a fantasy game, a "tale of two cities." The characters were created by a former graffiti artist, voices were provided by the players, and the game was called by a street game announcer.

Design Firm **Wieden & Kennedy, Portland, OR**
Creative Director **Dan Wieden**
Art Director **John C. Jay**
Designer **Imin Pao**
Illustrator **Javier Michalski**
Animator **Julia Tortolani**
Copywriter **Jimmy Smith**
Client **Nike, Inc.**
Production Company **@radical.media**

"Legends" TV Campaign (1995)

Nike "NYC" is a multimedia effort celebrating New York City's special love of basketball. In this city, the sport reaches mythical status and a player's single act of skill can resonate for decades. This video campaign pays homage to famous neighborhood playground courts and the legendary athletes who played and made their reputations there.

Design Firm **Wieden & Kennedy, Portland, OR**
Creative Directors **John C. Jay and Dan Wieden**
Art Director **Young Kim**
Designer **Imin Pao**
Copywriter **Jimmy Smith**
Director **Robert Leacock**
Editor **Livio Sanchez**
Client **Nike, Inc.**
Production Company **@radical.media**

▶

Six Monks (1990)

Chanting clergy make an incongruous star turn in this television spot. The ad, designed to distinguish Fan Fair Stores from other retailers that market licensed sports apparel, appeals to the prime purchasers of sports apparel — an audience of 12- to 24-year-old males. The spot builds dramatically before confessing its commercial intent in the final words.

Design Firm **BVK/McDonald, Milwaukee, WI**
Writer/Copywriter **Joe Locher**
Client **Fan Fair Stores**
Digital Video Producer **Partners' Film Co.**

▼

Panasonic "Big Game" (1995)

Created to air worldwide in the months preceding the 1996 Atlanta Olympic Games, this image spot captures the grand scope of the games while promoting Panasonic-supplied broadcast products. Athletes loom larger than life while products are integrated into the landscape at scale.

Design Firm **DESIGNefx, Atlanta, GA**
Director **Steve Colby**
Visual Effects Director **Jeff Doud**
Composite Artists **Scott Begunia, Ran Coney, Susan Detrie, Gordon DeWolf, and Jong Huh**
Client **Dentsu, Inc.**
Digital Video Producer **Nat Zimmerman**
Sound Editor **Acoustech, Atlanta, GA**

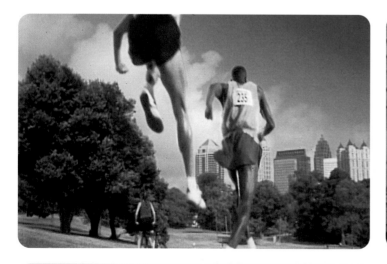
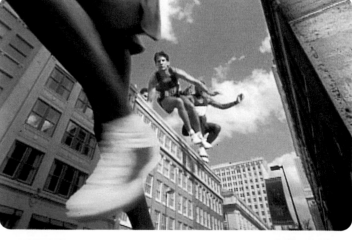
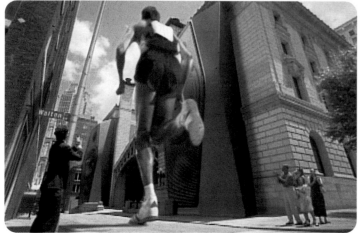
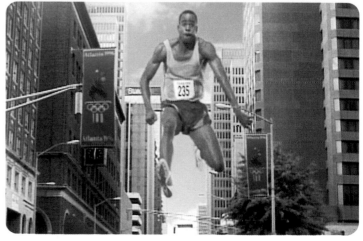

Stay in school.

▲

Burton Burning Chair TV Spot (1994)

Working with videographers, the designers developed storyboards, coordinated preproduction, art-directed, and guided post-production editing for this MTV video. Raw footage of a burning chair contrasts with full-color board action as a "visual war cry to end lazy-ass living."

Design Firm **Jager Di Paola Kemp Design, Burlington, VT**
Creative Director **Michael Jager**
Graphic Designer **David Covell**
Client **Burton Snowboards**
Video Producer **Driscoll Communications**

◄

Headgear (1989)

Created as part of the National Football League's 1989 "Stay in School" education initiative, this public service announcement communicates the NFL's commitment to education by characterizing each of its 28 member teams by its helmet, a symbol of power. Contrasted with a mortarboard — symbolic of the education that powers us through life — this simple roll call of icons proves that effective, strong advertising can be created without big budgets.

Design Firm **NFL Properties Advertising, NY, NY**
Creative Director **Bruce Burke**
Art Director **Mark Klein**
Client **National Football League**
Digital Video Producer **NFL Films**

Burton Factory Store (1994)

The designers used video, sound, interactive displays, and a variety of materials and merchandising structures to create a complete multimedia snowboarding environment for Burton's factory store. From the moment they walk through the door, customers are immediately immersed in a "riding experience" infused with a raw excitement that drives sales.

Design Firm **Jager Di Paola Kemp Design, Burlington, VT**
Creative Director **Michael Jager**
Art Director **David Covell**
Graphic Designers **David Covell and Michael Jager**
Client **Burton Snowboards**

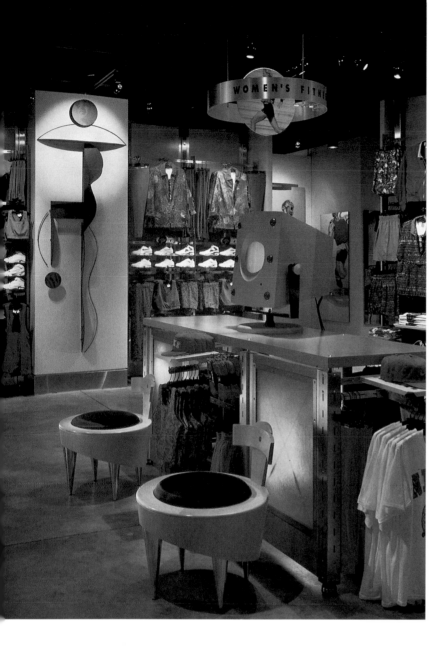

◄

Women's Pavilion NikeTown Atlanta (1993)

This retail area was designed for the women's fitness market. The space uses an abstract aerobics figure as well as chairs that suggest the women's symbol through the configuration of the seat and chair back. The designer's challenge was to be less sports- and training-specific, and deliver a broader message of women's fitness.

Design Firm **Nike Inc., Beaverton, OR**
Art Directors **John Farnum and Michele Melandri**
Graphic Designer **Michele Melandri**
Client **Nike, Inc.**
Fabricators **Bob Kjenslee, Photocraft, Heartwood**

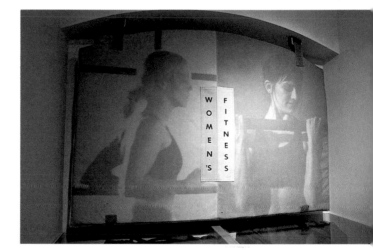

►

**Women's Pavilion
NikeTown Portland** (1995)

The women's fitness area in the Portland, Oregon, NikeTown was designed to focus on training. Design elements feature gym banners, climbing ropes, gym pads, and wooden flooring to create an authentic athletic retail environment for sports and fitness footwear and apparel.

Design Firm **Nike Inc., Beaverton, OR**
Art Directors **John Farnum and Michele Melandri**
Graphic Designer **Michele Melandri**
Client **Nike, Inc.**
Fabricators **Photocraft, Wy'east Color**

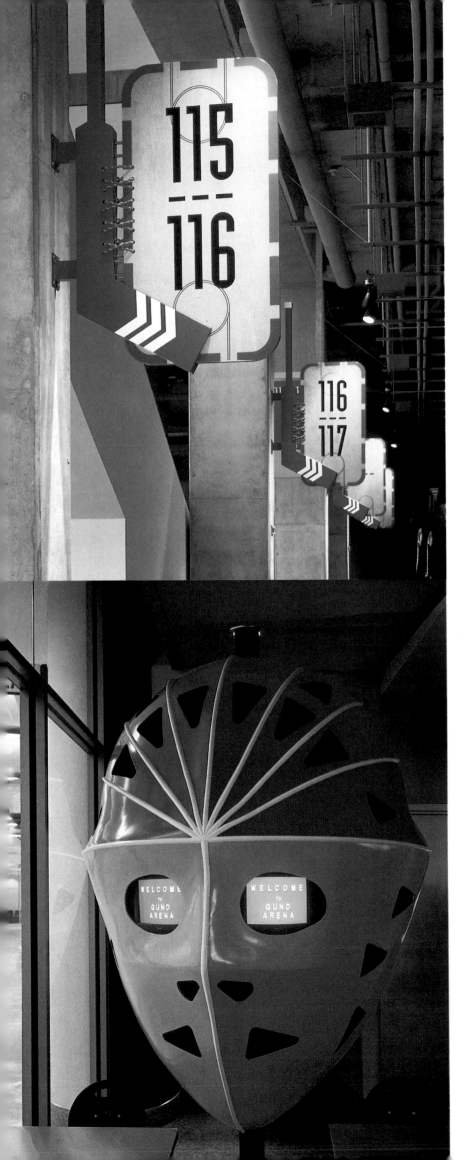

◄

Kiel Center Arena
Wayfinding Signage (1994)

This state-of-the-art sports and entertainment complex in downtown St. Louis showcases a variety of world-class events. The designers were challenged to develop graphic themes and images that would appeal to diverse audiences, from family concert-goers to avid sports enthusiasts. Accordingly, the design team developed graphics based on hockey and basketball images and materials: an oversize hockey stick and basketball court laced together form a section wayfinding signs, while real basketball leather adds a texture, pattern, and visual interest to restroom signage.

Design Firm **Kiku Obata & Company, St. Louis, MO**
Creative Director **Kiku Obata**
Graphic Designers **Amy Knopf, Patty LaTour, Tim McGinty, Kay Pangraze, Jeanna Stoll, and Heather Testa**
Photographer **Cheryl Pendleton**
Client **Kiel Center Partners**
Fabricator **AGI**

◄

Cleveland Cavaliers/Gund Arena (1994)

Sussman/Prezja's work for the Cavalier's basketball team began with graphics and interiors for their new 21,000-seat Gund Arena in downtown Cleveland, which they will share with other sports teams, entertainers, and events. This particular application is part of an overall graphic program that features floor and wall patterns, fabrics, interior color, signage, and other arena amenities, including the planning and design of a restaurant and sports bar. The designer's dynamic imagery was inspired by powerful industrial forms — lakefront bridges and factories — and the physical forms of the players and performers who will use the arena. As the project evolved, the scope of work increased: the redesign of the new team logo, a new playing floor, and team uniforms and warmup suits. The existing Cavalier's mark was reworked as a more dynamic and useful system of graphic identification.

Design Firm **Sussman/Prejza & Co., Inc., Culver City, CA**
Design Principal **Deborah Sussman**
Project Manager **Mark Nelsen**
Interiors **Fernando Vazquez**
Photographer **Timothy Hursely**
Clients **Gateway Economic Development Corp. of Greater Cleveland and Gund Investment Corp.**
Fabricator **Peter Carlson Enterprises**

NikeTown Directories (1995)

The designers' goal was to create a retail directory unique to NikeTown. They divided the store into two floors of sports-related categories. Each floor was assigned a color and each category represented by a series of interchangeable, easy-to-update athletics and fitness photos.

Design Firm **Nike Inc., Beaverton, OR**
Art Directors **John Farnum and Michele Melandri**
Graphic Designer **Michele Melandri**
Copywriter **Emily Brew**
Client **Nike, Inc.**
Typographer **Lena James**
Fabricator **Bob Kjenslee**

Kids Sign NikeTown Orange County (1995)

This sign was designed to call out the the Nike Kids in-store merchandising area. The deliberately oversized equipment suggests the activities for which Nike Kids footwear and apparel are intended. The designers purposely avoided using the traditional red, yellow, blue juvenile color palette in favor of the distinctive Nike Kids color combinations.

Design Firm **Nike Inc., Beaverton, OR**
Art Directors **John Farnum and Michele Melandri**
Graphic Designer **Michele Melandri**
Client **Nike, Inc.**
Fabricator **Bob Kjenslee**

Shea Stadium Neon Murals (1986)

Seven simple profiles — baseball players depicted in
neon — become graphic icons for seven windscreen
murals that surround Shea Stadium, home of the New
York Mets. Each figure measures approximately ninety
by sixty feet. Color activates the sense of movement
in each player's stance — the batter's swing, the field-
er's stretch, the runner's gait. The murals are fabricated
out of double neon tubing using two colors per wind-
screen. Transformers are concealed behind the wind-
screen panels. The U-channels that frame and house the
neon are painted to mirror the illumination so that the
mural's colors can be read in daylight.

Design Firm **Richard Poulin Design Group, Inc.,**
New York, NY
Art Director **Richard Poulin**
Graphic Designer **Richard Poulin**
Client **New York Mets**
Fabricator **Universal Unlimited, Inc.**

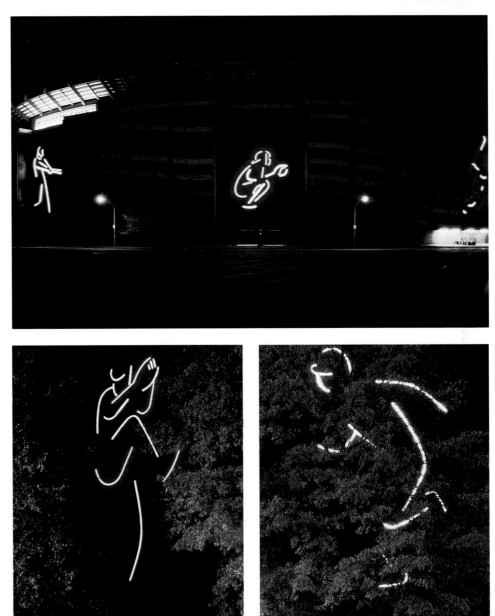

"Hit It Here" at Camden Yards (1993)

Smack in the heart of right center field at Oriole Park at Camden Yards — a stadium heralded for re-creating the intimate character of earlier ballparks — stands this sign created for Maryland's State Lottery. Calling on lottery players and baseball fans alike, the Hit it Here sign has since become a mainstay of the ballpark and remains the subject of animated conversation and friendly debate.

Design Firm **TBC Design, Baltimore, MD**
Creative Director **Allan Charles**
Art Director **Steve Bleinberger**
Copywriter **Allan Charles**
Client **Maryland Lottery**

Nike Golf Point of Purchase (1995)

This point-of-purchase display was designed for use in golf pro shops and country clubs across the nation. The structure needed to display several pairs of shoes, communicate an "air technology" consumer message, and position Nike as a leader on the green. The palette for the design and materials takes its visual cues from the game — the curve of the swing, the shape of the golf pin and cups, the texture of wood, sisal, and air from the shoes — and gives them form in the display.

Design Firm **Nike Inc., Beaverton, OR**
Art Directors **John Trotter and Jeff Weithman**
Graphic Designers **John Trotter and Jeff Weithman**
Illustrator **Chris Mc Cullick**
Copywriter **Bob Lambie**
Client **Nike, Inc.**

▲

Harajuku Environment

"Alley Hoop," located in Harajuku, Japan, combines a competitive basketball court with a retail environment. The space was designed to create energy and excitement about Nike basketball products and celebrate the game. Interior banners depict Nike athletes and tie into the court graphics. The large exterior mural highlights the attitude of streetball. The 3-D exterior banners suggest stylized basketball hoops and showcase Nike basketball stars.

Design Firm **Nike Inc., Beaverton, OR**
Art Directors **John Norman and Jeff Weithman**
Graphic Designers **John Norman and Jeff Weithman**
Illustrators **Gerald Bustamante, John Norman,**
and Ben Wong
Architect **Brad Berman**
Client **Nike, Inc.**

◄

ISPO Trade Show (1995)

ISPO is a biannual sporting goods trade show held in Munich. In 1995, Nike's corporate initiative was "Big Ideas," which suggested an exhibition design focusing on the big creative ideas behind the company's soccer, tennis, outdoor, and women's product lines. The exhibition emphasized two unique footwear designs, using them as educational tools to illustrate Nike's creative process for developing specific footwear technology.

Design Firm **Nike Inc., Beaverton, OR**
Art Directors **Greg Hoffman and John Trotter**
Graphic Designer **Greg Hoffman and John Trotter**
Photographers **Sound Images**
Copywriter **Stanley Hainsworth**
Client **Nike, Inc.**
Fabricator **Exhibits International**

San Jose Arena
Environmental Graphics (1993)

In a neutral, Modernist building, graphics add spirit and provide a colorful visual map of the facility. The designers created two layers of functional signage: one at eye level to conform with ADA codes, and a second layer overhead in anticipation of crowds that block visibility. The project includes identification and directional signage for storefronts, freestanding concessions, and portable food carts; architectural color and materials consultation; uniforms for ushers, food servers and bartenders; marketing materials, and press kits.

Design Firm **The Office of Michael Manwaring, San Anselmo, CA**
Project Designer **Michael Manwaring**
Designer **Jeff Inouye**
Clients **San Jose Redevelopment Agency and San Jose Sharks**
Fabricators **Heath & Company and Prime Signage Contractor**

Communication
Graphics

Awards

I remember a conversation I had with a friend of mine who works in the music industry. We were comparing the creative sides of our businesses and found many similarities. Both fields require a great deal of originality, long hours, pain, and enthusiasm. Later, we highlighted the contrasting margins for award-winning success. First of all, in the artistic side of the music business, you generally have to craft a hit song. It's hard enough writing the lyrics and composing the melody — then imagine creating something that millions (yes, millions) of people can connect with on a powerful emotional level. So much so, that they will buy your record and give it repeat revolutions. After this comes the second challenge ... making the music worthy of winning a Grammy. Without belittling graphic design, this sure made creating an award-winning brochure seem like child's play.

My point? We all know that design, at its highest level, is never easy. We face many pressures and endure far more emotional ups and downs than most of our friends do. However, the next time you create, and then submit your AIGA entry, remember the Paul McCartneys of this world and the climb they make.

In judging this year's AIGA *Communication Graphics* show, we began our official call by asking the entrants to submit not just their best work, but work that stood for the truth and highest level of integrity. Without exception, our judging of those entries followed the same criteria. For the most part, we agreed through consensus on the submissions that brought forward the honest elements of character and expression. It all culminated with a final decision-making process and a group review with my judging colleagues. Given the load of work we evaluated, we were still more surprised by the small but unique number of finalists that made the cut. Our judging was fair and collaborative and there probably isn't a finer group of people you could spend three days with in a closed room.

I thank Galie, Karin, Paula, Jim, and most important, you, for making this judging a truly worthwhile experience.

Dana Arnett
Chair

Call for Entry

Design
Dana Arnett, Ron Spohn,
Mike Noble,
VSA Partners, Chicago

Printing
The Bradley Printing Company

Photography
Archive Photos

Paper
Potlatch Karma, 80# Text

Dana Arnett
Paula Scher
Galie Jean-Louis
Karin Hibma
James Cross

Dana Arnett is a founding principal of VSA Partners Inc. of Chicago. He and his firm have been recognized globally by over thirty of the top-ranked competitions and professional magazines for their work in the areas of design, film, and new media. In 1994 Arnett was named to *I.D.* magazine's ID40, an international list of the forty most important people shaping design. He is a frequent guest lecturer and competition juror. Most recently, he has participated as a presenter at the Smithsonian Institution/ Graphis Series, received a Gold Medal from the Art Directors Club, and been awarded "Best of Show" in the AR100 annual report competition for three consecutive years. Among the clients that VSA serves are Arthur Andersen, Kodak, Time Warner, Harley-Davidson, and Potlatch Papers.

Paula Scher is a master of the big image who takes a bold approach to communicate subtle and monumental graphic design solutions. She has developed identity systems, promotional materials, packaging, and publication designs for clients that include *The New York Times Magazine,* the Joseph Papp Public Theater, the American Museum of Natural History, Champion International, and Ambassador Arts. Scher joined Pentagram as a partner in 1991 after building her practice and reputation at her own New York consultancy, Koppel & Scher. She has received hundreds of design awards, including four Grammy nominations from the National Association of Recording Arts and Sciences, and her work is represented in the collections of New York's Museum of Modern Art, the Zurich Poster Museum, the Denver Art Museum, and the Centre Georges Pompidou, Paris.

Galie Jean-Louis Toronto native Galie Jean-Louis is an art director, illustrator, and author. She is the design director of the *Anchorage Daily News,* which was awarded third place for design worldwide by the Society of Newspaper Design in 1995, the same year in which her innovative poster and cover designs were honored with Gold and Silver medals from the New York Art Directors Club and the Society of Publication Design. Jean-Louis is also principal of Galie Inc. and the creator and art director of the acclaimed entertainment publication *Impulse.* She has received over 250 international awards for the design and creative direction of advertising and publications. Her design work and illustrations are featured in *Graphis, Communication Arts, Print, The New York Art Directors Annual,* Society of Publication Design and Society of Newspaper Design.

G A L L E R Y

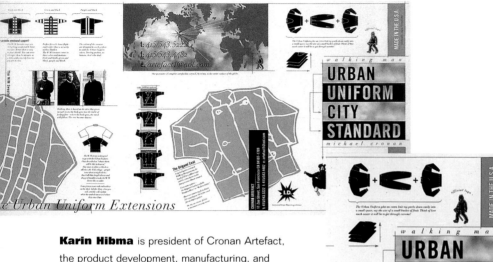

e'Urban Uniform Extensions

Karin Hibma is president of Cronan Artefact, the product development, manufacturing, and marketing company that launched Walking Man, an apparel line, designed by Michael Cronan, that won *I.D.* magazine's 1992 Consumer Product Gold Award and 1993 Honorable Mention. Hibma is also business director and chief financial officer of the design services firm Cronan Design, whose award-winning work is represented in the collections of the Library of Congress, the Smithsonian Institution, London's Victoria & Albert Museum, and the San Francisco Museum of Modern Art. Hibma is a former board director of San Francisco Women in Advertising, a current member of the AIGA, and a frequent speaker on entrepreneurial success and the business of design.

James Cross A graduate of UCLA School of Fine Art, James Cross also studied at the Chouinard Art Institute, Otis Parsons, and USC. He has taught at UCLA, Arizona State University, Maine's Portland School of Art, and the Art Center College. He has been a member of the board of directors of the AIGA and the Los Angeles Municipal Art Gallery, a trustee of the Millicent Rogers Museum in Taos, and a member of Art Center College's Design Advisory Council. Cross has also served as president of the Alliance Graphique Internationale and has lectured at numerous universities in the United States, Europe, and Japan. He was honored with the Lifetime Achievement Award from the Los Angeles Art Directors Club and is currently represented by Bobbie Greenfield Gallery.

Phaedra Poster

This poster announces a theater production of *Phaedra*. About this poster, the author states, "The elements of a Greek tragedy — blood, metamorphosis, animal passion, and fixation — are present in a way that contemporizes the myth: fragmented and recombined, uneasily bound as if it might implode." The audience is the downtown crowd of New York, and the poster was illegally sniped around the city. The power of blood to communicate viscerally commands the poster ... the type and information are all secondary.

Design Firm **Drenttel Doyle Partners, New York, NY**
Creative Director **Stephen Doyle**
Graphic Designer **Katrin Schmit-Tegge**
Printer **Red Ink Productions**
Paper **Champion Benefit**
Client **Creative Productions**

Dance 22 Poster

The objective of this poster was to publicize a dance concert, getting the attention of Hope College students and other community types through the front windows of famous places like Jim's Family Style Diner and House O'Floormats. With a piece of charcoal in one hand and a pad of tracing paper in the other, I made rubbings of letterforms to capture the spirit, energy, and motion of the dance experience. The concert director was so thrilled with the finished poster, she gave me two tickets to the concert, 87 cents off the JFSD Catch of the Day, and 15 percent off my next set of floormats.

Design Firm **Herman Miller Inc., Zeeland, MI**
Art Director **Kevin Krueger**
Graphic Designer/Illustrator **Kevin Krueger**
Printer **Herman Miller Corporate Publishing**
Paper **Consolidated Frostbrite**
Client **Hope College Dance Department**

Dance Month 1995

This poster was displayed around the city of Cambridge to generate interest among dancers and the general public about the dance events happening during the month. The front of the poster is intended to attract attention, while the reverse displays a calendar of activities. As a piece of communication, the poster first presents a purely visual experience — suggesting an abstract feeling of movement and expression — but also delivers the necessary factual information in a straightforward, organized way.

Design Firm **Visual Dialogue, Boston, MA**
Art Director **Fritz Klaetke**
Graphic Designer **Fritz Klaetke**
Photographer **Charles Barclay Reeves**
Writer **Rozann Kraus**
Printer **Pride Printers**
Paper **Champion Carnival 100# Text**
Client **Dance Complex**

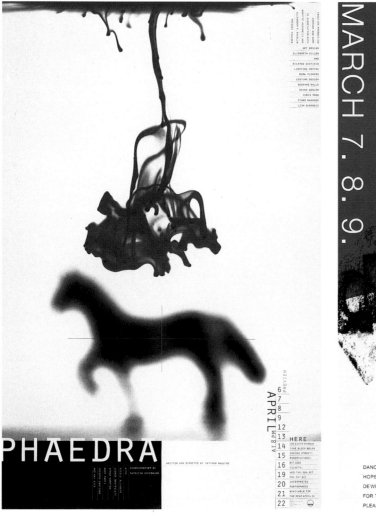

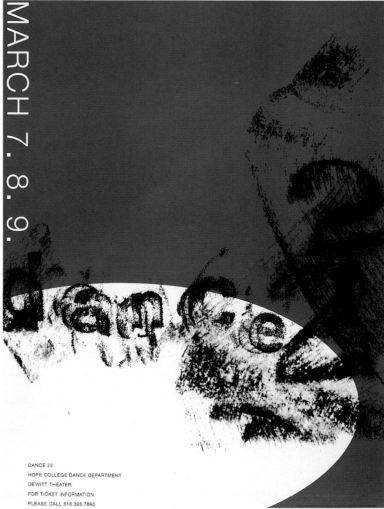

the official kick-off event:
dance-a-thon
saturday, may 6, 7:30 pm
at the dance complex
536 massachusetts avenue
central square, cambridge
it's free

for more info call (617) 547-9363

may

a month-long celebration of dance in cambridge

dance up

Artwalk NY Poster

Our objective was to promote Artwalk — a day when
artists in New York City open their studios to walking
tours, as a benefit for The Coalition for the Homeless —
via posters, brochures, and advertisements. The logo,
which is very rough and derived from the streets, is
placed over a diffused rose, a traditional metaphor for
beauty. The stark contrast between the juxtaposed
images gives all of the communications their unique
and arresting character.

Design Firm **Studio Morris, New York, NY**
Creative Director **Jeffrey Morris**
Graphic Designer **Kaoru Sato**
Writer **Doug Rosa**
Printer **Innovation Printing**
Paper **Champion Carnival**
Client **The Coalition for the Homeless**

Bumbershoot 1995

Bumbershoot is an annual Arts & Music Festival, attracting over 250,000 people on Labor Day weekend. For a ticket price of $8, you can see as many bands as humanly possible. I wanted a homemade, screen-printed poster. My intention was to reflect the fun and excitement of the event by having all the bands rain down on you!

Design Firm **Modern Dog, Seattle, WA**
Art Director **Robynne Raye**
Graphic Designer/Illustrator **Robynne Raye**
Copywriter **Terri Hiroshima**
Printer **Two Dimensions**
Paper **Neenah Classic Crest Natural**
White 65# Cover
Client **One Reel**

Central Pennsylvania 1996
Festival of the Arts

The Central Pennsylvania Festival of the Arts is an annual summer celebration of the visual and performing arts. Over the years, the poster has evolved into a commemorative item rather than an advertising piece for the festival. Because they are collectibles, the posters are made 24" x 36" so they fit a standard-size frame (and a standard sheet size, to be printed with little waste). Each of the twenty-three years I have designed the poster, I have tried to create a colorful image that spiritually relates to the vitality of the summer event and appeals to a variety of different audiences. Good clients make good design. The festival has been a wonderful client.

Design Firm **Sommese Design, State College, PA**
Art Director **Lanny Sommese**
Graphic Designer/Illustrator **Lanny Sommese**
Printer **Commercial Printing**
Paper **Mohawk Tomahawk**
Client **Central Pennsylvania Festival of the Arts**

Odysseus' Homecoming

A silkscreen poster for the showcase production of the Third New Immigrant Play Festival at the Vineyard Theatre in New York City. This is the story of an immigrant, called by the haunting voice of his wife, Penelope. He leaves his New York girlfriend, Calypso, to make a surreal odyssey back to his homeland. After a discussion with the director, Marcy Arlin, we decided to create an image showing the woman as the moving power behind Odysseus' voyage home.

Design Firm **Luba Lukova Studio, New York, NY**
Art Director **Luba Lukova**
Graphic Designer/Illustrator **Luba Lukova**
Writer **Ben-Hur Carmona**
Printer **Roseprint**
Paper **Fabriano Tiziano**
Client **Immigrants' Theatre Project**

The Bundle

A silkscreen poster for a production by the Irondale Project, an experimental Off-Broadway ensemble. *The Bundle* is an allegory of the eternal coexistence of good and evil. Strongly influenced by Bertoldt Brecht, it conveys an ideological statement, combining European, Asian, and American sensibilities.

Design Firm **Luba Lukova Studio, New York, NY**
Art Director **Luba Lukova**
Graphic Designer/Illustrator **Luba Lukova**
Writer **Edward Bond**
Printer **Rosepoint**
Paper **Splendorlux**
Client **Irondale Ensemble**

Not in My Name

A silkscreen poster for the street performances of a protest play against the death penalty. The idea came while watching the choreography during a Living Theatre rehearsal.

Design Firm **Luba Lukova Studio, New York, NY**
Art Director **Luba Lukova**
Graphic Designer/Illustrator **Luba Lukova**
Writers **Judith Malina and Hanon Reznikov**
Printer **Rosepoint**
Paper **Canson**
Client **The Living Theatre**

Anarchia

A silkscreen poster for the Italian production of the play *Anarchia*. The image was inspired by a section of the play quoting the Italian anarchist Malatesta.

Design Firm **Luba Lukova Studio, New York, NY**
Graphic Designer **Luba Lukova**
Illustrator **Luba Lukova**
Writer **Hanon Reznikov**
Printer **Rosepoint**
Paper **Kraft paper**
Client **The Living Theatre**

PUT YOUR PORTFOLIO WHERE YOUR MOUTH IS

1995 Recruitment Poster

Herman Miller has had a graphic design internship program for over ten years. We send out a poster to about sixty schools to promote this opportunity to work in the "real world." The poster has to get attention on a very low budget. To make it easier for the students, there is a tear-off pad of application forms so that the poster won't get stolen and so that they can have all the information on one piece of paper. As for the image: Some people say it's an infinity symbol, others say it's a beanie hat. You decide.

Design Firm **Herman Miller Inc., Zeeland, MI**
Art Director **Yang Kim**
Graphic Designer/Illustrator **Yang Kim**
Writers **Dick Holm and Yang Kim**
Printer **Etheridge Company**
Paper **Beckett Expressions 80# Cover — Iceberg**
Client **Herman Miller Inc.**

AIA Philip Johnson Poster

A poster commemorating Philip Johnson's award from the American Institute of Architects. The image combines Johnson's signature round glasses and the AIA initials.

Design Firm **Pentagram Design, New York, NY**
Art Director **Michael Gericke**
Graphic Designer **Michael Gericke**
Printer **Walnut Printing**
Client **American Institute of Architects, New York**

Ballet of the Dolls Nutcracker Poster

This two-color poster promotes an alternative production of *The Nutcracker.*

Design Firm **Dayton's Advertising, Minneapolis, MN**
Creative Director **Connie Soteropulos**
Graphic Designer **Jane Mueller**
Printer **Challenge Printing**
Paper **Karma**
Client **Ballet of the Dolls**

**Brooklyn Academy of Music 1995
Next Wave Festival Poster**

The Brooklyn Academy of Music's Next Wave Festival is New York's premier venue for avant-garde performance. The hand image makes the obvious pun on the festival's name. Like the festival's subjects, the type breaks boundaries.

Design Firm **Pentagram Design, New York, NY**
Art Director **Michael Bierut**
Graphic Designer **Emily Hayes**
Photographer **Timothy Greenfield-Sanders**
Printer **Ambassador Arts, Inc.**
Client **Brooklyn Academy of Music**

Q Action Poster

While very much at risk, many young gay and bisexual men in San Franciso do not believe HIV is their problem. This poster, which was displayed inside city busses, made explicit the connection between HIV and politics and thereby motivated young men to take action — both individually and as a group — to fight HIV and homophobia. The message, rich and complex, was ideal for consumption during 20-minute bus rides. While the poster was quite successful in achieving its specific goal — to attract new volunteers to Q Action, the young men's program of STOP AIDS Project — it also worked to shape the community-wide dialogue by queer men about HIV.

Design Firm **M.A.D., Sausalito, CA**
Art Directors **Erik Adigard and David Boyer**
Graphic Designer/Illustrator **Erik Adigard**
Writers **Erik Adigard and David Boyer**
Printer **NPA**
Client **Stop AIDS Project**

Ivan Chermayeff Collages 1982-1985 Corcoran Museum of Art

Ivan Chermayeff Collages
1982-1995, Corcoran Museum of Art

The collage poster for the Corcoran Museum of Art, using one of the pieces in the exhibition, recognizes that the poster is a souvenir, not to be posted but to be taken home. Hence, the headline title and the sponsor are set in 10-point type. The audience is all those who visit museums in Washington, D.C., who like my collages and choose to have one.

Design Firm **Chermayeff & Geismar Inc.,
New York, NY**
Design Director **Ivan Chermayeff**
Graphic Designer **Ivan Chermayeff**
Illustrator **Ivan Chermayeff**
Copywriters **Dore Ashton and David C. Levy**
Printer **Chroma Graphics**
Paper **LOE**
Client **Corcoran Museum of Art**

Visual Arts Museum:
The Master Series — Ivan Chermayeff

Behind the glove is a hand — writing, drawing, creating. The image is a suggestion, to students at the School of Visual Arts and others, that first comes the idea, then the execution. The invitation, poster, and catalogue are variations on a theme, using found gloves, adding color and writing rather than using type.

Design Firm **Chermayeff & Geismar Inc.,
New York, NY**
Design Director **Ivan Chermayeff**
Graphic Designer **Ivan Chermayeff**
Illustrator **Ivan Chermayeff**
Photographers **Various**
Copywriter **Ikko Tanaka**
Printer **Kenner Printing**
Paper **Mohawk Superfine**
Client **Visual Arts Museum at the School
of Visual Arts**

Tom Geismar at the Dallas Society
of Visual Communications

The audience was the Dallas graphic design community; the purpose, to announce Tom Geismar as the speaker for that month's DSVC meeting. The creative strategy was to show some major clients in a fun and interesting way. The Mobil pegasus is a well-known landmark in downtown Dallas, and it lent itself as a natural vehicle to use on the poster. The only parameters were to create a poster and not create a production monster for the low-budget project. Finally, it meant a lot to me to design a poster for a legend like Tom Geismar.

Design Firm **Peterson & Company, Dallas, TX**
Art Director **Scott Ray**
Graphic Designer **Scott Ray**
Illustrator **Melissa Grimes**
Photographer **Pete Lacker**
Copywriters **Scott Ray and John Sealander**
Printer **Color Marl**
Paper **Champion Pageantry**
Client **Dallas Society of Visual Communications**

The Master Series: Ivan Chermayeff Graphic Design: Art & Process Eighth in the series, Exhibition: October 2nd to October 20th 1995 Lecture: Thursday, October 5th, 7 pm, Museum Hours: Monday–Thursday 9 am–8 pm, Friday 9 am–5 pm Visual Arts Museum at the School of Visual Arts 209 East 23rd Street, New York, New York 10010

Michael Bierut at the Aquarium

This poster was an invitation to an AIGA-sponsored
event at the Dallas World Aquarium. New York
Pentagram partner Michael Bierut spoke about the firm
and "what it takes to keep 175 people at five offices
in three countries *afloat*." The idea of the floating type
makes a strong simple image — one that works well
as a poster.

Design Firm **Pentagram Design, Austin, TX**
Art Directors **Bill Carson and Lowell Williams**
Graphic Designers **Bill Carson and Jeff Williams**
Illustrator **Jeff Williams**
Printer **Color Dynamics**
Paper **Hopper Proterra Vellum Natural 80# Text**
Clients **AIGA/Hopper Papers**

Summertime Fun (Steve Frykholm Poster)

This poster announced a lecture by Steven Frykholm for the AIGA/Detroit chapter. The title of the lecture was "Summertime Fun," a presentation of twenty years of Frykholm's annual reports for Herman Miller. We wanted to play off the "S" in Steve and Summertime and the "F" in Frykholm and Fun. We threw in the photo of Steve because most people don't know what he looks like and can barely pronounce his name. We decided to save money by choosing a two-color solution. Champion International Paper was a co-sponsor, which made the paper selection easy.

Design Firm **Herman Miller Inc., Zeeland, MI**
Art Directors **Kevin Budelmann and Yang Kim**
Graphic Designers **Kevin Budelmann and Yang Kim**
Photographer **Michael Barile**
Writer **Kim Headbloom**
Printer **Image Masters Precision Printing**
Paper **Champion Pageantry 70# Text**
Clients **AIGA/Detroit and Champion Paper**

Art Directors Club of Houston 40th Anniversary Exhibition

The call for entries for this 40th anniversary show provided an opportunity to draw from sources as divergent as bad motel wallpaper and Modern design pioneers like Burtin and Brodovitch.

To capture the essence of period printing, artwork was produced at small scale and enlarged using a large format photocopier. On press, pressure between the blankets and cylinders was backed off to achieve the character of letterpress printing. It's not often that you can make a halftone of fake woodgrain look sophisticated. On that level, this works for me.

Design Firm **Geer Design, Inc., Houston, TX**
Art Director **Mark Geer**
Graphic Designer **Mark Geer**
Copywriter **Molly Glentzer**
Printer **The Beasley Group**
Paper **French Dur-o-Tone**
Client **Art Directors Club of Houston**

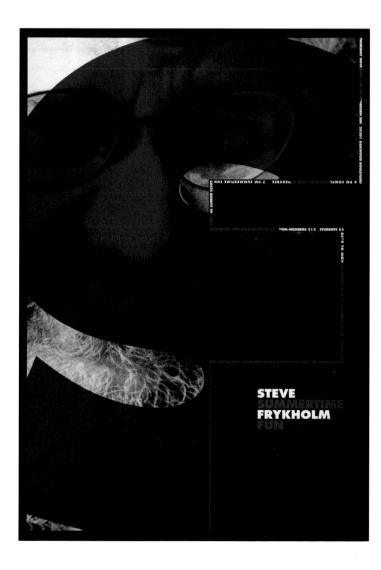

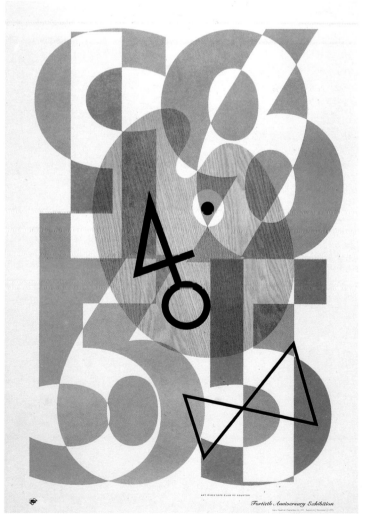

◀ OPPOSITE PAGE LEFT

Tag That Trophy Poster

This poster announced a speaking engagement
Modern Dog gave for AIGA/Portland. I enjoy this type
of work because I get to go through my collection of
outdoor life magazines and poke fun at all my relatives
back home in Montana. Gilbert paid us in paper on
another job and I got to use it on this project. They
call it "Special Brown" because the color is a mistake
but it worked perfectly, giving it that authentic "Bullet
Box" look.

Design Firm **Modern Dog, Seattle, WA**
Art Director **Coby Schultz**
Graphic Designer/Illustrator **Coby Schultz**
Copywriter **Coby Schultz**
Printer **All Print**
Paper **Gilbert "Special Brown" 80# cover**
Client **AIGA/Portland**

◀ OPPOSITE PAGE RIGHT

Gabby Shoe Card

This card was sent to celebrities in the music tele-
vision, and movie industries with a free pair of Gabby
Reece training shoes. The project had a small budget,
so only two colors could be used. I wanted to design
something with a fun, carefree mood and still talk
about product benefits.

Design Firm **Nike Design, Beaverton, OR**
Art Director **Dan Richards**
Graphic Designer/Illustrator **Dan Richards**
Writers **Laura Houston and Dan Richards**
Printer **Graphic Print Solutions**
Paper **Simpson Starwhite Vicksburg**
Client **Nike, Inc.**

1995 Black History Month Poster

The poster commemorated and celebrated Black
History Month and Coretta Scott King's arrival at Nike.
The equal sign on the front reflects the civil rights
movement and struggle for equality, while the names
coming through the background in white are of
individuals who made lasting contributions to society
and helped pave the way for the equal recognition
of African-Americans. The back of the poster lists the
names and contributions of those listed on the front.
The uncoated kraft paper and overlapping inks reflect
the many quickly printed postings and news flashes
of the day.

Design Firm **Nike Design, Beaverton, OR**
Art Director **Jeff Weithman**
Graphic Designers **Craig Barez and Jeff Weithman**
Writer **Stanley Hainsworth**
Printer **Graphic Arts Center**
Paper **Brown Kraft**
Client **Nike, Inc.**

Listen. To the empty buses roaring through the streets of
Montgomery. Listen. To the slamming of textbooks ringing
through the halls of Central High School in Little Rock.
Listen. To the cold stillness of the lunch counters in
Nashville. Listen. To the clang of barred steel in Albany.
Listen. To the frantic barking of police dogs in Birmingham.

Listen. To the whirring tires of the Freedom Riders' bus in
the Alabama night. Listen. To the muffled silence from the
voting booths in Selma. Listen. To the drum of 250,000 feet
marching down Pennsylvania Avenue. Listen. To the cry of
millions as the dream pauses in Memphis. Listen. And you will
hear the voices of the past echo in a deafening roar of freedom.

Preparing for the Competition

For the American Center of Design's annual Design Student Conference — to be held in Atlanta before the '96 Summer Olympics — the parallel was drawn between running a race to win and each student's pursuit of design excellence. To accommodate the tight production schedule, line art was chosen rather than time-consuming separations. The colors echo those of the Olympic rings, while two small icons in the corner comment ironically on the upcoming power struggle in the peach city of Atlanta. To appeal to the audience of art students overloaded with images and information, the message was kept simple.

Design Firm **Atlanta College of Art,**
Communication Design Department, Atlanta, GA
Art Director **Peter Wong**
Graphic Designer/Illustrator **Peter Wong**
Printer **Phoenix Communications Inc.**
Paper **Champion Carnival 80# White Vellum Text**
Client **American Center for Design**

Barry Sanders Poster

For the poster's audience of young men, I wanted to make the design simple and graphically strong. There was no photo shoot in the budget, so I found an NFL stock shot and converted it to black-and-white, took out the background, and cropped the shot in a dynamic way. I wanted to strike a visual balance between grit and sophistication.

Design Firm **Nike Design, Beaverton, OR**
Art Director **Dan Richards**
Graphic Designer **Dan Richards**
Photographer **Peabody**
Writer **Dan Richards**
Printer **Irwin-Hodson**
Paper **Weyerhaeuser Cougar Opaque**
Client **Nike, Inc.**

Better Than Ezra

I was asked by Moe's to design a poster for the band Better Than Ezra. Again, I was given total freedom. I was looking for cool imagery, and found this smartass kid with a bowling ball. What more can I say? He was better than Ezra!

Design Firm **Modern Dog, Seattle, WA**
Art Director **Vittorio Costarella**
Graphic Designer **Vittorio Costarella**
Printer **BSK Screen Printing**
Client **Moe Cafe**

THURSDAY ★ MARCH 16

M.O.E

MOE CAFE 925 EAST PIKE STREET SEATTLE

POSTER BY MODERN DOG. PRINTING BY BSKT

BETTER THAN EZRA

...PLUS

KATIES DIMPLES ★ THE GARDENIAS

221

◄ OPPOSITE PAGE

Blotto Studio Self-Promotional Poster

Design Firm **Blotto Studio, Miami, FL**

Creative Director **Brian M. Stauffer**

Graphic Designer/Illustrator **Brian M. Stauffer**

Printer **Continental Printing**

Paper **Newsprint**

Client **Blotto Studio**

◄ THIS PAGE TOP

1995 Best of Miami Poster

Design Firm **Blotto Studio, Miami, FL**

Art Director **Brian M. Stauffer**

Graphic Designer **Brian M. Stauffer**

Printer **Continental Printing**

Paper **Newsprint**

Publisher **New Times Newspapers**

Client **Miami New Times**

◄ THIS PAGE BOTTOM

Taste (Miami New Times Menu Guide)

Design Firm **Blotto Studio, Miami, FL**

Art Director **Brian M. Stauffer**

Graphic Designer **Brian M. Stauffer**

Printer **Continental Printing**

Paper **Newsprint**

Client/Publisher **New Times Newspapers**

1996 Black History Month Poster

The poster was designed as an educational/inspirational poster to be distributed to schools, African-American organizations, and publications across the country. There are two sides to every issue, just as there is no one correct way to look at this poster. The mirrored figure and integrated copy reflect the fact that inequalities and prejudices are a product of humanity. We are simply a reflection of how we see and treat one another.

Design Firm **Nike Design, Beaverton, OR**
Art Director **Jeff Weithman**
Graphic Designers **Craig Barez and Jeff Weithman**
Illustrator **Jeff Weithman**
Writer **Stanley Hainsworth**
Printer **Graphic Arts Center**
Paper **Brown Kraft**
Client **Nike, Inc.**

Backlash Poster

The purpose of the poster was to announce a speaking engagement on the Loyola campus by Susan Faludi, author of *Backlash*. My strategy was to capture Faludi's notion that feminism has become perceived as women's worst enemy. The more prominent a woman becomes in corporate America, the more she becomes a walking target. Due to limited time and budget, all design and prepress work were done in-house. I value this project for its ability to convey Faludi's arresting notion in a simple manner, evoking a clear reaction from passersby.

Design Firm **Loyola College in Maryland, Baltimore, MD**
Art Director **Dara Schminke**
Graphic Designer/Illustrator **Dara Schminke**
Printer **The Printing Corp. of America**
Paper **Mohawk Vellum Cream White**
Client **Gender Studies Dept., Loyola College in Maryland**

Flaming Lips Poster

I was asked by Moe's to design a quick poster for an upcoming show, *Flaming Lips*. They gave me total freedom, thank God! And this is what I came up with: a woman in an erotic pose (from an old porno mag) gave me inspiration. The final artwork was produced from a stencil and spray paint.

Design Firm **Modern Dog, Seattle, WA**
Art Director **Vittorio Costarella**
Graphic Designer/Illustrator **Vittorio Costarella**
Printer **BSK Screen Printing**
Paper **Whatever was free and on the floor!**
Client **Moe Cafe**

1. Flaming Lips
2. Archers of Loaf
3. Beatnik Film Stars

MAY 6 AND 7 $10 ADVANCE 925 EAST PIKE STREET
SEATTLE, WA.

Industrial Light and Magic Poster

This poster promoted a lecture featuring two key computer animators from Industrial Light and Magic, George Lucas's special-effects company. It uses visual cues that are taken from the design process to act as reminders of how technology affects and permeates the creative process with varying degrees of visibility.

Design Firm **Cahan & Associates, San Francisco, CA**
Art Director **Bill Cahan**
Graphic Designer/Illustrator **Michael Verdine**
Photographer **Kevin Irby**
Copywriter **Teresa Rodriguez**
Printer **Bacchus Printing**
Paper **Gilbert Esse**
Client **Creative Alliance**

UN/NYC Poster

The New York Host Committee was an organization of concerned public officials and private citizens whose mission was to coordinate various celebrations for the fiftieth anniversary of the United Nations in New York City. The UN/NYC poster was intended to acquaint the public with the fiftieth anniversary and planned events.

Design Firm **Designframe, Inc., New York, NY**
Art Director **Michael McGinn**
Graphic Designer/Illustrator **Michael McGinn**
Client **New York Host Committee**

**Sentenced to Repay:
Reform Social Security**

After recently giving birth to her first child, Trudy
Cole-Zielanski began reading about the Social Security
system's uncertain financial future. Her response:
make a poster. She photographed her daughter,
complete with Social Security card, and then ran the
picture through numerous generations of photocopying
to achieve the rough, grainy result. After printing the
poster at her own expense, she sent it to a variety
of politicians, "from the vice president on down," who
are involved in Social Security reform.

Design Firm **Trudy Cole-Zielanski Design,
Churchville, VA**
Art Director **Trudy Cole-Zielanski**
Graphic Designer **Trudy Cole-Zielanski**
Illustrator/Photographer **Trudy Cole-Zielanski**
Printer **Color Graphics, Harrisonburg, VA**

If A, Then B

This poster publicized a talk given at the Los Angeles chapter of the American Institute of Graphic Arts. Drenttel and Doyle are known for their combination of strategy and surprise. This poster expressed in a playful way the idea of analytical thinking (If A...) with an irreverent twist (you're not supposed to drill books). We're proud of this poster because the image is so evocative and slightly mysterious. The lecture was well attended and well received.

Design Firm **Drenttel Doyle Partners, New York, NY**
Creative Director **Stephen Doyle**
Graphic Designer **Stephen Doyle**
Photographer **Victor Schrager**
Printer **Donahue Printing**
Paper **S.D. Warren 60# Text, Somerset Matte**
Client **AIGA/LA**

The Music Makers

We had a small budget, but a client who was interested in exploring ideas. Public Radio International markets its products to approximately 500 affiliate stations. For a long time we had wanted to do something with a poster to make it more interactive, pull it out of two dimensions. This series of six distinctly different programs sold as a package proved to be the perfect opportunity. At a glance the overall message is conveyed. Turning over the various colored flaps reveals each of the six programs in greater detail. The most significant aspect of this piece is that it uses a device other than point size to deliver its message sequentially. And most important, it is a practical, legible communication that perfectly suited all criteria and was produced within budget.

Design Firm **Design Guys, Minneapolis, MN**
Art Director **Steven Sikora**
Graphic Designer **Richard Boynton**
Photographer **Darrell Eager**
Writer **Public Radio International**
Printer **Ideal Printing**
Fabricator **Lynn Schulte**
Paper **French Paper**
Client **Public Radio International**

1995 Atlanta Arts Festival Poster

Each year, Atlanta hosts one of the largest arts festivals in the country, exhibiting a wide range of visual and performing arts and drawing an equally diverse crowd. The poster was part of a system that was used to identify everything from a one-color parking pass to signage to sales merchandise. Working with a limited budget, we based our system on a flat yet highly recognizable color palette, with line art and typography that reflect the human side of the festival. Our emphasis was on high communication through a low-tech aesthetic.

Design Firm **Copeland Hirthler, Atlanta GA**
Creative Director **Brad Copeland**
Graphic Designer **David Butler**
Illustrator **David Butler**
Printer **Max Productions**
Paper **French Dur-o-Tone Butcher White 80#**
Client **Arts Festival Association of Atlanta, Inc.**

ARTS FESTIVAL OF ATLANTA 95

THE ARTS FESTIVAL OF ATLANTA IS PRODUCED BY THE ARTS FESTIVAL ASSOCIATION OF ATLANTA, INC. AND IS SPONSORED BY **THE CITY OF ATLANTA, **THE ATLANTA COCA-COLA BOTTLING COMPANY, **PUBLIX SUPER MARKETS, INC., **WXIA-TV 11-NEWS, **99X/WNNX, **PEACH 94.9, AND **NEWSRADIO WGST; WITH THE JOINT SUPPORT OF THE **FULTON COUNTY COMMISSION UNDER THE GUIDANCE OF THE FULTON COUNTY ARTS COUNCIL, **THE GEORGIA COUNCIL FOR THE ARTS THROUGH APPROPRIATIONS FROM **THE GEORGIA ASSEMBLY AND **THE NATIONAL ENDOWMENT FOR THE ARTS; AS WELL AS **FOUNDATION, **CORPORATE AND **INDIVIDUAL SUPPORT. PAPER: FRENCH DUR-O-TONE, BUTCHER WHITE 80 LB. COVER SUPPLIED BY MAC PAPERS. POSTER DESIGNED BY DAVID BUTLER, COPELAND HIRTHLER DESIGN + COMMUNICATIONS.

Shredded Ollie

This poster was originally designed to protest
Oliver North's 1994 campaign for the U.S. Senate.
Although freed on a technicality, North was nonetheless
convicted of lying to Congress and shredding docu-
ments. I offered this image to the Charles Robb cam-
paign — North's political opponent at the time —
but no one would return my calls. I later hired Hatch
Show Print in Nashville to letterpress-print an edition
of the poster for my own amusement.

Design Firm **BlackDog, San Anselmo, CA**
Graphic Designer **Mark Fox**
Writer **Mark Fox**
Typographer **Mark Fox**
Paper **Cheap white posterboard**
Printer **Hatch Show Print**
Client **BlackDog**

Dallas Society of Visual Communications Poster

The poster promotes two related events — a designer
jam session one evening at a local Dallas club, followed
by a design lecture two days later. The images, in com-
bination, represent the headline of the poster, while the
abbreviated text becomes decoration, as if it were a
printer's color bar.

Design Firm **Cronan Design, San Francisco, CA**
Art Director **Michael Cronan**
Graphic Designer **Michael Cronan**
Writer **Michael Cronan**
Printer **Williamson Printing**
Paper **Simpson Starwhite Vicksburg Tiara**
Client **Dallas Society of Visual Communications**

AIA Cesar Pelli Poster

This poster announced Cesar Pelli's "Buildings
& Thoughts" lecture at the Cooper-Hewitt, National
Design Museum, sponsored by the American Institute
of Architects. The image whimsically portrays one
of the architect's buildings envisioning itself as a
urban landmark (within a skyline of Pelli's buildings).

Design Firm **Pentagram Design, New York, NY**
Art Director **Michael Gericke**
Graphic Designer **Michael Gericke**
Printer **Ad Graphics**
Client **American Institute of Architects, New York**

SHREDDED OLLIE
SHREDDED OLLIE

Wed Jan 10 City Faces DSVC Lhentrfree Spnsr: Simpson Paper Nonmembs to Stu $5 MichaelCronan&KarinHibma Talking&Walking pprhoys6pm dinner 7pm Mon Jan 8 Club75 Adjam Fuzztones&Best TheAdjamBand&TheFuzztones Spnsrs:Adjam Fuzztones&SimpsonPaper CvrRck&Rll

Cesar Pelli Buildings & Thoughts Wednesday October 25, 1995 6:00 pm Cooper-Hewitt, National Design Museum

PEN Poster: "A Loss for Words"

The Canadian branch of PEN, the international writers' organization that campaigns for freedom of expression, requested a fundraising poster depicting the plight of writers who had been silenced for publishing their views. Blending illustration and photocollage, "A Loss for Words" shows someone gagged with a spool of narrative piled up, unread, inside his head. The main illustration was drawn directly onto pages from a suppressed Solzhenitsyn novel.

Design Firm **Viva Dolan Communications and Design, Toronto, Ontario**
Art Director **Frank Viva**
Graphic Designer/Illustrator **Frank Viva**
Photographer **Hill Peppard**
Writer **Doug Dolan**
Printer **Annan & Sons Lithographers**
Paper **Conqueror Bright White Wove Text**
Client **PEN Canada**

Poetry Readings Poster

For this poster, the designer avoided using a clichéd image to represent poetry, such as a quill, book, or microphone.

Design Firm **Access Factory Inc., New York, NY**
Creative Director **Alexander Gelman**
Graphic Designer **Alexander Gelman**
Illustrator **Alexander Gelman**
Printer **Mika**
Paper **Canson**
Client **Biblio's**

Slant Cowboy Poster

The intended audience of the Slant Cowboy poster was young adults, the readers of *Slant* magazine, which is published and distributed by Urban Outfitters. The theme for this issue was music. They asked for an image dealing with "cowboy music," which seemed slightly different from country or even Western music. The collage of images from singing-cowboy movie posters seemed like an appropriate expression. Limitations were one color.

Design Firm **Charles S. Anderson Design Company, Minneapolis, MN**
Art Director **Charles S. Anderson**
Graphic Designer **Charles S. Anderson**
Illustrator **CSA Archive**
Client **Urban Outfitters**

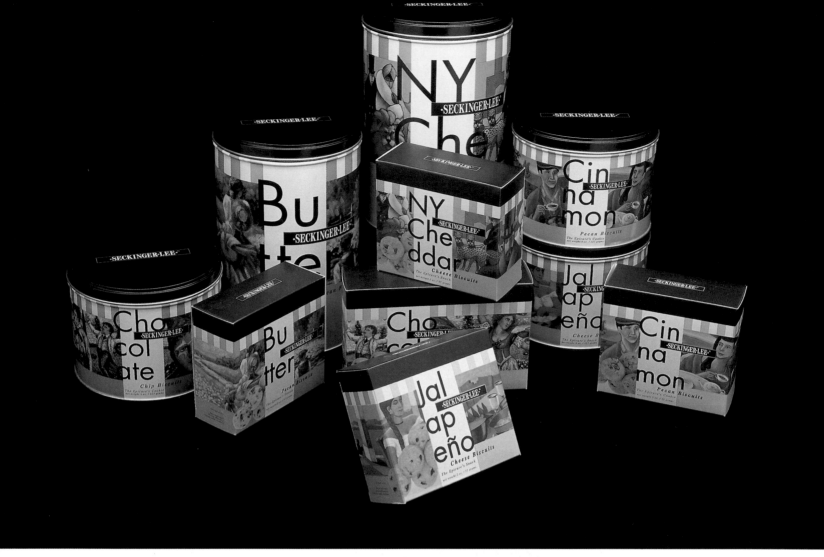

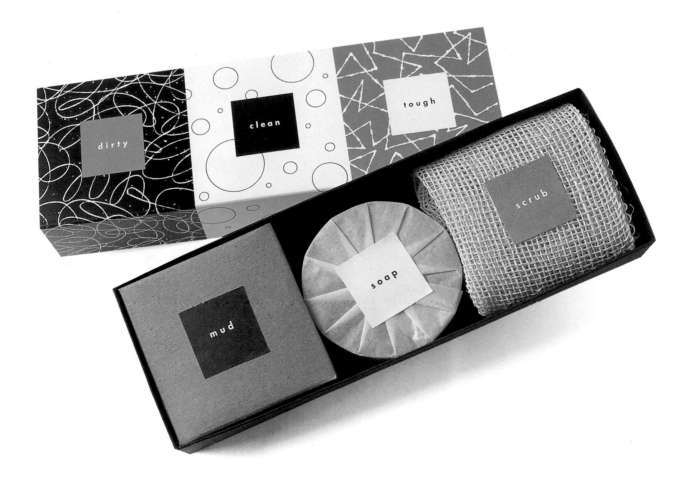

Seckinger-Lee Gourmet Cookie Packaging

Given the company's desire to place its product in upscale, high-volume retail venues like Neiman Marcus, Bloomingdale's, Barney's, and so on, our objective was to give the packaging a very elegant, tailored style. To keep the overall look the same in this family of products, but somehow convey each brand's distinctive flavor and entertainment attributes, we played up the brand name and created illustrations to suggest the dining experience of each brand. Once the packaging premiered, sales increased by 400 percent.

Design Firm **EM2 Design, Atlanta, GA**
Creative Director **Maxey Andress**
Graphic Designer **Maxey Andress**
Illustrators **Clem Bedwell, Jay Montgomery, and Lamar Smith**
Printer/Fabricators **J.L. Clark (tins), Waldorf (boxes)**
Client **Seckinger-Lee Company**

◄ BELOW

Dirty, Clean & Tough

As designers and manufacturers, we created Dirty, Clean & Tough to expand our soap line and further explore the men's personal-care market. Conservation International benefits from a portion of the proceeds of each soap sold. Although designed especially but not exclusively for men, Dirty, Clean & Tough has proven to have a wider market appeal. Its name is the absolute reflection of the product contained within the package.

Design Firm **Higashi Glaser Design, Fredericksburg, VA**
Art Directors **Byron Glaser and Sandra Higashi**
Graphic Designers **Byron Glaser, Sandra Higashi, and Jennifer Tatham**
Printer **Pohlig Brothers**
Fabricator **Zolo, Inc.**
Client **Zolo, Inc.**

Modern Dog Commercial Art Cards

Friends often ask for samples of our posters. Unfortunately, many are of limited runs because we like to screenprint and most of our clients who produce posters are in the artist entertainment fields (this means they have NO budgets!). We came up with this idea after seeing a deck of old MGM movie-poster cards while losing our money in Las Vegas. Our intention was to give them away, but because of the high production costs, we sell them also. Each card has a different Modern Dog poster on it, and is part of a limited edition of 2,500. We can't wait to do the next deck.

Design Firm **Modern Dog, Seattle, WA**
Art Directors **Robynne Raye and Michael Strassburger**
Graphic Designers/Illustrators **Vittorio Costarella and George Estrada (jokers); Michael Strassburger (package)**
Printer **Grossberg Tyler**
Fabricator **Modern Dog**
Paper **Springhill Coated**
Client **Modern Dog**

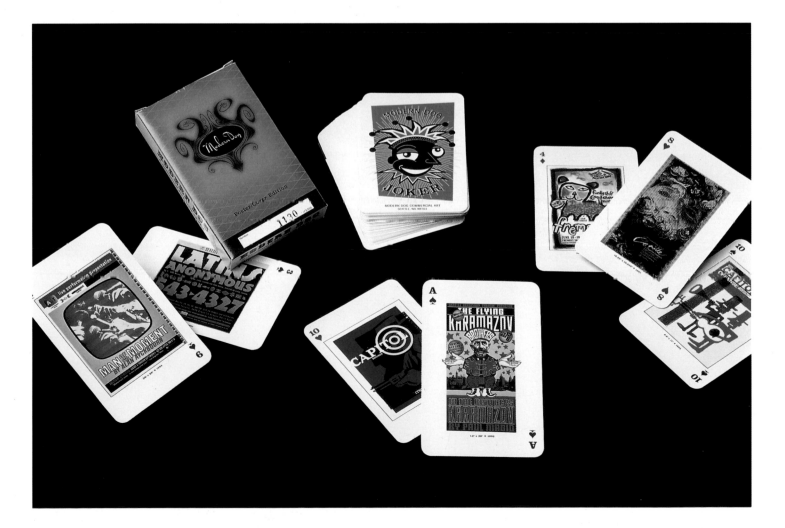

▶

Nike Corporate Packaging

We developed our new corporate packaging with
four considerations in mind: 1. Environment: 100%
recycled material, 100% recyclable, 50% inks, and no
glue. 2. Brand: Simple and direct design to launch
the Swoosh identity into retail. 3. Cost: Minimize cost.
Each penny of cost represents 1.8 million dollars a
year. 4. Strength: Make it strong to withstand the
rigors of shipping and the retail world. It's always fun
to take limiting design constraints and use them to
your advantage.

Design Firm **Nike Design, Beaverton, OR**
Art Director **Jeff Weithman**
Graphic Designers **Chris McCullick and**
Jeff Weithman
Writer **Bob Lambie**
Printer **Seattle Packaging**
Paper **E Flute**
Client **Nike, Inc.**

▶ B E L O W

Yakima Packaging

Yakima produces a dependable, high-quality roof
racking system. The first objective was to upgrade
the look of the packaging to match the value of
the products, yet keep the design simple and utilitarian
to convey the Yakima aesthetic. Second, the packaging
was designed to help the consumer with the product
features and component fitting using the icon system
for easier reference. Third, the design reinforced
Yakima's commitment to environmental responsibility
by using a high percentage of post-consumer waste
for packaging material.

Design Firm **Duffy Design, Minneapolis, MN**
Art Director **Kobe**
Graphic Designers **Jeff Johnson, Alan Leusink,**
and Kobe
Illustrator **Kobe**
Client **Yakima**

Saturn Car/USC Campus Cruiser

The car designed for the Saturn/USC Campus Crusier campaign was intended to create an awareness of the program, which offers free, safe rides anywhere on campus, twenty-four hours a day. A primarily typographic treatment, consisting of vertical and upside-down type contrasting the planes of the car, was used to create a visual impact.

Design Firm **Charles S. Anderson Design Company, Minneapolis, MN**
Art Directors **Charles S. Anderson and Todd Piper-Hauswirth**
Graphic Designer **Todd Piper-Hauswirth**
Illustrator **Erik Johnson**
Client **Saturn**

Vans Sandals Box

Vans was introducing a new product (sandals) and wanted cost-effective packaging. The packaging concept was developed around the quirkiness of the sandal. Bulky graphics, fun and uninhibited seasonal photography, colors that reflect the earth-tone palette of the sandals, and a theme of casualness gave the box an attitude of its own. For the printing we used an existing box die, and crashed it two-color on kraft, allowing for fun imperfections to appear.

Design Firms **DGWB Advertising/Jeff Labbé Design, San Francisco, CA**
Creative Director **Wade Kaniakowsky**
Art Director **Jeff Labbé**
Graphic Designer/Illustrator **Jeff Labbé**
Photographer **Kimball Hall/Stock**
Printer **Scope Packaging**
Client **Vans Shoes, Inc.**

The Super Market Viewmaster

This self-promotion pokes fun at the idea of cutting-edge technology by using a pop-culture icon to display our work. It is sent to existing and potential clients to (re)introduce them to The Super Market, a marketing, advertising, and design firm. The use of rough one-color type on corrugated board is a juxtaposition to the high-tech "disk" the recipient may expect to see inside. While many design firms are sending out floppies and CD-ROM, this decidedly low-tech "disk" provides an amusing and nostalgic vehicle to present our portfolio.

Design Firm **The Super Market,
East Longmeadow, MA**
Art Director **David Cecchi**
Graphic Designer **David Cecchi**
Photographer **David Ryan**
Copywriter **David Cecchi**
Printer/Packaging **Mt. Tom Box**
Fabricator **Tyco Viewmaster**
Paper **B. Flute Corrugated**
Client **The Super Market**

Alcatraz Ale Packaging

The bottle was designed to look as if it were produced in Alcatraz Penitentiary by the prisoners themselves. Its overall metallic coating and regimental typography help distinguish it from the many other beer products on the grocery shelf.

Design Firm **Cahan & Associates, San Francisco, CA**
Art Director **Bill Cahan**
Graphic Designer **Sharrie Brooks**
Client **Boisset USA**

CSA Archive Zippo Lighters

The CSA Archive product collection was created to give its audience of designers and advertisers an idea of the enormous variety of possible applications of the historical and original images in the CSA archive catalogue of stock art. The metal corners, felt insert, and rough chipboard used in the limited-edition collector's box were intended to create a textural contrast to the slick, brushed stainless-steel Zippos.

Design Firm **Charles S. Anderson Design Company,
Minneapolis, MN**
Art Director **Charles S. Anderson**
Graphic Designers **Charles S. Anderson, Erik
Johnson, and Joel Templin**
Illustrator **CSA Archive**
Copywriter **Lisa Pemrick**
Printer **KEA Inc.**
Paper **French Dur-o-Tone White Newsprint**
Client **CSA Archive**

Simpson NEO Paper Promotion

This annual publication is more than a paper promotion. It is a thoughtful look at some of the topics that are important to the design community as a whole. It covers individuals and subjects that include architecture, photography, music, and film.

Design Firm **A Design Collaborative, Seattle WA**
Art Directors **Dave Mason and John Van Dyke**
Graphic Designers **Dave Mason and John Van Dyke**
Illustrator **Wendy Wortsman**
Photographers **Various**
Writers **Steve Astle, Delphine Hirasuna,**
and Peggy Roalf
Printer **H. MacDonald Printing**
Paper **Various**
Client **Simpson Paper Company**

Weyerhaeuser Route 66 Brochure

The Traveler's Guide to Route 66 is the third in Weyerhaeuser Paper's series entitled "American Artifacts." The audience is graphic designers, art directors, and printers. The intended use of the promotional brochure is to stimulate ideas and demonstrate the qualities of Weyerhaeuser's Cougar Opaque paper through myriad printing processes. The subject matter offers an entertaining glimpse at America's most legendary highway and the unique culture and iconography surrounding it.

Design Firm **Sibley/Peteet Design, Dallas, TX**
Art Director **Don Sibley**
Graphic Designers **Donna Aldridge and Don Sibley**
Illustrators **Gerald Bustamante, Andy Dearwater, John Kleber, and Ed Mell**
Photographers **Dorothea Lange, William Lesch, Dick Patrick, Ron Sanford, and Quinta Scott**
Writer **Don Sibley**
Printer **AZ Dryography**
Paper **Weyerhaeuser Cougar Opaque**
Client **Weyerhaeuser Paper Company**

Simpson Paper "Tools of the Trade #2: Photography" Promotion

Each edition of this series focuses on an artist's medium and is printed on the most appropriate Simpson paper. As part of the company's larger "Tools of the Trade" campaign, the photography book is an effective, easy-to-use reference guide as well as a beautiful promotional piece.

Design Firm **Pentagram Design, New York, NY**
Art Directors **John Klotnia and Woody Pirtle**
Graphic Designers **John Klotnia and Ivette Montes de Oca**
Photographers **Various**
Copywriter **Peggy Roalf**
Printer **MacDonald Printing**
Paper **Simpson Starwhite Vicksburg**
Client **Simpson Paper Company**

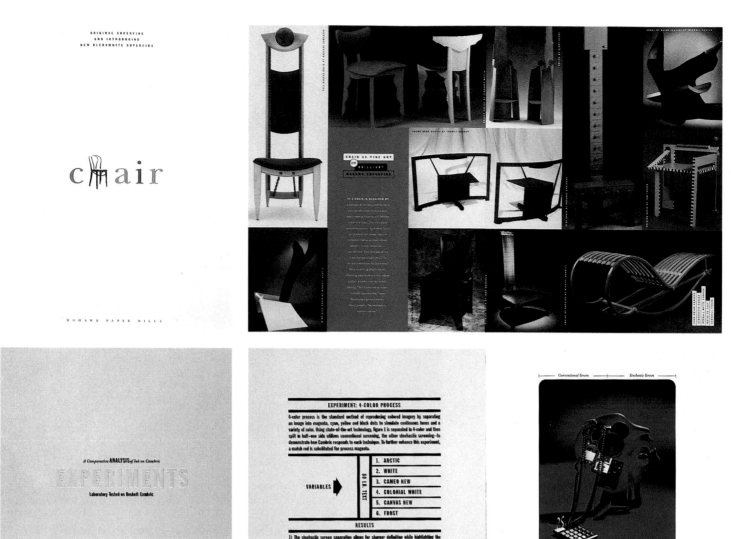

Mohawk "Chair" Promotion

Mohawk Superfine is the most beautiful white uncoated paper in the world. It lacks many of the characteristics of uncoated texts and covers that make them easy and interesting to promote: colors, pronounced texture, and so forth. Ubiquitous, elegant, and utilitarian, the chair was chosen as a subject for this piece, which relaunched Superfine after years of dormancy. We worked especially hard to make the content interesting, funny, and memorable.

Design Firm **Pentagram Design, New York, NY**
Art Director **Michael Bierut**
Graphic Designer **Esther Bridavsky**
Illustrators/Photographers **Various**
Copywriter **Sam Angeloff**
Printer **Heritage Press**
Paper **Mohawk Superfine**
Client **Mohawk Paper Mills**

Experiments

This promotion was specifically geared toward an audience of designers, printers, and print buyers. The parameters, much like any paper promotion, included the need to show how the paper performs as well as enhances many potential project specifications from halftone to four-color process, from line art to stochastic screen printing. We feel that the strength of this project is its reference to the history, attitude, and eccentricity inherent in the product itself.

Design Firm **VSA Partners, Chicago, IL**
Art Director **James Koval**
Graphic Designer **Steven Ryan**
Photographer **Paul Elledge**
Writer **Mike Noble**
Printer **Active Graphics**
Paper **Beckett Cambric**
Client **Beckett Paper**

Monadnock Revue Recycled

The piece was created as a paper promotion and printing demonstration for Revue, a premium recycled paper, and to introduce a new 100% post-consumer-waste paper. The brochure was designed for the most efficient use of a 25" x 38" sheet of paper with minimum amount of waste. Images of nature through the seasons, accompanied by relevant poetry and prose, link the natural cycle of regeneration to the process of recycling. We hoped that by providing helpful information and beautiful images, we would create a useful paper promotion that would perhaps be saved and not added to the world's overflowing landfills.

Design Firm **Pollard Design, East Hartland, CT**
Graphic Designers **Adrienne Pollard and Jeff Pollard**
Photographer **Kathryn Kleinman**
Writer **Adrienne Pollard**
Printer **Allied Printing Services**
Paper **Monadnock Revue Recycled**
Client **Monadnock Paper Mills**

"WE LEARN FROM OUR GARDENS TO DEAL WITH THE MOST URGENT QUESTION OF THE TIME: HOW MUCH IS ENOUGH?" ∾ WENDELL BERRY

Recycling is one element of a

multi-faceted and integrated environmental strategy — a joint

public/private cooperative effort for reducing solid waste globally.

The use of post-consumer waste fiber contributes significantly to

the reduction of the solid waste stream burdening world landfills.

In 1990, the U.S. paper industry set a goal to recover 40% of the

nation's used paper fiber by 1995. By the end of 1994, 41% of all paper

used in the United States was recovered for recycling and reuse, fully

one year ahead of schedule. Now a new goal has been set: to recover

50% of all paper and board (about 50 million tons) by the year 2000.

Monadnock Paper Mills is committed to helping achieve this goal.

Response 10 Brochure

This is a self-contained direct mail brochure, used by Herman Miller dealers in their local markets. Targeted to small and mid-size businesses — an audience that is less familiar with the complexities of contract furniture — it is designed and written to be simple and catalogue-like, yet still communicate the breadth of Herman Miller's product line: systems furniture packages, chairs, storage products, and fabric and finish options. Though color photography was needed to show products in realistic contexts, the cost to the dealer had to be under one dollar.

Design Firm **Herman Miller Inc., Zeeland, MI**
Art Director **Kevin Budelmann**
Graphic Designer **Kevin Budelmann**
Illustrator **Gould Design**
Photographers **Nick Merrick, Jim TerKeurst, and Herman Miller Archives**
Writers **Nancy Nordstrom and Julie Ridl**
Printer **Etheridge Company**
Paper **Simpson Satinkote 70# Text and 65# Cover**
Client **Herman Miller Inc.**

Robert Talbott Style Brochure 1996

This direct-mail brochure was developed to position Robert Talbott men's furnishings and neckties to an existing client base as well as new, younger clients. Images of the product were used in relation to other fine things of quality as reference point for value, such as fine cognac, antique furniture, elegant cigars, and so on.

Design Firm **Vanderbyl Design, San Francisco, CA**
Art Director **Michael Vanderbyl**
Graphic Designers **Karin Myint and Michael Vanderbyl**
Photographer **David Peterson**
Writer **Penny Benda**
Printer **Campbell Group**
Paper **Mead Signature Satin and Dull 80# Cover**
Client **Robert Talbott, Inc.**

▶ BELOW
Ceci N'est Pas un Catalogue

(This Is Not a Catalogue)

This is a collection of conceptual products and a satire of "designer"-oriented merchandise and catalogues. The primary audience was graphic and industrial designers and the principal theme was: "The more you know, the less you need." The piece was printed with the Indigo Digital Press, which requires no film or plates.

Design Firm **Bielenberg Design, Boulder, CO**
Creative Director **John Bielenberg**
Graphic Designers **John Bielenberg and Chuck Denison**
Contributors **Various**
Printer **D & K Printing (Indigo Digital Press)**
Paper **Warren Lustro Dull 100# Text**
Client **Virtual Telemetrix, Inc.**

RESPONSE 10™ PROGRAM

Out our door 10 days after you place your order

FROM HERMAN MILLER

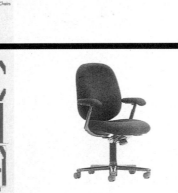

ERGON 3 CHAIRS

This is the latest advancement of the Ergon® chair, the very first ergonomic work chair, designed by Bill Stumpf and introduced in 1976. Ergon chairs have supported millions of office workers around the world. And now Ergon 3 chairs build in greater performance with enhancements that help meet the needs of an evermore diverse work force. Three sizes of Ergon 3 chairs support a broad range of physical types–large and small, tall and short, male and female. New sizes, adjustable arms, and other features enhance the chair recognized for its familiar profile of thick, waterfall cushions.

Work Chair Options

Three sizes: a, b, or c
Knee tilt with or without forward angle adjustment
Back angle or no back angle adjustment

Adjustable arms, fixed arms, or no arms
Hard casters for use on carpet or soft casters for use on hard floors

Time passes, but always we are faithful to beauty, true to real elegance and luxury. We want to have the best, to make the finest things our own. We wish to live simply and well, among objects that answer our passion for things of quality, for sumptuous materials and deft craftsmanship. Among such objects of value, Robert Talbott neckties and shirts are classics of masculine elegance. Without apology, luxurious. Without reservation, the finest expression of the textile artisan's skill and the designer's art. The collection bespeaks not only a certain refinement of taste in its handsome patterns and weaves, but an attention to detail that adds up to perfection. Neckties and shirts that look and feel quite extraordinary.

CECI N'EST PAS
UN CATALOGUE

MR. MUZZLE™

It's a universal problem: what to give the religious or political zealot that has everything? Oops, think again—he already received those surface-to-air missiles and night vision goggles last high holy day! Give him something he'll thank you for years later, and the rest of us will thank you for right away: Mr. Muzzle! Unlike other muzzles which may restrict constitutionally guaranteed speech, Mr. Muzzle still allows your zealot to snarl, whine, and gnash his teeth to his heart's desire—while nonetheless preventing him from accosting his fellow taxpayers. Please specify your Mr. Muzzle model by name when ordering. For small zealots, we suggest the BlowHard; for medium-sized zealots, try the GasBag; if your zealot has a particularly fat head, ask for the Newt. *Mr. Muzzle: Striving to make the intolerant tolerable.*™

$29⁹⁵

(Catalogue No.)
B761924

PASTA FLATWARE

Mangia! Finish your steaming plate of fettucini alfredo and then eat your utensils. Organic recycling at its best. Available in both spaghetti and linguini, regular or new zesty pesto flavor.

$2⁹⁵/set

(Catalogue No.)
TY320325
Greg & Pat Samata
Photo by
Pete Grannis

1995-96 K2 Snowboards 'Zine

The problem presented to us by our client, K2, was "a ton of information and products with a tiny budget." Our solution was this low-budget, basement art 'zine. We had a lot of fun working on it and snowboarders liked it too. The riders consider themselves out of the mainstream and this piece had to reflect that attitude.

Design Firm **Modern Dog, Seattle, WA**
Creative Directors **Brent, Hayley, & Luke**
Graphic Designers/Illustrators
Vittorio Costarella, George Estrada,
Robynne Raye, and Michael Strassburger
Photographers **Jimmy Clarke, Jeff Curtes,**
Reuben Sanchez, and Aarron Sedway
Copywriters **Mike, Robynne, Vito, George,**
Hayley, Brent, & Luke
Printer **Valco**
Paper **Simpson Evergreen Matte**
Client **K2 Snowboards**

◄ BELOW

EON Portable Performance Series User's Guide

The user's guide developed for the JBL EON line is a triumph of condensation and simplification. Rather than creating thirty separate guides (six different products described in five languages), one user guide was developed that contains information about all the products in five different languages. More than 100 pages of technical and user information were consolidated into 28 pages. The layout, graphics, and typeface reflect a high-tech yet friendly feel. The text and visual step-by-step representations are simple and direct, to enhance understanding on the part of the consumer.

Design Firm **Fitch, Inc., Boston, MA**
Art Director **Jeff Pacione**
Graphic Designers **Kate Murphy and Art Tran**
Illustrator **Francis Cozza**
Photographers **Glen Cramer, John Shotwell,**
and Mark Steele
Writer **Mark Henson**
Production **Patrick Newbery**
Client **JBL Professional**

Urban Outfitters 1995 Fall Product List

The 1995 Urban Outfitters Fall Product List is designed to suggest a printer's makeready sheet in size, structure, and technique. Black-and-white lifestyle shots randomly overlap spot colors derived from an old industrial catalogue. The mix of elements reflects the Urban Outfitters approach to retail fashion: a mix of old and new, raw and refined. The Fall Product List, the only national advertisement used by the company each year, is inserted into campus and weekly papers and targets the college-age market. It works as a price sheet and an image piece, bringing its audience into the stores.

Design Firm **Charles S. Anderson Design Company, Minneapolis, MN**
Art Directors **Charles S. Anderson and Howard Brown**
Graphic Designer **Erik Johnson**
Photographers **Charles Peterson and Rex Rysted**
Copywriter **Lisa Pemrick**
Printer **Litho Inc.**
Paper **French Dur-o-Tone White Newsprint**
Client **Urban Outfitters**

"I Liked Core. I learned to become confident in basic things like making a line." Nat Parsons, Painting

core

california college of arts and crafts

U C L A EXTENSION

WINTER QUARTER BEGINS
JANUARY 6TH
1996

◄

The California College of
Arts and Crafts View Book

The view book for the California College of Arts and Crafts was designed for students as a mosaic that reflects the institution and allows them to imagine their own potential. It presents the school's two campuses and the diversity of the art — everything from conceptual to multimedia art to block printing — that is practiced there. The richness of the institution was expressed through juxtapositions of texts and images, lending meaning to elements in proximity. It was also a goal to make the design of the catalogue subservient to the artwork it presents.

Design Firm **Cronan Design, San Francisco, CA**
Art Director **Michael Cronan**
Graphic Designers **Tripp Badger, Michael Cronan,
Regan Gradet, Lisa Smedley, Geordie Stephens,
Lisa Van Zandt, and Anthony Yell**
Illustrators **Michael Cronan and Geordie Stephens**
Photographers **Michael Cronan, Neil Hoffman,
and Joel Puliatti**
Writer **Penny Benda**
Printer **Diversified Graphics, Inc.**
Paper **Potlatch Mountie Matte**
Client **California College of Arts and Crafts**

◄ B E L O W

UCLA Extension Program Course Catalogue

The month of January was named for the ancient Roman god Janus, who traditionally looks back on the past year and forward to the new one. The two opposite faces of Janus are appropriate images to symbolize the Winter Quarter as it begins on the threshold of the new year.

Design Firm **George Tscherny, Inc., New York, NY**
Creative Director **InJu Sturgeon**
Graphic Designer **George Tscherny**
Illustrator **George Tscherny**
Printer **Trend Offset Printing**
Color Separator **Sandy Alexander, Inc.**
Client **UCLA Extension**

▼

The Future Today

The goal of this brochure was to attract professionals to a series of lectures by well-known people in advertising and design. It takes the series theme ("Where are advertising and design headed?") and gives it an ironic spin, creating a crank-prophet figure to announce the event in apocalyptic terms. The text within is clean and classically simple, with just the odd typographic joke.

Design Firm **Viva Dolan Communications and Design,
Toronto, Ontario**
Art Director **Frank Viva**
Graphic Designer/Illustrator **Frank Viva**
Writer **Doug Dolan**
Printer **Arthurs Jones Lithographing Ltd.**
Paper **Conqueror Diamond White Velvet 80# Cover**
Client **The Advertising and Design Club of Canada**

▼

Communications in the Age of
MTV and Even Emptier Promises

The audience was potential Kilter clients and, to a
lesser extent, potential employees. Rather than boast-
ing, the brochure attempts to demonstrate our capa-
bilities and exemplify our point of difference: design-
driven communication. In some ways, the most challeng-
ing aspect of this project was the lack of parameters.
We were not limited to a size or a number of colors
(we eventually used ten). We think highly of the piece
because it blends rational argument and emotional
images and integrates strategy, copy, and design in
a way that distinguishes us from traditional agencies.

Design Firm **Kilter Incorporated, Minneapolis, MN**
Creative Director **Cynthia Knox**
Art Director **David Richardson**
Graphic Designer **David Richardson**
Illustrator **Joelle Nelson**
Photographer **Bob McNamara**
Separations and Printing **Maximum Graphics**
Paper **Consolidated Centura Plus**
Client **Kilter Incorporated**

▼

Council of Fashion Designers of
America 1995 Awards Gala Journal

This brochure is distributed at the annual awards gala
of the Council of Fashion Designers of America. It
is meant to offer the winners a tribute more permanent
than the evening's presentation. The challenge is to
make an appropriate holder for so many stylish subjects.

Design Firm **Pentagram Design, New York, NY**
Art Director **Michael Bierut**
Graphic Designer **Lisa Anderson**
Photographers **Various**
Copywriters **Various**
Printer **Finlay Brothers**
Paper **Mohawk Superfine Ultrawhite, 80# Text
and Cover, Eggshell Finish**
Client **Council of Fashion Designers of America**

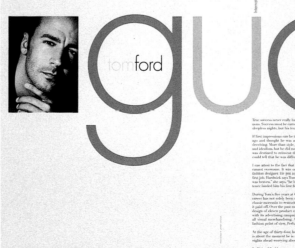

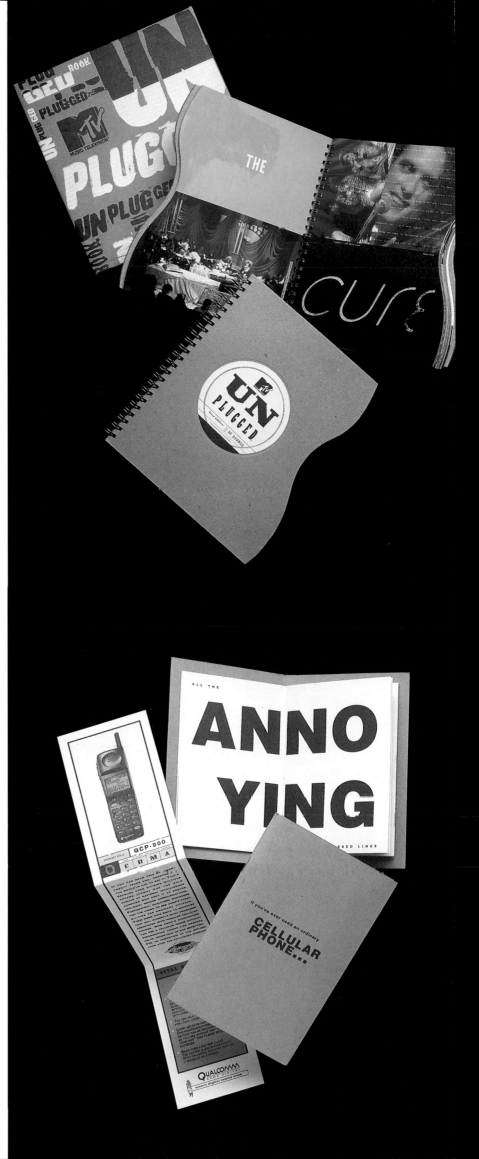

The Unplugged Book

How do you infuse a coffee-table book with the emotion and content of a popular television program featuring over seventy unique artists ... successfully? I was also stuck with a pre-formed aesthetic of the "Unplugged" show, which had become vernacular. People were using the term "un" to mean everything not uptight, high-tech, or pretentious. My initial solutions involved discovering semiotic meaning in "un," and ascribing it literally with a unique shape, typefaces, materials, colors, and visual textures, while remaining true to the popular notion of "un." Of course, liberties were taken with the style of delivery.

Design Firm **MTV Off-Air Creative, New York, NY**
Creative Director **Jeffrey Keyton**
Graphic Designer **Christopher Davis**

QCP 800 Brochure

Qualcomm Inc. wanted to tell the world that they were the developers of CDMA technology and sell a new product that uses this technology: the QCP 800 cellular phone. The creative path we took was to educate the public on the fundamental difference in performance between analog and digital phones. The look and "government" feel of the piece arose from of the history of CDMA technology, which was used by American spies in the 1940s. We printed most of the brochure with black. Various French Paper stocks acted as additional colors.

Design Firms **DGWB Advertising/Jeff Labbé Design, San Francisco, CA**
Creative Directors **Felipé Bascope and Jon Gothold**
Art Director **Jeff Labbé**
Graphic Designers **Jeff Labbé and Marilyn Louthan**
Illustrator **Charles Spencer Anderson Design Co.**
Photographer **Kimball Hall**
Copywriters **Ed Crayton, Chris Cruttenden, and Eric Springer**
Printer **Calsonic, Inc.**
Paper **French Dur-o-Tone Newsprint Aged**
Client **Qualcomm Inc.**

Outstanding in their field

The staff at B&R's office in Beaune know their way
around Europe, including the nearby Burgundy vineyards
(a few skipped our photo and headed right to the cellar).
Having lived and worked in France for three decades,
we know the value of a home base from which to scout
trips, make local contacts, maintain the bike fleet,
coordinate van support and arrange every detail.

Our springtime ride winds through a series of whitewashed hill towns.

Every spring we take our bikes to this sun-drenched corner of southern Spain
and ride among whitewashed villages, Roman ruins, Baroque churches and a
fascinating architectural legacy reflecting 700 years of Moorish domination.
Our easygoing route follows country roads and cobbled village streets
between the fascinating towns of Cordoba and Sevilla, exploring a quiet,
rural landscape that has resisted the intrusions of modern life and where the
afternoon *siesta* is still a way of life. Come to Andalucia and savour the *paella*,
gazpacho and every known *tapa* while basking in sunshine, listening to
Flamenco or simply admiring the views from a sunlit terrace.

BIKING
under the sun
in southern Spain

ANDALUCIA CLASSIC BIKING
8 DAYS / 7 NIGHTS
US$2,975 ($370 single supplement)

Rendezvous in Cordoba, site of the Great Mosque. After
a tour of the military equestrian stable at Las Turquillas,
a warm-up ride through olive groves to Ecija. "City of
Towers." Explore Baroque churches, Renaissance palaces
and the fountain of the Plaza de España. Back to the sim-
ple ambience of family-run **Hotel Plateria**. Cycle on
toward the rugged Sierra Morena range, riding into the
foothills near Puebla de los Infantes for a paella lunch.
Our hotel in Palma del Rio is the unique **Hospederia de
San Francisco**, a former 15thC monastery.

To the Cortijo Moreno estate for equestrian demonstra-
tions, then to Carmona, with its Roman necropolis,
Moorish castle and Mudejar palaces. The hotel **Parador
Nacional de Carmona**, a former palace of King Don
Pedro I, is perched on a hilltop with incredible views
toward Sevilla. Cycle through fragrant orange groves for
a fiesta at **Hotel El Cortijo Aguila Real**, an elegant estate.
Another ride through rich farmland around Sevilla, then
back for an exhibition in the hotel's private bull ring. Last
morning, by private coach to Sevilla.

Andalucia

43

▲

**Butterfield and Robinson Europe
'96 Trip Catalogue**

The catalogue is the main vehicle by which B & R
sells its upscale biking and walking trips. Clients
expect a visually striking, elegantly produced, well
written and organized brochure, reflecting B & R's
reputation for quality and attention to detail. An arrest-
ing cover photo of a farmer replaces the more pre-
dictable biker or walker. Inside, a series of trip pages,
hierarchically complex yet accessible, are counter-
pointed by theme photographs — an art-directed
"spine" to unify a hodgepodge of stock and in-house
photography. A gallery of whimsical illustrations gives
added unity to the book.

Design Firm **Viva Dolan Communications
and Design, Toronto, Ontario**
Art Director **Frank Viva**
Graphic Designer/Illustrator **Frank Viva**
Photographers **Patrick Harbron,
Amy Hewichon, MacDuff Everton**
Writer **Doug Dolan**
Printer **Arthurs Jones Inc.**
Client **Butterfield and Robinson**

▼

Louie

Style magazine published biannually by Louis, Boston. Articles focus on menswear as well as the changing attitude toward fashion in America in the nineties.

Design Firm **Tyler Smith, Providence, RI**
Art Director **Tyler Smith**
Photographers **Various**
Writers **Various**
Printer **Universal Press**
Paper **Mead Signature**
Client **Louis, Boston**

▼

Double Take Magazine, Premiere Issue: Summer 1995

DoubleTake is a general-interest magazine, the result of physician Robert Coles and photographer Alex Harris's shared commitment to the documentary tradition. This quarterly seeks to render the lives of individuals and communities through photography, reportage, essays, fiction, and poetry. Recognizing that photography and writing each have narrative and explorative capabilities, the work of writers and photographers is presented on equal footing. The simplicity of its design and the craftsmanship of its printing complete a collaborative process to present the clearest, most faithful reproduction of the work at hand.

Graphic Designer **Molly Renda**
Photographers **Various**
Writers **Various**
Printer **Harper Prints, Inc.**
Paper **Repap Lithofect Plus**
Publisher **Center for Documentary Studies at Duke University**

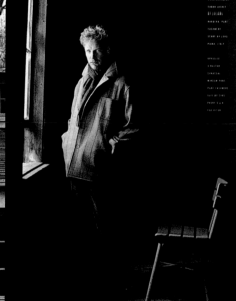

You are cordially invited to the wedding

of *Azita*, daughter of Yousef and

Manigeh Panahpour, and *Babak*,

son of Kourosh and Aghdass Farzami,

on Saturday, 14 October 1995, at 8pm.

The Tower Room, Equitable Tower, 787

Seventh Avenue, at 51st Street, New York City

*M*_____

_____ Will not attend

_____ Will attend

The favor of your response is requested by September 8, 1995

Wedding Invitation

This invitation was designed to tell the story of how the bride and groom met, as well as invite the guests to become a part of their love story. The hardcover format gave the narrative the solid, everlasting presence it deserved. It demonstrates excellence in communication graphics because of its uniqueness in the category. It also became a piece that people kept and shared with others.

Design Firm **Panahpour & Partners, New York, NY**
Art Director **Azita Panahpour**
Graphic Designer **Azita Panahpour**
Photographer **Babak Farzami**
Writers **Chris D'Rozario and Azita Panahpour**
Printer **Studio 8**
Fabricator **Panahpour & Partners**
Paper **Hammermill**
Client **Babak Farzami, Azita Pamaphour, and Families**

SoHo with Dick and Jane

SoHo with Dick and Jane is the second in the Dick and Jane primer series. The series was created to educate designers about technology in an accessible manner and to also to associate that technology with Gilbert Paper. With the design audience in mind, the books are whimsically educational, yet sophisticated. Visually and strategically the design was innovative and effective, with crossover appeal to those in all facets of communication graphics.

Design Firm **The Valentine Group, New York, NY**
Art Director **Robert Valentine**
Graphic Designers **Jim Chung and Pamela Hunt Thomas**
Illustrator **Jessie Hartland**
Copywriters **Jessie Hartland and Robin Williams**
Printer **Canfield Printing**
Paper **Gilbert Oxford 80# White, Text and Cover**

Ivan Chermayeff Collages 1982-1995, Corcoran Museum of Art

Design Firm **Chermayeff & Geismar Inc., New York, NY**
Design Director **Ivan Chermayeff**
Graphic Designer **Ivan Chermayeff**
Illustrator **Ivan Chermayeff**
Copywriters **Dore Ashton and David C. Levy**
Printer **Chroma Graphics**
Paper **LOE**
Client **Corcoran Museum of Art**

24 **Tomato** *1993 30¼ x 22¼*

25 **Black Lady** *1995 30 x 22*

Storm F.I.T. Waterproof Invitation

This piece invited journalists to a press conference announcing Nike's new Storm F.I.T. fabric. The press conference was held inside the penguin house at the local zoo. I wanted to design the invitation to be intriguing enough not to be thrown away. I had fun with the obvious tie-in to the penguin house. The quantity of th project was low enough that the invitation could be hand-assembled.

Design Firm **Nike Design, Beaverton, OR**
Art Director **Dan Richards**
Graphic Designer **Dan Richards**
Illustrators **David Gill and Dan Richards**
Writer **Stanley Hainsworth**
Printer **Mollet Printing**
Paper **Gilbert Esse, Gilclear Vellum**
Client **Nike, Inc.**

Envisioning Change

A booklet developed to commemorate an exhibition of the career in design of Robert Vogele, founder of VSA Partners, Inc. The audience consisted of present and former employees, peers, personal friends, suppliers, and staff of the University of Illinois, the sponsoring institution. The piece is a compilation of Robert Vogele's personal biography, his design philosophy, and comments of his peers, who were interviewed by Mike Noble. The design reflects Bob Vogele's personal style and offers an intimate look at one man's career in design.

Design Firm **VSA Partners, Chicago, IL**
Creative Director **Curtis Schreiber**
Art Director **Robert Vogele**
Graphic Designers **Jeff Breazeale and Adam Smith**
Photographers **Ken Fox, James Schnepf, and Various**
Copywriters **Mike Noble and Robert Vogele**
Printer **Dupli-Graphic**
Publisher **VSA Partners**
Client **Robert Vogele**

THE PENGUIN HAS A THICK COAT OF WATER-PROOF FEATHERS.

Design BIG D

Design is the process of maximizing the perceived value of organizations, products and services in the marketplace.

In Design, it is not necessarily the Designer's idea, but rather the best idea that the Design process is trying to identify and make tangible.

Design brings unrealized potential into being.

◄

Carnegie International 1995

This project is part of the identity system we designed for the 100th anniversary of the "Carnegie International" exhibition at the Carnegie Museum of Art in Pittsburgh. The typographical grid served as a guide representing a historical timeline. The steely blue, copper, and black colors were selected to represent Pittsburgh's steel and industrial history and the museum's architecture. A symthe-sewn binding allows the catalogue to lie flat when open, in order to capture the experience of viewing the exhibition. The catalogue cover reflects the challenge of successfully producing a foil-stamped duotone image.

Design Firm **Plus Design Inc., Boston, MA**
Art Director **Anita Meyer**
Designers **Anita Meyer and Dina Zaccagnini**
Photographers **Various**
Typographer **Moveable Type Inc.**
Publisher **The Carnegie Museum of Art**
Printer **W.E. Andrews Company**
Bindery **Acme BookbindinG**

The 1995 MTV Movie Awards Program Guide

The idea was to evoke the glitz and drama of 1940s-era Hollywood in a humorous and slightly surreal parody of the old movie posters. In fact, the guide was largely inspired by a set of trading cards based on pre-war movie posters. We wanted to write a story that strung together all of the sensational language of those old movie posters, subtly intertwining the narrative with references to the golden age of Hollywood. The printing style was intentionally off-register, to recall the look of 3-D movies as well as the amateur, corner-shop printing of old pulp fiction novels.

Design Firm **MTV Off-Air Creative, New York, NY**
Art Director **Steven Baillie**
Graphic Designer **Steven Baillie**
Illustrator/Animator **Kevin Sykes**
Writer **Dimitri Ehrlich**

The Departure of Fruit and Vegetables from the Heart of Paris

This commemorative brochure celebrates the sculpture of the same name and introduces artist Raymond Mason to the United States. The brochure recreates his sketchbook and shows the evolution of the sculpture from pencil sketch to finished piece. The color palette and printing techniques were selected to evoke the feeling and texture of a well-used personal sketchbook. Postcards inserted at the back and a torn grocery list present more illustrations and serve as keepsakes, personal mementos of *The Departure*.

Design Firm **Wood Design, New York, NY**
Creative Director **Tom Wood**
Graphic Designers **Clint Bottoni,
Alyssa Weinstein, and Tom Wood**
Writer **Mary Anne Costello**
Printer **Daniels Printing**
Paper **Mohawk Vellum**
Client **Four Seasons**

◄ BELOW

Joanie Bernstein Illustrators Promotions

These are promos for two very different illustrators, both represented by one agent. We wanted them to capture the feeling of each artist's style and grab an art director's attention while still maintaining a loose system and an ongoing identity for the agent. They were produced on very limited budgets, using found objects and unusual printing materials.

Design Firm **Werner Design Werks, Minneapolis, MN**
Art Director **Sharon Werner**
Graphic Designers **Sarah Nelson and Sharon Werner**
Illustrators **Eric Hanson and Dan Picasso**
Printers **Heartland Graphics and Pilot Print**
Paper **Various**
Client **Joanie Bernstein, Artists' Representative**

Boy Scouts Plan Booklet

The objective of this booklet was to remind us of the values of scouting and its importance in our communities. It is a simple and direct piece dictated by both budget and clarity of the message.

Design Firm **Van Dyke Company, Seattle, WA**
Art Director **John Van Dyke**
Graphic Designer **John Van Dyke**
Writer **Tom McCarthy**
Printer **Graphic Arts Center**
Paper **French Dur-o-Tone Packing Gray 80# Cover
and 80# Simpson Coronado SST**
Client **Boy Scouts of America**

We will place major emphasis on expanding the number of younger children who participate in Scouting at the Tiger Cub and Cub Scout levels. This will strengthen the flow of young people into the more advanced Scouting programs, providing them with positive experiences they might otherwise miss. To meet this goal we will dedicate a larger portion of our existing camps to these younger ages.

TEOUS

give children courage. But you can help them reach for it. You can help them through small, do-able assignments

ViewStar

SEEING YOUR
customers
for who they are.

In the larger picture,
we are all both consumers and providers of
information. Like a series of nested Russian
dolls, we are connected on both sides to
links in the information chain. We depend
upon larger resources to obtain the knowl-
edge we need to make decisions, and then in
turn impart this wisdom to those who need
it to do their jobs.

In a similar way, the ViewStar system
recognizes the importance of everyone in a
company's process chain—beginning with the
ultimate consumer, your customer, and con-
tinuing on through your customer service
representatives, departmental managers, MIS
supervisors and executive management.

A forthcoming view of automation.
At ViewStar, this notion guides us in helping
companies see the important relationships
that exist among people and processes within
their businesses. As we help our customers
examine their workflow methodologies, we
pay particular attention to the way people are
involved—as individuals, team members and
supervisors.

At ViewStar, we develop strong relation-
ships with our customers—which include some
of the largest, best-known corporations in the
world—to ensure that systems are well designed,
rapidly implemented and easily maintained.
In defining applications, for example, users
are consulted early in the process for their

input and feedback through a unique "proto-
cycling" process, so that there won't be any
surprises later on. But our focus on our cus-
tomers doesn't stop once a solution is
implemented. That's because like the ViewStar
system itself, we're committed to offering the
easiest and most convenient ways to transfer
our knowledge and expertise. ViewStar
clients and partners can take advantage of a
curriculum with course content based on
their particular needs. Each set of classes is
specific to an individual's job function and
progresses from beginning to advanced levels.

These course offerings for system admin-
istrators, application developers and managers
focus on case studies of real business examples.
They combine the theories of process automa-
tion, document management and imaging
with practical instruction centered around
application prototyping and rapid application
development and maintenance.

Finally, through a wide range of resources—
from hotline, BBS and Internet services to a
Lotus Notes knowledgebase of ViewStar best
practices to onsite training—our customer
support group and partners provide our clients
with in-depth support on product usage,
development practices, application integration
and system configuration.

After all, when it comes to satisfying your
customers, it's all in how you see them.

Viewstar Corporate Brochure

Viewstar makes sophisticated business software. Since their competition was producing overly technical literature, we wrote and designed their brochure so their technology made sense to ordinary people. After we were done, even the client understood their product better.

Design Firm **Frazier Design, San Francisco, CA**
Art Director **Craig Frazier**
Graphic Designer **Rene Rosso**
Ilustrator **Craig Frazier**
Writer **Steve Goldstein**
Printer **Lithographix**
Paper **Mead Signature Dull**

◄ BELOW

Paging Is No Longer a One-Way Street

This piece was designed to introduce the new two-way Flex paging protocol to providers of paging services. We digested reams of technical material, boiled it down to key features and benefits, and presented it in a simple, engaging, and attention-getting little booklet.

Design Firm **Pinkhaus, Miami, FL**
Creative Director **Joel Fuller**
Graphic Designer/Illustrator **Susie Lawson**
Copywriter **Frank Cunningham**
Printer **H & D**
Paper **Gilbert Esse 80# Text, Textured**
Client **Motorola Paging Products Group**

Hansberger Global Investors: The Art of the Advantage

Our brief was to design a booklet in which the firm's strategy was clearly stated in elegantly written copy and in which the design would denote quality, subtle differentiation, classical elegance, and a sense of history and exploration to the small, focused, and sophisticated Hansberger market. The typographic design refers to classical early book design, especially in the use of the delicate colored rules. The illustrations are reproductions of historic maps. The unusual use of a binding hand-sewn with thread enabled the design to incorporate alternating paper stocks for each page.

Design Firm **Pentagram Design, New York, NY**
Art Director **Peter Harrison**
Graphic Designer **John Klotnia**
Copywriter **Roger Morrow**
Printer **MacDonald Printing**
Client **Hansberger Global Investors**

Girl's Night Out Sweepstakes
Affiliate Brochure

This brochure, describing a sweepstakes promoting
lifetime television's "Girls' Night Out" comedy series,
was mailed to cable affiliates. The affiliated stations
returned the enclosed response card in order to receive
the corresponding promotional materials to run the
sweepstakes.

Design Firm **High Design, Ocala, FL**
Art Director **Julia Horowitz**
Graphic Designer **David J. High**
Illustrator **David J. High**
Client **Lifetime Television**

▼

Regal Invitation/Name Change Announcement

This piece announces a new name for an existing company, poking fun at the lack of originality of both the new name and the new logo. The design uses Yellow Pages names and graphics, emphasizing the generic quality of the company's identity. The self-deprecating concept proved to be a good way to get people to notice and remember an otherwise forgettable name and logo.

Design Firm **Dennard Creative, Inc., Dallas, TX**
Creative Director **Bob Dennard**
Graphic Designers **Bob Dennard,**
Wayne Geyer, and Chris Wood
Illustrators **Bob Dennard and Chris Wood**
Writers **Bob Dennard and Wayne Geyer**
Printer **Regal Printing**
Paper French **Dur-o-Tone Newsprint White**
Client **Regal Printing**

▼

Keilhauer Designer Dictionary 2

A small promotional piece aimed at architects and designers — basically making fun of the "design speak" we often use in front of our clients to sell our ideas. This was the second dictionary in the series for the Keilhauer Furniture Company.

Design Firm **Vanderbyl Design, San Francisco, CA**
Art Director **Michael Vanderbyl**
Graphic Designer **Michael Vanderbyl**
Illustrator **Eric Donelan**
Writer **David Betz**
Printer **Campbell Group**
Client **Keilhauer**

Regal Jewelry 2050 N Stemmons Frwy 75207 –748-2288

mul•ti•task•ing *vt.* 1. an industry term for a work station that can perform many functions at one time *i.e. walking and chewing gum.*

▼

Nike 1995 Annual Report

The concept for the 1995 annual report was to express the breadth of the Nike brand. This breadth is evident in the frequency with which Nike appears throughout the sporting world, at all levels, in all places. By showing the ubiquity of Nike's presence, the involvement we have in the sports world, and the motivation we provide for all athletes and the dreams they chase, we were able to show Nike's emotional connection to a near-universal predisposition of humans toward sport, competition, and simple play.

Design Firm **Nike Design, Beaverton, OR**
Art Director **Ann Schwiebinger**
Graphic Designer **Ann Schwiebinger**
Photocollage Designer **Craig Barez**
Photographers **Various**
Writer **Bob Lambie**
Printer **The Hennegan Company**
Paper **Mohawk Superfine**
Client **Nike, Inc.**

▼

Chatham Printing Brochure

Chatham Printing approached us to produce a capabilities brochure to introduce their newly acquired six-color press. We used signs as visual metaphors to humorously reinforce the copy, which explains Chatham's work ethic and attitude.

Design Firm **Cummings & Good, Chester, CT**
Creative Directors **Peter Good and Christopher J. Hyde**
Graphic Designer **Christopher J. Hyde**
Photographers **Peter Good and Christopher J. Hyde**
Copywriter **Christopher J. Hyde**
Printer **Chatham Printing Company, Inc.**
Paper **Warren Lustro Dull 100# Text**
Client **Chatham Printing Company, Inc.**

▲
The Energy Foundation
1995 Annual Report

The Energy Foundation publishes an annual report
aimed at scientists, policy-makers, and business lead-
ers. Its purpose is to act as a forum to promote energy
efficiency and renewable energy. This annual featured
a technical discussion of the electric car.

Design Firm **Frazier Design, San Francisco, CA**
Art Director/Illustrator **Craig Frazier**
Graphic Designers **Craig Frazier and Rene Rosso**
Copywriter **Hal Harvey**
Printer **Lithographix**
Paper **Simpson Coronado and Simpson Evergreen**
Client **The Energy Foundation**

▲
Rational Software 1995 Annual Report

Rational Software provides tools and methodologies
to make the development of complex software systems
easier. Since it is difficult to understand this area
of expertise, we chose accessible, consumer-oriented
illustrations to help convey how ubiquitous the micro-
processor is in products throughout the world. Simple
statistics, such as how many microprocessors you
encounter in a day, are included to show how large the
market is for Rational's technology.

Design Firm **Cahan & Associates, San Francisco, CA**
Art Director **Bill Cahan**
Graphic Designer **Bob Dinetz**
Illustrator **Jeffrey Fisher**
Copywriter **Tim Peters**
Printer **Watt/Peterson**
Paper **Kashmir and Starwhite Vicksburg**
Client **Rational Software Corporation**

In 1995 we launched a major assault on America's leading disabler with two new stroke initiatives—one aimed at the general public and the other targeted at stroke survivors. ¶ In partnership with six area hospitals, the AHA invited Chicago area residents to find out their risk of "brain attack" through free stroke prevention screenings held in May. Five hundred people participated, and the program will be expanded in 1996 to meet the great demand for this service. ¶ Helping survivors prepare for life after stroke is the goal of our Stroke peer Visitor Program, which trained its first group of visitors in 1995. Stroke survivors are now paying visits to patients in three area hospitals to provide support, advice and most importantly, hope. ¶ Through these and other community programs the American Heart Association links health care providers with local residents to raise aware ness and improve long-term health.

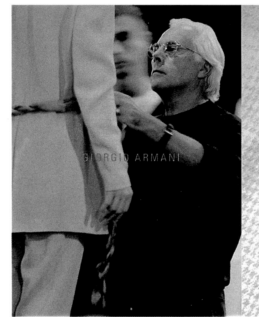

"I would say that the fundamental challenge for a fashion designer is to manage paradox — to be the same but different, to provide security and a thrill at the same time, to use a familiar language to say something new. For the retailer, the task is not so different. But add to it — in the case of that distinctly American phenomenon called the luxury specialty store — the challenge of presenting a whole world of style and fashion, encompassing wildly divergent points of view, while always being itself. As a designer with an important, often anchoring, presence in Neiman Marcus and Bergdorf Goodman stores, I trust those stores not only to convey my image, but to enhance it through the total shopping experience they offer their customers."

Our stores receive nearly $100 million of merchandise from Giorgio Armani annually. As our largest single resource, the Armani label has a special meaning for Neiman Marcus and Bergdorf Goodman customers. Our challenge as retailers is to select, edit and present that merchandise in a way that reflects Armani's unique style as well as that of our stores. Meeting that challenge daily are talented merchants who edit and coordinate collections from a variety of resources that differ from each other but can still work together to create a distinct statement. We design our stores to offer a convenient shopping experience with just the right amount of drama and excitement through enticing displays and special events like trunk shows and designer appearances. Our customers rely upon us to edit and present the very best in designer merchandise in a way that allows them to fulfill their own very special needs.

GIORGIO ARMANI

MANAGING THE PARADOX OF FASHION

The Neiman Marcus Group

1995 ANNUAL REPORT

The Neiman Marcus Group

◄

American Heart Association of
Metropolitan Chicago 1995 Annual Report

The primary use of this annual report is fundraising to
support continuing research on cardiovascular diseases
and stroke. We presented much of the information as a
fact book, adding the elements of humor and surprise
starting with the cover. Because the AHA is a nonprofit
organization and costs are always a concern, we deliber-
ately printed the job in only one color, interspersing four
fluorescent color papers to add visual interest. Overall,
this book communicates the information in a clear and
concise manner and has fun doing it.

Design Firm **SamataMason, Dundee, IL**
Art Director **Pat Samata**
Graphic Designers **Joe Baran and Pat Samata**
Illustrators **Joe Baran and CSA Archive**
Writer **Liz Andrews**

◄ BELOW

The Neiman Marcus Group
1995 Annual Report

The intended audience for this principal corporate
image document was investors, employees, customers,
and designers. The tactile elements of the book —
hand-sewn binding, French folds, specialty paper, tex-
tural imagery, and non-traditional printing inks — are
meant to reflect the high-quality image of both Neiman
Marcus and Bergdorf Goodman. This report helped to
maintain the Neiman Marcus Group's position as the
pre-eminent upscale retailer of designer merchandise.

Design Firm **Belk Mignogna Associates, Ltd.,**
New York, NY
Creative Directors **Howard Belk and Steve Mignogna**
Graphic Designer **Brett Gerstenblatt**
Photographers **Richard Seagrave (Cover) and Various**
Writer **Joanne Parker**
Printer/Fabricator **The Hennegan Group**
Paper **Gilbert Gilclear Light, Gilbert Esse**
Client **The Neiman Marcus Group**

▼

YMCA Annual Report 1994–1995

In addition to reviewing performance highlights, the
report's goal is to communicate the value of YMCA
programs to donors and volunteers. A phrase from
the YMCA's vision statement — "the heart of a healthy
community" — provides a unifying thematic thread.
Ten well-known photographers and artists were each
invited to interpret a heart-oriented thought. The
narrative sections are designed like book chapters to
emphasize the literary feeling of first-person accounts.

Design Firm **Viva Dolan Communications**
and Design, Toronto, Ontario
Art Director **Frank Viva**
Graphic Designer **Frank Viva**
Illustrators **Various**
Photographers **Various**
Writer **Doug Dolan**
Printer **Bowne of Canada**
Client **YMCA of Greater Toronto**

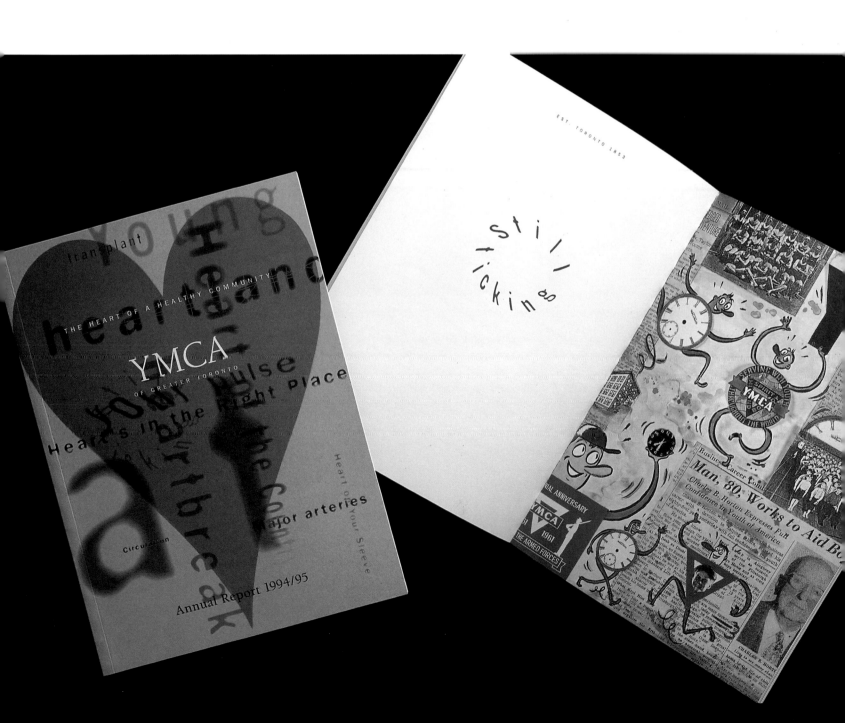

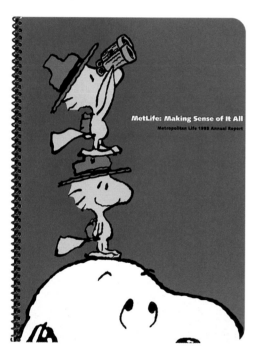

Premark 1994 Annual Report

Premark is a holding company made up of three groups: Tupperware, Food Equipment Group, and Consumer and Decorative Products. Because the markets are so diversified, the strength of this book lies in the strategic positioning of each group through the use of straightforward product photography and text. The information has been simplified and clarified, which allows the audience of investors, analysts, and employees to understanding the company more easily.

Design Firm **SamataMason, Dundee, IL**
Art Director **Greg Samata**
Graphic Designer **Dan Kraemer**
Photographer **Sandro, Inc.**
Writer **Chris Hanneman**
Printer **Anderson Litho**
Paper **Simpson Kashmir 80# Cover and 100# Text;**
Champion Benefit Squash 70# Text
Client **Premark**

MetLife: Making Sense of It All —
The Metropolitan Life 1995 Annual Report

Our task was to introduce company-wide process reengineering policies to employees and policyholders in a clear and accessible way. We paralleled the new initiatives with proverbs and illustrated them with brightly colored, boldly cropped images of Peanuts characters. The oversized format, matte inks on matte paper, rounded corners, and bright red spiral binding add to the friendly, fun, and inviting nature of this annual.

Design Firm **Belk Mignogna Associates, Ltd.,**
New York, NY
Creative Director **Howard Belk**
Graphic Designers **Wendy Blattner and**
Michelle Marks
Illustrator **Peter LoBianco**
Photographer **Peter Gregoire**
Printer/Fabricator **Graphic Arts Center**
Paper **Zanders Ikonofix Matte Cover and Text**
Client **Metropolitan Life Insurance Company**

ARCO 1994 Annual Report

The typical annual report for the petroleum industry might show only oil rigs and pipelines. ARCO's unique diversity in the marketplace, however, became the focal point for the company's 1994 annual report. Globes, maps, diagrams and photographs were rendered in different styles to reinforce the company's own diversity. The entire project was printed with six match colors and specially made uncoated stock.

Design Firm **The Jefferies Association,**
Los Angeles, CA
Art Director **Ron Jefferies**
Graphic Designer **Scott Lambert**
Writer **Linda Dozier**
Printer **George Rice & Sons**
Paper **Gilbert Gilclear 40# Cover and**
Hopper Valorem 80# Text
Client **ARCO**

Trident Microsystems 1995 Annual Report

Trident Microsystems designs, develops, and markets multimedia chipsets, GUI accelerators, and graphic controllers. To communicate that the company is enabling live video and has achieved its strategic goal in the marketplace, an animated message on the cover changes from "follow" to "lead." The core technologies that positioned the company for success are featured inside the annual report through video images.

Design Firm **Cahan & Associates, San Francisco, CA**
Art Director **Bill Cahan**
Graphic Designer **Bob Dinetz**
Photographers **Various**
Copywriter **Tim Peters**
Printer **Grossberg Tyler**
Paper **Vintage Velvet**
Client **Trident Microsystems, Inc.**

BC Telecom 1994 Annual Report

This report engages the reader with the communication links we make every day. Our design presents the reader with technology as the invisible connection we have all become accustomed to, and emphasizes its importance in our daily lives.

Design Firm **A Design Collaborative, Seattle, WA**
Art Directors **Dave Mason and John Van Dyke**
Graphic Designers **Dave Mason and John Van Dyke**
Writers **Tom McCarthy and BC Telecom**
Printer **Mitchell Press**
Paper **Simpson Gainsborough Cover 80# Frost White and Simpson Coronada SST Text**
Client **BC Telecom**

South Texas College of Law 1995 Annual Report

The annual report allows the dean to issue a "state of the union" address to the school's constituents and is used as a development tool to thank the donors. The 1995 report also commemorated the inauguration of the new dean, Frank T. Read. The dean's inaugural speech, describing his wish to return the legal profession to its former stature, recalled the idealism of 1950s American commerce, which set the style for our visual approach.

Design Firm **Geer Design, Inc., Houston, TX**
Art Director **Mark Geer**
Graphic Designers **Mandy Beausoleil and Mark Geer**
Photographer **Beryl Striewski**
Writer **Frank T. Reed**
Printer **The Beasley Company**
Paper **Simpson Quest, Starwhite Vicksburg, Mohawk Vellum**
Client **South Texas College of Law**

Chicago Mercantile Exchange
1994 Annual Report

The Chicago Merc is a global arena where the financial world congregates, competes, and communicates. This annual report focuses on four distinct areas of business: AG commodities, global currencies, interest rates, and stock indices. By breaking up the business graphically through the use of charts and a symbolic image in each section, this very complicated financial structure becomes easy to understand. The cover, which is blind embossed on the outside and printed on the inside, wraps around the book completely.

Design Firm **SamataMason, Dundee, IL**
Art Directors **Dave Mason and Greg Samata**
Graphic Designers **Erik Cox, Pamela Lee, and Dan Kraemer**
Photographers **Mark Joseph and Marcus Lyon**
Printer **Bruce Offset**
Paper **Fox River Quality Cover, Monadnock Astrolite Vellum, Job Parilux, James River Graphika**
Client **Chicago Mercantile Exchange**

National Audubon Society 1995 Annual Report

This oversized annual report gives birds, wildlife, and habitat an expansive spread each. Teeming with information, color illustrations, and photographs, the full but few pages give the annual report depth and brevity.

Design Firm **Pentagram Design, New York, NY**
Art Directors **John Klotnia and Woody Pirtle**
Graphic Designers **Seung il Choi, John Klotnia, and Ivette Montes de Oca**
Illustrators **Lori Anzalone, Dugald Stermer, and Kevin Torline**
Printer **Sandy Alexander, Inc.**
Paper **Mohawk Vellum, 60# Text Recycled**
Client **National Audubon Society**

ICOS Corporation 1994 Annual Report

This report conveys a sense of the accomplishments and direction of the firm, a biotech company establishing a pipeline of product candidates as it moves toward clinical trials.

Design Firm **Van Dyke Company, Seattle, WA**
Art Director **John Van Dyke**
Graphic Designers **Ann Kumasaka and John Van Dyke**
Photographer **Jeff Corwin**
Writers **Tom McCarthy and ICOS Corporation**
Printer **H. MacDonald Printing**
Paper **Simpson Coronado SST Cover 80# Text and Cover Recycled**
Client **ICOS Corporation**

▶ BELOW
Earth Tech 1995 Annual Report

Earth Tech's 1995 annual report was a workhorse document for the company during a transitional period in which Earth Tech was being acquired. Designed to be bound several different ways with varying levels of information, the different versions of the book function as an annual report, a corporate overview, or a service capabilities piece. The simple component-based structure makes the book practical as well as elegant.

Design Firm **Rigsby Design, Inc., Houston, TX**
Creative Director **Lana Rigsby**
Graphic Designers **Lana Rigsby, Michael Thede, and Alvin Ho Young**
Photographers **Chris Shinn, Sebastião Salgado**
Copywriter **JoAnn Stone**
Printer/Binder **MacDonald Printing**
Paper **Champion Benefit Vertical and Simpson Starwhite Vicksburg**
Client **Earth Tech**

National Audubon Society 1995 Annual Report

Slant: Issue #3, #4, #6

Slant is targeted at an 18- to 30-year-old male and female college-educated audience. Our objective is to present information in a unique and visually compelling format that lets viewers enjoy the newspaper even if they don't read it. Each issue focuses on a central theme. Freelance designers and illustrators are used to lend the newspaper diversity in personality and style. *Slant* communicates effectively on two levels — text and image — and excels because of its versatility. Both disciplines are needed to satisfy *Slant's* diverse and culture-oriented constituency.

Design Firm **Urban Outfitters, In-House,
Philadelphia, PA**
Art Directors **Howard Brown and Mike Calkins**
Graphic Designers/Illustrators **Howard Brown,
Mike Calkins, and Gary Panter**
Printer **Stepladder Press**
Paper **Newsprint**
Client/Publisher **Urban Outfitters, Inc.**

A LONG-TIME AIDE. A FEW THOUSAND DOLLARS' WORTH OF DUBIOUS INSURANCE **SCALDED** RECEIPTS. A CAULDRON OF ALLEGATIONS. U.S. ATTORNEY KENDALL COFFEY HAS BEEN...

(BY KIRK SEMPLE)

Continued on page 23

Science + Technology

4

Slant

Paranormal +

Mutilation + Abduction

Scalded

Design Firm **Blotto Studio, Miami, FL**
Art Director **Brian M. Stauffer**
Graphic Designer **Brian M. Stauffer**
Writer **Kirk Semple**
Paper **Newsprint**
Printer **Sun Sentinel**
Publisher **New Times Newspapers**
Client **Miami New Times**

Slant Cover

Slant is a quarterly publication produced by Urban Outfitters. The topic of this issue was the paranormal — UFOs, alien abductions, cow mutilations, and crop circles. The cover was an exploration, using existing imagery in a modern context.

Design Firm **Charles S. Anderson Design Company, Minneapolis, MN**
Art Director **Todd Piper-Hauswirth**
Graphic Designer **Todd Piper-Hauswirth**
Illustrator **CSA Archive**
Client **Urban Outfitters**

p 24

AN-OTHER STAT-ISTIC

PETER KUPER 1994

p 25

Nozone #6 "Crime"

Nozone is an independently published comics and graphics journal changing theme and format from issue to issue. The "Crime" issue (special pocket-thriller size) investigates the morality of crime, the banality of violence, and the function of law enforcement through an unusual hybrid of words and images. The value of this project lies in its protean format and its belief in the power of the satirical image to bring about social awareness. Nozone's marginal audience is believed to include disaffected youth, visionary dystopians, and disgruntled art directors.

Art Director **Knickerbocker**
Illustrators **Various**
Printer **Grenville Printing & Management, Ltd.**
Paper **French Dur-o-Tone Newsprint**

Ten Exciting New Colors by Gilbert Paper

Gilbert asked us to do a limited-edition paper sample
for an annual design conference. We screenprinted
black-and-white colors on postcard-size paper stock
and screenprinted black on kraft paper bags that we
purchased for $15 (1,000). We designed this to feel
like a keepsake instead of spending thousands on
an expensive brochure that would probably end up in
the trash or recycling bin — at least, that's where
they go in this office.

Design Firm **Modern Dog, Seattle, WA**
Art Director **Michael Strassburger**
Graphic Designers/Illustrators
**Vittorio Costarella, George Estrada, Robynne Raye,
and Michael Strassburger**
Printer **Two Dimensions**
Fabricators **Volunteers at Envision 21, Sacramento**
Paper **Gilbert Esse and Oxford**
Client **Gilbert Paper**

Gallagher Bassett Services
Advantage Quarterly

The Advantage, a quarterly publication, presents a communication link between Gallagher Bassett, a third-party administrator, and its clients. The oversize format, 11" x 17", is conducive to large imagery and interesting type treatments. Each issue uses a different paper stock to avoid repetition. A single symbolic image relating to one of the inside stories always appears on the cover. The interior format changes with each issue and allows room for powerful communication of current subjects of interest in the industry.

Design Firm **SamataMason, Dundee, IL**
Art Director **Pat Samata**
Graphic Designer **Joe Baran**
Photography **Stock**
Writers **Tracy Mock and Dawn Skluzacek**
Printer **Bruce Offset**
Paper **French Dur-o-Tone Butcher**
Off White 70# Text, etc.
Client **Gallagher Bassett Services**

CORPORATE AMERICA SUFFERING AN OVER-DOSE. DRUG-FREE WORKPLACE THE ROAD TO RECOVERY. Substance abuse is on the rise again in the US.

SOBERING FACTS ABOUT SUBSTANCE ABUSERS

Managed Care Services
ADDS NEW WORKERS COMPENSATION PPO NETWORK OPTION

MANAGED CARE PROGRAM POSTS DRAMATIC INCREASE IN CLIENT SAVINGS

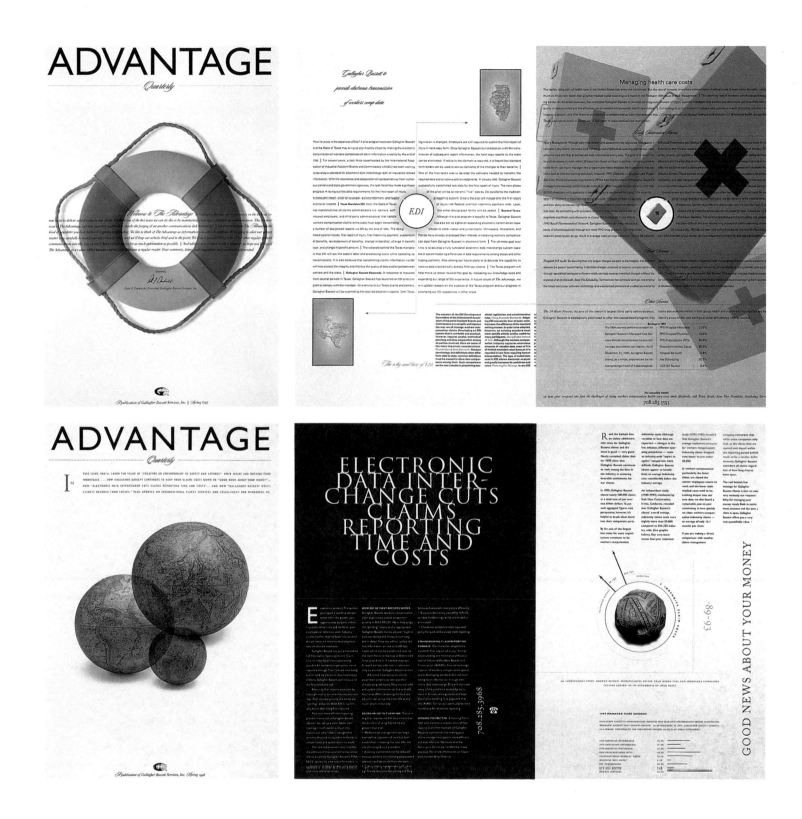

Querencia

The first in a series of journals for the Connecticut Art Directors' Club, attempting to understand and define our role in the world as designers and communicators, and to help develop an awareness of the power inherent in creating communications. The journal is not only intended to inform, but to challenge and provoke thinking and discussion about issues relevant to our work and our lives.

Design Firm **Pollard Design, East Hartland, CT**
Creative Director **Jeff Pollard**
Graphic Designer **Adrienne Pollard**
Photographer **Frank Marchese**
Editors **Christine Schrager and Pam Williams**
Printer **The Finlay Brothers**
Paper **Strathmore Elements (Dots)**
Client **Connecticut Art Directors Club**

Jack Lenor Larsen Letterhead

Renowned textile designer Jack Lenor Larsen needed an identity system to promote his consultancy work and to distinguish himself from Jack Lenor Larsen, the corporation. Larsen's initials were used to create vertically extended letterforms suggesting fiber. The symmetry of composition, especially notable on the envelope, refers to Larsen's admiration of traditional Eastern crafts. The vertical lines were originally to bleed but Larsen wanted them to stop short of the edges, which in textiles indicates a custom piece, somewhat the opposite of offset lithography.

Design Firm **Clouse + Deere, New York, NY**
Art Directors **Bill Deere and Jack Lenor Larsen**
Graphic Designer **Bill Deere**
Printer **Karr Graphics**
Paper **Crane's Crest Natural White,
Wove Finish, sub 28**
Client **Jack Lenor Larsen**

► BELOW
The Dog School Identity System

Purpose: To create an identity for a new company whose primary business is training dogs. Creative strategy: We used positive dog commands to reinforce the activity involved in each item. Why we value this project: It's fun! It has a sense of humor! Why we believe it demonstrates excellence in communication graphics: Ask your judges. They picked it.

Design Firm **Studio A, Alexandria, VA**
Graphic Designers **Antonio Alcalá and John Jackson**
Illustrator **John Jackson**
Paper **Hopper Proterra**
Client **The Dog School**

Seattle Vision Identity System

Seattle Vision is an upscale, urban retailer seller of high-fashion eyewear located in a chic gallery mall. Their target customers are looking for beautiful eyewear from exclusive designers, regardless of price. The identity we created for them is both classical and whimsical — reflective of the varying types of merchandise they sell. The clean, simple "eye-catching" system has a high-end look.

Design Firm **The Leonhardt Group, Seattle, WA**
Creative Director **Jon Cannell**
Graphic Designers **Jon Cannell and Mark Popich**
Illustrator **Mark Popich**
Printer **The Copy Company**
Paper **Simpson Starwhite Vicksburg**
Client **Seattle Vision Care**

The Edison Group Stationery System

The Edison Group, a graphic design firm, wanted a stationery system that expressed the concept of a cohesive firm made up of unique individuals. To achieve this, a large letter "E," signifying Edison, was used on all pieces. But on the fronts of the business cards, the large letter was the employee's first initial, with the "E" on the back.

Design Firm **The Edison Group, Minneapolis, MN**
Graphic Designer **Jo Davison**
Printer **Meyers Printing**
Paper **Champion Pageantry and Curtis**
Tuscan Antique
Client **The Edison Group**

Dean Rogers Music and Sound Design Logo

This logo for Dean Rogers Music and Sound Design was targeted at the producers and creative directors who typically buy these services. The simplicity of the music note working as type demonstrates the core of the concept and leaves a solid image of what Dean does.

Design Firm **GibbsBaronet, Dallas, TX**
Art Directors **Willie Baronet and Steve Gibbs**
Graphic Designer **Bronson Ma**
Client **Dean Rogers Music and Sound Design**

Jerry Garcia Illustration

Design Firm **Rolling Stone, New York, NY**
Art Director **Fred Woodward**
Illustrator **Milton Glaser**
Publisher **Wenner Media**
Client **Rolling Stone**

Panther

Design Firm **Rolling Stone, New York, NY**
Art Director **Fred Woodward**
Illustrator **Anita Kunz**
Writer **Peter Travers**
Publisher **Wenner Media**
Client **Rolling Stone**

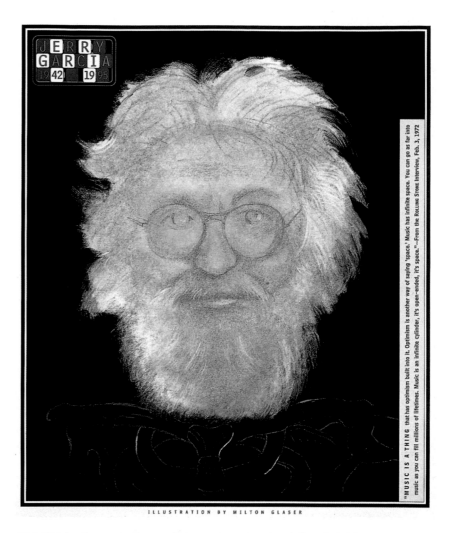

ILLUSTRATION BY MILTON GLASER

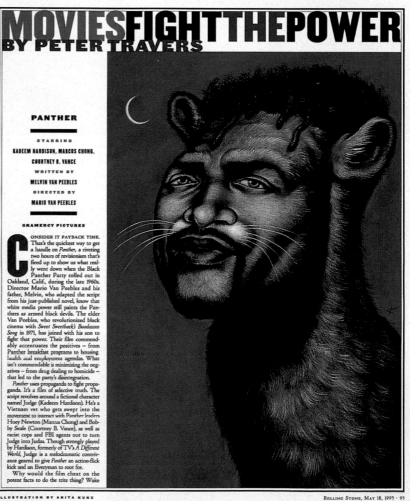

ILLUSTRATION BY ANITA KUNZ

ROLLING STONE, MAY 18, 1995 · 95

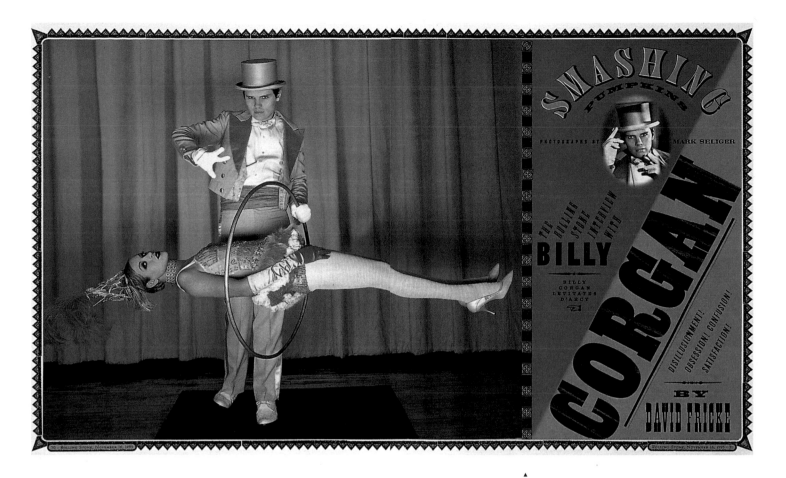

Smashing Pumpkins

Design Firm **Rolling Stone, New York, NY**

Art Director **Fred Woodward**

Graphic Designers **Geraldine Hessler**
and Fred Woodward

Photographer **Mark Seliger**

Writer **David Fricke**

Photo Editor **Jodi Peckman**

Publisher **Wenner Media**

Client **Rolling Stone**

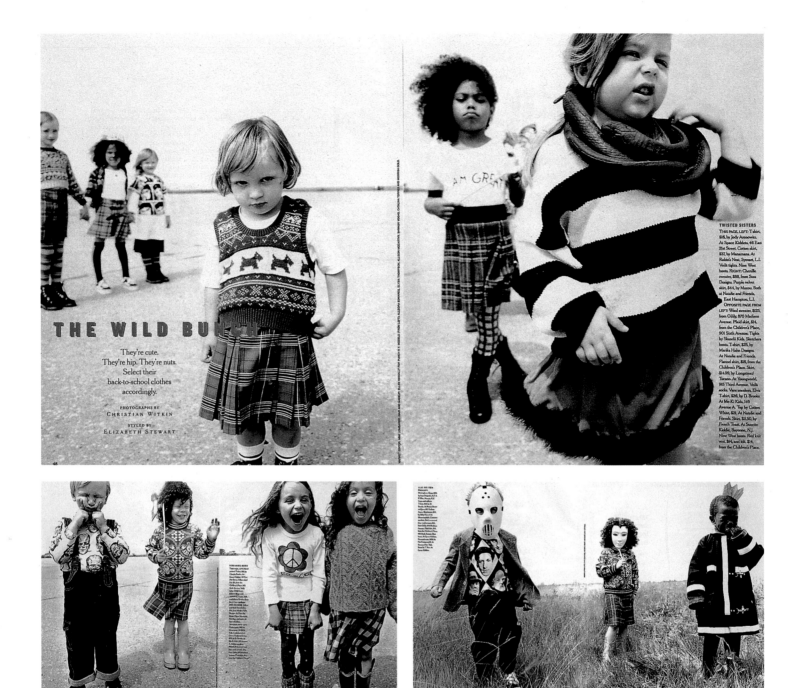

The Wild Bunch

These photographs were shot by Christian Witkin
for a twice-yearly children's fashion feature in the *New
York Times Magazine*. Although we have full four-color
capability, the images were shot in black-and-white
for strength and simple emotional quality. The pictures
are wonderful because they capture children in an
entirely unconventional and irreverent way. They speak
of the unself-conscious, goofy, scary, emotional period
called childhood.

Design Firm **The New York Times Magazine,
New York, NY**
Art Director **Janet Froelich**
Photographer **Christian Witkin**
Stylist **Elizabeth Stewart**

▼

Casualties of War

Design Firm **Rolling Stone, New York, NY**
Art Director **Fred Woodward**
Graphic Designers **Gail Anderson and**
Fred Woodward
Photographer **Sebastião Salgado**
Photo Editor **Jodi Peckman**
Publisher **Wenner Media**
Client **Rolling Stone**

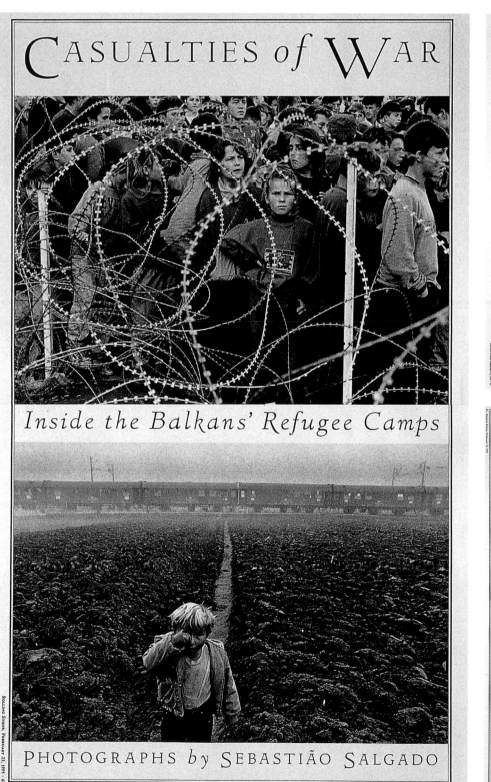

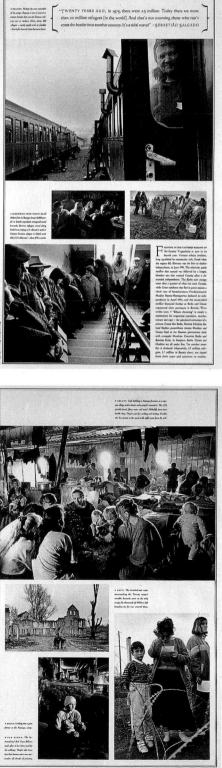

THE DEVIL AND ANNE RICE

A SOUL-SEARCHING
INTERVIEW
WITH
THE PRE-EMINENT
AUTHOR OF
THE SUPERNATURAL
AND AN
EXCERPT FROM HER
NEW BOOK,
MEMNOCH THE
DEVIL

BY MIKAL GILMORE For nearly 20 years now, Anne Rice has been telling stories that share secrets — secrets of life and death, of sex and the soul, of monsters and humans. In particular, though, it is with her series of novels known as The Vampire Chronicles that Rice has created her most enduring mix of mystery and meaning, as well as what may prove her most enduring body of literature. Interview With the Vampire (1976) — the first of the Vampire Chronicles and Rice's first published novel — is a horror narrative unlike any other. It is the story of Louis de Pointe du Lac, an 18th-century New Orleans plantation owner who has lost faith in his life and in God. Seeking death one night, Louis instead finds a vampire and a cruel paradise: This broken man who wanted to die must now endure lifetimes of no meaning, and he must murder daily to do so. Interview is also the story of the French-born Lestat de Lioncourt, the smart, mean aristocrat who made Louis a vampire, and Claudia, the child immortal who unites Louis and Lestat in a bitter kinship and eventually separates them at an awful price. Mostly, though, Interview With the Vampire is a haunting medita-

ILLUSTRATION BY JOHN COLLIER

WELCOME TO THE JUNGLE

Texas teenager Rudy Meinecke was tortured for three days and nights. His alleged tormentors included hustlers, drag queens and drug dealers. They were all children of the Montrose

By Kevin Heldman

The Devil and Anne Rice

Design Firm **Rolling Stone, New York, NY**
Art Director **Fred Woodward**
Graphic Designer **Geraldine Hessler**
Illustrator **John Collier**
Writer **Mikal Gilmore**
Publisher **Wenner Media**
Client **Rolling Stone**

Welcome to the Jungle

Design Firm **Rolling Stone, New York, NY**
Art Director **Fred Woodward**
Graphic Designers **Gail Anderson and Fred Woodward**
Photographer **Exum**
Writer **Kevin Heldman**
Photo Editor **Jodi Peckman**
Publisher **Wenner Media**
Client **Rolling Stone**

Jay Leno

Design Firm **Rolling Stone, New York, NY**
Art Director **Fred Woodward**
Graphic Designers **Gail Anderson and Fred Woodward**
Photographer **Mark Seliger**
Writer **David Wild**
Photo Editor **Jodi Peckman**
Publisher **Wenner Media**
Client **Rolling Stone**

P.J. Harvey

Design Firm **Rolling Stone, New York, N**
Art Director **Fred Woodward**
Graphic Designers **Gail Anderson and Fred Woodward**
Photographer **Kate Garner**
Writer **Neil Strauss**
Photo Editor **Jodi Peckman**
Publisher **Wenner Media**
Client **Rolling Stone**

"The first year, I was perceived as the bad guy. People felt that Dave got screwed out of this job."

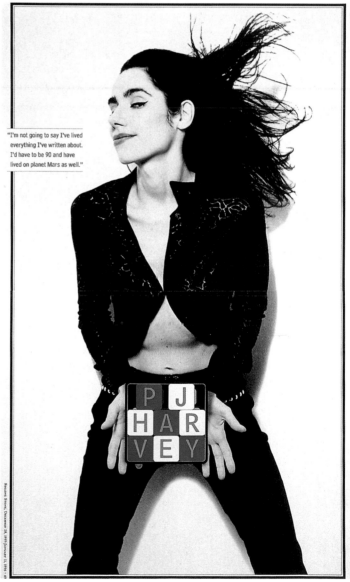

"I'm not going to say I've lived everything I've written about. I'd have to be 90 and have lived on planet Mars as well."

Smoke and Mirrors

These powerful graphic images were shot for a beauty feature in the *New York Times Magazine*. Their message, however, has less to do with makeup than it does with photography, manipulation, and style. The power and simplicity of the images, deriving from their focus on parts, called for simple, elegant typography. The strength here is in juxtaposition, and in what is left out.

Design Firm **The New York Times Magazine, New York, NY**
Art Director **Janet Froelich**
Graphic Designer **Lisa Naftolin**
Photographer **Matthew Rolston**
Stylist **Elizabeth Stewart**

Moby

Design Firm **Rolling Stone, New York, NY**
Art Director **Fred Woodward**
Graphic Designers **Lee Bearson and Fred Woodward**
Photographer **Amy Guip**
Writer **Lorraine Ali**
Photo Editor **Jodi Peckman**
Publisher **Wenner Media**
Client **Rolling Stone**

▶ BELOW

Drew Barrymore

Design Firm **Rolling Stone, New York, NY**
Art Director **Fred Woodward**
Graphic Designers **Geraldine Hessler and Fred Woodward**
Photographer **Mark Seliger**
Writer **Chris Mundy**
Photo Editor **Jodi Peckman**
Publisher **Wenner Media**
Client **Rolling Stone**

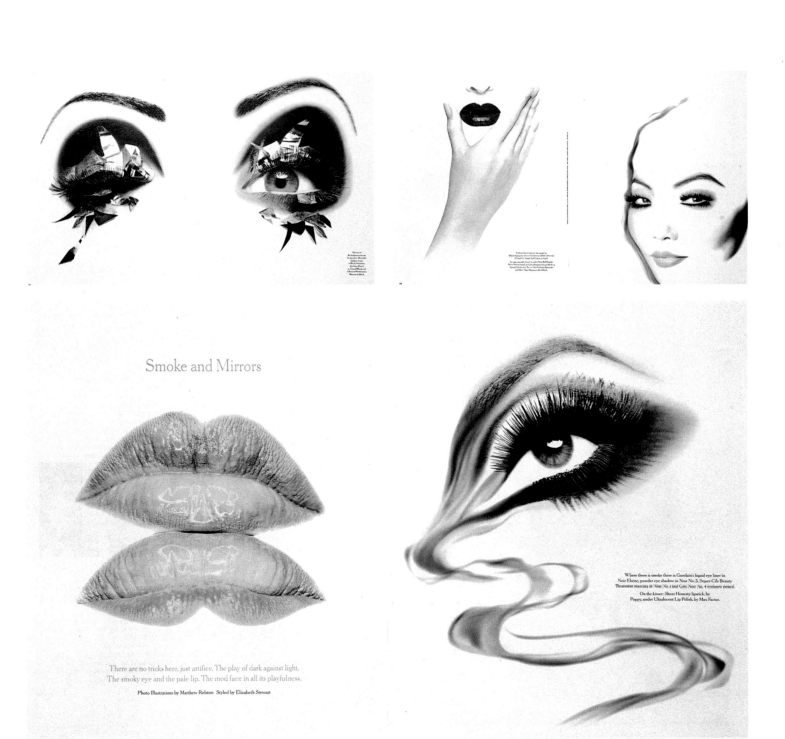

Smoke and Mirrors

There are no tricks here, just artifice. The play of dark against light.
The smoky eye and the pale lip. The mod face in all its playfulness.

Photo Illustrations by Matthew Rolston Styled by Elizabeth Stewart

Where there is smoke there is Guerlain's liquid eye liner in
Noir Ebène, powder eye shadow in Noir No. 5, Super-Cils Beauty
Treatment mascara in Noir No. 1 and Gris Noir No. 4 eyebrow pencil.
On the kisser: Sheer Honesty lipstick, by
Poppy, under Ultralucent Lip Polish, by Max Factor.

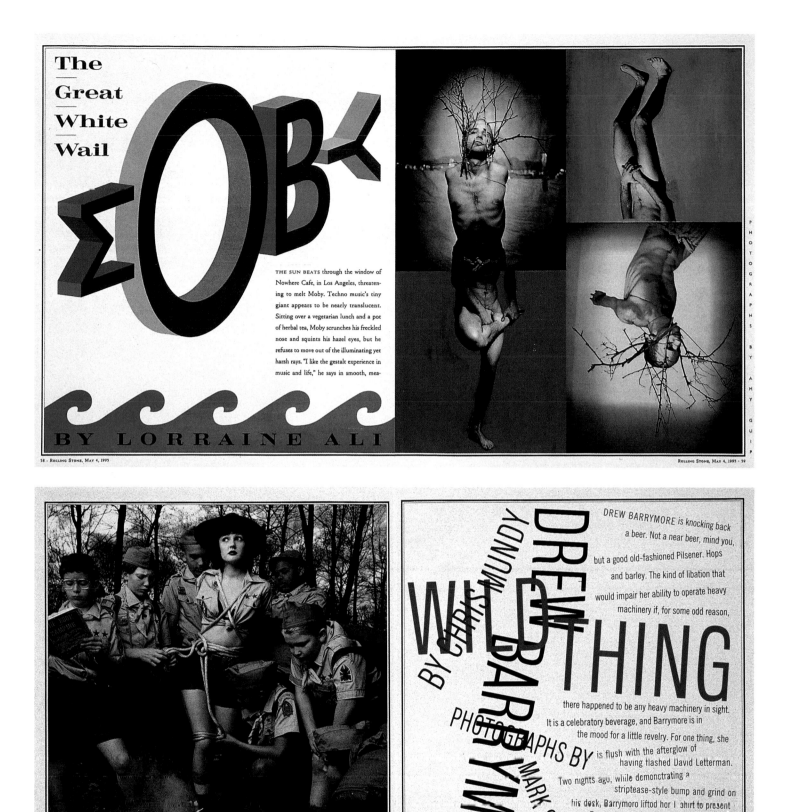

THE LAKE NEAR WEST 72D STREET, LOOKING WEST.

OASIS

In a steel-and-granite Sahara, Central Park is a watering hole for the people, a garden of earthy delights for both the observer and the observed.

PHOTOGRAPHS BY BRUCE DAVIDSON · TEXT BY PATRICIA VOLK

PEOPLE HAVE THEIR OWN WAYS OF USING CENTRAL PARK. SUMMERS it's for lovers, patzers, dreamers, cruisers, anglers, birders, foragers and practitioners of t'ai chi. Anything can happen. Here's proof: Once, playing with my friends near the 86th Street transverse, I looked up and saw a large brown handbag swinging from a tree. The reward was big enough for lunch at Schrafft's and a movie. In the monkey house at the old zoo, Caroline the gorilla spat at my grandmother and hit her in the face. (Caroline's cagemate was Jo Ann, *the same name as my older sister*.) The park is where, when my mother was 5, she buried Dickie, her pet canary, in a corn flakes box. Once, when there was a restaurant at Bethesda Fountain, I saw a man order an "arty-choky." He ate the whole thing, even the fur, with a knife and fork. Other,

more amazing summer encounters: Egrets that look as if they're posing for Audubon, Madonna, Bill Clinton and almost every old boyfriend I ever had. Central Park is where you want to be in love, or feel more in love if you already are. It's where you must, must be kissed. For years growing up, I thought the bridle path was where you went to get married. Eau de coconut oil, dental floss bikinis, Bruce Davidson (who's been taking pictures in the park for four years), four kinds of music in Ivesian overlap on a Kelly green beach, the miracle when you're little of discovering mica in Manhattan schist and lying on your back in the sun in the exact same place you steered your sled that winter. It's democracy in action. There's no palm to grease for a honey hole at the Harlem Meer. Central Park is an oasis in a steel-and-granite Sahara, the center

of the city that's the center of the universe. Once, when my son was sick, I opened his window and the sound of Simon and Garfunkel wafted in. Svengalistized, we got our bikes and went out into the night. The park was a party. Peter breathed cool air. By the time we got home, he was cured. Central Park is my gym, my Walden Pond, my $5 tennis club. Walking around the reservoir, I can't tell if what I'm hearing is a siren or a loon. We take from the park what we need. There's enough to go around — 843 acres and it's all ours.

Bruce Davidson is a New York-based photographer. These pictures are from "Central Park," to be published by Aperture in late October. Patricia Volk's last article for the Magazine was an entomological survey of her apartment.

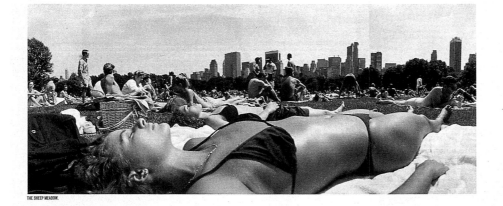

THE SHEEP MEADOW.

THE POOL AT WEST 100TH STREET.

THE RUSTIC SHELTER IN THE RAMBLE.

ALONG THE POOL NEAR WEST 100TH STREET AND CENTRAL PARK WEST.

PHOTOGRAPHS BY BRUCE DAVIDSON/MAGNUM

◀

Oasis

The photographer Bruce Davidson offered his book
to the *New York Times Magazine* for excerpting. We
chose a number of photographs for mood, heat, and
sheer pleasure. The image on the opening spread, a
hand's down favorite, conjures up childhood memories
of summer watering holes for everyone who sees it.
The typography, reflecting ideas about mirage, and the
desert oasis add the subtlety of color to a black-and-
white spread.

Design Firm **The New York Times Magazine,
New York, NY**
Art Director **Janet Froelich**
Graphic Designer **Joel Cuyler**
Photographer **Bruce Davidson**
Photo Editor **Kathy Ryan**

▼

Rwanda

Design Firm **Rolling Stone, New York, NY**
Art Director **Fred Woodward**
Graphic Designer **Fred Woodward**
Photographer **Sebastião Salgado**
Writer **Donatella Lorch**
Photo Editor **Jodi Peckman**
Publisher **Wenner Media**
Client **Rolling Stone**

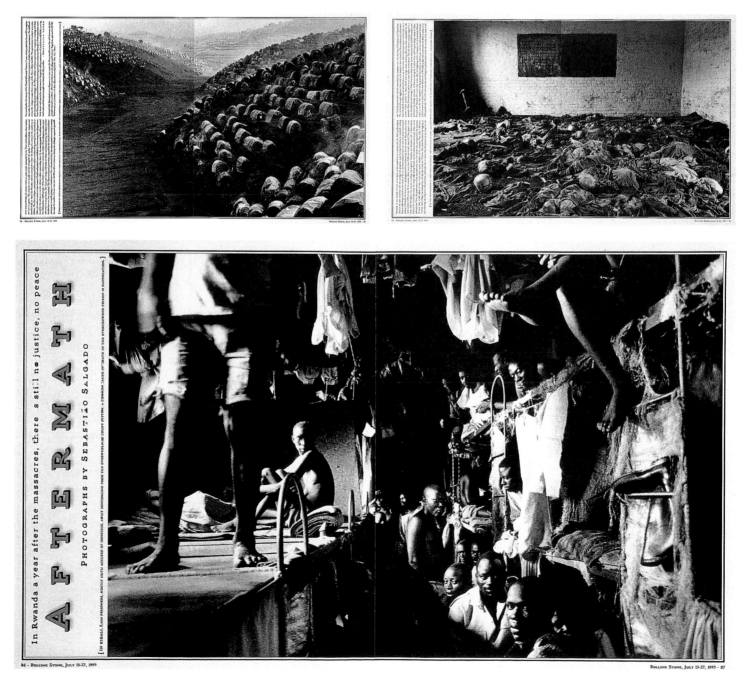

▲

Toad the Wet Sprocket "Dulcinea"
CD Extra

Design Firm **Sony Music Creative Services,**
Santa Monica, CA
Creative Director **Mary Maurer**
Graphic Designer **Mary Maurer**
Illustrator **Jason Holley**
Photographers **Dana Tynan and Michael Wilson**
Digital Graphic Artists **Sheldon Drake,**
Robert Sagerman and Nelson Wong
Additional Design **Hooshik and Christine Wilson**
Client **Columbia Records**

▼

Toad the Wet Sprocket "In Light Syrup"

Design Firm **Sony Music Creative Services,**
Santa Monica, CA
Art Director **Mary Maurer**
Graphic Designer **Hooshik**
Illustrator **Bill Barminski**
Photographers **Dana Tynan and Various**
Client **Columbia Records**

Triple Fast Action "Broadcaster"
10-Inch LP

Triple Fast Action is a brand-new alternative rock band signed to Capitol. Our mission was to find a unique way to introduce the group and conceptually base our direction on their title "Broadcaster." With no need to put a photo of an unknown group of guys on the cover, we tried to find simple, iconographic images that would relate to broadcasting. We chose different kinds of antenna for the regular CD package, from the classic television aerial silhouetted against a Technicolor sky to cockroaches, cootie bugs, and UFOs. We used a wonderful vintage photo as an alternative image for the triple 10-inch collectible vinyl version of the album for a special college radio promotion.

Design Firm **Capitol Records**
In-House Art Dept., Hollywood, CA
Art Director **Tommy Steele**
Graphic Designer **George Mimnaugh**
Photographer **Unknown (Archival)**
Printer **Erica Records**
Paper **12pt. SBS uncoated board**

Alice in Chains "Jar of Flies" CD Extra

Design Firm **Sony Music Creative Services,**
Santa Monica, CA
Creative Director **Mary Maurer**
Graphic Designers **Doug Erb, Jennifer Frommer,**
Mary Maurer, and Robert Sagerman
Photographers **Pete Cronin, Mark Leialoha,**
Rocky Schenck, and Marty Temme
Illustrator **Robert Sagerman**
Client **Columbia Records**

James Taylor "Best Live" CD Extra

Design Firm **Sony Music Creative Services,
Santa Monica, CA**
Creative Directors **Jennifer Frommer and
Stephanie Mauer**
Graphic Designers **Jennifer Dunn, Sheldon Drake,
Galo Moraus, Robert Sagerman, and Nelson Wong**
Illustrators **Jennifer Dunn, Sheldon Drake,
Galo Moraus, Robert Sagerman, and Nelson Wong**

► ABOVE

Alice in Chains

Design Firm **Sony Music Creative Services,
Santa Monica, CA**
Art Director **Mary Maurer**
Designer **Doug Erb**
Photographer **Rocky Schenck**
Client **Columbia Records**

► BELOW

**Ultra Lounge Limited-Edition
Promotional CD**

Capitol Records had an untapped musical archive in
the Ultra Lounge series. In its day the music was
romantic and full of sexual innuendo, yet the epitome
of bachelor-pad coolness. It is still cool today to a whole
new generation, as we're seeing in fashion, movies,
and clubs. Our job was to provide a unique and afford-
able way to showcase selections from this series.
Having named the series Ultra Lounge, what could be
more "ultra" than using fake fur and a plastic logo
on our packaging — seductive materials for seductive
music, even down to the martini olive on the CD itself.

Design Firm **Capitol Records In-House Art Dept.,
Hollywood, CA**
Art Directors **Andy Engel and Tommy Steele**
Graphic Designer **Andy Engel**
Illustrators **Andy Engel and Various**
Photographer **Don Miller, Capitol Archives**
Writer **R. J. Smith**
Printer/Fabricator **AGI**
Client **Capitol Records**

Ottmar Liebert "Opium" CD Extra

Design Firm **Sony Music Creative Services,**
Santa Monica, CA
Art Directors **Nancy Donald and Jennifer Frommer**
Graphic Designers **Jennifer Dunn, Galo Moraus,**
Robert Sagerman, and Nelson Wong
Illustrators **Jennifer Dunn, Hooshik, Galo Moraus,**
Robert Sagerman, and Nelson Wong

▲

Blind Melon – "Soup" Special Package

"Soup" was Blind Melon's second album, following
their first triple-platinum release. They have a large and
avid base of fans who collect singles, imports, and
anything special that the group endorses. After viewing
the cover photo we wanted to house the CD booklet
and disk in a classic protective menu cover that
you might find in some greasy diner. We produced a
special five-color CD label for this limited edition, to
give their audience more of a reason to buy this version.
Just a note: the man on the cover is the producer of
the record and the soup itself is a prop.

Design Firm **Capitol Records**
In-House Art Dept., Hollywood, CA
Art Directors **Jeffery Fey and Tommy Steele**
Graphic Designer **Jeffery Fey**
Photographer **Danny Clinch**
Printer/Fabricator **AGI**
Client **Capitol Records**

▲

Richard Thompson – "You? Me? Us?" CD

Our objective was to speak of Richard Thompson's artistry and integrity, while incorporating the album title conceptually into our graphics. We were also looking for ways to showcase an unadorned acoustic CD and an electric CD in the same package. The illustrator collaged the concept for the front cover while creating a portrait of Richard on the back to thread his Dadaist style throughout. The design had to reflect the same vernacular with restraint and spontaneity. Collages of type and a few illustrations and photos were made, hoping for no typos or revisions.

Design Firm **Capitol Records**
In-House Art Dept., Hollywood, CA
Art Directors **Jeffery Fey and Tommy Steele**
Graphic Designer **Jeffery Fey**
Illustrator **David Plunkert/Spur Design**
Photographer **Michael Wilson**
Printer **Queens Litho**
Client **Capitol Records**

Telling Stories to the Sea CD

The music is a compilation of Portuguese-influenced
music from the African islands of Cape Verde and Sao
Tome. We unified the wide range of different lyrics
and artists with a hole that is die-cut through the entire
booklet. A friend of mine (who reads more Taoists
than I do) suggested the central theme of the cover is
"nothingness."

Design Firm **Sagmeister Inc., New York, NY**
Art Director **Stefan Sagmeister**
Graphic Designers **Veronica Oh and**
Stefan Sagmeister
Illustrator **Indigo Arts**
Photographer **Tom Schierlitz**
Copywriters **David Byrne and Morton Marks**
Printer/Fabricators **WEA/Ivy Hill**
Paper **20# Coated**
Client **Warner Bros. Records Inc.**

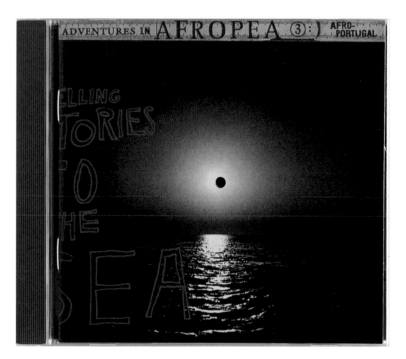

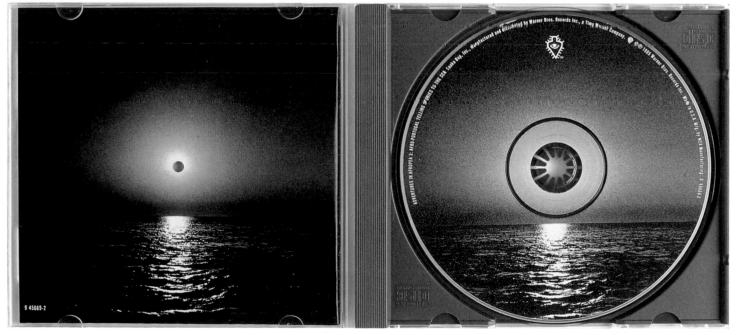

Bettmann Screen Saver

Where else would Nixon and Honest Abe meet face to face? The objective was to define and develop a promotional vehicle that would revitalize Bettmann and emphasize their unique status in the minds of its existing client base. CSA came up with a screen saver that is an animated collage using twenty portraits from the archives. When the facial features are randomly combined, they create over 160,000 humorous and bizarre compositions. The concept and design communicate the Archives — exposing "a few of the faces and the thousands of possibilities at Bettmann" — and make Bettman relevant to the contemporary creative process. The promotion embraces new technology with a cost-effective solution: the animated collage format requires minimal memory and allows for maximum variety and content.

Design Firm **Carbone Smolan Associates, New York, NY**
Art/Creative Director **Ken Carbone**
Graphic/Interface Designer **Justin Peters**
Photographers **Various**
Copywriter **Justin Peters and Dan Pierce**
Paper **18pt. Solid Bleached Sulfate (SBS)**
Client **Bettmann Archives**

VizAbility CD-ROM

VizAbility is an interactive CD-ROM developed by MetaDesign with authors Kristina Hooper Woolsey, Scott Kim, and Gayle Curtis. Based on a Stanford course by Bob McKim, it guides users through exploratory seeing, drawing, and diagramming exercises to enhance their natural visual abilities. It encourages new ways of thinking, imagining, and communicating.

Design Firm **MetaDesign. San Francisco, CA**
Creative Director **Terry Irwin**
Interface Designer **Jeff Zwerner**
Writers **Gayle Curtis, Kristina Hooper Woolsey, and Scott Kim**
Programmer **Marabeth Harding**
Client/Publisher **PWS Publishing**

Block Builder
Introduction

Spatial visualization is a complex skill, useful not only for solving puzzles but for tackling many real-world tasks. Learn to visualize three-dimensional patterns in this shadow-casting Block Builder game.

Hidden Pictures
Color

Find the small piece in the big picture and click on it.

CBO Interactive Premiere

Featuring a synergistic blend of technology and imagination rarely seen in today's CD-ROM, CBO Interactive Premiere is a full audiovisual tour, spotlighting the firm's impressive body of work for major motion picture studios, music labels, television, and cable networks.

Design Firm **CBO Multimedia, Hollywood, CA**
Creative Director **Jill Taffet**
Interface Designer **Jill Taffet**
Digital Artists **Luke Davis, Connie Nakamura, and Robert Vega**
Photographers **Eric Toeg and Various**
Writers **Michael Caldwell and Taylor Negron**
Programmer **John Peterson**
Client **Cimarron, Bacon, O'Brien**

Gearheads CD-ROM

A rhizome is a plant that grows in a horizontal, open-ended fashion like grass, as opposed to a vertical, hierarchical structure like a tree. Our "rhizomatic" approach to software design builds complexity from the ground up with simple rules that can be combined in an infinite variety of ways. The surprising and intricate play of Gearheads emerges from the interactions between the dozen independent characters, giving the game experience fast reflex action, subtle strategic depth, and genuine originality.

Game Concept & Design **Frank Lantz and Eric Zimmerman**
Technical Director **Daniel Reznick**
Programmers **Ephraim Cohen and Mart Nilsen**
Designers **Brian Loube, Karen Sideman, and David Zung**
3-D Computer Graphics **Marl Voelpel and Various**
Music & Sound **Michael Sweet/Elias Associates**
Art & Animation **Susan Brand Studios**
Background Artist **Eleanor Shelton**
Logo Design **Laura Williams**

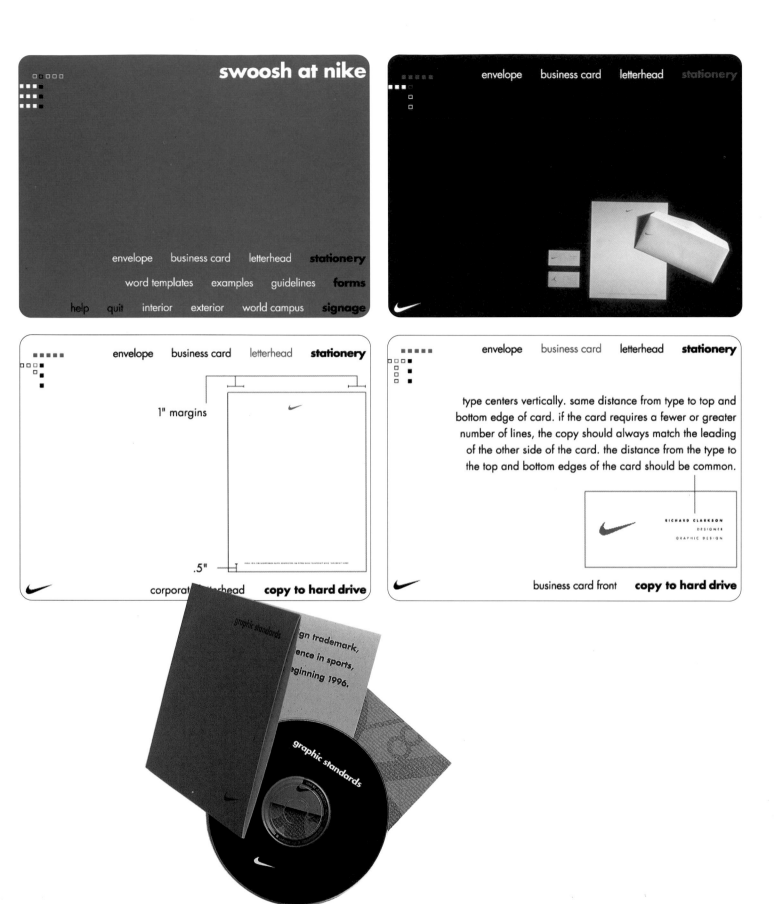

Nike New Corporate Identity Launch

Design Firm **Nike Design, Beaverton, OR**

Art Director **Ron Dumas**

Graphic Designers **Ron Dumas and Clark Richardson**

Photographer **Gary Hush**

Writer **Bob Lambie**

Interface Designer **Christa Panfilio**

Client **Nike, Inc.**

California Institute of the Arts
25th Anniversary CD-ROM

The CD-ROM set out to show CalArts' 25-year history while grounding it firmly in the design context of the present day. The mix of archival material, recent work, and video-bites was intended to be energetic and enticing to the visually literate audience. It succeeds on the level of communication graphics by being easily accessible, organized, and methodical, while still leaving room for user exploration, humor, and discovery. Its strength lies in its tone of voice. The design is content-specific rather than offering a universal interface solution.

Art Director **Michael J Worthington**
Graphic and Interface Design **Deborah K. Littlejohn and Michael J. Worthington**
Animators **Various**
Photographers **Bryan Bailey, Steve Gunther, and Rachael Slowinski**
Digital Video **Farzad Karimi and Michael J. Worthington**
Programmer **Michael J. Worthington**
Sound Editors **Hunter Ochs and Michael J. Worthington**
Publisher **CalArts**
Client **Office of Public Affairs, CalArts**

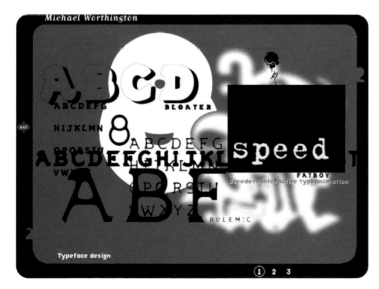

Adobe Graphics Sampler CD

The Adobe Graphics Sampler CD was created to showcase Adobe's graphics products in a visually rich environment created with the software itself. The CD was intended to get current and prospective customers excited about the products by showing them the artwork and digital videos of professionals who use our software. We chose a jazz theme partly because it was fresh and interested us but also because the design and layout of the great fifties album art made for a clean yet fascinating interface, while not interfering with the information.

Design Firm **Adobe Creative Services,
Mountain View, CA**
Art Director **Gail Blumberg**
Graphic Designer **Jonathan Caponi**
Digital Video Producer **eMotion Studios**
Programmer/Producer **Ethan Diamond**
Sound Editor/Original Music **Andrew Diamond**
Client **Adobe Systems Inc.**

volume **1** A COLLECTIVE IMPROVISATION BY THE ADOBE ALL STAR QUARTET **volume 2** PREMIERE STRAIGHT AHEAD **volume 3** PAGEMAKER COOL **volume 4** PHOTOSHOP SOUL CLINIC **volume 5** ILLUSTRATOR JAM SESSION

FontBoy Interactive Catalogue

FontBoy doesn't have the money or the inclination to be in the catalogue printing business. Thus, we created an interactive, screen-based catalogue that allows the viewer to see and print out bitmapped samples of fonts, get ordering information, and find out about future releases — all within a warm, fuzzy environment of goofy colors, witty words, and funny sounds. The catalogue is small enough to fit on one high-density floppy disk, allowing for easy distribution of the project and ensuring quick downloading.

Design Firm **Aufuldish & Warinner, San Anselmo, CA**
Art Director **Bob Aufuldish**
Graphic Designer **Bob Aufuldish**
Writer **Mark Bartlett**
Programmer **Dave Granvold**
Sound Editor **Bob Aufuldish**
Sound Designers **Bob Aufuldish and Scott Pickering**
Font Designers **Bob Aufuldish, Eric Donelan,
and Kathy Warinner**
Client **FontBoy**

▲

Soul Coughing Interactive Press Kit

The design challenges for this project were to fit all the
material requested by the client into one 1.4M floppy
disk, and to project the band's wacky, over-the-top per-
sonality with multiple layers of animation and loud typog-
raphy. The graphics were kept simple and bold. All type
was bitmapped instead of dithered, and photographic
imagery was used at low resolution. Large text blocks of
information were stored off to the side of each major
screen (where they can be dragged into view if desired)
and by using a pop-up interface on each screen. When
the cursor is moved around, small hidden typographic
animations and other images appear.

Design Firm **Aufuldish & Warinner, San Antonio, CA**
Creative Director **Jeri Heiden**
Art Director **Kim Biggs**
Graphic Designer **Bob Aufuldish**
Illustration **Steven Wacksman and Warner Brothers**
Photographers **Anthony Artiaga, Annalisa,**
Bob Aufuldish, and Warner Brothers
Interactive Programmers **Bob Aufuldish and**
David Karam

Knoll Propeller

This interactive presentation was used to launch Knoll's Propeller tables at Westweek, the industry's annual promotional event. The design objective was to complement Knoll's long-standing successful visual identity and add interactive multimedia to their design vocabulary. The product's designer, Emmanuela Frattini, contributed her own sketchbook and video accounts. Existing photography was used in large part, copy was limited to focus the marketing message, and animations were created to communicate the advantages of the Propeller tables in a wired and constantly changing workplace.

Design Firm **Burnett Group, New York, NY**
Creative Director **Lisette Buiani**
Interface Designer **Mike Grisham**
Animator **Geoff Atkins**
Photographer/Writer **Knoll, Inc.**
Digital Video Producer **Geoff Atkins**
Programmer/Sound Editor **Geoff Atkins**
Client **Knoll, Inc.**

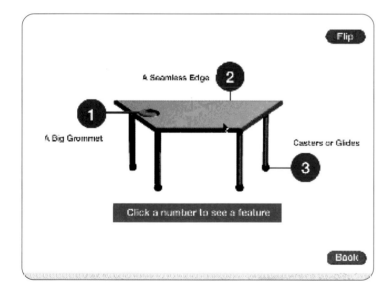

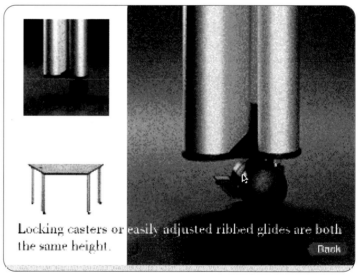

Locking casters or easily adjusted ribbed glides are both the same height.

Emanuela Frattini

Discovery Channel Online Website

Discovery Channel Online is committed to programming deep, original non-fiction entertainment exclusively for a Web audience. It is our belief that the Web could become the fourth mass medium, are investing seriously in creating daily entertainment that can build and sustain a large, loyal, and ultimately demographically desirable audience. The content is created for an audience interested in science, nature, history, technology, and new media. New stories in a variety of presentation formats are added every day to encourage return visits. Overall unity of the site is achieved by using consistent typography and an intuitive navigational scheme.

Design Firm **Discovery Publishing, Bethesda, MD**
Creative Director **John Lyle Sanford**
Art Director **Lisa Waltuch**
Graphic Designers **Irwin Chen, Brian Frick, Britt Funderburk, Jessica Helfand, John Lyle Sanford, and Chris Sprouls**
Photographers **Ole Brask, Scott Goldsmith, and Various**
Photographer **Sovfoto/Eastfoto**
HTML Progammers **Christine Brumback, Jeanna Scheirer, and Lori Wark**
Website Architect **Jim Jones**
Publisher **Discovery Communications, Inc.**

Levi's Website

The Levi's website provides young adults ages 18-24 with a hip forum for exploring contemporary lifestyle trends in fashion, popular culture, and history. The strategy was to create an environment that combines provocative design and intuitive interface. The site design engages the participant and provides accessible navigation for massive amounts of information.

Design and Production Company
R/GA Digital Studios, Inc.
Creative Directors **Tim Price and Jakob Trollbeck**
Art Director **Samantha Osselaer**
Designers **Sasha Kurtz, Jeremy Lasky, and Antoine Tinguely**
Digital Artist **Isaac Ruben**
Producer **Todd Moritz**
Copywriters **Tracy Cohen and Martin Lauber**
Executive Producer **Brian Loube**
Client **Foote Cone & Belding, San Francisco**

Get inside The Fly Zone for a closer look at what's up all over the world. From the inner-city art of graffiti to anything else we think of, live, learn and sound like you know what you're talking about just by getting in 'The Zone.'

INNER SEAM

Dear Diary
Scrapbook
Spike Jonze
Media Gallery

How do they come up with that amazing advertising? If you're dying to know, we put some answers in our "501 Reasons" Diary and Scrapbook. See what super-hype director Spike Jonze has to say about his own "reason." Check out some finished product in the Media Gallery.

501 501 **501** 501 501

Fashion Institute of Design and Merchandising Website

Seeking new ways to position itself as a global competitor among fashion schools and to offer its research resources to the fashion industry, the Fashion Institute of Design & Merchandising turned to the World Wide Web. We built a website that's easy to navigate and easy to expand — with a look that's distinctively FIDMs.

Design Firm **Maddocks & Company LA/NY**
Creative Director **Mary Scott**
Graphic Designers **Lawrence Azerrad, Paul Farris, and Charles Field**
Photographer **Brad Lansil**
Copywriter **Eric LaBreque**
Programmer **Charles Field**
Client **The Fashion Institute of Design Merchandising**

Hal Apple Design, Inc. Website

To meet our goal of offering website design to our clients, we designed our own site. The five-month process included training, surfing, designing, and more surfing. From babies to brontosauri, the Hal Apple Design website offers an intriguing glimpse into multimedia ingenuity, as well as a few surprises, including a free beverage. Our website demonstrates successful design, programming, and navigational clarity while avoiding a tiring portfolio review. The process enabled us to expand our capabilities into website design with confidence and receive significant immediate and future interactive projects.

Design Firm **Hal Apple Design, Inc., Manhattan Beach, CA**
Art Director **Hal Apple**
Graphic Designer **Alan Otto**
Interface Designer **Rebecca Cwiak**
Photographers **Hal Apple, Doug Cwiak, Rebecca Cwiak, and Jason Ware**
Writers **Jamie Apel, Hal Apple, Rebecca Cwiak**
Programmer **Rebecca Cwiak**
Client **Hal Apple Design, Inc.**

The Fashion Institute
of Design & Merchandising

FIDM

FIDM at a Glance

CONTENTS
FIDM calendar
help & map
guestbook

© FIDM 1996

MAJORS

At FIDM, majors are geared to actual job categories in the fashion and interior design industries. No other college offers curricula as responsive to fast-paced changes in the real world. Please call 1 (800) 711-7175 (California and USA), 1 (213) 624-1201 (Internationally), email us at "info@fidm.com" or fax 1 (213) 622-9643 for more information.

- Apparel Manufacturing Management
- Cosmetics and Fragrance Merchandising
- Fashion Design
- Fashion Merchandise Development
- Fashion Merchandise Management
- Interior Design
- International Manufacturing and Product Development
- Textile Design
- Theater Costume
- Visual Presentation & Space Design

Resource Center

CONTENTS
global calendar
help & map
guestbook

© FIDM 1996

A Feast of Fashion and Interior Design

Imagine what it would be like to step into the shoes of Marlene Dietrich. Tip the top hat of Fred Astaire. Don Rudolph Valentino's suit of lights...

...Examine the apparel, accessories and artifacts of the First Families of California as well as regional costumes from around the world...

...And supplement this visual wonderment with additional specialized divisions housed in the FIDM Museum and Library Foundation...

ALUMNI & student work

alumni in focus

President's Message & Advisory Board

John Cole

What's New

Resource Center

FIDM at a Glance

Gallery

Contents

global calendar
help & map
guestbook

Additional alumni Ha Nguyen & Marlene Stewart are featured in the Gallery.

"If you can get through FIDM, you can take on anything."
Pam Lewis, Costume Design

"I really enjoyed my time at FIDM because I felt everyone was on the same wavelength."
James Ballante, Visual Presentation

"The instructors were very approachable and gave me so much support. That really helped build my self-esteem and confidence!"

FIDM
© FIDM 1996

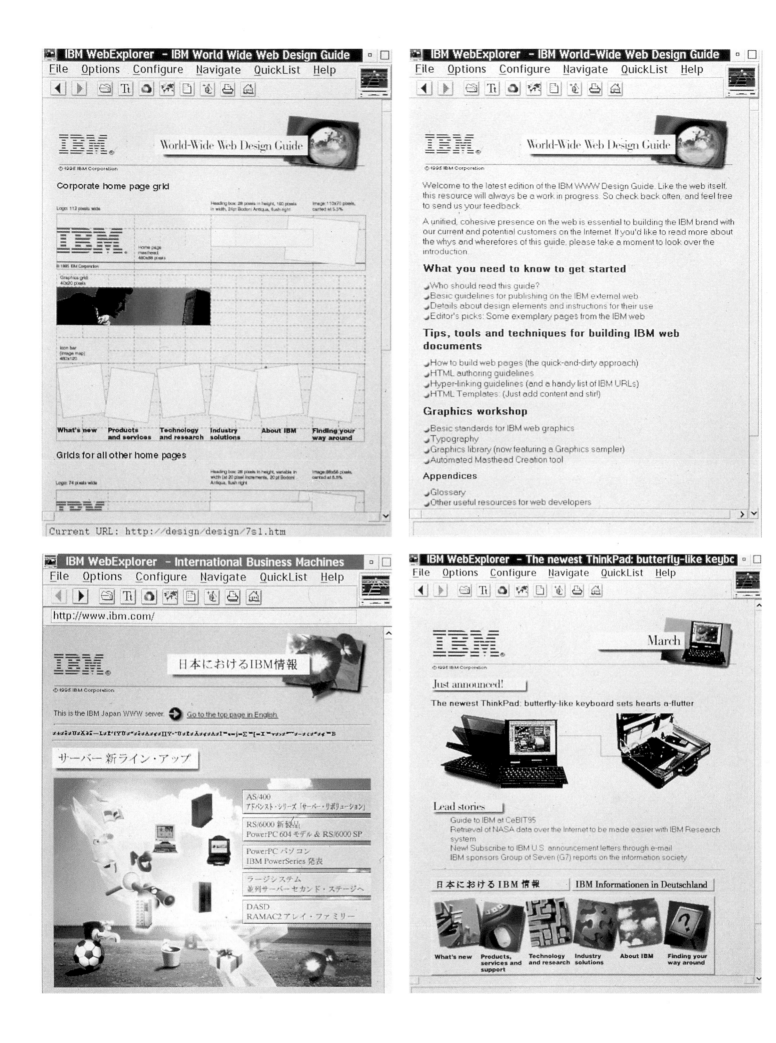

IBM Internet Website Design Guideline

Design Firm **C3 Inc., New York, NY**
Creative Director **Randall Hensley**
IBM Graphic/Interface Designers **Lee Green**
and Lori Neuman
Client **IBM Corporate Design**

Toad the Wet Sprocket
"Semper Absurdim: House of Toad"

Design Firm **Sony Music Creative Services,**
Santa Monica, CA
Creative Director **Mary Maurer**
Graphic Designer **Mary Maurer**
Illustrators **Bill Barminski and Jason Holley**
Photographers **Dana Tynan, Michael Wilson,**
and Various
Additional Design **Hooshik and Christine Wilson**
Client **Columbia Records**

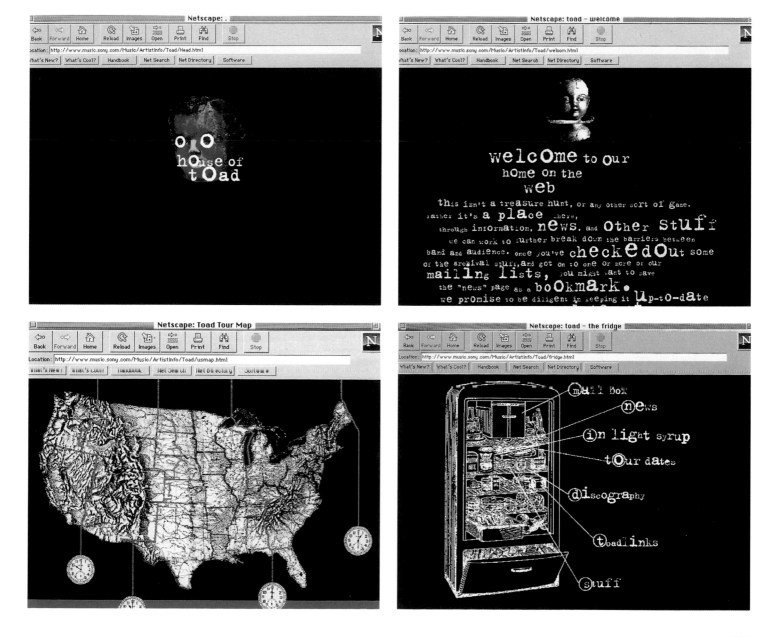

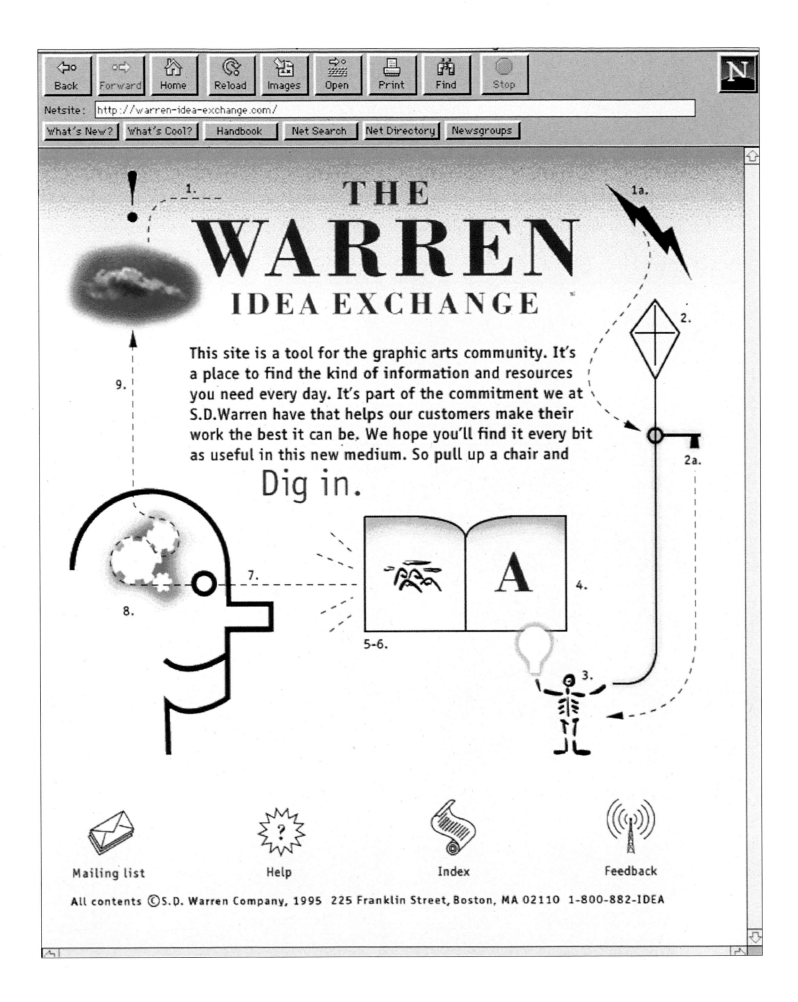

THE WARREN
IDEA EXCHANGE

This site is a tool for the graphic arts community. It's a place to find the kind of information and resources you need every day. It's part of the commitment we at S.D. Warren have that helps our customers make their work the best it can be. We hope you'll find it every bit as useful in this new medium. So pull up a chair and

Dig in.

Mailing list

Help

Index

Feedback

All contents ©S.D. Warren Company, 1995 225 Franklin Street, Boston, MA 02110 1-800-882-IDEA

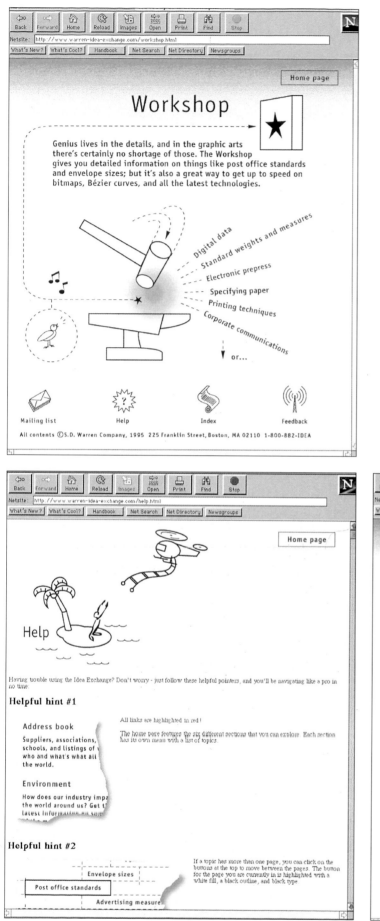

Workshop

Genius lives in the details, and in the graphic arts there's certainly no shortage of those. The Workshop gives you detailed information on things like post office standards and envelope sizes; but it's also a great way to get up to speed on bitmaps, Bézier curves, and all the latest technologies.

Digital data
Standard weights and measures
Electronic prepress
Specifying paper
Printing techniques
Corporate communications
or...

Mailing list Help Index Feedback

All contents ©S.D. Warren Company, 1995 225 Franklin Street, Boston, MA 02110 1-800-882-IDEA

S.D. Warren Website

S.D. Warren has always served as a source of information and inspiration for the graphic arts community, and we strove to create an on-line environment supporting that reputation. The site offers useful resources in a playful manner. Line art was used because it is inexpensive, quick to create, and the image size is reasonable. Color palettes were limited to three or four bits, and a seemingly large background pattern was cleverly created with a mere ten pixels. The site complements our print work for S.D. Warren, but it has a life — and a personality — all its own.

Design Firm **Siegel & Gale, New York, NY**
Creative Director **Cheryl Heller**
Design Director **Patrick O'Flaherty**
Designers **Tony Hahn and Alex Ku**
Illustrator **Barnes Tilney**
Project Manager **Evan Orensten**
Software Designers **Kathleen Dolan, Tom Elia, and Andrew Zolli**
Client **S.D. Warrren Company**

Help

Having trouble using the Idea Exchange? Don't worry - just follow these helpful pointers, and you'll be navigating like a pro in no time:

Helpful hint #1

Address book
Suppliers, associations, schools, and listings of who and what's what all the world.

Environment
How does our industry impa the world around us? Get t latest information on som

All links are highlighted in red !

The home page features the six different sections that you can explore. Each section has its own menu with a list of topics.

Helpful hint #2

Envelope sizes
Post office standards
Advertising measure

If a topic has more than one page, you can click on the buttons at the top to move between the pages. The button for the page you are currently in is highlighted with a white fill, a black outline, and black type

THE WARREN
IDEA EXCHANGE

Address book
Suppliers, associations, schools, and listings of who's who and what's what all over the world.

Environment
How does our industry impact the world around us? Get the latest information on some of the most important issues facing us today.

Workshop
Our unique collection of technical and educational materials. All designed to make your job a little easier.

The Idea Exchange
Where to turn for ideas. Over 10,000 samples available to provide creative inspiration and spark new ideas in over 120 categories of design and production. A free service.

Printers' forum
Important information for everyone in the printing industry.

S.D. Warren and Sappi
Our company, our products, and where you can find us.

WARREN
A Sappi Group Company

S.D. Warren, a member of the Sappi Group, is the largest manufacturer of coated free-sheet paper in the world. You can see our products everywhere—in the highest quality magazines, catalogs, books, annual reports, and other brochures.

Mailing list Help Index Feedback

MTV Online Where's the Beat? Web Page

Where's the Beat? is original content on MTV Online. This site offers a database of music information for cities throughout the USA. Users can locate record stores, clubs, and radio stations by selecting a city. This page shows a 3-D model of the United States texture-mapped by a photo of a sirloin steak. The humorous elements of the page serve to entertain the users as they browse through an otherwise boring database. With a cool interface design, the sometimes arduous task of information gathering can be less boring and maybe even fun for the user.

Design Firm **MTV Online, New York, NY**
Creative Director **Allie Aberhardt**
Art Director **Manabu Inada**
Graphic Designer **Josh Nichols**

MTV Online Buzz Clips

MTV Online's Buzz Clips page contains downloadable music video clips from MTV's on-air program "Buzz Clips." The page shows an abstract image of a honey bee, which obviously brings to mind the buzzing sound of a bee, but also symbolizes the buzz sound associated with TV static. It is a comparison between technology and animal instinct. The concept was influenced by various cyberpunk novels and movies. The metallic and mechanical shape of the bee was made using 3-D computer graphics and photocollage. The graphic elements serve to emphasize the futuristic qualities of the visual concept.

Design Firm **MTV Online, New York, NY**
Creative Director **Allie Aberhardt**
Art Director **Manabu Inada**
Graphic Designer **Manabu Inada**

MTV Online Hot Spot Web Page

One of the most popular and important pages on MTV Online, the Hot Spot page promotes what is hot and new on MTV's website, changing daily with new information. The home page shows an eyeball engulfed in a ring of fire, merged with a computer chip. Conceptually, the page design combines images of technology with images influenced by Eastern religions. This future-primitive vision with its intense, computer-generated graphics provide strong impact when a user visits the page.

Design Firm **MTV Online, New York, NY**
Creative Director **Allie Eberhardt**
Art Director **Manabu Inada**
Graphic Designer **Manabu Inada**

▼

M.A.D. Website

This site is M.A.D.'s portfolio. The on-line medium
allows worldwide viewing instantaneously, which
is convenient for M.A.D.'s potential clients, who
need to see things immediately. The site is bold
and visually compelling so that the viewer can get
a broader sense of the studio rather than just a
repetitive list of images.

Design Firm **M.A.D., Sausalito, CA**
Creative Director **Patricia McShane**
Graphic/Interface Designer **Patricia McShane**
Illustrators/Animators **Erik Adigard and**
Patricia McShane
Host **Woodwind.com**
Programmer **Patricia McShane**
Publisher/Client **M.A.D.**

Funnel Website

Funnel is conceived as a "virtual sandbox" for experimental art and graphic design. This kinetic website project is a collaboration between writers, programmers, designers, and artists. The Funnel site isn't just for show, either. VI'R'US, as this edition of Funnel's digital display is called, tackles the risky theme of contagion in the modern world.

Design Firm **M.A.D., Sausalito, CA**

Art Directors **Erik Adigard and Patricia McShane**

Graphic/Interface Designers **Erik Adigard and Patricia McShane**

Illustrators/Animators **Erik Adigard, Laurence Arcadias, Lindsay Garavette, and Patricia McShane**

Writer **Ken Coupland**

Host **Woodwind.com**

Programmers **Erik Adigard, Dave Granvold, and Patricia McShane**

Sound Editor **Erik Adigard**

Publisher/Client **M.A.D.**

Access Factory Website

The website showcases the work and philosophy of
Access Factory, with a keyhole serving both as a sym-
bol of the firm and as a navigational device. The site
features an "Aspects of Access" gallery of visual puns,
the company manifesto, on-line interactive proposal
request forms, a portfolio of work, and senior staff bios.

Design Firm **Access Factory Inc., New York, NY**
Creative Director **Baruch Gorkin**
Interface Designer **Baruch Gorkin**
Programmer **Leonid Dubinsky**
Client **Access Factory Inc.**

Divon Furniture Website

This on-line furniture catalogue features an experimental interface that enables the user to interact quickly and intuitively with the displayed information.

Design Firm **Access Factory Inc., New York, NY**
Creative Director **Baruch Gorkin**
Interface Designer **Baruch Gorkin**
Programmer **Leonid Dubinsky**
Client **Divon Furniture Manufacturer**

ESPN/ESPN2 Extreme Games

The Extreme Games are an Olympic-style competition that focuses on unconventional sports: bungee jumping, sky surfing, street luge, skateboarding, mountain biking, sport climbing, windsurfing, in-line skating, and eco challenge. To convey the edgy nature of the games and reflect the attitude of the participating athletes, we used a deconstructed font combined with images of equipment and live-action shots. Animations were organized into event "pods," which are a series of nine openers and related graphics for each discipline. The logo, pods, openers, and hallmark identity created a cohesive look for the Extreme Games, while reflecting the styles of ESPN and ESPN2.

Design Firm **PMcD Design, New York, NY**
Creative Director **Patrick McDonough**
Graphic Designer **Steve Tozzi**
Digital Video Producer **John Lennon**
Client **ESPN2 — Nonbar Stone**

◄ BELOW

ESPN2 College Football

The College Football "Bracket"/Open is an extension of the on-air look PMcD Design developed for the launch of ESPN2, reflective of its positioning as the wilder younger son of ESPN. It maintains the network look and incorporates a progression of the 2 logo.

Design Firm **PMcD Design, New York, NY**
Creative Director **Patrick McDonough**
Graphic Designer **Steve Tozzi**
Photographer **Pat Donnelly**
Editor **Patrick Inmofer**
Digital Video Producer **John Lennon**
Client **ESPN/ESPN2 — Nonbar Stone**

Cut to the Chase Show Opener

Cut to the Chase was intended for the E! viewer with a sense of humor who loves the early film classics, but never has time to watch them. The demographic is fairly broad (ages 18-49, both male and female), so the graphics and program needed mass appeal. This show opener emulates the concept behind E!'s on-air program *Cut to the Chase*, which offers a fast-forward comic condensation of a classic movie feature. The visuals are playful and reiterate the idea of film being cut. Dancing scissors remind the viewer of the Busby Berkeley era. Heavy film sound conventions were also emphasized in the audio track. Overall, we kept the animation simple and approchable to a wide audience.

Design Firm **E! Entertainment Television, Los Angeles, CA**
Creative Director **Andy Hann**
Graphic Designer **Ulrike Kerrer**
Animators **Lyndon Barrios, Electric Filmworks, Inc., and Tony Venezia**
Digital Video Producer **Karin Rainey**
Music **Elyse Schiller, Shake-a-Leg Productions**
Client **E! Entertainment Television**

Turner Classic Movies:
Director of the Month

Turner Classic Movies Director of the Month series
is aimed at film buffs and features the work of various
directors. The title sequence introduces each program.
The creative strategy was to reflect the golden age
of film titles, both in composition and the style of anima-
tion - to make it look as if the sequence was shot thirty
years ago on film, yet give it a contemporary edge.

Design and Production Company **R/Greenberg**
Associates, Inc., New York, NY
Creative Director **Glenn Kesner**
Art Directors **Shannon Davis Forsyth and John DiRe**
Designers **Jeremy Lasky and Antoine Tinguely**
Editor **David Elkins**
Producer **Mary Maffei**
Client **Turner Classic Movies**

Seven: Main Titles

The film *Seven* is a psycho thriller about a serial
murderer. Our goal in designing the main titles was to
simultaneously rivet and repulse viewers with glimpses
of the killer's handiwork. The creative strategy was to
shoot a sequence that looked as good as the movie
itself and visually conveyed the obsessive dementia of
a criminal psychotic. The title sequence intrigues the
audience and sets the edgy tone for the film.

Design Firm **R/Greenberg Associates, Inc.,**
New York, NY
Director **David Fincher, Propaganda Films**
Graphic Designers **Kyle Cooper and Jennifer Shainin**
Music **Nine-Inch Nails**
Editor **Angus Wall**
Director of Photography **Harris Savides**
Producers **Peter Frankfurt and Steven Puri**
Special Image Engineer **Findlay Bunting**
Client **New Line Cinema**

Partnership For a Drug-Free America Video

Design Firm **Frankfurt Balkind Partners, New York**
Creative Directors **Aubrey Balkind, Andreas Combuchen, and Kent Hunter**
Graphic Designers **Arturo Aranda and Yoo Mi Lee**
Photographer **Deena DelZotto**
Copywriter **Michael Clive**
Digital Video Producer **Valerie Edwards**
Sound Editor **Elias Music**
Client **Partnership For a Drug-Free America**

Mayfly Thirteen-Hour Sale

What if television were controlled by the people who made those science film strips in elementary school? This was the concept. Since the budget was small, we scrimped on everthing but the Flame we used to put it together. Artists never created those film strips, so we tried not to be artistic, and ended up with a negative of an image, in a sense — where bad is actually good.

Design Firm **DH-DSD Advertising, Minneapolis, MN**
Art Director **Ross Phernetton**
Graphic Designer/Writer **Walter Pitt**
Animator **Jake Parker**
Digital Video Producer **Lamb & Co.**
Sound Editor **Ken Brahmstedt**
Client **Marshall Field's**

MEXICO CITY 1968

TOKYO 1964

FOR THE FANS

FOR THE FANS

Always

Archival photos reveal Coca-Cola's long-standing popularity with Olympics fans. The word "Always" in red type at once activates the product and signage and implicitly reiterates Coca-Cola's relationship with the Olympic Games.

Design Firm **Wieden & Kennedy, Portland, OR**
Creative Directors **Todd Waterbury and Peter Wegner**
Directors **Mark Hensley and Donna Pittman**
Copywriter **Peter Wegner**
Client **The Coca-Cola Company**

Rings

Coca-Cola's historical relationship with Olympics fans is realized in archival images of past games. Product and signage are located by a red ring, which graphically evokes both the Olympic rings and the red Coca-Cola icon.

Design Firm **Wieden & Kennedy, Portland, OR**
Creative Directors **Todd Waterbury and Peter Wegner**
Directors **Mark Hensley and Donna Pittman**
Photographers **Various**
Copywriter **Peter Wegner**
Client **The Coca-Cola Company**

Nike Super Show 1996

The Super Show in Atlanta is Nike's platform for show-casing our newest product and initiatives for the coming year. In 1996 the Nike Design Team designed an environment to highlight the company's technologies for the season. The experience began with a ten-minute film projected onto a 300-foot screen, which becomes transparent to reveal the four focus pavilions that lay beyond. The pavilions were designed to display product and information and were styled to capture the emotion and essence of each category and technology.

Design Firm **Nike Design, Beaverton, OR**
Art Director **John Hoke**
Design Team **Richard Elder, Greg Hoffman, David Poremba, Danny Rosenberg, Chuck Roth, and Valerie Taylor-Smith**
Writers **Bob Lambie and Stanley Hainsworth**
Producers **Allan Brabo, Trish Fitzpatrick, and Sara Thurman**
Fabricators **IDEAS/Exhibit Group**
Client **Nike, Inc.**

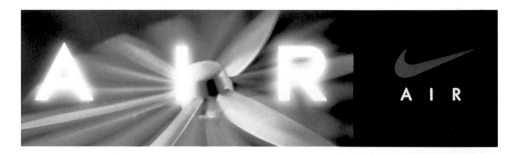

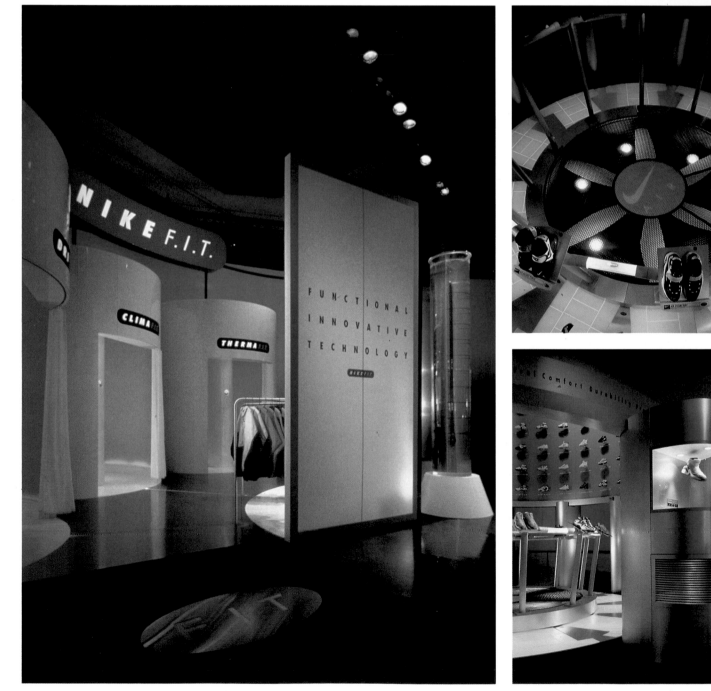

▲

Fusion Restaurant Environment

Fusion at PDC is a high-end restaurant located in the
Pacific Design Center in L.A. The restaurant's name
and design concept refer to the multicultural fusion of
ideas and traditions that are specific to Southern
California. All aspects of the project, including identity,
signage, interior color and material, dinnerware, and
packaging were kept simple and honest, in counterpoint
to the clutter and ornamentation of competing area
restaurants. The project proved that the audience
of designers, architects, actors, producers, and agents
was more than ready to accept a solution based on
good, unpretentious design.

Design Firm **Adams Morioka, Inc., Beverly Hills, CA**
Creative Directors **Sean Adams and Noreen Morioka**
Graphic Designers **Sean Adams, Noreen Morioka,**
Jim Rehberger, and Richard Shanks
Architect **Raw Architecture**
Typographer **Typetown**
Printer **Donahue Printing**
Fabricator **Ampersand Signage**
Paper **Champion Benefit**
Client **Fusion at PDC, LLC**

The Voice of the Homeless

To alleviate the invisibility of the homeless, we aspired to collect and express their feelings about the labels and judgments imposed on them by society. Their collective words form an encircling frieze of inscriptions in a rotunda. Facing outward toward a corporate skyline of banks, an interactive electronic information system empowers the homeless to exercise a public voice through their mastery of computer technology.

Design Firm **B.J. Krivanek, Chicago, IL**
Art Director **B.J. Krivanek**
Environmental Designer **Joel Breaux**
Photographer **Jeff Kurt Petersen**
Technical Assistant **Martha Najera**
Writers **The Residents of the Union Rescue Mission**
Fabricator **Peter Carlsen Enterprises**
Client **The Union Rescue Mission**

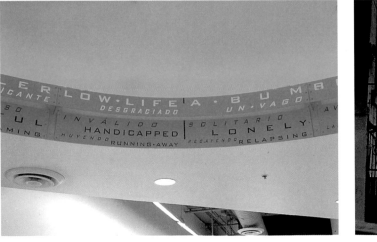

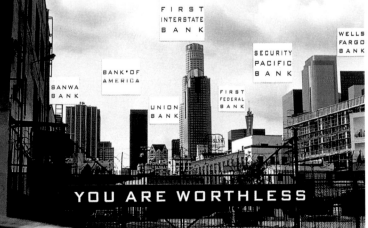

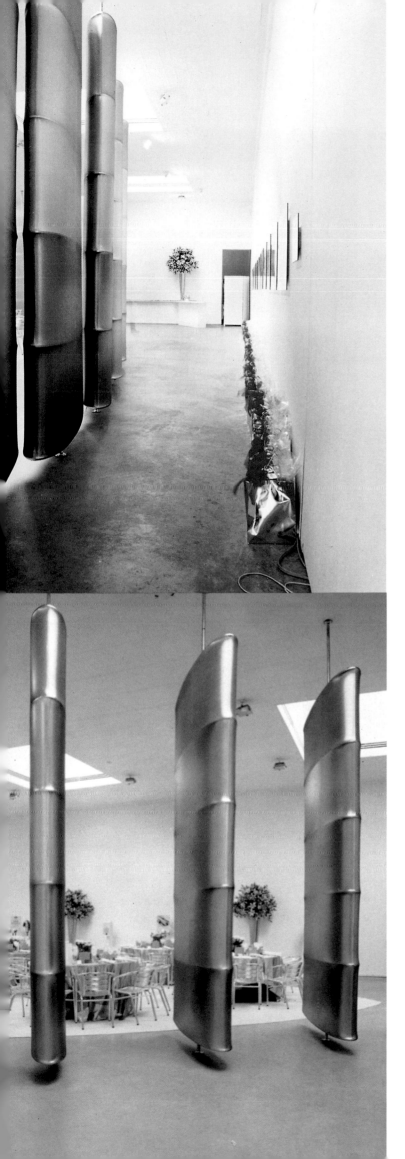

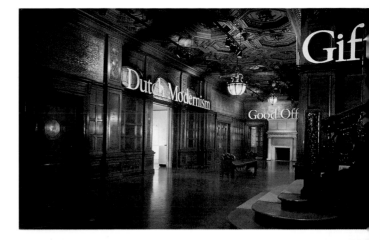

▲

Environmental Graphics:
Cooper-Hewitt, National Design Museum

To proclaim the museum's mission as a national advocate for design, a new identity was created. The design program emphasizes the client's new name — National Design Museum — and includes large-scale environmental graphics. The museum's mission is to spread the word that design is an activity that affects every aspect of our daily lives: a process, not just a class of objects. All aspects of the environmental graphics attempted to address this new mission — namely, by surprise, intrigue, and illumination, all on a tight budget.

Design Firm **Drenttel Doyle Partners, New York, NY**
Creative Director **Stephen Doyle**
Graphic Designer **Terry Mastin**
Client **Cooper-Hewitt, National Design Museum, Smithsonian Institution**

◄

L'Oréal Beauty Event

At a press lunch in the Matthew Marks Gallery in New York City, L'Oréal introduced the top beauty and fashion editors to Cybershine, their new make-up line. The huge industrial space was converted into a dream world in the new sheer, shiny, metallic L'Oréal colors.

Design Firm **360°, Inc., New York, NY**
Art Directors **Herta Kriegner and Janine Weitenauer**
Designers **Jochen Schapers and Mark Seelen**
Photographer **Mark Seelen**
Fabricators **SFI Interiors**
Client **L'Oréal**

Walt Disney Feature Animation Building

The graphics program for this building — the work-space for the creators of Disney's animated feature films — suggests the classic structures of Kem Weber, architect of the Disney Studios. In this 243,000-square-foot building, the 750 room identification signs reflect the building's unique shape; the floors are color coded. Functional yet entertaining directional signs relate to 1930s signs on the studio lot.

Design Firm **Beck & Graboski Design Office, Santa Monica, CA**
Creative Directors **Constance Beck and Terry P. Graboski**
Graphic Designer **Terry P. Graboski**
Photographers **Peter Aaron, Terry P. Graboski, and Ave Pildas**
Fabricators **Ampersand Contract Signing and Cornelius Architectural Products**
Client **Disney Development Co.**

Rock and Roll Hall of Fame and Museum Exhibition Design

The design brief for the 40,000-square-foot museum and Hall of Fame was to provide fresh interpretations of the subject matter for visitors who in a sense already "own" the art. The tools of rock — sound, video, changing lighting effects, costumes, and memorabilia — are combined with dynamic exhibit structures and graphic imagery to create a new type of museum environment that expresses the music's edge and energy. Visitors can explore rock and roll via four interactive computer programs — each composed of large databases of audiovideo material.

Design Firm **The Burdick Group, San Francisco, CA**
Designers **Bruce Burdick, Susan Burdick, Aaron Caplan, Johnson Chow, Jerome Goh, Cameron Imani, Bruce Lightbody, Stuart McKee, and Jeff Walker**
Photographer **Timothy Hursley**
Printer **ScreenAmerica (silkscreen) for Design & Production**
Fabricator **Design & Production, Turner Construction**
Client **Rock and Roll Hall of Fame and Museum**

Craig • Singleton • Hollomon/Architects Signage

The interior landmark sign, fabricated of raw, mild steel, measures approximately 40 inches square. The surface is a study in contrasts: the firm's square mark is made evident by leaving the naturally dark and modeled steel untreated and exposed to develop further patina, whereas the surrounding borer is scribed, brushed, and routed to a bright finish and sealed to preserve the intricately reflective shine. Dimensional steel letterforms playfully spell "ARCH+ECTS" while the partners' names are applied in crisp vinyl letters around the tooled border, punctuated with brass accents.

Design Firm **Communication Arts Company, Jackson, MS**
Art Director **Hilda Stauss Owen**
Graphic Designer **Hilda Stauss Owen**
Fabricator **Ed Millet (Steel Sculptor)**
Client **Craig • Singleton • Hollomon/Architects**

Minnesota Children's Museum

This wonderful museum provides "hands-on" fun for children of all ages. The rest is rather obvious.

Design Firm **Pentagram Design, New York, NY**
Creative Director **Michael Bierut**
Graphic Designers **Michael Bierut and Tracey Cameron**
Photographers **Michael O'Neill (children's hands) and Judy Olausen**
Interior/Signage **Don F. Wong**
Fabricator **Cornelius Architectural Products**
Client **Minnesota Children's Museum**

Simple Shelter

Simple Shelter, a prototypical tent, was developed
in response to consumers' request to lower the cost
of the extended rental burden for a seasonal farmer's
market. Simple Shelter provides a functional, portable,
and easily assembled shelter. The project was con-
ceived, designed, tested, and manufactured in less than
ninety days. The cost per tent was under $300, signifi-
cantly less than the accumulated rental costs for the
standard four-post pyramid canvas tent.

Design Firm **Wagner Murray Architects,
Charlotte, NC**
Art Director **David K. Wagner**
Fabricator **Erdle Perforating, Inc.**
Client **Charlotte Uptown Development Corporation**

The Most Amazing Larry Ever Is Here. ⑤LARRY'S SHOES

Larry's Shoes Outdoor Billboard

To introduce a new superstore being added to the
Larry's Shoes chain, we created a teaser campaign
that reinforced the client's name and their innovative
approach to retail. Larry's offers their customers
cappuccino, foot massages, live music, and a shoe
museum — in addition to a large assortment of men's
shoes at great prices. The most successful part of
our campaign is the way each "Larry" appeals to each
segment of Larry's customer base — which is any
man who has ever watched TV.

Design Firm **Joiner Rowland Serio, Dallas, TX**
Creative Director **Robert Joiner**
Graphic Designer **Allen Weaver**
Photographer **Stock**
Writer **Jim Sykora**
Client **Larry's Shoes**

XIX Amendment Installation
at Grand Central Station

The objective of this installation was to increase aware-
ness of the seventy-fifth anniversary of the Nineteenth
Amendment. The budget was small and the room
enormous. By enlarging the law to fill the room, we con-
fronted passersby with the monumental one-sentence
amendment itself. The actual text of the amendment
was applied in eight-foot letters (9,936-point type) to
the marble floors of the main waiting room in Grand
Central Station. A 20-foot "tower" presented historical
references enlightening the history of the struggle for
suffrage.

Design Firm **Drenttel Doyle Partners, New York, NY**
Creative Directors **William Drenttel,**
Stephen Doyle, and Miguel Oks
Graphic Designers **Stephen Doyle and Lisa Yee**
Architectural Designer **James Hicks**
Photographer **Scott Frances**
Printer (Tower Imagery) **Duggal Color Projects**
Client **New York State Division for Women**

Street Sign Billboard

Design Firm **MTV Off-Air Creative, New York, NY**
Art Director **Jeffrey Keyton**
Graphic Designer **Darlene Cordero**

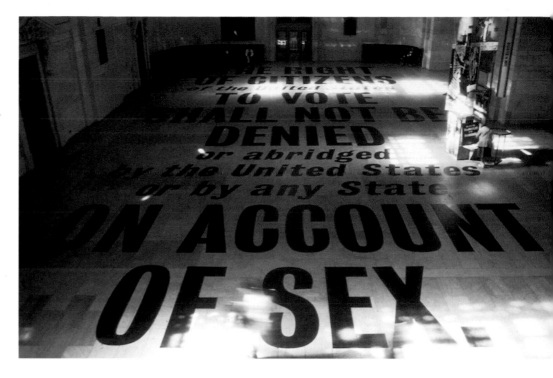

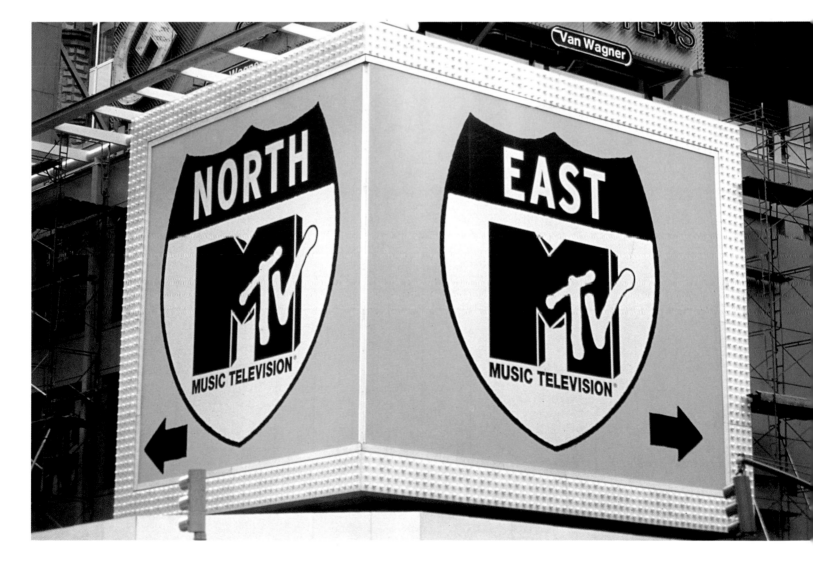

Fish Tales

by Moira Cullen

Not less than fifty years ago
in nineteen hundred forty-six
a "house" was built near Union Square
by Farrar Straus Giroux.

As publishers, indeed, they chose
to shun not prose or poetry
in order to purvey the best
in literary wares.

As for a mark to brand their goal —
work by those elusive, prized —
three fish of glinting scale and tail
lured by contract, not line
or pole.

Soon medals, honors, awards were won
with many a Pulitzer and Nobel.
Careers were launched, the imprint esteemed
both nationwide and 'round the world.

Draped across these written tomes
were jackets — sleeves of paper
layering image, type with color, form
revealing content unexposed.

The creators of these cover tales
remained, discreet, behind the scenes;
their graphics spoke — a visual song
that informed, enthralled
(and beckoned sales).

Then in the fall of ninety-six
preparing for its fiftieth,
FSG recalled those who had portrayed
its list with style and care.

They asked these masters of media
to render the corporate personal
Their logos — a fish in fifty forms —
were gathered to be shown, then sold.

September saw the fish on view
in the AIGA's design gallery.
A gala celebration concluded the show
with a silent auction by Sotheby's.

The proceeds went to nonprofit groups
dedicated to Manhattan's youth
and literacy in public schools,
for oft a cover hooks new readers
to the pleasures of the book.

Exhibition poster designed
by Michael Ian Kaye

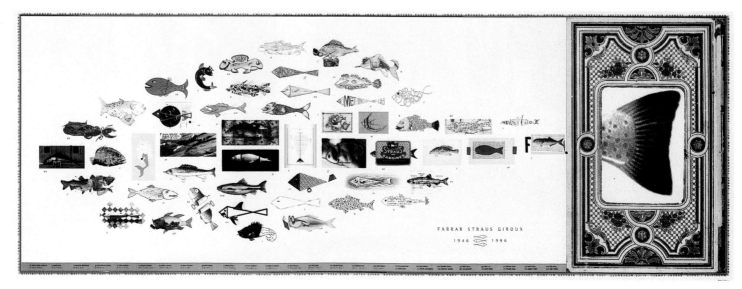

50

FARRAR

STRAUS

GIROUX

Exhibition logo designed
by Michael Ian Kaye

**Participating
Designers,
Photographers,
and Illustrators**

Robert Clyde Anderson

Natalie Babbitt

Paul Bacon

Syndi Becker

Roxanna Bikadoroff

Marty Blake

Carol Devine Carson

Brock Cole

Chris Conover

Alexandra Day

Barbara De Wilde

Drenttel Doyle Partners

Olivier Dunrea

Richard Egielski

Sara Eisenman

Louise Fili

Evan Gaffney

Roy Gerrard

Milton Glaser

Carin Goldberg

Leslie Goldman

Janet Halverson

Melissa Hayden

Miles Hyman

Tove Jansson

Michael Ian Kaye

Chip Kidd

Satoshi Kitamura

Edward Koren

Cynthia Krupat

Marshall Lee

Laura Ljungkvist

Leah Lococo

Lee Lorenz

Fred Marcellino

Mona Mark

Ruth Marten

Michael McLaughlin

Wendell Minor

Lawrence Ratzkin

Paul Sahre

Uri Shulevitz

Peter Sis

David Small

Adriane Stark

William Stieg

Mark Tauss

James Victore

Chip Wass

Julie Wilson

Design on the Street

Mixing Messages
in Public Space

The urban environment is annotated with countless visual messages, from global ad campaigns to political posters and promotions for cultural events. Corporations, city governments, and advertisers as well as museums, theaters, artists, and activists compete for the public's attention on the street. Graphic designers use typography and imagery to shape the meaning and impact of innumerable communications that confront us each day, imploring us to buy, to watch, and to participate.

Graphic design has become an increasingly forceful presence in our lives over the past fifteen years. During this period, technological innovations have triggered an enormous explosion of creativity in all forms of visual communication, from the printed page to the Internet. No single aesthetic approach identifies contemporary design, which has accommodated diverse styles and methods, media and messages, producers and users of visual information.

Design elicits responses in a crowded landscape of competing signals. The mix of messages that characterizes contemporary design reaches a peak of intensity in

urban public space. The special installation assembled in the AIGA gallery invokes the context of the street — a place where numerous modes of communication converge and overlap — as a microcosm of design practice.

This special installation (on view from October 3 to November 23, 1996) was organized by the Cooper-Hewitt, National Design Museum, and the AIGA. The exhibition was made possible by the Design Arts Program, National Endowment for the Arts, and was designed and assembled by Eva Christina Kraus. The project was directed by Ellen Lupton, curator of contemporary design at the Cooper-Hewitt, National Design Museum. *Design on the Street: Mixing Messages in Public Space* was organized in conjunction with *Mixing Messages: Graphic Design in Contemporary Culture,* an exhibition at the Cooper-Hewitt, National Design Museum.

Special thanks to Bullet Space/Andrew Castrucci, Eddy Desplanques, Camilo José Vergara, and the dozens of artists whose work was included in the exhibition.

Time for Prevention
Designer: Matuschka

a fragrance for
a man or a woman

Calvin Klein

GeNIUS →

Leopold + Loeb
Love gone mad. History gone bad.

JeW ↑

MURDeRER ↰

QUeeR ↙

SWOON

SOMETHING'S WRONG WHEN
FRIGIDAIRE AND WESTINGHOUSE
DO A BETTER JOB
OF HOUSING THE HOMELESS
THAN NEW YORK CITY.

COALITION FOR THE HOMELESS

Nina, Kate & Joey, ck One
Creative Director: Fabien Baron
CRK Advertising

Gypsy Cab Cards
Collection of Camilo José Vergara

Something's Wrong...
Designers: Peter Cohen and Leslie Sweet

Swoon
Designers: Marlene McCarty and
Donald Moffett, Bureau

The AIGA Corporate Partners

The AIGA gratefully acknowledges the following corporations for their in-kind and financial contributions this past year. We appreciate and value their support, and recognize the contribution they make to the success of the AIGA's conferences, programming events, competitions, publications, and much more. The AIGA will continue to build alliances with corporate partners that are strategic and mutually beneficial to meet the needs of our membership and their long-term objectives.

Adobe Systems Incorporated
AGFA
Anderson Lithograph
Apple Computer
Appleton Papers, Inc.
Beckett Paper
Blazing Color, Inc.
Central Florida Press
Champion International Corporation
Crane Business Papers
Crown Vantage, Curtis Fine Papers Division
CTI Paper USA, Inc.
Daniels Printing
Dickson's Inc.
DIGEX, Inc.
Domtar Specialty Fine Papers
Fine Arts Engraving Company
Fox River Paper Company
Fraser Papers
French Paper Company
George Rice & Sons
Georgia-Pacific Papers
Gilbert Paper
Graphic Arts Center
Graphis, Inc.
Grossberg Tyler Lithographers
Hammermill Paper
The Hennegan Company
Heritage Press

Howrey & Simon
Island Paper Mills
K.P. Corporation
L.P. Thebault Company
Lithographix, Inc.
Luxana Fine Paper
Mead
Milocraft, Inc.
Mohawk Papers Mills, Inc.
Monadnock Paper Mills, Inc.
Neenah Papers
NFL Properties
Nike
Pantone, Inc.
PhotoDisc, Inc.
Potlatch Corporation
The Press
S.D. Warren
Simpson Paper Company
Strathmore Papers
Stinehour Press
Tony Stone Images
Trojan Lithograph
Wace The Imaging Network
Western Paper
Westvaco Corporation
Weyerhaeuser
Williamson Printing Corporation
Zanders USA, Inc.